FutureNatural

We are living in an age when 'nature' seems to be on the brink of extinction yet, at the same time, 'nature' is becoming increasingly ubiquitous and unstable as a category for representation and debate.

FutureNatural brings together leading theorists of culture and science to discuss the concept of 'nature' – its past, present and future. Contributors discuss the impact on our daily life of recent developments in biotechnologies, electronic media and ecological politics, and how scientific theories and models have been taken up as cultural metaphors that have material effects in transforming 'ways of seeing' and 'structures of feeling'.

This book addresses the issue of whether political and cultural debates about the body and the environment can take place without reference to 'nature' or the 'natural'. This collection considers how we might 'think' a future developing from emergent scientific theories and discourses. What cultural forms may be produced when new knowledges challenge and undermine traditional ways of conceiving the 'natural'?

Editors: **George Robertson**, **Melinda Mash**, **Lisa Tickner**, **Jon Bird**, **Barry Curtis**, **Tim Putnam**, all at Middlesex University.

Contributors: Sean Cubitt, Karl Figlio, Evelyn Fox Keller, N. Katherine Hayles, Sarah Kember, Les Levidow, Trinh T. Minh-ha, Nelly Oudshoorn, Sadie Plant, Mark Poster, Andrew Ross, Neil Smith, Kate Soper, Tiziana Terranova, Tom Wilkie, Richard Wright, Slavoj Žižek.

FUTURES: New perspectives for cultural analysis

Edited by Jon Bird, Barry Curtis, Melinda Mash, Tim Putnam, George Robertson and Lisa Tickner

Recent postmodern philosophers have undermined the viability of social and cultural futures as an urgent priority for cultural theory. The 'Futures' series sets out to reinstate the discussion of the future in cultural enquiry through a critical engagement with postmodernity. The books arise from and continue the concerns of *Block* (1979–1989), the journal of visual culture. Each volume will draw together new developments in a range of disciplines that have taken as their common focus some particular aspect of social transformation and cultural analysis.

Other titles in this series

Travellers Tales: Narratives of Home and Displacement
Mapping the Futures: Local Cultures, Global Change

FutureNatural

Nature, science, culture

Edited by George Robertson,
Melinda Mash, Lisa Tickner, Jon Bird,
Barry Curtis and Tim Putnam

London and New York

Funded by
THE
ARTS
COUNCIL
OF ENGLAND

First published 1996
by Routledge
11 New Fetter Lane, London EC4P 4EE

Simultaneously published in the USA and Canada
by Routledge
29 West 35th Street, New York, NY 10001

Typeset in Times Ten by Florencetype Ltd,
Stoodleigh, Devon

Printed and bound in Great Britain by
Biddles Ltd, Guildford and King's Lynn

British Library Cataloguing in Publication Data
A catalogue record for this book is available from the
British Library

Library of Congress Cataloguing in Publication Data
FutureNatural: nature, science, culture / edited by George Robertson
. . . [et al.].
p. cm. – (Futures, new perspectives for cultural analysis)
Includes bibliographical references and index.
1. Nature. 2. Culture. 3. Human ecology. I. Robertson, George.
II. Series.
QH81.F88 1996
304.2–dc20 95-25912

ISBN 0–415–07013–9 (hbk)
ISBN 0–415–07014–7 (pbk)

Contents

Figures

Notes on contributors

Sean Cubitt is Reader in Video and Media Studies at Liverpool John Moores University. He is the author of *Timeshift: On Video Culture* (1991) and *Videography: Video Media as Art and Culture* (1993). A member of the editorial boards of *Screen* and *Third Text*, he has published widely on contemporary arts, media and culture.

Frank Dexter writes for *Here and Now* Magazine (PO Box 109 Leeds LS5 3AA).

Karl Figlio is a psychoanalytic psychotherapist with the Association for Group and Individual Psychotherapy in London and is also the Director for the Centre for Psychoanalytic Studies at Essex University. His research interests include psychoanalysis and culture and the place of nature in psychoanalytic theory.

N. Katherine Hayles is Professor of English at the University of California, Los Angeles. She teaches and writes on relations between literature and science in the twentieth century. Her books include *Chaos Bound: Orderly Disorder in Contemporary Literature and Science* (1990) and *Chaos and Order: Complex Dynamics in Literature* and *Science* (1991). She is currently finishing a book entitled *Virtual Bodies: Evolving Materiality in Cybernetics Literature and Information*.

Evelyn Fox Keller teaches on the Program in Science, Technology and Society at the Massachusetts Institute of Technology. She is the author of *Reflections on Gender and Science* (1985), and *Secrets of Life, Secrets of Death: Essays on Language, Gender and Science* (1992), and has co-edited *Body/Politics: Women and the Discourses of Science* (1990) and *Conflicts in Feminism* (1990), most recently she has written *Refiguring Life: Metaphors of Twentieth-century Biology* (1995).

Sarah Kember is a lecturer in Media and Communications at Goldsmiths' College, University of London. She is the author of several articles on photography and new imaging technologies, and the relationship between

technology and subjectivity; her forthcoming book is *Virtual Anxiety: Photography, New Technology and Subjectivity.*

Les Levidow is a research fellow at the Open University, where he studies the safety regulation of agricultural biotechnology. He has been Managing Editor of *Science as Culture* since its inception in 1987. He has co-edited several books including *Science, Technology and the Labour Process* (1985), and *Cyborg Worlds: The Military Information Society* (1989).

Trinh T. Minh-ha is a writer, film maker and composer. Her more recent works include the books *Framer Framed* (1992) and *When the Moon Waxes Red* (1991); and the films *A Tale of Love* (1995), *Shoot for the Contents* (1991), *Surname Viet Given Name Nam* (1989), and *Naked Spaces* (1985). She is Professor of Women's Studies and Film at the University of California, Berkeley.

Nelly Oudshoorn is Professor of Gender and Technology at the University of Twente, Enschede and an assistant professor in the Department of Science and Technology Dynamics at the University of Amsterdam. Her research interests include the institutional and material conditions for developing knowledge around sex and the body; she is currently focusing on the constraints in the development of male contraception. She is the author of *Beyond the Natural Body: An Archaeology of Sex Hormones* (1994).

Sadie Plant is a Research Fellow at Warwick University. She is author of *The Most Radical Gesture: The Situationist International in a Postmodern Age* (1992), and the forthcoming *Beyond the Spectacle*. She has written widely in the area of Cyber-feminism and other themes relating to Cybernetics.

Mark Poster is Professor of History and Computing Science at the University of California, Irvine. He is editor of *Selected Writings of Jean Baudrillard* (1988), author of *The Mode of Information: Post-structuralism and Social Contexts* (1990) and *The Second Media Age* (1995).

Andrew Ross is Professor and Director of the Program for American Studies at New York University. His previous publications include *No Respect: Intellectuals and Popular Culture* (1989), *Strange Weather: Culture, Science and Technology in the Age of Limits* (1991) and most recently, *The Chicago Gangster Theory of Life: Nature's Debt to Society* (1994). He is co-editor of the journal *Social Text.*

Neil Smith is Professor of Geography and Resident Fellow at the Center for the Critical Analysis of Contemporary Culture at Rutgers University, New Jersey. He is the author of *Uneven Development: Nature, Capital and the Production of Space* (1984), co-editor of *Geography and Empire*

(1994) and author of *New Urban Frontier: Gentrification and the Revanchist City*.

Kate Soper is Senior Lecturer in Philosophy at the University of North London, and has worked as a journalist and translator. She is the author of *On Human Needs* (1981), *Humanism and Anti-humanism* (1986), *Troubled Pleasures* (1990) and most recently *What is Nature? Culture, Politics and the Non-Human* (1995).

Tiziana Terranova is researching high-tech subcultures and is currently based in London (Goldsmiths' College) and in New York (NYU).

Tom Wilkie has been Science Editor of the *Independent* newspaper since its foundation in 1986 and was formerly Features Editor of *New Scientist*. He is the author of *British Science and Politics since 1945* (1991) and most recently *Perilous Knowledge: The Human Genome Project and its Implications* (1993), which investigates the technical advances in modern genetics and provides a critical analysis of its moral, social and political consequences.

Richard Wright is a media artist specialising in computer animation. He writes widely on electronic art and culture and was lecturer in computer graphics at London Guildhall University. His latest project *Heliocentrum* is a computer animation about Louis XIV and the technology of leisure.

Slavoj Žižek is a philosopher and psychoanalyst. He is the Senior Researcher at the Institute for Social Sciences at the University of Ljubljana. His most recent publications include *Tarrying with the Negative: Kant, Hegel and the Critique of Ideology* (1994), *Metastases of Enjoyment: Six Essays on Women and Causality* (1994) and he is also editor of the forthcoming *Mapping Ideology* (1995).

Jon Bird, Barry Curtis, Melinda Mash, Tim Putnam, George Robertson and Lisa Tickner are the editors of the 'Futures' series.

Acknowledgements

With this the third volume in the 'Futures' series, our thanks and acknowledgements begin to have a familiar ring, so once again our thanks go to the Education Department of the Tate Gallery, London, especially to Richard Humphreys, Andrew Brighton, Sylvia Lahav and Julie Gomez for their continuing help and advice. Recognition must also go to the warders and maintenance staff of the Tate Gallery who restored order with speed and efficiency when nature (in the form of flood) threatened to engulf the first morning of 'The Future of Nature'; Sandy Nairne's level-headedness and calming welcome were also much appreciated at this moment. Respect is also due to Andrew Ross and Evelyn Fox Keller for keeping their cool in the face of techno-adversity.

At the Visual Arts Department of the Arts Council of Great Britain we gratefully acknowledge the support of Marjorie Althorpe-Guyton, Jane Bilton, and Eileen Daly. At Routledge, we salute Rebecca Barden who has been unstinting in her support and her colleagues Helen Wythers and Jennifer Binnie.

We are also much indebted to colleagues at Middlesex University for advice and assistance: our special thanks must also go to Sally Stafford for her patience and invaluable help. Melinda Mash and George Robertson, in particular, would like to thank Doug Wilkie for material assistance in that space where science meets culture.

Introduction: look who's talking

Today nature is filmed, pictured, written about and talked about every-where. As the millennium approaches, those images and discussions are increasingly phrased in terms of crisis and catastrophe but the current crisis is not only out there in the environment; it is also a crisis of culture. It suffuses our households, our conversation, our economies. To speak uncritically of the natural is to ignore these social questions.

Alexander Wilson[1]

Any consideration of possible futures must attend, not only to economic, social and political disruptions (as in the previous two volumes in this series), but also to the dramatic changes wrought by radically new devel-opments in science, not only on our technologies but on our sense of being and our models for understanding the world. The hazards involved in confronting 'science' as a topic for a BLOCK conference proved unmanageable and we decided to approach these issues obliquely under the rubric of 'The Future of Nature' (Tate Gallery, London; November 1994).

On one level 'nature' is like all concepts, a product of discourse, but its referent is also the subject of politics. There are real threats to what-ever we conceive the 'natural' to be; the air, the land, the oceans, our bodies. The fragility of the concept 'nature' and the instability of its referent are strikingly demonstrated in the muddled vocabularies of envi-ronmental politics and in our struggles to come to terms both with the implications of new genetic and reproductive technologies and with the psychic consequences of the loss of 'nature' as a foundational concept, a ground of being, a stable otherness to the human condition.

The concerns of *Futurenatural* are thus threefold; the construction and reproduction of 'nature', the ways that this 'nature' is then instrumental in defining what is or is not natural, and how formulations of 'what is natural' eventually attain the status of convention that present 'nature' and 'the natural' as seemingly unproblematic. But central to these themes are also questions about the future configurations of 'nature' and 'the

natural' in the light of technological developments that threaten radically to disrupt most of the certainties we hold about the social world.

Thinking a 'future of nature' requires us to situate the specifically contemporary aspects of thinking about the natural; and, it would seem to be that there are two overlapping varieties of current concern about the continued pertinence of the natural, focusing respectively on the ways in which knowing or transacting the world posit a terrain which is then undermined. Although the circumstances which give rise to each are presented as 'just happening', they partake of long-established traditions of epistemological self-consciousness and critical reflection on technology.

So, on the one hand 'nature' is an apparently indispensable structural concept that is, as Kate Soper points out, invoked as 'an independent domain of intrinsic value, truth or authenticity'. On the other, this 'political' configuration of 'nature' contrasts radically with the contention that 'nature' is no more than the effect of discourse, existing 'only in the chain of the signifer'. Simultaneously, contestation over what nature 'means' must deal with increasing scientific and technological interventions into 'the natural', with the constraints these effect and the resulting elusiveness of a concept that can barely sustain the weight of competing articulations. How can we distinguish meaningfully between a 'nature' that is both 'real' and 'illusionary'?

Various theoretical engagements with 'nature' – feminist theory, poststructualism, deconstruction – have made it impossible to maintain previous understandings of 'nature' as an innocent given; it is always a construct, created between 'absence' and 'presence': impossible to pin down, yet necessary for the production of meaning (for both culture and the subject). If theoretical tinkering with 'nature' has resulted in the conceptual dissolution of the ground, this is mirrored in the 'real' world by the constant blurring of boundaries between the 'natural' and 'the technological'. So, in contemporary discussions and practices we find both signs that self-awareness about the way knowing works makes the natural recede and the old notion of 'nature' as ground difficult to sustain, and signs of renewed efforts to posit a 'natural' and indeed to work polemically with 'nature' in social critique. Thus we are 'after' nature on two oddly juxtaposed ways and the various papers in the collection exhibit signs of this tension and ambivalence.

The question of what remains to the 'natural' when nature is cultural – a product of discourse – and when what had been the territory of the 'natural' is taken over by the intervention of human engineering, is a pressing one. But when critical attention is drawn to the socially constructed nature of scientific enquiry or technological enterprise (and thus of nature) the primary effect seems to feed a movement to naturalize social convention, rather than do without the natural altogether.

Traffic has been particularly heavy around the catagory of the person (and the phenomenology of the body), as cybernetic and genetic technologies simultaneously extend its scope and invade its autonomy. In a sense the problems thus raised around the naturalizing of the individual subject are familiar, prefigured in mind/body and freedom/reason debates. As our contemporaries thus struggle to reinvent human nature in suitable discourse, its material perimeters are being continually modified in struggles between social powers and movements concerning the direction and application of science and technology. What, for instance, might future notions of the self be, given that existing models of psychic structuring are grounded in an essential relationship to the (natural) maternal body, when new genetic and biomedical technologies threaten (or promise) radically to disrupt this 'natural' relationship? Or, where is the subject in cyberspace? Does access to new forms of information representation offer up the possibility of exploring and experiencing an unlimited range of 'new' subjectivities, or simply involve a masking of a core matrix of identity?

In planning *Futurenatural* we also wanted to focus on questions of epistemology – on how knowledge structures and mediates both individual and social being. The contributors to this book follow two main tacks. The first is a recognition that while you cannot ostensibly refer to nature, studying the material practices of scientific representation does give an approach to nature as a graspable entity – an understanding of the discursive formation of scientific knowledge allows for the potentiality of disrupting pre-existing, conventionalized forms of knowledge and then re-configuring both that knowledge and its significatory function. The second approach is to speculate in the longer term on what may be the epistemological fall-out of a nature re-contextualized within dramatic new technologies and scientific world-views. The questions being asked and the languages being used are at times oblique and contradictory, but at their heart there is a general sense that we are on the cusp of an epistemic break. An example: most people on first acquaintance with quantum physics, are struck by a superficial correspondence to post-structuralist theory – stress contingency, indeterminacy, plurality and possibility. The more mystically inclined may also see a convergence with a certain 'New Age sensibility' – holistic, interconnected, reality as an illusion.

An obvious problem is how do we describe the not-yet-knowable; what exactly does it mean to talk about connections, correspondences, analogies, paradigms, and so on? What, if any, is the relationship between, for instance, a new cultural form such as interactive multi-media or hypertext and the new physics? The text is (supposedly) infinitely open, the cultural object as such has disappeared, to be replaced by the process, and the text produced from this process can be likened to the wave function of quantum theory – only ever fixed (collapsed) by the intervention

of human agency. This may, of course, be nothing more than 'metaphor' but, increasingly, scientific theories and models have been taken up precisely as cultural metaphors which have material effects in transforming 'ways of seeing' and 'structures of feeling'. Does this in itself suggest the preconditions for a paradigm shift and the development of a new epistemology? What does it mean to invoke the 'quantum self', the 'virtual community', or the 'holographic universe', and what is the use-value of such formulations?[2]

We interrogate nature in a range of voices and registers. Answers are elusive; in trying to comprehend them we recall a line from Laurie Anderson:

> All of nature talks to me
> if I could just figure out what it was trying to tell me.

NOTES

1 Alexander Wilson (1992) *The Culture of Nature*, London: Blackwell: 12.
2 See, for instance, Danah Zohar (1991) *The Quantum Self*, London: Flamingo; Alan Moore and Bill Sienkiewicz (1990) *Big Numbers*, Northampton: Mad Love (Publishing); David Bohm (1980) *Wholeness and the Implicate Order*, London: Routledge; Stanislav Grof (1993) *The Holotropic Mind*, New York: Harper Collins; Micheal Talbot (1991) *The Holographic Universe*, New York: Harper Collins.

Part I

The nature of 'nature'

Chapter 1

The future is a risky business

Andrew Ross

In the late 1970s, when I was a graduate student, I, like others of my intellectual formation, spent a good deal of my time in reading groups devoted to Marx and Freud. The context for these groups was what was often referred to as the crisis of the human sciences, for which Marx and Freud were authoritative forebears. Today, the location of some of the crises has moved into the realm of nonhuman nature, and into the natural sciences. If students asked me today, in the mid-1990s, all things being equal, how they might profit from a similar pursuit, I think I would suggest that they form a Darwin reading group. For, in many ways, it is the legacy of ideas about evolutionary science that is increasingly occupying the forefront of our social and political environment. If the authority of nature and biology has been kept at bay for much of this century, it has made a remarkable return in recent years, and is once again the ground of appeals to social policy and cultural righteousness. The contest over Darwinism, in one form or another, may turn out to be one of the more crucial debates of the next decade, and it is a debate that cultural critics and social theorists should be part of. In this essay, I will look at just a few of the symptoms of this revival.

A FEW GOOD SPECIES

The recently publicized plan to reconstruct the Pentagon building according to ecological, energy-efficient principles is an outward sign of a much heralded remodelling of the military's image. New acquisition regulations for weapon systems are being geared to, 'integrating environmental considerations' into assessments of their 'life-cycles'. Native Americans may soon be allowed access to religious and sacred sites on Department of Defense (DoD) lands. The military's mighty surveillance networks are being revamped as ecological early-warning systems. What next? The reforestation of Vietnam? In an apparently humour-free gesture, the Marine Corps also introduced a new recruiting poster which shows an amphibious landing at Pendleton Beach, Calfornia. Strutting in

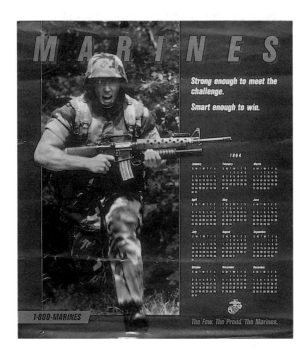

Figure 1.1 Before

the foreground is a Western snowy plover, a bird that made it on to the Endangered Species list in 1993, and whose Pendleton Beach habitat is now apparently protected through its use by the Marines as a combat training area. Riffing off the Marines' unofficial motto ('We're Looking for a Few Good Men'), the poster's smugly captioned graphic – 'We're Saving a Few Good Species' – is, among other things, a droll reminder of the Marines' overseas role as military executors of social Darwinism for an entire century now (if we take the Hawaiian coup in 1893 as an official point of origin). But it also captures one of the most incongruous spectacles of our times – the so-called greening of the armed forces, or, from another perspective, the emergence of a military-industrial-environmental complex.

Since the cessation of the Cold War, and the onset of the half-hearted *conversion* of the permanent war economy, and in the wake of Operation Provide Comfort in Kurdistan, Operation Sea Angel in Bangladesh, Operation Restore Hope in Somalia, Operation Uphold Democracy in Haiti, and Operation Support Hope in Goma, Zaire, the US armed forces and their allies have taken on many of the public relations functions of a 'health care provider' in their attention to operations other than war

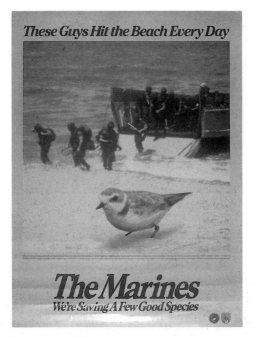

Figure 1.2 After

(OOTW). Things have got so soft for the leathernecks in the new peace-keeping industry that Secretary of Defense, William Perry recently complained to Congress: 'We are an army, not a Salvation Army.' As for the military's new ventures into environmental preservation and restoration, a good deal of their focus has been on 'iatrogenic' problems, which, in medical terminology, are illnesses induced by exposure to medical institutions themselves. In common with many of the new developments in technoscience, the Pentagon is increasingly fighting a battle against threats generated by its own industrialization. The bill for cleaning up the military's own Cold War legacy is already enough to sustain a sizeable Defense industry on its own. The DoD's current clean-up estimate begins at $30 billion and rises as high as $200 billion. Thomas P. Grumbly, environmental supremo at the Department of Energy (DoE), who presides over the largest environmental budget in the world, estimates the clean-up cost of the nuclear weapons complex (at Hanford, Rocky Flats, Savannah River and thousands of other DOE facilties) at $1 trillion. The mess includes 100 million gallons of highly radioactive waste, 66 million gallons of plutonium waste, even larger volumes of low-level radioactive waste, and an ocean of toxic materials such as heavy metals and hazardous chemicals. For the job of mopping up at over 10,000 military sites at home

and abroad, his respective counterparts at each of the armed services hustle for their massive budgets with the same technorationality as they sue for new weapons systems. As Lieutenant Colonel Sherman Forbes, chief of the Air Force's acquisition pollution prevention programme, shrewdly puts it, his people 'are environmental managers, not environmentalists', ensuring environmental compliance in the same way as they ensure combat readiness.

Do these developments represent an ethical awakening of the military mentality as we know it? Or are they just another PR greenwashing campaign of the sort pioneered by the giant chemical and oil companies? No one needs to believe that the Pentagon's mission is really being reshaped along humanitarian lines to see that attention to environmentalism has become one of the doctrinal cornerstones for the future of the Defense establishment. For the first half of the 1990s, the concept of 'environmental security' (introduced at the 42nd session of the UN General Assembly in 1987) was touted as one of the more likely successors to the 'Communist threat' as an organizing principle of military-industrial policy. With the Republican takeover on Capitol Hill, it has been joined, but not displaced, by the more bellicose concept of the 'two war' strategy.

Consider the testimony of Sherri Wasserman Goodman, in her recently created position as Deputy Under Secretary of Defense for Environmental Security, speaking in the US Senate before a fiscal appropriations meeting of the Armed Services Subcommittee on Military Readiness and Defense Infrastructure, on 9 June 1993.

> I was just down last week at Fort Bragg and I had a chance to see how the Army is doing in protecting the Red Headed Woodpecker at the base. And let me say, I think it is doing a terrific job there. It has protected the pine trees in which this bird lives. It is one of the few homes for this bird remaining. In fact, the Army now even builds homes for these birds in the trees because the bird requires 3 to 5 years to actually peck its home, and the Army goes out and builds some additional homes for it.

This kind of talk must have given Pentagon lifers the creeps, and may well provide ammo for all the Gingrich 'tree-hugger' haters now in control of the House committees (some substantial cuts have already been legislated in the DoD's Environmental Restoration Account). But listen to Ms Goodman as she goes on to brief this, and many subsequent, committees, on the threats to environmental security faced by the national interest. Broken down into the Pentagon's customary theatres of operation, these threats are either global – such as 'ozone depletion, global warming and loss of biodiversity', regional – such as 'environmental terrorism, conflicts caused by scarcity or denial of resources, and cross border or global commons contamination', or national – such as 'risks to public health and

the environment from DoD activities, increased restrictions on military operations, inefficient resource use, reduced weapons system performance, and erosion of public trust'. Goodman's description meshes with the plans for a Strategic Environmental Initiative (phrased as a Democrat counter to Star Wars) favoured by the military's friends in the previously Democrat-controlled Congress, as well as with the vision of a global Marshall Plan to meet the new environmental threats that was advanced in Al Gore's book, *Earth in the Balance*.[1] Not only were these initiatives intended to help preserve the massive research infrastructure and budget of the military and intelligence agencies, they would also provide a virtuous defense of just wars everywhere, and an opportunity to speak the language of free-market environmentalism, vying to become the new lingua franca of the global economy.

With the evaporation of the communist threat, the business of international security is no longer hedged around by ideological values, 'free' versus 'totalitarian'. Increasingly, security overviews and wargame scenarios focus on the new tensions and conflicts caused by environmental 'threats': shortages of natural resources, water and oil, cross-border pollution, including radioactivity and acid rain, the environmental underbelly of North–South trade, resource degradation, and population control in the new migrant economy generated by economic restructuring. To cite one symptom, the map-makers at the CIA no longer highlight military installations and intercontinental ballistic missile sites. They compile demographic maps, detailing where ethnic, national and religious groups live, and environmental maps, pinpointing sites of nuclear power plants, especially in Russia and the Third World, where chances of meltdown are highest, and where plutonium smuggling originates. According to a cartographer,

> We at the agency are in the predicting business, and when we think about what will explode, demographic factors and environmental factors are what we look at first now. What policy makers want to know most from us when they ask for maps is the ethnic mix, because that is what determines the hot spots.[2]

Many other government agencies that are officially non-military have followed suit. NASA now sends the space shuttle on environmental missions – its space radar equipment, designed for espionage by national security agencies, is now used to detect changes in vegetation, land movement and water-flow that could cause earthquakes and other catastrophes.

The environmental problems of today have little regard for national boundaries. Food chains connect all over the earth, pollution crosses borders, and, while wealth, power and class geography can differentiate the social impact of many of these threats, nuclear, chemical and genetic

hazards tend not to distinguish hierarchically between or within nation states. Even the North-South toxic trade is not a one-way flow; its effects are returned to the North through their largely invisible presence in consumer commodities and food produce. This is the 'boomerang effect' cited by Ulrich Beck in his influential book *The Risk Society*,[3] in which he argues that a society characterized by the overproduction of risks, from which no one is ultimately immune, no longer corresponds to the paradigm of a class society: hunger is hierarchical, nuclear contamination is not. From a military perspective, what is most threatened by these transboundary activities and conditions is the old nation-state alliance system, which lives on informally in the faultlines of the new security trans-state symbolized by global coalitions like the Montreal Protocol on Substances that Deplete the Ozone Layer, and the Basel Convention on the Control of Transboundary Movements of Hazardous Waste and their Disposal.

Conceptually, 'environmental security' is a strange bird, especially when invoked by corporate-military powers against threats generated by the very industrialization from which their interests have traditionally profited. Old hands at Cold War doublespeak will recognize a similar circular logic in the new rhetoric of risks. Likewise, if the Cold War garrison state conducted foreign policy very much like the dominant competitor in a cartel trade war, the new military jurisdiction is governed by the neo-liberal economics of risk that holds sway in the liquid world of GATT. Most favoured is the administrative rationality known as 'risk assessment', and all of its related techniques in McNamara whiz-kid jargon: risk management, risk communication, risk prioritization, and the like. Risk assessment, a form of cost–benefit analysis that conceals social interests in the form of mathematical possibilities, evolved as a managerial strategy to respond to the massive Cold War public anxiety about hazardous technologies. Recently, it has become the new interface language between Congress, the Pentagon and Defense contractors. Both the DoD's Sherri Goodman and the DoE's Thomas P. Grumbly, have become expert rhetoricians, rationalizing all environmental expenditure in the name of Goodman's new military rubric of '$C^3 P^2$' – cleanup, compliance, conservation and pollution prevention. Sometimes the tone is abstract, almost philosophical. Mr Grumbly, for example, is prone to quoting at length to Congressional committees from the likes of Pericles of Athens:

> We Athenians . . . take our decisions on policy or submit them to proper discussion. . . . We are capable at the same time of taking risks and of estimating them beforehand. Others are brave out of ignorance; and when they stop to think, they begin to fear. But the man who can most truly be accounted brave is he who best knows the meaning of what is sweet in life and what is terrible, and then goes out to meet what is to come.

When military hacks on Capitol Hill choose to be Greeks instead of Romans then we know some sea change has occurred.

At other times, the risk calculus is used to undermine existing environmental regulation. In the process of returning military bases to productive civilian use, the stricter and nonconditional clean-up required by Superfund is being passed over in favour of standards tied to land use considerations under CERFA (the Community Environmental Response Facilitation Act of 1992). Why observe environmental standards appropriate for a daycare centre when the community plans to convert the contaminated site into a parking lot? (But who knows what will replace the parking lot at some future date?) As budgets get tighter, bases may be forced to stay open to evade the high cost of decontamination. Risk assessments of global environmental hazards routinely assign dollar values to the lives of citizens from different countries (a recent UN report valued a US citizen's life at $1.5 million, and that of a Bolivian at $150,000).

Risk assessment may seem a far cry from the Cold War mathematical heyday of nuclear megadeath projections, but it is much more than a fiscal mechanism of military policy-making. HR 9, the massive Republican bill on 'regulatory reform', makes the vast bureaucracy of risk assessment a budgetary requirement for the enforcement of all existing legislation relating to public health and environmental safety. This Contract with America bill is intended to paralyse the process of effective regulation, but it is basically an upgrading of Democrat-initiated policies, whereby acceptable levels of risk like the 'maximum tolerated doze' (MTD) are assessed, i.e. How many people's lives have to be endangered before it is cost-effective to legislate? For example, in the case of the 1993 decision to dismantle Hanford in seventy-five years it was estimated that while the natural disintegration of the reactors would result in twenty additional cancer deaths over 10,000 years, dismantling them now would result in an indefinite number of cancer deaths to workers and residents living near the facility. In seventy-five years, some of the waste will have decayed to harmless levels at a site officially classified as one where exposure is occurring right now, and likely to increase as the oldest holding tanks built for radioactive waste give out. In instances such as these, scientific rationality collides head-on with social rationality. To resolve the stand-off, the politics of economic scarcity is wheeled in, and the ethical quandaries are subsumed under the gospel of budgetarism that increasingly dictates virtually the whole of the political life of government. Fiscal demands that environmentalism should pay its way are now co-extensive with the pollution credit markets and debt-for-nature swaps, in accord with the general principle that environmental accountability should prove itself to be a *condition* for economic growth, and not a *cause* of the limits to growth. Many in the ecology movement once viewed it as an article of faith that capitalism could not absorb the social costs of environmental

accounting and preserve its vital metabolism at one and the same time. Today, we are accustomed to hearing the likes of Al Gore proclaim that environmentalism is not an impediment to capitalism, it is an opportunity to perfect capitalism.

The ascendancy of risk assessment affects much more than the spread of free-market environmentalism; at the level of the state, it also facilitates the classic task of population management, favouring the kind of government that seeks to turn the welfare state against its clients, while gutting the core of social citizenship. Through an assortment of technical appraisals, individuals and groups can be identified as social risks or threats and assigned destinies in the technostructure according to their likely level of competitiveness and social investment potential. In this manner, the 'risk' to society is contained or is dispersed across society, just as the social guarantees of a welfare state are already broken down and scattered around by a highly rationalized process managed by the huge insurance companies that dominate corporate medicine. In our medical institutions, and especially in the genetics field, this recipe for social eugenics has already been partially implemented. But individuals identified as genetically able to pass on their risks to society are not the only ones affected by the new preventive social medicine. Prevention of risk by any means necessary is becoming the principle of administration in a liberal society that no longer wants to assist its poor citizens nor be perceived as visibly repressive, but needs to guarantee safe passage for its predictive capability. What does this mean for the engineering of personal identity? The ego-ideal of a risk-free, auto-immune personality with all-access security clearance to the sanitized upper levels of corporate-liberal life? What remains of the welfare state will increasingly be redefined as an institutional opportunity to protect 'society' *against* the risks posed by its costly clients. Notwithstanding the devolutionary barking of the Gingrich pitbulls, welfare institutions have a healthy future – as the nemesis, and not the guarantor, of the social democratic vision of society.

A prime example of the new fiscal wisdom of risk, the greening of the military is an early model for this tendency to reformat existing institutions. 'The new partnership between the DOD and the EPA', in Goodman's words (both agencies have testified jointly), means that the watcher and the watched are now in bed together. The Pentagon is being touted as the ecological 'steward' of the 25 million acres of public land, embracing 100,000 archaeological sites and 300 listed and candidate endangered species; its Corps of Engineers is the new eco-police, and its surveyors and cartographers are the new guardians of biological diversity.

What is wrong with this picture? Mainstream environmentalists have come to see eye to eye with big business. Why not with the military? Should the Pentagon be appointed to direct a federally funded wing of

the ecology movement? Can the military, which has been such a large part of the problem, be part of the solution? It is not enough to say that a leopard cannot change its spots. On the one hand, environmental compliance simply means that the Pentagon is abiding by the laws of the nation. Taxpayers might be happy to see the Defense budget (or 2.5 per cent of it) being put to progressive uses for once in their lives. So, too, the principle that the polluter pays sets a good example for the corporate sector. And, who knows, we may see some reforms in the nature of military masculinity as a result of taking on the traditionally gendered role of cleaning up.

On the other hand, we are confronted with tough political questions about the moral behaviour of institutions. The relationship between the US military and the corporate state has seen the most profound distortion of the workings of democracy in modern times. This has resulted in a truly psychotic consciousness that has proven structurally incapable of thinking and acting in a fashion consistent with the common or public good that is ecology's bailiwick. The dementia runs so deep that it cannot see the folly of funding hard-energy weapons production *and* environmental programs from the same Defense budget that researches and executes environmental warfare. In its attempts to identify a new global enemy in the existence of environmental 'threats', the Defense establishment displays yet again its structural need for all forms of planetary life to mirror its own bellicose mentality. Risk assessment, among other things, is emerging as the new managerial language for preserving this mentality. If the Pentagon succeeds in its kinder, gentler missions, it may result not in the greening of the military but in the militarization of greening.

BACK TO NATURE

Outside the military, the new developments in technoscience are feeding the return of the hygienic utopia to the forefront of our social imagination if not our daily environments. The technology-intensive screening and management of populations in the name of body normalization already pervades medical and other disciplinary institutions to such an extent that it is more proper today to speak of a partially achieved utopia, where, as Evelyn Fox Keller has argued, eugenic goals can be accomplished by technological means rather than by social control.[4]

Concern about the revival of eugenics has been running high over the last decade, especially in response to developments in molecular biology, the biotechnology industry and genetic medicine. Following their victories in the sociobiology wars in the mid to late 1970s, opponents of biological determinism have been resisting the spread of ideas that specifically tie genetics to variants of social Darwinism in the field of policy. In the autumn of 1994 these ideas had a resurgence in public

consciousness, with the publication of a spate of books in the United States, all of them pushing genes into the purview of policy.

The development began in the summer, when a lull opened up in Americans' communal chit-chat about O.J. Simpson. *Time*'s August cover story, 'Infidelity: it may be in our genes' was one of the topics that rushed into the bar and dinner-party conversation vaccum. Loose talk about family values, male biological drives, and the inherently dark side of human nature provided a neat segue from the Simpson trial into the *Time* article's discussion of the genetic basis of extramarital behaviour. As it happened, the Simpson trial also had its own genetics hook. Much ado about DNA testing of Simpson's blood samples was being converted, by free association in the public mind, into armchair theorizing about 'genetic criminals', out-performing speculation about the 'killer instinct' of running backs. In the meantime, press reports about the discovery of genes linked to this or that disease continued unabated.

The *Time* article was an excerpt from Robert Wright's book, *The Moral Animal*, about the new evolutionary psychology, which, in his account, has survived many academic trials by fire in order to reclaim the holy grail of genetic 'human nature' from a social science orthodoxy that has unfairly downplayed the biological determinants of social life.[5] Convinced that a rational Darwinism can be of service to bi-partisan policy-makers, Wright argues that his Darwinian view of human nature is likely to be correct, but that we are not obliged to accept it as a desirable model for how to organize society. In his account, evolutionary psychology shows our basic moral impulses to be an unsavory mix that involves sexual manipulation, self-promotion, deep inegalitarianism, social climbing and moral deceit, all of it incessantly driven by our genes' determination to get themselves into the next generation. A life of decency and justice is against the odds, but still worth fighting for. For those willing to try, moral conservatism is the way to go, by which Wright means a revival of pre-1960s morality, well before the excesses of the left ('hallucinogenic drugs and sex') and the right ('non-hallucinogens and BMWs') got us into the current free-wheeling mess. Natural selection, we are told, 'intended' us to live in cute English villages like Darwin's Shrewsbury, and not mega-dens of iniquity like New York or London.

Ultimately, Wright's primary focus on sexual and marital relations is designed to feed directly into today's hothouse debates about 'family values' and the welfare state. Because monogamy, which is against 'human nature', has only developed in relatively egalitarian societies, Wright argues that the typically liberal emphasis on redistribution of wealth is not incompatible with the conservative obsession with heterosexual family morality. Against all the odds, here, then, is an instance of how liberals and conservatives might agree that following the example of human nature is not the best thing for society. Wright thinks that evolutionary biology

is an infallible source of social analysis, even if it is one that we will have to disobey to obtain the most just results. But it is no coincidence that Wright's 'human nature' is so depraved that keeping it in check requires a severe programme of moral austerity and a form of sexual politics that used to be called neanderthal. Besides, what are the chances that any policy-maker will push an agenda because it is contrary to human nature? Very slim, especially when sociobiology's single-bullet theory of everything is designed to be the more effective crowd-puller than the much messier spectacle of social determinism. Wright's social policy talk is typical of the obsequious, bi-partisan temper that has come to be associated with centrist Clinton Democrats.

A different temper is revealed if we turn to the book that caused a storm of discussion in the public media two months later: *The Bell Curve*, written by Charles Murray,[6] the favourite welfare-basher of the Reagan years, and Richard Herrnstein, a well-known feeder at the academic trough reserved for those intent on establishing a link between genes and IQ. For at least three months, it was well-nigh impossible to budge an inch in the United States without running into discussion of this book. Murray (Herrnstein died before the book's publication) and his providers in the glossy weeklies, campaigned hard as exhumers of truths persistently buried by the gatekeepers of polite, liberal society. Lifting a liberal taboo here, exposing a liberal shibboleth there, waving *their* data in the air like *we* just don't care, Murray and Herrnstein became a publicist's wet dream. The anti-incumbency mood of a mid-term election favoured their posturing as disenfranchised pariahs and their book circulated like a Willie Horton ad (an infamous racist political ad used by George Bush in his successful campaign bid of 1988), raising the temperature on the policy hotspots of the moment: immigration, the balance-sheet of 'positive' government, social welfare, remedial education, multiculturalism. *The Bell Curve* belongs to a genre of publication increasingly crucial to the PR industry that scripts political life by reducing gigabyte scholarship to the minimal fraction of political RAM needed to access the public memory. For some time now, we have been aware of the industrial process which can recycle, say, a single magazine article into several recombinant forms – book, film, soundtrack, TV series – as it passes up the food-chain of culture industries owned by the same transnational company. Given the oxygen of publicity, an analogous process can transform a policy-oriented article or book into a major political speech or even the White House's paradigm of the month. Charles Murray had already been on this express elevator ten years ago when *Losing Ground*[7] provided academic ammo for the second, and worst, Reaganist round of welfare rollbacks. Books like *The Bell Curve* are increasingly made to order. Funded lavishly by right-wing foundations (presumably, with the backing of the American Enterprise Institute, Murray did not need support from the eugenicist

Pioneer Fund, which has bankrolled his fellow-traveller hereditarians Arthur Jensen, William Shockley, Roger Pearson and J. Philippe Rushton)[8] such books are aimed at capturing the cover of the weeklies and the hot seat on talk shows. They are primed to re-ignite old race fires, and calculated to consume the energies of liberals and progressives in old battles about biology that have to be fought over and over again.

Murray and Herrnstein's barnacled appeals to genetic determinism are no more novel than their obsession with public policy involving race. What *is* new about the context for hearing these appeals is an emergent industrial environment driven, in part, by biotechnology and genetic medicine. Despite *The Bell Curve*'s alleged connection between genes and intelligence, the book makes no mention of hard science, least of all the kind of molecular biology that has reinvented our thinking about genetics in recent decades. In the splice-and-dice biotechnology laboratories, genetic material no longer has the fixed, immutable status it used to occupy in the theory books of destiny. If anything, industry-boosters have revelled in the claim to be able to intervene in and modify the alleged connection between genes-and-anything, thereby opening up a whole new chapter (kinder and gentler?) in the history of eugenics.

Murray and Herrnstein have good reasons for avoiding hard science, but their adversaries do not. Virtually none of the public commentary on *The Bell Curve* saw fit to invoke the relevance of this industrial environment to the wholesale revival of biologism and genetic determinism currently dominating public discussion. Of course, there is no direct causal relation between how biotechnology stocks are doing (rather badly, as it happens, but such vacillations are native to the venture capitalist market), the latest press releases from the laboratories, and the publication of books like *The Bell Curve*, Wright's *The Moral Animal* and J. Phillipe Rushton's *Race, Evolution, and Behavior*,[9] among a spate of others. But there is obviously some affinity between ideology and economy here, and it is scandalous that critics are less and less equipped to point it out. In an age when R&D in basic science is the primary motor of capital investment, and when the name of biotechnology, in particular, has been synonymous with the promise of a new economic revolution, any kind of public interest in the topic of genes is highly serviceable to the investors' cause. Familiarity not only breeds contempt, it also produces consent. Given their book's focus on the topic of smartness and the emergence of 'cognitive stratification' in a postindustrial society, it is also telling that Murray and Herrnstein have nothing much to say about the industrial environment of information technology. Computers have long been designed and employed to outsmart the knowledge workers, appropriating the functions of intelligent labour in much the same way as industrial machinery earlier appropriated the skills and artisanal know-how of manual workers and tradespeople. At the very moment when what *The*

Bell Curve calls the cognitive elite is supposed to be assuming power, smartness is passing out of the human domain, and increasingly is an attribute of technology itself. As we know, the deindustrialization of wage labour that underpinned this transition took a heavy toll: the decimation of stable, working-class and middle-class employment, the deepening of class polarization, and the appearance of an informal economy created largely by racially inflected policies. Murray and Herrnstein have no time for such socioeconomic explanations. For them, the fact that poverty levels have barely budged since 1969 has nothing to do with top-down economic restructuring, it is simply the result of inheritable 'cognitive disadvantages' combined with the increasing market value of intelligence.

Unlike Daniel Bell, who once forecast the benign rule of intelligence over capital, Murray and Herrnstein are not so enamoured of the new smart elite. Ventriloquizing a page or two from the Great Book of Populism, *The Bell Curve* agonizes over the growing power of an affluent mandarin caste, socially isolated from a dumbed-down populace whom they will learn to fear and resent, and immune to the traditional opposition of the intelligentsia, with whom they will have made a big-brained alliance. The fact that chief executives are more educated these days *may* be something to worry about; as a result, capitalism will doubtless become even more efficient, i.e. ruthless. As for the intelligentsia, I honestly do not think that we are going to see too many marriages of convenience between habitués of the Bohemian Grove and PhDs from history of consciousness programmes, although the success of *The Bell Curve* will surely spawn many more unlikely alliances of the sort that brought together an IQ quack like Herrnstein and a welfare-basher like Murray.

Most disturbing to Murray and Herrnstein is their dystopian vision of a near future 'custodial state' featuring 'a high-tech and more lavish version of the Indian reservation for some substantial minority of the nation's population', who will have become 'permanent wards of the state' through welfare dependency (526). In the custodial state it will finally be proved that inequalities related to genetic endowment can never be overcome, and least of all by spreading tax dollars around. Murray and Herrnstein's practical recommendations are all too predictable: abandon all welfare and education programmes aimed at the disadvantaged, institute a draconian immigration policy, and encourage rich women to have more babies. This is nothing but smelly old eugenics, scented with the statistical bouquet of dark-side social science.

Slightly more original is *The Bell Curve*'s version of conservative multiculturalism. Just as its authors put a right-wing spin on populist and left critiques of credentialism, so too they offer a new racist gloss on radical claims to cultural justice based on some principle of 'difference'. They call it 'wise ethnocentrism', it appeals to cultural difference as much as to biology, and we are likely to see more and more of it. Ethnic minority

groups, Murray and Herrnstein argue, should be released from the injunction to assimilate, and should be encouraged to protect and sustain their 'clannish' self-esteem. Cultures are different, they should remain so, and there is no need to compare one with another. Best not to mix at all, really. This new segregationism masquerades as tolerance for human variation. Behind it lurks Murray's hankering after a Jeffersonian natural aristocracy and a caste order where everyone has a place and perceives that place to be a comfort zone. Indeed, he insists that the only way to effect such a society is to change our value system by eradicating every last vestige of Jacobin faith in egalitarianism. Liberal guilt will be released, like so much hot air. Everyone will then cheerfully accept their point of distribution on the bell curves. The gene pool, presumably, will take the place of the safety net.

As far as their book's impact on public consciousness goes, it doesn't matter much that Murray and Herrnstein's working definitions of 'race' are at once hokey and neanderthal. (In their observations about cultural essentialism, they can be just as giddy about white ethnicity: 'The Scotch-Irish who moved to America tended to be cantankerous, restless, and violent' [36].) When push comes to shove, they know that enough white people *need* the respectable cover of social science to vindicate their own racism. Murray and Herrnstein need not create a case, they need only reinforce a welter of racist perceptions that are already out there in the daily mind, and are being hammered into policy gab by neo-liberal senators such as Daniel Patrick Moynihan, who has recently been spouting nonsense about 'speciation' among welfare clients.

Nor does it matter whether they come anywhere near to resolving that old chestnut – the exact ratio of genes or environment that is responsible for our social behavior (between 40 and 80 per cent is genetic, in their final estimate). If *any* of it is genetic, they say, then the whole situation is quite intractable, a thesis that makes the bulk of their book quite redundant. Welcome to the new Darwinism. If nothing else, *The Bell Curve* is the book that finally explained the meaning of Beavis and Butthead; only white guys could be that stupid and still be alive.

In the wake of the 1994 US elections, the right-wing moral majority is within reach of the assumption of power. Its congressional ideologues have been calling loudly for a *normalization* of American values, invoking the cult of the demographic majority, and declaring war on the counterculture. And their equivalents in the academy have opened up a new front in their highly funded assault on higher education – the science wars, which may make the culture wars look like a minor skirmish.

Each of these campaigns, conceived as military operations, takes 'nature' as its court of appeal, if not its ground of authority. In the return of the genetic determinists, biology feeds directly into policy. For the defenders of rationalist faith, natural science is a pure, unsullied weapon

to beat back the rag-tag infidels who have contaminated the humanities and social sciences and are even now at the gates. For the moral majoritarians, cultural values that do not extol the suburban nuclear family are a loathsome abuse of human nature. And, as for military science itself, I have tried to demonstrate its increasing dependence on the identification of environmental threats as a principle of mobilization on behalf of the nation state system. To conclude, so far the future of nature looks remarkably like the past, in other words, the history, well known to us, of attempts to naturalize social and cultural arrangements in the name of power. One of the lessons of Darwinism was to undercut species arrogance, and accept the continuity of human life with the natural world. But this lesson generated an equally powerful counter-politics, one that has persistently connected the struggle against biological determinism with the struggle for social ecology and cultural justice. More than anything, it seems to me, we need to remember this double legacy of Darwinism as we confront the naturalism of the near future.

NOTES

1 Al Gore, *Earth in the Balance: Ecology and the Human Spirit* (Boston: Houghton Mifflin, 1992).
2 Thomas L. Friedman, 'Cold War Without End', *New York Times*, 22 August 1993, section 6 Magazine Desk, p: 28.
3 Ulrich Beck, *Risk Society: Towards a New Modernity*, trans. Mark Ritter (London: Sage Press, 1992).
4 Evelyn Fox Keller, 'Nature, nurture, and the human genome project', in Daniel Kevles and Leroy Hood (eds), *The Code of Codes: Scientific and Social Issues in the Human Genome Project* (Cambridge: Harvard University Press, 1992), pp. 281–99.
5 Robert Wright, *The Moral Animal: Why We Are the Way We Are: The New Science of Evolutionary Psychology* (New York: Pantheon, 1994).
6 Charles Murray, *The Bell Curve: Intelligence and class structure in American life* (New York: Free Press, 1964)
7 Charles Murray, *Losing Ground: American Social Policy, 1950–1980* (New York, Basic Books: 1984).
8 Charles Lane ably examines *The Bell Curve*'s sources in the *New York Review of Books*, December 1, 1994.
9 J. Philippe Rushton, *Race, Evolution and Behavior* (New Brunswick, Transaction Press, 1995).

Chapter 2

Nature/'nature'

Kate Soper

In considering the future of nature, it is difficult not to be struck by the conjuncture at the present time of two influential critiques of modernity whose political prescriptions and agendas are in some ways complementary and overlapping, but which are talking to us about nature in very different ways. I am speaking here of ecology on the one hand and what might broadly be termed 'postmodernist' cultural theory and criticism on the other. Both have denounced the technocratic Prometheanism of the Enlightenment project, and inveighed against its 'humanist' conceptions: ecology on the grounds that this has encouraged an 'anthropocentric' privileging of our own species which has been distorting of the truth of our relations with nature and resulted in cruel and destructive forms of dominion over it; postmodernist theory on the grounds that it has been the vehicle of an ethnocentric and 'imperializing' suppression of cultural difference. Both, moreover, have emphasized the links between the dominion of 'instrumental rationality' and the protraction of various forms of gender and racial discrimination.

Yet while the ecologists tend to invoke 'nature' as an independent domain of intrinsic value, truth or authenticity, postmodernist cultural theory and criticism emphasizes its discursive status, inviting us to view the order of 'nature' as existing only in the chain of the signifier. Nature is here conceptualized only in terms of the effects of denaturalization or naturalization, and this deconstructivist perspective has prompted numerous cultural readings which emphasize the instability of the concept of 'nature', and its lack of any fixed reference. In contrast, moreover, to the naturalist impulse of much ecological argument, which has emphasized human affinities with other animals, and regards a dualist demarcation between the cultural and the natural as a mistaken and inherently un-eco-friendly ontology, post-structuralist theory has emphasized the irreducibly cultural and symbolic order of human being and has consistently criticized naturalist explanations of the being of humanity. Thus Foucault presents the distinction between the 'natural' and the 'unnatural' (or 'perverse') as itself discursively constituted, and rejects

the explanatory force of the reference to a common natural foundation in the approach to psychology or sexuality. People are not 'mad' by nature but as a result of classification; the discourses of sexuality are in an important sense the source of so-called 'natural' sexual feeling itself; even the body must be viewed as the worked-up effect of a 'productive' power and its cultural inscriptions.

In sum, while the ecologist refers to a pre-discursive nature which is being wasted and polluted, postmodernist theory directs us to the ways in which relations to the non-human world are always historically mediated, and indeed 'constructed', through specific conceptions of human identity and difference. Where the focus of the one is on human abuse of an external nature with which we have failed to appreciate our affinities and ties of dependency, the other is targeted on the cultural policing functions of the appeal to 'nature' and its oppressive use to legitimate social and sexual hierarchies and norms of human conduct. Where the one calls on us to respect nature and the limits it imposes on cultural activity, the other invites us to view the nature-culture opposition as itself a politically instituted and mutable construct.

I want to offer some reasons here for questioning the acceptability of both types of discourse, and to suggest that both 'nature-endorsing' and 'nature-sceptical' perspectives need to incorporate a greater awareness of what their respective discourses on 'nature' may be ignoring and politically repressing. Just as the green movement can afford to be more discriminating in its deployment of the concept of 'nature' and to pay heed to some of the slidings of the signifier which have been highlighted in postmodernist theory so the postmodernists should accept that the ecologists are talking about features of the world which we cannot afford to ignore; and just as a simplistic endorsement of 'nature' can seem insensitive to the emancipatory concerns motivating its rejection, so an exclusive emphasis on 'discourse' and signification can very readily appear evasive of ecological realities and irrelevant to the task of addressing them. Both therefore, one may argue, need to review their theoretical perspectives in the light of the other's political agenda, especially wherever there is a presumption that these agendas are committed to projects which are in principle mutually supportive.

Let us begin by noting some of the problematic aspects of two prescriptive positions on nature that are often present in the argument of ecological critics.

The first is that which invites us to think of 'nature' as a wholly autonomous domain whose so-called 'intrinsic' value has been necessarily and progressively depreciated as a consequence of the intrusive and corrupting activities of the human species. One problem with this rhetoric is that it tends to obscure the fact that much of the 'nature' which we are

called upon to preserve or conserve (most obviously the so-called 'natural' landscape) takes the form it does only in virtue of centuries of human activity, and is in an important material sense a product of cultivation or 'cultural construct'. Indeed some would question whether there are any parts of the earth – even its remoter arctic regions and wildernesses – which are entirely free of the impact of its human occupation. If nature is too glibly conceptualized as that which is entirely free of human 'contamination', then in the absence of anything much on the planet which might be said to be strictly 'natural' in this sense of the term, the injunction to 'preserve' it begins to look vacuous and self-defeating.

But a further point is that this abstraction from the human role in the production of much that we refer to as 'natural' necessarily tends to over-look the often very exploitative social relations which have gone into the making of the environment and are inscribed in its physical territory – in the United Kingdom, for example, in its grouse moors and enclosures, its feudal hamlets and country estates. Much that the preservationist and heritage impulse speaks of as 'natural' landscape or seeks to conserve as the encapsulation of a more harmonious order in time – as a more natural past way of living – is the product of class, gender and racial relations whose social origins and sources of discord are disregarded in these retro-spections. It is easy, moreover, to be sceptical of such nostalgia for the supposedly more organic and 'natural' order of the past, given how regularly it has figured in the laments of the critics of 'progress'. When, after all, it might be asked, has historical reflection on the present not sought to contrast this to a more fortunate moment in time – to a prelapsarian time-space of 'nature' whether conceived directly in mythical-theological terms as an absolute origin in Eden or Arcadia, or more mundanely and relatively as the utopia of the erstwhile rural stability which has been displaced by modernity? And when has the appeal to 'nature' in this sense not tended to legitimate social hierarchies which needed to be challenged?[1]

I would emphasize here, however, that I am not suggesting we should adopt a purely cynical attitude to the preservationist impulse or treat it only as the vehicle of a patrician and conservative sentiment. This itself seems a blinkered response to what is, in many ways, an understandable and warranted reaction to the encroachments of technological modernity, and one which is by no means confined today to the more privileged sectors of the community. Certainly, there is elitism and phony organicism associated with the urge to environmental and heritage preservation, and one cannot deny the extent to which it is caught up in the same mythologies about 'our' heritage and the 'common land' which have helped to sustain the power and property of those most directly responsible for ecological destruction. Yet, no serious analysis of the contemporary environmentalist impulse can stop short at exposing the ideological dimensions of this

response, which is clearly witness to insecurities and dissatisfactions which cannot be dismissed as ecologically irrelevant. There is a good measure of truth in Adorno's point, in fact, that:

> As long as the face of the earth keeps being ravished by utilitarian pseudo-progress, it will turn out to be impossible to disabuse human intelligence of the notion that, despite all the evidence to the contrary, the pre-modern world was better and more humane, its backwardness notwithstanding. Rationalization has yet to become rational; the universal system of mediations has yet to generate a livable life. In this situation the traces of an old immediacy, no matter how outdated and questionable they may be ... are legitimate in view of the outright denial of gratification by the present state of things. ... While it is true that nowadays an aesthetic relationship to the past is liable to be poisoned by an alliance with reactionary tendencies, the opposite stand-point of an ahistorical aesthetic consciousness that brushes the dimension of the past into the gutter as so much rubbish is even worse. There is no beauty without historical remembrance.[2]

Certainly there is no beauty to be had in that blind forgetting of the past which would simply celebrate the incursion of a new motorway as another instance of 'progress', man's mastery over nature, and so on. My point is only that the historical remembrance involved here also requires us not to expunge the record of the human relations which went into the making of the countryside which we now seek to preserve from the destruction of the motorway. Nor should we forget the extent to which our conceptions of the aesthetic attractions and value of the natural world have themselves been shaped in the course of our interaction with it and must be viewed, at least in part, as reactive responses to its effects. To offer but one very obvious example here, the shift from the aesthetic of the cultivated to that of the sublime landscape, and the Romantic movement into which it subsequently fed, have clearly to be related to the impact of Enlightenment science and industry in knowing and subduing a 'chaotic' nature. Untamed nature begins to figure as a positive and redemptive power only at the point where human mastery over its forces is extensive enough to be experienced as itself a source of danger and alienation. It is only a culture which has begun to register the negative consequences of its industrial achievements that will be inclined to return to the wilderness, or to aestheticize its terrors as a form of foreboding against further advances upon its territory. The romanticization of nature in its sublimer reaches has been in this sense a manifestation of those same human powers over nature whose destructive effects it laments.

Our conceptions, then, of the value and pleasures of the natural world have clearly changed in response to actual human transformations of the environment. They have also been continuously mediated through artistic

depictions and cultural representations whose perception of nature has often been partial and politically inflected.[3] We should note, therefore, that the relationship between the aesthetic experience of landscape and its portrayal in art or literature is not one way but mutually determining; and that the political meanings embedded in the latter are both reflective of the actual inscription of social relations within the environment and refracted back into the aesthetic responses to it. Those who refer us to the unmediated aesthetic value of nature should bear in mind how far preferences in nature have, in these senses, been the 'construct' of cultural activity and of its particular modes of artistic representation.

Indeed, in our own time, as Alex Wilson has pointed out, 'nature' is often enough being materially constructed in ways which both adapt it to contemporary needs while at the same time encouraging a culturally specific perception of its aesthetic attractions.[4] The great national parkways of North America, he argues, have been built to please a 'motorist's' aesthetic – one which is essentially visual and has ruled out taste, touch and smell; for which landscape becomes an event in 'automotive space', and is comparable in its one-dimensionality to the view of it had in aerial photography. In the process the designers of these scenic routes have literally instructed their users in the 'beauties' of nature by promoting some landscapes at the expense of others, by removing whatever bits of it were deemed unsightly, and by restricting all activities incompatible with the parkway aesthetic. The overriding strategy

> is the production of nature itself. All of the road's design features organize our experience of nature. The result is that nature appears to produce itself with no apparent relation to the cultures that inhabit it or use it. Magnificent vistas now happily present themselves to us without the clutter of human work and settlement. The seasons begin to be synchronized with the tourist calendar: June is Rhododendron Time, autumn is Fall Foliage Time, winter is Wonderland.[5]

If we are to give full due both to the actual history of the making of the environment, and to the contemporary tailoring of 'nature' to modern needs and perceptions, we must inevitably recognize the conceptual difficulty of simply counterposing nature and culture as if they were two clearly distinguishable and exclusive domains. Much which ecologists loosely refer to as 'natural' is indeed a product of culture, both in a physical sense and in the sense that perceptions of is beauties and value are culturally shaped.

But there are also, of course, ethical and political objections to conceptualizing nature as an autonomous locus of intrinsic value which we should always seek to preserve from human defilement and instrumental appropriation. After all, this is a logic that might seem to require us entirely to abstract from human interests, and to give priority to 'other'

nature regardless of what merit it might have in our eyes, and whatever its ravages upon human health and well-being – which is a policy as absurd in its practical recommendations as it is immoral in its implications. Others, more acceptably, have argued that human self-realization is itself best served by biocentric identification with all life-forms, though this too is a problematic argument to say the least. Arne Naess, for example, justifies his call for the development of a 'deep identification of individuals with all life forms', precisely in terms of its significance for the individual adopting such a perspective.[6] But it is clear that anyone arguing for preservation on this basis is operating within a value system which makes it extremely difficult to defend the equal value and rights to survival of all life-forms. Anyone inviting us to view all life as having equal intrinsic value, or deeply to identify with the mosquito or the locust, the strepto-coccus or the AIDS virus cannot consistently place more weight on human self-realization than on the gains that will accrue to any other participant in the ecosystem. Either some parts of nature are more valuable (rich, complex, sentient, beautiful . . .), and hence to be more energetically preserved, or they are not. But if they are not, then we should take the measure of the value system involved, and not present biocentrism as it if were plainly in the interests of the species being called upon to adopt its values. We cannot, that is, both emphasize the importance of human self-realization and adopt a position on the value of nature which would, for example, problematize the use of antibiotics in the prevention of childhood illness.

But there is the further point that the polemic against 'anthropo-centricity' readily lends itself to a simplistic anti-human speciesism, which in treating all human beings as equal enemies of nature abstracts from the social relations responsible for its abuse, even as it lends itself to policies on its disabuse which are likely to hit hardest those sectors of humanity which are least to blame for ecological depletion and pollution. It is not necessary to be a committed eco-fascist to fall into these errors of thinking. The professed aim of a recent book by Robert Goodin, for example, is to supply a theory of value for Green Party politics, and he is clearly committed to the democratic and humanly emancipatory aspects of the Green Party programme.[7] But when Goodin argues that green politics is driven by a 'single moral vision' rooted in the primary, self-occurring value of nature, and that it is always more important that this value be preserved than that it be preserved in a particular way or through a particular agency, he is offering a moral foundation for ecology which could in principle legitimate the most reactionary policies on conservation.

Goodin is no doubt right that value and agency are divorced in the sense that ecological crisis might be accommodated in a variety of politi-cal modes. But it is precisely because a regard for the immediate interests

of nature may be consistent with the least democratic political forms, and the implementation of totalitarian methods of controlling human consumption, population and migration, that a green politics which professes a concern for global equity and the collective well-being of future generations must eschew a simplistic theory of value. The attempt to accomodate ecological scarcities can be made in a variety of ways (capitalist, socialist, authoritarian, fascistic), all of them in contestation over what it means for human beings to flourish (which means also over the issue of whether some more than others should be allowed to do so both now and in the future).

The second dimension of green rhetoric which needs to be carefully scrutinized for its political implications, is the tendency to defend a form of naturalism which emphasizes how similarly (rather than differentially) placed we are to other animals in respect of our 'essential' needs and ecological dependencies and seeks to ground ecological policy in this recognition. Being 'green' in our attitudes to non-human nature is often presented as if it involved overcoming human–animal dualism, and eroding the conceptual distinctions between ourselves and other creatures. One problem with this, which is relevant to the point about the differential political forms in which we might accommodate ecological scarcity, is that it might invite too static and fixed a conception of our needs. We may be similarly placed to other animals in respect of certain basic needs of survival, but we are very unlike them in respect of our capacity consciously to monitor our impact on the environment and to rethink our forms of consumption in the light of ecological constraints – and this malleability or underdetermination in respect of our pleasure and modes of flourishing, needs to be emphasized as a potential asset of ecological adjustment. For us, unlike other creatures, living in harmony with nature involves rethinking our conditions of flourishing in the light of current and likely future resources, the value we place on equality within the human community in the present and the obligations we feel to future generations. Dealing with ecological scarceties may require us quite possibly to restrict some sources of gratification and self-realization (very swift and flexible means of transport, for example), which it seems mistaken simply to dismiss as 'false' or 'unnatural' needs. It will certainly require us to be imaginative and undogmatic in our attitudes to what we can enjoy: to open ourselves to the possibilities of an alternative hedonism and to modes of living and self-fulfilment rather different from those associated with current assumptions about flourishing. A naturalist approach to our position in the ecosystem which implies that human beings are possessed by nature of a set of needs whose satisfaction is a condition of their flourishing, and of which we could in principle gain an objective knowledge, does not necessarily encourage this form of hedonist rethinking.

But we should note, too, that an emphasis on human–animal affinities can put us on the slippery slope which ends up in the endorsement of the crudest forms of sociobiological reductionism, and it is important that eco-politics avoids talking about humans and animals in ways which abstract from the critical differences between them in respect of the role played by language and symbolization in mediating human relations to biology. To neglect the distinguishing features of, say, human sexuality is to risk ignoring the varying, historical and constantly contested forms in which human beings experience their desires, their bodily existence and their functions in reproduction. Here too, relative to other animals and in part in virtue of their specific biological evolution, humans are biologically underdetermined in respect of the ways they will experience and respond to these conditions. The oppression of women, of gay and lesbian sexuality, and so on, must be associated with the refusal to respect these distinctions, and it is therefore important that ecological argument avoids talking about the 'communality' of humans and animals in ways which conflate the biological and cultural and symbolic dimensions. Ecological argument also needs to be cautious in accepting the classic genderization of nature as feminine, as it does whenever it simply inverts an Enlightenment devaluation of both women and nature as, by associa-tion, the exploitable objects of a masculine instrumental rationality in favour of a celebration of the 'maternal' and/or 'virginal' nature which has been rejected and/or violated by her rapacious human son or suitor. This is in part because it reproduces the woman–nature coding which has served as legitimation for the domestication of women and their confine-ment to the nurturing role (and may overlook the extent to which iconic associations of 'woman' with the land and earth-bound values have served as the prop for national cultures whose actual policies towards women, land ownership and the division of labour are deeply conservative). It is in part, because in the process of symbolic identification it tends to repeat the exclusion of women from 'humanity' and 'culture'. Any eco-politics, in short, which simply reasserts the claims of a feminized space/ being of nature against its human dominion is at risk of reproducing the implicit identification of the human species with its male members in its very denunciations of 'human' abuse of 'nature'.

These, then, are some of the reasons why the more naive forms of nature valorization encountered in the discourse of ecology need to be critically reviewed in the light of the emphasis on the semiotics of nature and the social and sexual policing functions performed through its endorsement. Indeed, it is important to go with the 'nature-sceptical' impulse if this is interpreted as a resistance to these forms of naturalization. And I would question the assumption of those ecologists who suppose that only anti-dualist or naturalist metaphysics is consistent with the promotion of the

green agenda. There is no inherent contradiction between the insistence of much contemporary theory on the irreducibly symbolic dimension of human culture and on the essential differences this introduces between human and animal orders, and respect for ecological priorities.

But having said that, we have also to question the coherence of the 'constructivist' rhetoric associated with much postmodernist theory of gender and sexuality – that which refuses, for example, to recognize any extra-discursive natural determinations and seeks to present all supposably natural aspects of human subjectivity as the artefact of culture. This rhetoric informs a good deal of rather glib reference to the 'culturality' of nature, but is perhaps most evident in the argument of those who insist that there is no 'natural' body; that even needs, instincts and basic pleasures must be viewed as the worked-up effects of discourse; and that everything which is presented as 'natural' must be theorized as an imposed – and inherently revisable – norm of culture.[8]

For this too seems muddled and politically dubious. In the first place, there is an inconsistency in allowing 'culture' to have reference to an independent domain of reality having determinate effects, while denying any such reference to 'nature'. One must question, in fact, whether there can be any claim to the effect that the nature–culture dichotomy is itself conventional, which does not tacitly rely for its force on precisely that objectively grounded distinction between what is humanly instituted and what is naturally ordained, which is being rhetorically denied. When anti-realists insist upon the relative and arbitrary character of the nature–culture antithesis they are implicitly assuming what they purport to deny: that both terms have reference to distinguishable orders of reality.

But there is also a confusion in supposing that because we can only refer in discourse to an extra-discursive order of reality, discourse itself constructs that reality. What matters politically is not the positing of an independent order of nature, but the adequacy of its representations, and we can only dispute any given representation from a position which acknowledges that independence. Contesting though it does the supposed naturality of current sexual practices and institutions, this extreme conventionalism on nature, strictly speaking, denies itself any basis either for justifying this critique of existing practice, or for defending the more emancipatory quality of the alternatives it would institute in its place. For if there are, indeed, no 'natural' needs, desires, instincts, and so on, then it is difficult to see how these can be said to be subject to the 'repressions' or 'distortions' of existing norms, or to be more fully or truly realized within any other order of sexuality.

Constructivists clearly dislike any reference to 'nature' for fear of lending themselves to biological determinism and its political ideologies. But to take all the conditioning away from nature and hand it to culture is to risk en-trapping ourselves again in a new form of determinism in

which we are denied any objective ground for challenging the edict of culture on what is or is not 'natural'. The prescriptive force of the constructivist critique is, in other words, systematically undermined by the insistence on the purely politically determined character of the divide between the supposed givens of nature and the impositions of culture. Equally, such anti-naturalism is at loggerheads with any ecological argument that recalls our biological dependency upon the ecosystem.

Just as some forms of ecological rhetoric about nature can be charged with being too ready to abstract from the political effects of its cultural representation, so the constructivist rhetoric can be accused of being too ready to deny the nature which is not the creation but the prior condition of culture. This is what might be termed nature in the realist sense: the nature whose structures and processes are independent of human activity (in the sense that they are not a humanly created product) and whose forces and causal powers are the condition of and constraint upon any human practice or technological activity, however Promethean in ambition (whether, for example, it be genetic engineering, the creation of new energy sources, attempted manipulations of climatic conditions or gargantuan schemes to readjust to the effects of earlier ecological manipulations). This is the 'nature' to whose laws we are always subject, even as we harness it to human purposes, and whose processes we can neither escape nor destroy.

Such a conception of nature as the permanent ground of environmental action is clearly indispensable to the coherence of ecological discourses about the 'changing face of nature' conceived as surface environment, reliant as this is on a distinction between the causal powers working at a deep level and the historicity of their consequences, whether these are naturally precipitated (the earthquake or volcanic eruption) or humanly engineered (the ancient barrow or nuclear bunker). But it is also essential to any discourse about the culturally constructed body and its mutable gender significations, since the very emphasis on the variable and culturally relative quality of human sexuality requires as its counterpart a recognition of the more constant and universal features of embodied existence if it is to be meaningful. We must recognize a natural body in this sense if we are to speak of any controlling intervention in it, of any cultural 'work' upon it, whether this be voluntary or coerced, and whether it be undertaken with a view to conforming to certain ideals of beauty and gender identity, or in defiance of them. If those who tell us that 'there is no nature' are denying its reality and specific determinations in this sense, then they are committed to a form of idealism which is clearly incompatible with ecological argument – and incoherent in itself.

Moreover while both bodies and landscape may be said to be culturally formed in the double sense that they are materially moulded and transformed by specific cultural practices and at the same time experienced

through the mediation of cultural discourse and representation, we should still recognise that they are not literally constructed in the sense that, say, an aeroplane or telephone might be said to be. They are not, that is, artefacts of culture, and it is no more appropriate to think of bodies and sexualities as wholly artefactual products of cultural practice and discourse than it is to think of the landscape as constructed out of agricultural practices or as the discursively constituted effect of Romantic poetry.

To the objection that my argument speaks to the prejudices of scientific culture itself in supposing there to be an objective account of the workings of nature, my response would be that those who seriously espouse this form of relativism should also refrain from any confident pronouncements about the damage inflicted by science or the risks incurred by the adoption of its methods. For to condemn the effects of conventional medicine, to target the poisons or pollutants of modern industry, or to offer any similar critique of the negative impact of a technical fix approach to nature is implicitly to accept as 'true' the accounts of biological and physical process which are offered by science itself. Moreover, it is one thing to question the hegemony of western science and instrumental rationality, and to point to the many damaging and oppressive consequences it has had, both within the industrial nations themselves, and upon the life of other cultures. It is another to suggest that any and every attempt to bring a scientific and rational perspective to bear on the management of human affairs (including our relations to nature) is inherently oppressive. At the very least, I think we need to be wary of adopting positions in cultural theory which would problematize any technical intervention to correct the ravages of nature or transcultural initiatives to guarantee ecological sustainability.

It is an error to suppose that in defending the possibility of an objective knowledge of natural process one is committed to an uncritical acceptance of the 'authority' of science or bound to endorse the rationality of the modes in which its knowledge has been put to to use. It is, on the contrary, to seek to further the rational disenchantment with those forms of scientific wisdom and technological expertise which have proved so catastrophic in their impact on the environment. Likewise to pit a religious or mystical conception of nature against these forms of technological abuse is less to undermine than to collude in the myth of the omnipotence of science: it is to perpetuate the very supposition which needs to be challenged – that because science *can* achieve results which magical interactions with nature cannot, it is always put to work to good effect.

In any case, it is not clear that by becoming more mystical or religious about nature one necessarily overcomes the damaging forms of separation or loss of concern which have been the consequence of a secular and instrumental rationality. What is really needed, one might argue, is not so much new forms of awe and reverence of nature, but rather to extend

to it some of the more painful forms of concern we have for ourselves. The sense of rupture and distance which has been encouraged by secular rationality may be better overcome, not by worshipping this nature that is 'other' to humanity, but through a process of re-sensitization to our combined separation from it and dependence upon it. We need, in other words, to feel something of the anxiety and pain we experience in our relations with other human beings in virtue of the necessity of death, loss and separation. We are inevitably compromised in our dealings with nature in the sense that we cannot hope to live in the world without distraining on its resources, without bringing preferences to it which are shaped by our own concerns and conceptions of worth, and hence without establishing a certain structure of priorities in regard to its use. Nor can we even begin to reconsider the ways in which we have been too nonchalant and callous in our attitudes to other life-forms, except in the light of a certain privileging of our own sense of identity and value. All the same, we can certainly be more or less aware of the compromise, more or less pained by it, and more or less sensitive to the patterning of the bonds and separations which it imposes.

Finally, it is an implication of my argument that while we shall always have to live with the consequences of our cultural transformations (or perish as a result of them), nature in the realist sense determines only somewhat minimally the modes in which we respond to its limits and potentials. It may recommend certain types of action, and it will always have its say in determining the effects of what we do, but it does not enforce a politics. Heterosexual relations, for example, which are often presented in contemporary theory as an arbitrary and coercive norm of human sexual conduct are a prescription of nature in the sense that they have been essential to the reproduction and thus the history of the species. Yet it is in principle possible to attempt, as some feminists have suggested we might, to avoid or circumvent the heterosexual contacts involved in natural reproduction. This however would not be to escape the determination of biology. On the contrary we would have to know an awful lot more about biological law and process before we could even begin to commit ourselves to such a scenario. The point is only that nature is not going to stop us trying it on, if that were to prove a general political option. The same goes for ecology, where nature in the realist sense will exercise its determining impact on whatever we do or try to do, and will to some extent constrain what we can attempt. But it will only set rather elastic limits on this, and it is we who have to decide what it is ethical to do or try to do within those limits.

But this does not mean that we can do whatever we choose to the environment or ourselves and still expect the planet and its various life-forms, including our own, to survive and flourish. It is one thing to recognize the relative autonomy of our political powers in respect of our use of nature, and our technical capacities to act upon them, but another

to suppose that we could ever escape the constraints which nature imposes on what we can enjoy, or experience as practically feasible or morally acceptable. If the request to respect nature is construed in these terms, then it is perfectly valid; indeed without it, it would seem impossible even to begin to make the distinctions between human nature and the nature destroyed be human culture, or between ecological and ideological conceptions of nature, which are so important to disentangling the oppositions of contemporary theory around the idea of 'nature'.

NOTES

1 See Raymond Williams's discussion of the relativism of the nostalgia for a lost time/space of 'nature' and of the tendencies of the literary pastoral tradition to 'cancel history', in *The Country and the City*, London: Hogarth Press, 1973, especially 9–45.
2 Theodor Adorno, *Aesthetic Theory*, London: Routledge & Keegan Paul, 1984, 95–6.
3 One relevant instance is the way in which a distinction between different types of landscape, and the taste in them, served in the 'civic humanist' aesthetic of the eighteenth century to map – and hence politically legitimate – a supposed difference between social strata. A distinction between the 'panoramic', ideal landscape, and representations of occluded, enclosed landscapes without much depth of field, figured a difference between a refined capacity for thinking in general terms, and a vulgar (and supposedly also female) incapacity to do so, with the taste in the former being associated with the powers of abstraction essential to the exercize of political authority. See John Barrell, 'The public prospect and the private view' in *Landscape, Natural Beauty and the Arts*, Salim Kemal and Ivan Gaskell (eds), Cambridge: Cambridge University Press, 1993, 81–102. See also Barrell's *The Dark Side of the Landscape*, Cambridge: Cambridge University Press, 1980.
4 Alexander Wilson, *The Culture of Nature: North American Landscape from Disney to the Exxon Valdez*, Oxford: Blackwell, 1992, *passim*, but see especially ch. 1.
5 Ibid., 37.
6 Arne Naess, *Ecology, Community and Lifestyle*, Cambridge: Cambridge University Press, 1989, 85; see also 194–5.
7 Robert Goodin, *Green Political Theory*, Oxford: Polity,1992, especially 24–83.
8 The major influence on this line of argument has been Foucault, though Foucault is not entirely consistent in what he says about the 'body', and it is debatable how far his account supports those who have drawn on it to deny it any 'naturality' (see, for example, Susan Bordo, 'Anorexia nervosa: psychopathology and the crystallization of culture', in *Feminism and Foucault: Reflections on Resistance*, I. Diamond and L. Quinby (eds), Boston: Northeastern University Press, 1988, 87–117; M.E. Bailey, 'Foucauldian feminism: contesting bodies, sexuality and identity' in *Up Against Foucault*, C. Ramazanoglu (ed.), London: Routledge, 1993, 99–122). The fullest and most sophisticated defence of the 'constructivist' account of the body is to be found in the argument of Judith Butler (see *Gender Trouble: Feminism and the Subversion of Identity*, London: Routledge, 1990; *Bodies that Matter: On the Discursive Limits of Sex*, London: Routledge, 1993).

Chapter 3

The production of nature

Neil Smith

> Our goal is to provide you with products, insights and experiences which
> kindle your own sense of wonder and which help you feel good about
> yourself and the world in which you live.
>
> The Nature Company

DESIGNER NATURE

In November 1994, 'the actress Mary Tyler Moore offered a $1,000
"ransom"' to a restaurant in Malibu, California 'that is keeping a 65-year
old lobster in a tank. The lobster, christened "Spike", is the star attrac-
tion at "Gladstones 4 Fish" restaurant. Ms Moore and the organization,
People for the Ethical Treatment of Animals told Reuter they want to
have the twelve-and-a-half pound lobster returned to the waters off the
coast of Maine. "Although I do not pretend to know how Spike feels
living in a small tank ... I am certain that by whatever means a lobster
can feel and understand its surroundings, this one would prefer to be back
home in his native waters." '[1]

Numerous claims have been made that the new environmental move-
ment of the last two or more decades is a kindred spirit of postmodernism,[2]
but the story of Spike the lobster points in a rather different direction.
In fact this animalist vision combines an Enlightenment romancing of
nature (the natural harmony that will be restored upon Spike's return to
'his native waters') with a thoroughly pre-modern spiritualism of nature:
Spike is endowed with a smattering of feelings, comprehension and
preferences; indeed, during his captivity, he even appears to have under-
gone religious conversion, having acquired a 'christian' name.

This kind of celebrity environmentalism – saving lobsters, spray-painting
furs – is a symptom of the pervasive commodification of nature as much
as a visceral emotional response to it. It is as much about making
its advocates feel good about themselves and their world as it is
about lobsters. It is by no means clear, for example, that Spike could even
survive the secular nativity of the waters of Maine after decades in the

mellow, effortless confines of a Malibu window tank. But such a practical question about nature seems never to have occurred to Spike's handlers. More curious still, is the choice of Spike as symbol for a nature to be saved: what about Spike's lesser pals in the back of the restaurant who meet a steamier fate on a nightly basis? For some, at least, designer nature would seem to be open to culinary compromise.

Although it may not be immediately obvious, a similar brand of environmentalism guides The Nature Company. The Nature Company is a multinational retail chain that sells nature: it 'creates, sources and sells products that enhance observation, understanding and appreciation of the natural world', according to the company's annual report. Each of its 150 or more outlets is less a store than a presentation of nature intended to elicit an alternately contemplative and interactive response. Nature at The Nature Company includes natural objects, simulated nature, and representations of nature, either free-standing or emblazoned on everyday consumer objects. They sell fossils, gem stones and agates, all labelled with their precise countries of origin and global distribution – Brazil, Australia, South Africa. Their tree seed and plant kits beg you to grow your own nature on the window sill, while the precise Latin species labels and descriptions of ideal habitats and ecological requirements somehow guarantee a mainline to the ordered harmony of nature: everything has its place in nature, and The Nature Company is devoted to seeking out and celebrating the world's forgotten natural origins. Telescopes and microscopes, offering access to natural secrets at opposite scales of terrestrial resolution, are on sale to assist this rediscovery as remembrance. 'The Nature Company owes its vision to the world's great naturalists', reads the plaque outside each syndicated store, and as if to give its merchandising a noble philosophical mission derived from popular environmentalism, a list of said naturalists follows: 'Charles Darwin, Henry David Thoreau, John Muir, David Brower, Rachel Carson, Jacques Cousteau and many others. Through their inspiration, we are dedicated to providing products and experiences which encourage the joyous observation, understanding and appreciation of the world of nature.'

The Nature Company's commodities promise urban middle-class consumers a recuperative re-immersion in 'nature'. Yet nature places a few of its own limits on the terms of its commodification – it is not always commerce-friendly – and so the constructed 'authentic' can just as easily be jettisoned for representative maps of nature. Globes of the planet, small and large, on stands or as key chains, brightly coloured or brightly lit, as place mats or jigsaw puzzles, give the big picture. A bright blue illuminated 'globe-clock' lets you track the cyclical movement of daylight and darkness across the planet. Maps of national parks and biodiversity reserves, field guides for bird and butterfly watchers, posters of endangered species or tropical fish, children's eco-friendly storybooks, games

and toys, and lavishly illustrated coffee-table books of Antarctica or the Sahara all express The Nature Company's contention that nature should be fun and adventurous as well as educational. The Nature Company uses 'an interactive creative concept to connect with its customers' while at the same time indicating its support of certain mainstream environmental organizations such as the Nature Conservancy. 'While there's no doubt that The Nature Company cares about protecting the environment,' note two business commentators, 'the creative, educational and entertaining approach is what works best in communicating and connecting with its customers.'[3]

The paradoxical hallmark of The Nature Company's vision is the simultaneous idolization and commodification of nature combined with an aggressive exaltation and effacement of any distinction between real and made natures. Thus global, expansive and ambitious as it is, the Nature Company's commodification of nature is not unlimited: 'We do not advocate and will not allow to be sold in our stores any products which result in the killing of wild animals for trophy purposes', declares the front door plaque. Nor indeed do they sell live animals. But to the extent that particular fauna are considered exotic, charismatic, dangerous or otherwise fascinating, The Nature Company sells cutified plastic replicas: snakes and spiders, smiling killer whales, furry five-inch tigers, crocodile eggs (faux of course). An audio series offers the sounds of 'The Last Places on Earth', while *Virtual Nature* – the video – takes to the limits this genre of nature as psychic soporific. With appropriate New Age instrumental accompaniment, cascading waterfalls in verdant forests and soaring vistas of crystal white snowfields wash over the pacified viewer.

A global leader in eco-commerce, The Nature Company entered 1995 with outlets in the United States, Canada, Australia and Japan. Twenty new stores were planned for 1995, and Britain is the next frontier. Outlets are typically located in tourist festival market places such as Baltimore's Harborplace or San Francisco's Embarcadero Center, suburban malls (Woodbridge Mall in New Jersey and Denver International Airport) or in upscale gentrified neighborhoods like New York's SoHo. Store designs replicate the precise compartmentalization of nature that their commodities project, with different rooms devoted to different kinds of 'products and experiences': 'harmony with nature', 'space', 'life', 'rainforest'. And just in case this consumer experience tempts you to try the real thing, The Nature Company sells appropriate safari-style clothing as well.

The Nature Company's focus is avowedly 'high-end retailing', according to Rob Forbes, vice president for marketing.[4] The company is owned by the CML Group, a conglomerate with over 6,800 workers, $400 million in assets and 1994 sales of $772 million (The Nature Company's share was more than $200 million). CML's portfolio of retail and mail-order operations provides a veritable triptych to the corporate connection

between health, style and the environment: the tony Smith and Hawken gardening catalogue, Britches of Georgetowne, and the more populist Nordic Track. Seeking to expand its markets, The Nature Company in 1993 sought a joint marketing agreement with The National Geographic Society, but premature leaks may have sabotaged the deal. But The Nature Company has acquired 'two early stage retail concepts, Hear Music and Scientific Revolution that sell music and science-related merchandise, respectively.'[5]

In reality, The Nature Company's gentrified nature is two natures in one. The first nature is the external world of fossils and fauna, time, climate and flora which operates according to its own physical and bio-logical laws, immune to human interference, primordial, pre-societal. The company sees its mission as the delivery of this nature at the local mall or boutique, encouraging you to take it home, set it up and plug it in, get involved in the magnificence of its grand mysterious design. 'Exercise your sense of wonder', reads the subtitle of The Nature Company catalogue. But in their second nature, the grand design includes human 'experience'; it places 'us' – undifferentiated consumer humanity – in the middle of nature. We are alternately the all-powerful designers of a universal nature, wittingly or otherwise, or its necessarily humble consumers. If it retains the overtones of a pre-modernist designed nature,[6] this affable contradiction between *external* and *universal* natures goes to the heart of modernist, bourgeois ideologies of nature and I shall return to it presently.

It is worth clarifying the conservatism of The Nature Company's alle-giance to 'the environment', for if they exude a cuddly moralism that we love nature, they are no ally of environmental activist politics. For The Nature Company, interactivism (or activism) in the re-immersion with nature begins and ends with consumption. Indeed, their concern with environment is ultimately subordinated to the glory of consumption, and this is startlingly reaffirmed in a revealing grammatical slip on their front door plaque: 'We do not advocate and will not allow to be sold in our stores any products which result in the killing of wild animals for trophy purposes.' Sounds reasonable. But does the selling of an animal product really 'result in' the 'killing of wild animals'? Actually, it is the other way round: the animal is killed first, worked into a saleable product, and only *then* appears on the shelf. The selling of such products results *from* (not in) the 'killing of animals'. This may seem like a picayune point, but The Nature Company's grammar says more about their vision of the social relationship with the environment than they intend. Not only is the rel-ationship between environment and consumption reversed but the whole production process is entirely erased; consumption not production makes the world. It may not be surprising, then, that while The Nature Company is headquartered in Berkeley, California and CML, the parent

company, in Massachusetts, The Nature Company retains its 'fulfillment and communications system' in the right-to-work state of Kentucky. And they are proud of their multiple out-sourcing: 'The company has many domestic and foreign suppliers, none of which accounts for more than 5% of its purchases. Generally, the Company is not dependent upon any single source for any items of merchandise.'[7] The Nature Company's political correctness, postured at the front door, seems not to extend from fauna to people – its own workers in particular.

SAVING NATURE – AND OTHER IDOLATRIES

The mid to late twentieth century may well be seen in retrospect as the nadir of a process lasting several centuries in which 'western' societies most completely flattered themselves about their autonomy from the natural world. In intellectual terms, this tradition is conventionally traced back to Francis Bacon and the Renaissance, while the Enlightenment is credited with deriving the range of scientific vision and philosophical concepts for framing the peculiarly 'human condition'. In practical terms, of course, it was the emergence of capitalist society, its attendant industrial revolutions, the harnessing of scientific objectivism, and in this century the globalization of capitalist social relations, that made such a flattery seem even possible. Where Francis Bacon only dreamt of the 'conquest of nature', the majority of the citizenry of late modern Europe, North America and Japan live from day to day under conditions that take a large measure of this control for granted. Only at the margins – on the frontiers of genetic engineering or space exploration, with extreme climatic or geological events (or indeed for millions of peasants and poor urbanites in Africa, Asia and South America, whose experiences are largely unrepresented in 'western' conceptions of nature) – is nature seen to reassert itself with real force, and when it does it brings with it a romantic as much as physical force. Social relations with nature are widely scripted as a kind of inevitability of the human condition, a 'natural' glorious, breathless jouissance with a recalcitrant, irrepressible, m/other nature.[8] The flattery of an autonomous social world, distanced from an equally independent and *external* nature, is here again reaffirmed by its opposite: the assumption of a *universal* nature that incorporates human and nonhuman worlds in endless union.[9]

The trek back from such an impossible, contradictory ideology of nature is vital if environmentalism is to be a powerful social movement in making the future of nature. But it will be an arduous trek. From The Nature Company's life-like posters of pandas and endangered big cats to Malibu Spike, the nature-idolatry of unsuspecting 'charismatic megafauna'[10] expresses a conservative exhortation to 'save' a nature that is no longer recognizable. Implicitly or explicitly it appeals to the politics of apocalypticism

on which so much of the new environmental movement is based. Together with parallel pronouncements of the 'death of nature' or the 'end of nature', the ambition to 'save nature' is utterly self-defeating insofar as it reaffirms the externality (otherness) of a nature with and within which human societies are inextricably intermeshed.[11] It is precisely this presumption of externality – from Francis Bacon to atomic science and the Human Genome Project – which facilitated the supposed destruction of nature in the first place, an externality that is revisited, not reversed, by the romantic assumptions of nature idolatry.

The prospects for a vital environmentalism are no more encouraging if we look to the harder heads of the new environmental policy establishment. Dominated by engineers and physical scientists along with a smattering of more technocratically minded social scientists, especially economists, the environmental policy establishment spans a global network of institutions and organizations: national and international bureaucracies from the World Bank and the United Nations to various national Departments and Ministries of Environment (and their local counterparts), Departments of Energy, even Departments of Defense; private sector consultancies and corporations devoted to environmental clean-up, contract research, and environmental strategy advising; and watch-dog non-governmental organizations (NGOs) and academic bodies that monitor environmental conditions, campaign with and against private and governmental organizations for legislation, and offer policy advice. The pragmatism of this environmental policy establishment is doubly inimical to a vital environmentalism. Ideologically committed to the conventional assumption of an external nature, albeit a damaged but fixable nature, they are equally dedicated to reproducing the very social conditions of production, consumption and 'development' that have given rise to environmental concerns in the first place. The global conservatism of this policy establishment was most visibly exposed with the affirmation of the 'World Commission on Environment and Development' at the Rio Earth Summit of 1991.

As much as environmental policy has succeeded in reducing levels of pollution from some traditional technologies in some parts of the world that can afford the cost of clean-up and technology conversion – for example auto emissions – the new environmental policy establishment has also facilitated an ideological redefinition of 'environmental hazard'. What began as a well-meaning liberal environmental notion in the academy, summed up in the title of an influential 1970s text, *Environment as Hazard*,[12] has been turned on its head to connote a world in which the environment itself is the enemy. This reversal may well have culminated in Ronald Reagan's famous remark that trees cause pollution. Since, in this view, the environment itself is a potential hazard, it is difficult to talk of an environmental crisis *per se*. Only in this political climate,

then, could the nuclear industry, the scourge of 1970s and early 1980s environmentalism, reinvent itself as the 'clean alternative' in the late 1980s. Likewise, as the enthusiastic bureaucratic appropriation of 'sustainable development' makes clear, environmental policy actually provides a new, clean, and socially acceptable cover for imperialism at a global scale – that is, business as usual. For the World Bank, sustainability is defined not in strictly environmental terms but within the same economic embrace as the Bank has always defined development: it is the profit rate, in the end, that is to be sustained, and the viability of the private market. Not only does the public sector absorb the costs of corporate environmental profligacy, by performing the necessary 'clean-up', but it actively subsidizes the emergence of an environmental industry which, along with its ideological twins, the health and exercise and natural foods industries, has for more than a decade been one of the fastest-growing, multi-billion dollar industrial sectors contributing to sustained capital accumulation on a global scale.[13]

'Nature' is an established, trenchant and powerful weapon in 'western' discourse; its power trades precisely on the slippage from the externality to the universality of nature. The authority of 'nature' as a source of social norms derives from its assumed externality to human interference, the givenness and unalterability of natural events and processes that are not susceptible to social manipulation. Yet when this criterion of 'naturalness' is reapplied to social events, processes and behaviours, it necessarily invokes the assumption of a universal nature, a sufficient homology between human and nonhuman natures. The explanation of certain social *differences* such as class, race and gender, as natural *inequalities* (another slippage) or the explanation of some social behaviours (homosexuality) as unnatural while others are deemed natural (competition) brings to bear the full authority of an inevitable, suprahuman nature.

Finally, insofar as the flattery of social autonomy from nature is premised on the economic practices of capitalist societies which have made such a separation violently real (at the same time, of course, as they have immersed human society more deeply in nature than ever before), there is little reason to assume that the future of nature will be radically and qualitatively different. Whereas the environmental consciousness that emerged out of the 1960s and 1970s has been selectively strained into the cultural economy of the *fin de siècle*, absorbed, upended, pulped and re-represented by the cultural and economic apparatuses of production and consumption – such that George Bush could promote himself as the 'environmental' President and Dow Chemical could advertise themselves as the 'environmental people' – the ruthless objectification of nature remains a central tenet of capitalist production, and one that will significantly circumscribe the intellectual and ideological reconnection of social and natural worlds that is now afoot.

CULTURE AND AMPUTATED NATURE

There are of course many and diverse environmentalisms. Perhaps most notable lately in academic circles is the discovery of nature in cultural studies. Commentary on such obvious texts as *The Tempest*, *Heart of Darkness*, or *The Hound of the Baskervilles* notwithstanding, nature has not traditionally been a major player in literary discourse. Where it appears, nature is usually rendered a backdrop, a mood setter, at best a refractory image of, or rather simplistic metaphor for, specific human emotions and dramas that inscribe the text. The play of human passions is the thing.

It is not that nature has been absent in literary texts, quite the opposite. Literature oozes with nature. It could hardly be otherwise. Curiously, however, no one has yet done for nature what Bruce Robbins, for example, has done for the invisible servant classes in literary texts. Robbins demonstrates 'the exclusion of the people from literary representation' despite the fact that the traditional canon of English literature is thoroughly steeped in unacknowledged and unexamined references to the working classes. As Robbins puts it, ordinary people have been made invisible because they were powerless, their hands amputated from history.[14] Nature too has been largely amputated from the literary critical gaze. The rediscovery of 'nature's hand' in literature is surely a long overdue project.[15]

The emergence of a more explicitly political cultural studies, however, may have begun the process of recovering an active nature. Entwining with currents of the new environmental movement and a spreading environmental consciousness, a 'green cultural criticism'[16] has been announced. The results, however, are not always encouraging, given the overwhelming sway of an environmental movement that remains steeped in the contradictory nature ideologies of bourgeois modernism. Here, for example, is how Ruth Perry opens her recent article on 'Engendering Environmental Thinking', in the *Yale Journal of Criticism*:

> Once, at a time of great stress in my life, I bought a cottage on a salt marsh south of Boston. I found the tidal rhythms infinitely soothing, a reminder that life was not structured by semesters or fiscal years. Twice every day the tides flush the channels, making silvery little waterways in what otherwise looks like a meadow.[17]

The bulk of this piece attempts an exploration of environmentalist analysis informed largely by feminist and social scientific work – a voyage of enlightenment in many ways. It recognizes, in ways that some green cultural criticism has not, that a substantial political analysis of environment has been pursued over the last couple of decades. And yet these beginning sentences are disturbing. With no later redress, they replicate

the uncritical and unreflected treatment of nature as social sanitarium, space of recuperation, Thoreauvian anti-social retreat. Nature *is* the home you *can* go back to. Put this way, of course, when a recuperative nature is juxtaposed so directly with the gendered construction of 'home', the ideological contours of such a nature become more apparent. And it is precisely this frothy ideology of recuperative nature that The Nature Company taps so effortlessly in their dedication to 'help you feel good about yourself and the world in which you live'. Further, the elitism of such a construction of nature always has to be confronted: how many people can respond to 'a time of great stress' by buying 'a cottage on a salt marsh south of Boston'? Only at the risk of jeopardizing a vital environmental movement do we forget that access to nature, and cultural constructions of nature, are centrally questions of class and race as well as gender and other dimensions of social difference.

I do not mean to pick unfairly on one author. I refer to this piece, rather, to highlight the point that the politics of nature are complex and not necessarily self-evident. 'Nature' in fact is a little like a spy's attaché case. It contains lots of hidden compartments that you have to work hard and carefully to find; if you are not familiar with the luggage it could blow up in your face. Defusing the case – 'de-naturalizing nature' – is an intricate procedure.

Like much first phase green cultural criticism, this piece perceives the importance of the work of some environmentalists, feminists, social scientists and activists, and tries to import it into cultural discourse. But it fails to take the second step by using this work in such a way that it changes the place from which it started. The social scientific, feminist and activist work on environment remains a displacement, an alternative to existing cultural analyses rather than an ink with which *also* to rewrite 'culture'.

Andrew Ross, by contrast, does attempt to rewrite culture with ecology, and crisply so. He makes the perceptive assessment that by the 1990s, 'capitalism and its liberal political institutions appear to have achieved a leveraged buyout of environmentalism,' and he recognizes the ambivalent globalism through which this has taken place.[18] On the one hand, the discourse of environmental globalism in the 1980s and 1990s has evolved in tune with a language of globalized political economy that both whipped Wall Street into a feeding frenzy and justified its gluttony. On the other hand, the globalization of the economy has spawned a sense of 'global environmental citizenship' upon which corporate environmentalism has quite literally capitalized. In his most recent book, Ross offers a kind of running interpretive commentary on current events – the Gulf War, the World Trade Center bombing, Polynesian preservationism, the men's movement and biogeneticism – harnessed to the overriding message that the same corporate and state institutions that created the 'ecological crisis' in the first place have captured the ideological soul of mainstream environmentalism.

An ecologically sane future will not be achieved without some form of revolution in social and economic justice. ... Let us get on with the task, crucially deepened by the ecology movement, of challenging and transforming those institutions which profit [from cycles of socially created scarcity and abundance] and which are even now wearing their newfound environmentalism like some bad-taste badge of honor.[19]

Grounded in an erudite familiarity with the gamut of environmental debates, this proposition of an ecologically sane future, attainable only through a 'revolution in social and economic justice' should have wide appeal. It reiterates the potentially broad common ground between social ecologist, socialist, feminist, racial justice and other environmental agendas premised on various versions of revolutionary social change. And yet the hard analytical work that wove these contributory threads into such a critical environmental vision are only weakly carried forward here. This might seem to be a rather academic objection, except that it results in a retrospective amputation of the history of a politicized nature. The politicization of nature is conveyed less as the result of historical achievements or political activities than of a rhetorical diagnosis of contemporary cultural forms and events. The historical, political and theoretical record of environmental struggle is by no means absent; it is richly distilled into Ross's account, in fact, but in such a way that it remains inaccessible to the uninformed reader. In a similar vein, the political implications of this 'revolutionary environmentalism'[20] are not immediately obvious. Where do we go from here? How do we get involved in the politics? Or is continued critical conceptual vigilance the most important political task?

The analytical and political imperatives are closely intertwined here in ways that it may be difficult to express via a green cultural criticism. A brief examination of Alexander Wilson's proposal of a 'restoration ecology', proposed in his influential *The Culture of Nature: North American Landscape from Disney to the Exxon Valdez*, may help to illustrate this dilemma further. Ross's book in fact is dedicated to the 'memory and example' of Alexander Wilson, who died tragically young in 1993. Building on the analysis and interpretation of various landscapes – tourist destinations and parks, Disneyland and nuclear plants, World's Fairs and zoos, highways and golf courses – as well as film and TV representations of nature, Wilson points to the intellectual and political complexity of 'nature'. He prefers to begin from the premise that North American nature is a socially constructed environment:

Nature is a part of culture. ... [N]ature too has a history. It is not a timeless essence, as Disney taught us. In fact, the whole idea of nature as something separate from human experience is a lie. Humans and nature construct one another. Ignoring that fact the one way out of the

current environmental crisis – a living within and alongside of nature without dominating it.[21]

For Wilson, the notion of 'landscape' embodies the active production of material culture in relation with nature, and provides a more tangible, less evanescent and less ideologically laden focus for political analysis and action.[22] He not only seeks 'to return landscape to the center of cultural debate', therefore, but sees in landscape construction and design the potential lodestone of a new and progressive politics of nature: 'socially useful tourism' (in contrast with the ecological destruction of most contemporary tourism); a reclaiming of natural 'heritage' from the right wing through local institutions such as village museums; habitat reconstruction; restorative garden design; landscape design that remakes the suburbs, confounding the country–city distinction. Countercultural and restorative landscaping that provokes questions of 'authentic landscape', the identification and appropriateness of native or original species, and so forth are central to this enterprise. In Wilson's concluding words, 'We need to gain a sense of how our constructed environment connects to the natural one surrounding it, and to its history. Only then can we be mobilized to restore nature and to assure it, and ourselves, a future.'[23]

Elsewhere, Wilson explains more fully what this 'restoration ecology' would look like. It is worth quoting him at length:

> Restoration ecology . . . is more than tree planting or ecosystem preservation: it is an attempt to reproduce, or at least mimic, natural systems. It is also a way of learning about these systems, a model for a sound relationship between humans and the rest of nature. Restoration projects actively investigate the history of human intervention in the world. . . .
>
> Restoration actively seeks out places to repair the biosphere, to recreate habitat, to breach the ruptures and disconnections that agriculture and urbanization have brought to the landscape. But unlike preservationism, it is not an elegiac exercise. Rather than eulogize what industrial society has destroyed, restoration proposes a new environmental ethic. Its projects demonstrate that humans must intervene in nature, must garden it, participate in it. Restoration thus nurtures a new appreciation of working landscape, those places that actively figure a harmonious dwelling-in-the-world. . . .
>
> As landscaping ideas have been reinterpreted and reversed, the boundaries of the garden have become less distinct. Much recent work attempts to reintegrate country and city, suggesting that what was once nature at home may soon become nature as home. [24]

Several things are impressive about Wilson's vision. A horticulturalist and landscape designer during his short career, he works from a detailed knowledge of ecology. Second, the seriousness with which he understands

geographical landscape as both a social product and social subject is in marked contrast to the historicism that has utterly dominated twentieth-century social and cultural commentary, especially in the United States but to a lesser extent also in Europe and Wilson's native Canada. Third, and most perceptively perhaps, Wilson adroitly places human work and labour at the centre of nature: the history and future of nature alike are figured by the consequences of human work.

Yet the disjuncture between this analytical sophistication and the deliberately modest localism of 'ecological restoration' as the basis of an environmental politics is ultimately unsustainable. Notwithstanding that ecological restoration implies a creative *reworking* of nature, nor his hardheaded insistence on a nature imbued with labour, Wilson's 'ecological restoration' is an inadequate response to environmental crisis in three central ways. First, it retains a yearning for an unnecessarily nostalgic and one-dimensional re-immersion in nature. Little other conclusion is available from the argument that the 'ruptures' of nature must be 'repaired', nature 'mimicked', a 'harmonious dwelling-in-nature' restored: nature again as home. If not quite elegiac, this vision nonetheless embodies a romantic universalist view of human society and nature that utterly forgets the vicious externalization of nature as object of capitalist labour. And it forgets too that universal nature is every bit as much a capitalist as a pre- and post-capitalist project; the totalist ambitions and ideologies attached to capital accumulation ought never to be underrated. In its anti-capitalism, Wilson's rejection of the objectivism of nature has fastened on only part of the problem.

Second, the limits of the restorationist solution become clear in international context. Much as the North American or European middle classes may have the luxury of pursuing ecological restoration, the coca farmers of Bolivia or the groundnut-growers of the Sahel are sufficiently imprisoned in the global market for 'ecological restoration' to seem a cruel joke. In fairness to Alex Wilson, he did not propose the extension of this vision beyond North America, and yet the globalization of corporate environmentalism, of which he was wholly aware, does require a global-level response. Therefore, third, it seems to me that 'ecological restorationism' seriously underestimates the level of political response required. If Wilson's discussion has the merit of political concreteness and a certain reassuring localism, it lacks the realism that leads to the prescription of a revolutionary environmentalism.

THE DOMINATION OF NATURE?

Alex Wilson says at some point that the aspiration of an environmental politics ought to be to live within and alongside nature without dominating it. This vision of 'the domination of nature', 'mastery of nature' or

'control of nature' is a ubiquitous theme in leftist treatments of nature, but I want to argue that it is theoretically and politically misconstrued. We ought in fact to purge our environmental manifestos of the language of the 'domination of nature'. From Francis Bacon, who dreamed of 'mastering' nature, through the Enlightenment to the present, the question of domination has been central to western treatments of nature. In its present more critical usage, however, it derives most directly from Hegel and Marx, and especially from the use made of Marx by the Frankfurt School.

For Marx, the social struggle with nature was an inevitability, although different modes of production organized this relationship differently. Capitalism, he argued, was characterized by the ruthless and relentless way in which it attacked and subdued nature and labour simultaneously. Especially after 1945, according to Martin Jay, as the Frankfurt School moved away from a concern with class struggle, they came to treat 'the larger conflict' between human beings and nature as the basic 'motor of history'.[25] According to Horkheimer and Adorno, writing in *Dialectic of Enlightenment* on the eve of Hiroshima, 'human society' as a whole, not just capitalism, was becoming 'a massive racket in nature', and they theorized about the imminent 'revenge of nature'. But it was Herbert Marcuse, arguably, who pursued the implications of this argument furthest. Whereas technology was the central mediator between human beings and nature, and the project of technological development was primarily a project of human domination over nature, Marcuse also insisted that the domination of nature was also driven as a means by which some human beings could dominate others. He therefore retained the political ambition of a more benign and liberatory relation with nature, but it was a slim hope. It was foreclosed by his student and in many ways successor, Jurgen Habermas, who concluded that 'technology, if based at all on a project, can only be traced back to a "project" of the human species *as a whole*, and not one that can be historically surpassed'.[26] Technology itself was virtually naturalized here, in an argument that still has a bearing on Habermas's more recent work.

Echoing a widely voiced criticism, Raymond Williams once suggested that marxism embodied a 'triumphant version of man's conquest of nature'.[27] In the Frankfurt School we see at least what might be thought of as a negative triumphalism. And it is a vision that has effectively captured left thinking on nature since the 1960s. Thus, in a recent debate in *New Left Review*, Reiner Grundmann could state axiomatically: 'Humanity's special position within nature is characterized *by its domination of nature*.' There are several problems with the negative triumphalism of 'the domination of nature'. First, as Benton has argued in response to Grundmann, 'the idea of a limitless mastery, the project of "controlling all natural and social processes", is literally unthinkable:

it is incoherent'.[28] However, although this is undoubtedly true it does not deal with the possibility of domination as a project never entirely accomplished. More theoretically, as William Leiss argued more than two decades ago in the first sustained critique of the 'domination of nature' thesis, the 'notion of a common domination of the human race over external nature is nonsensical' insofar as it is premised on a 'methodical separation of 'society' and "nature"'.[29] In fact, the Hegelian care of Marcuse and Horkheimer notwithstanding, the 'domination of nature' thesis has evolved in such a way that it mirrors exactly the contradiction between external and universal natures which, as we saw, characterizes bourgeois ideologies of nature. This is nowhere more evident than in the influential argument by Alfred Schmidt, also of the Frankfurt School, concerning *The Concept of Nature in Marx*. He judges Marx to be utopian precisely because he does not fully accept the inevitability of the domination of nature.[30]

More important, the 'domination of nature' thesis is of dubious political value, and has arguably led the environmental movement astray. In the first place, it is not immediately clear what would constitute a reasonable political response to the inevitability of domination. Does one accept such a desperate conclusion as part of the 'human condition' *à la* Grundmann (in which case environmental politics is presumably limited to finding friendlier modes of dominating nature)? Or does one revolt against 'the human condition' itself as some eco-anarchists have been tempted to do? Either way, there is no obvious social solution to environmental crisis. The 'domination of nature' thesis is thereby of a piece with the Frankfurt School's larger politics of despair. Among the German Greens, especially, it is now demonstrable that this residual contradictoriness of the 'domination of nature' thesis has virtually scripted the political divisions that have emerged since the 1980s between those who, seeking to soften the domination of nature, have joined their political agendas to the Reichstag and those who, in resisting this move, have become increasingly nature-essentialists of various sorts.

THE PRODUCTION OF NATURE

But what of Marx's supposed utopianism? Did Marx indeed believe that socialism would take human beings beyond the necessity to dominate nature? The picture is not particularly clear. On a rare reference to socialism, and in perhaps his most outspoken statement about the future of nature, Marx did after all maintain:

> Freedom in this field can only consist in socialised [human beings], the associated producers, rationally regulating their interchange with nature, bringing it under their common control, instead of being ruled

by it as by the blind forces of nature; and achieving this with the least expenditure of energy and under conditions most favorable to, and worthy of, their human nature.[31]

Human society remains tied to nature, to be sure, and under socialism, this relationship would take a different form. But Marx seems to be saying more: the 'control' of nature would continue. It was left to Engels to make this argument explicit: 'Socialized production upon a predetermined plan becomes henceforth possible. . . . Man, at last the master of his own form of social organization, becomes at the same time the lord over nature, his own master – free.'[32] If there is a utopianism here it may be precisely in the belief that the 'mastery' of nature *is* possible.

This is hardly a savory vision from the standpoint of an environmental or a feminist politics. For these reasons – and because Marcuse was undoubtedly correct at least insofar as he saw the 'domination of nature' as a vehicle for dominating other human beings – it does not belong in a socialist conception of nature either. And yet it would be premature to use this single quote to hang Marx of triumphalism. Benton seems to have this passage by Marx in mind when, in trying to get around its more damning implications, he proposes that 'in their more sober formulations', it is the human *'interchange'* with nature rather than nature itself that Marx and Engels thought could be controlled.[33] And this is not wrong as far as it goes: nature 'itself' is not much of a marxist category. And yet we miss an opportunity by so quickly excusing Marx, and especially Engels, who makes various such 'triumphalist' declarations of the imminent mastery of nature.

If Marx retained a critical ambivalence to the 'control' of nature, it is less clear that his own vision superseded this classical Enlightenment argument. In any case, the larger point is that a political theory of nature has to find a way of expressing several things: the inevitability and creativity of the social relationship with nature; the very real project of domination embodied in the capitalist mode of production; the differentiated relationship with nature according to gender, class, race, sexual preference; the implausibility of an autonomous nature; and a strong response to the almost instinctive romanticism which pervades most treatments of nature in bourgeois and patriarchal society. If we take seriously the centrality of labour in the relationship with nature, then we need to begin to think in terms of *the social production of nature*.[34]

In the modern period, Hegel has taught us to see a difference between 'first nature' – the given, pristine, edenic nature of physical and biotic processes, laws and forms – and 'second nature'. Second nature comprises the rule-driven social world of society and the market, culture and the city, in which social change is driven by a parallel set of socially imposed laws. If this second nature is certainly produced, the 'production of nature'

thesis goes further in proposing that the distinction between first and second nature is now largely moot. Second nature continues to be produced out of second nature, but increasingly first nature is produced from within and as a part of second nature.

This argument of 'the production of nature' has the advantage, in that it gets beyond the powerful fetishism of a 'nature-in-itself' to focus on the social relationship with nature. It takes seriously the constructedness of nature at the turn of the twenty-first century, but it does so in such a way that it incorporates material with conceptual construction. The production of nature is as much a cultural as it is an economic process and should be understood in the broadest sense of transforming received natures. Further, it is inspired by anti-essentialist feminist critiques of the ideological equation of women and nature, and draws on arguments about the production of gender and sexuality, and 'human nature' more generally.[35] If it indulges a certain anthropomorphism, I would argue that it accurately expresses the extent to which advanced capitalist societies have intruded human activity at the centre of nature. If it were even possible somehow to take society suddenly out of nature – nature itself, literally – nature would very quickly become something very different. Further, production is not the same as control. This is the primary flaw in the 'domination of nature' thesis, namely that it conflates the making of nature with the control of nature. If all societies 'produce' nature at one scale or another, capitalist society has for the first time achieved this feat on a global scale. How else should we conceive of global warming? Global warming was socially produced in the fullest sense, but it resulted not from the control of nature or even control of the social relationship with production but precisely from lack of control – Marx's 'rule by the blind forces of nature'. Further, the 'production of nature' both replaces the gendered language of mastery and opens a means for discussing gendered productions of nature. Indeed, insofar as it eschews the whole problematic of control it also promotes the simultaneous critique and refusal of gendered natures. Finally, the notion of the 'production of nature' has the political advantage in that it focuses the politics of nature around the question of how, and to what ends, alternative natures might be produced. The gloom of 'the end of nature', 'the death of nature', 'the domination of nature', and so forth, is relinquished for a perspective which, in its continuity between the present and the future, makes a future of nature plausible. The political question becomes this: how, by what social means and through what social institutions, is the production of nature to be organized? How are we to create democratic means for producing nature? What kind of nature do we want? These are, in the end, the central questions for a revolutionary environmentalism.

Whatever his concerns with controlling nature, Marx's *oeuvre*, even if not always in his more 'sober formulations', presents an argument that

was entirely consistent with this proposal of 'the production of nature'. Put differently and in hindsight, this notion of the 'production of nature', for all its quixotic suggestiveness, parallels Foucault's argument about the mutuality of knowledge and power:

> we must cease once and for all to describe the effects of power in negative terms: it 'excludes,' it 'represses,' it 'censors,' it 'abstracts,' it 'masks,' it 'conceals.' In fact, power produces; it produces reality; it produces domains of objects and rituals of truth. [36]

The comparison here is precise. The negativity of 'domination', 'control', 'mastery', and so forth provides a very limited basis either for understanding the constructedness of nature or for fashioning a politics of nature geared toward the positive production of alternative natures.

Others have taken the argument in this direction, and I want to highlight two such contributions. Proposing a 'cyborg feminism', for example, Donna Haraway not only finds 'the deep constitution of nature in modern biology' to be steeped in the metaphor of labour, but sees labour as central to the 'invention and reinvention of nature':

> The labour process constitutes the fundamental human condition. Through labour, we make ourselves individually and collectively in a constant interaction with all that has not yet been humanized. Neither our personal bodies nor our social bodies may be seen as natural, in the sense of existing outside the self-creating process called human labour. What we experience and theorize as nature and as culture are transformed by our work. All we touch and therefore know, including our organic and our social bodies, is made possible for us through labour. Therefore, culture does not dominate nature, nor is nature an enemy. [37]

In a similar vein, McKenzie Wark proposes that we recognize the birth of 'third nature'. 'If there is a qualitative change in the social relations of culture which deserves the name of postmodern, perhaps this is it,' he says, referring to Manuel Castells' claim that we now live in a space of flows rather than a space of places.

> Or perhaps we could call this state of affairs 'third nature.' Second nature, which appears to us as the geography of cities and roads and harbours and wool stores is progressively overlayed with a third nature of information flows, creating an information landscape which almost entirely covers the old territories.[38]

CONCLUSION: THE FETISHISM OF NATURE

An inevitable result of the emergence of a popular environmentalism is undoubtedly a certain fetishism of nature. The Nature Company's production of nature both feeds this fetish and profits from it. Where its

commodities are less than faithful replicas of nature, their function as fetish is self-evident. But where they are natural objects themselves the fetish is even more intense. In Nature Company stores and catalogues, these objects are presented in such a way as to erase the social memory of production and labour that was vital in bringing even gem stones and minerals to the market shelf. And yet, as The Nature Company has discovered, that labour process is not so easy to erase; nature bears the indelible trace of labour.

In June 1993, the United States Environmental Protection Agency (EPA) cited The Nature Company's parent organization as a 'Potentially Responsible Party' in efforts to clean up an environmental 'Superfund' site in Conway, New Hampshire. An area designated a superfund site represents the most extreme toxic hazard and is slated for immediate remedial action. Faced with a bill from the EPA for $7.3 million in clean-up costs, the Company, which claims never to have used the site for manufacturing, has argued that the toxic hazard comes from an adjoining vacant site, the owner of which is bankrupt. They have challenged the EPA estimate of clean-up costs, maintaining instead that they have 'reserves and insurance coverage ... for environmental liabilities at the site in the amount of approximately $2.3 million'. Whatever the liability of The Nature Company and its parent CML for the Conway site, CML is also under investigation by the EPA for 'the release of hazardous substances by a former subsidiary at a hazardous waste treatment and storage facility in Southington, Connecticut'. As the EPA calculates clean-up costs, CML has not denied liability in this case.[39]

So much for feeling good about yourself and the world you live in, indeed the world you make. But it is precisely the nature of fetishism, I suppose, that things are not always what they seem.

NOTES

1 *New York Times*, 19 November 1994.
2 See, for example, Michael E. Zimmerman, *Contesting Earth's Future: Radical Ecology and Postmodernity*, Berkeley: University of California Press, 1994; Arran Gare, *Postmodernism and the Environmental Crisis*, London: Routledge, forthcoming.
3 Jeff Haggin and Bjorn Kartomten, 'Show your customers RESPECT!' *Catalog Age,* October 1992, 91–2.
4 Quoted in Mark Poirier, 'CML switches tracks', *Catalog Age* March 1993: 55.
5 'Form 10-K', submitted to the Security and Exchange Commission on behalf of CML Group, Inc., 31 July 1994, 7.
6 For the best historical treatment of the idea of a designed earth in the pre-modern era, see the extraordinary intellectual history of nature by Clarence Glacken, *Traces on the Rhodian Shore: Nature and Culture in Western Thought from Ancient Times to the End of the Eighteenth Century*, Berkeley and Los Angeles: University of California Press, 1967. A materialist grounding of this

work, or indeed its continuation beyond the eighteenth century, remains to be done. Glacken himself found it easier to deal with the world prior to capitalism than during or afterward.

7 CML, 'Form 10-K': 3.
8 For an extraordinary statement of this gendered jouissance with nature, see John McPhee, *The Control of Nature*, New York: Farrar Straus Giroux, 1989.
9 For an elaboration of this contradictory ideology of nature, see Neil Smith, 'The ideology of nature', in my *Uneven Development: Nature, Capital and the Production of Space*, Oxford: Basil Blackwell, 1984.
10 The phrase is Cindi Katz's.
11 See, for example, Carolyn Merchant, *The Death of Nature*, San Francisco: Harper Row, 1980; Bill McKibben, *The End of Nature*, New York: Random House, 1989.
12 This idea was most directly embodied in an influential text published by several geographers in the late 1970s. See Ian Burton, Robert Kates and Gilbert White, *Environment as Hazard,* Oxford: Oxford University Press, 1978.
13 See Michael Redclift, *Sustainable Development: Exploring the Contradictions,* London: Routledge, 1987.
14 Bruce Robbins, *The Servant's Hand*, New York: Columbia University Press, 1986. See also, on the elision of empire in literary criticism, Edward Said, *Culture and Imperialism*, New York: Alfred Knopf, 1993.
15 In saying this, I want to make perfectly clear that no sort of geographical or environmental determinism is intended. I hope it is obvious that such a political displacement is anathema to the argument I am developing.
16 Andrew Ross, *Strange Weather*, London: Verso, 1991, 6; McKenzie Wark, 'Third nature', *Cultural Studies* 8 (1) (1994): 127. See also Wark, 'Greens in the Post', *Australian Left Review* 133 (1991): 36–9; 'The green old days', *Australian Left Review* 141 (1992): 46–8.
17 Ruth Perry, 'Engendering environmental thinking: a feminist analysis of the present crisis', *The Yale Journal of Criticism* 6 (2), 1993: 1.
18 Andrew Ross, *The Chicago Gangster Theory of Life: Nature's Debt to Society*, London: Verso, 1994, 3.
19 ibid., 15–16, 273.
20 On the proposal of a revolutionary environmentalism, see Andy Stewart, 'The politics of nature: towards a revolutionary environmentalism'. unpublished paper, Department of Geography, Rutgers University, 1994.
21 Alexander Wilson, *The Culture of Nature: North American Landscape from Disney to the Exxon Valdez*, Cambridge, MA: Basil Blackwell, 1992, 12–13.
22 And yet the concept of landscape ('*landschaft*') played a prominent role in Nazi politics between 1933 and 1945. Sufficiently prominent that the geographer Richard Hartshorne felt he had to rid the disciplinary lexicon of this concept. See Richard Hartshorne, *The Nature of Geography*, Lancaster, Penn.: Association of American Geographers, 1939. And Neil Smith, 'Geography as museum: private history and conservative idealism in "The Nature of Geography"', *Annals of the Association of American Geographers Occasional Papers*, 1989.
23 Wilson, op. cit., 291.
24 ibid.: 113–5.
25 Martin Jay, *The Dialectical Imagination*, London: Heinemann, 1973, 256.
26 Max Horkheimer and Theodor Adorno, *Dialectic of Enlightenment*, New York: Herder & Herder, 1972 edn; Max Horkheimer, 'The revolt of nature', in Max Horkheimer ed. *The Eclipse of Reason*, Oxford: Oxford University Press, 1974; Jurgen Habermas, *Toward a Rational Society*, Boston: Beacon Press, 1970: 87.

27 Raymond Williams, 'Problems of materialism', *New Left Review* 109 (1978), 3–17.

28 Reiner Grundmann, 'The ecological challenge to Marxism', *New Left Review* 187 (1991), 103–20; Ted Benton, 'Ecology, socialism and the mastery of nature: a reply to Grundmann', *New Left Review* 194 (1992): 67. While Benton's critique of the critically applied thesis of domination (or mastery) of nature is long overdue, his own resort to the argument of natural limits presents many problems.

29 William Leiss, *The Domination of Nature*, Boston: Beacon Press, 1974, 123, xi.

30 Alfred Schmidt, *The Concept of Nature in Marx*, London: New Left Books, 1971. For a critique of this work see Neil Smith, 'The Ideology of Nature', in my *Uneven Development: Nature, Capital and the Production of Space*, Oxford: Basil Blackwell, 1984: 17–28.

31 Karl Marx, *Capital* III New York: International Publishers, 1967, 820. I have altered the quotation to decapitalize 'nature'.

32 Frederick Engels, *Anti-Duhring: Herr Eugen Duhring's Revolution in Science*, London: Lawrence & Wishart, 1975, 338.

33 Benton, op. cit., (See note 28): 67.

34 For a fuller statement of this argument, see the opening two chapters of my *Uneven Development: Nature, Capital and the Production of Space*. Oxford: Basil Blackwell, 1984.

35 Needless to say, I take a quite opposite position from Norman Geras who attempts to reinstate a 'universal human nature' as a central marxist tenet: Norman Geras, *Marx and Human Nature*, London: New Left Books, 1983.

36 Michel Foucault, *Discipline and Punish*, New York: Viking, 1979, 194.

37 Donna Haraway, *Simians, Cyborgs and Women*, New York: Routledge, 1991, 2, 10.

38 McKenzie Wark, 'Third nature', *Cultural Studies* 8 (1) (1994): 120. Much of the discussion of the production of nature has been carried out in the pages of Antipode. See Neil Smith, 'Postscript: the production of nature', *Antipode* 17 (1985): 88; Michael Redclift, 'The production of nature and the reproduction of the species', *Antipode* 19 (1987): 222–30; Margaret FitzSimmons, 'The matter of nature', *Antipode* 21 (1989): 106–20; Noel Castree, 'The nature of produced nature', *Antipode* 27 (1994): 12–48.

39 CML, 'Form 10-K', 8–9.

Chapter 4

Simulating mother nature, industrializing agriculture

Les Levidow

The prospect of a genetically engineered future evokes hopes and fears for ultimate human control over nature. In the case of agricultural bio-technology, diverse languages of 'risk' express different concepts of environmental threat.

Indeed, each account of the problem has its own inner link between risk and benefit. For biotechnology proponents, society is at risk from failing to reap the indispensible benefits of this technology, which offers us a benign means of controlling environmental threats to agriculture. For opponents, society is 'at risk' from biotechnology, which imposes a sinister control, transgresses natural boundaries, creates new pollutants, perpetuates intensive monoculture, and/or precludes beneficial alter-natives (Levidow and Tait 1991).

To some extent, biotechnological 'risk' becomes a proxy for contending concepts of sustainable agriculture, even of nature itself. Biotechnologists promise to overcome the problems of chemical-intensive agriculture by further industrializing it. Critics warn against the prospect of aggravating familiar agronomic hazards as well as generating new ones.

In general, 'risk' debate nominally concerns unintended effects, also known as side-effects, though it also involves implicit models of the environment and society. That is, do our problems arise from external natural threats and/or from 'progress' itself? Do new problems warrant more of the same solutions?

Such issues have been theorized by the sociologist Ulrich Beck: 'Modernization risks are the scientized "second morality" in which negoti-ations are conducted on the injuries of the industrially exhausted ex-nature in a socially "legitimate" way, that is, with a claim to effective remedy' (Beck 1991: 81). For biotechnology, for example, in dispute are the diag-noses of and remedy for the limits of chemical-intensive agriculture.

Risk debates also manifest an epochal shift in the way that science treats past problems and mistakes. In primary 'scientization' which corresponds to early modernization, the scientific project liberates society from its pre-existing dependencies upon nature. Science presupposes a clear boundary

between its objects of study (the problem 'out there') and itself (the solution); science objectifies errors as external problems: 'Wild, uncomprehended nature and the unbroken compulsions of tradition are "to blame" for the sicknesses, crises and catastrophes from which people suffer.' Even when a scientific discipline begins to diagnose its own mistakes, it transforms them into development opportunities for further progress, while generally keeping any critical discussions away from a non-specialized public (Beck 1992: 159–60)

Later, in secondary (or reflexive) scientization, technoscientific development is increasingly recognized as a problem for itself. As unintended consequences are analysed by interdisciplinary approaches, different scientific disciplines confront each other publicly, undermining faith in progress through scientific expertise alone. Risks tend to 'force *new forms for the division of labour* within the relationship of science, scientific practice for the public sphere' (ibid.: 160).

In such ways, technoscientific development encounters conflicts over how its expertise shall treat the industrial sources of environmental problems. Beck outlines an historical progression from denial to acknowledgement, that is, from primary to secondary scientization. In practice, however, scientization may negotiate a tension rather than progress from one distinct stage to another.

Insofar as R&D agendas deny and externalize internal instabilities, this tendency may involve the psychodynamic phenomena of splitting and projection. As originally analysed in children, we split objects into wholly good and bad parts; correspondingly, we may project idealized parts of ourselves onto the former, and unwanted parts onto the latter. In particular, an omnipotence phantasy serves as a defence against fear of persecution, for example, by annihilating the persecutor. This phantasy may help the infant to contain anxiety but may also intensify it, for example, through fear of being annihilated in turn (Klein 1975).

Such infantile phantasies often drive adult experiences in which we recapitulate and contain primitive anxieties. Splitting also informs attitudes towards 'nature', which serves as a symbolic terrain for contesting or legitimizing technological change. Of course, industrial society has largely socialized nature, which some ambivalently label 'the semi-natural environment'. Yet we commonly split nature into idealized and demonized parts; not merely rhetorical, this splitting can drive political debate and even R&D agendas.

This essay analyses how the biotechnology debate expresses antagonistic models of nature. Protagonists split nature into good/bad parts, each in their own way, as they dispute how best to simulate (or even reconstruct) mother nature. In particular, when biotechnologists select and enhance 'natural' genetic properties, they invest nature with metaphors of computer codes and commodities. Their R&D designs a clean, industrialized

nature to overcome external threats from an untamed, wild nature. By contrast, opponents tend to idealize a pre-industrial nature as a model for agriculture.

The above analysis will be developed through the following aspects: perspectives on symbolic splitting; rhetorics of environmental insecurity; biotechnology as a 'clean' defence; new biopesticide strategies; sustainable agriculture; and the future of socialized nature.

WHOSE INSECURITY?

The agricultural biotechnology industry has portrayed its technical advances as essential for achieving global security. This self-portrayal can serve the public-relations purposes of marginalizing political opposition and minimizing state regulation. However, the industry's language is more than merely rhetorical; it diagnoses an environmental insecurity which defines the problem for biotechnologists to solve. What does its R&D agenda take for granted? How does it prescribe the future?

In the language of the agricultural biotechnology industry, its products will be necessary to protect the common good from environmental insecurities, which happen to demand genetic remedies. In particular, we must correct genetic deficiencies in order to secure and expand the food supply, argues the US Industrial Biotechnology Association. That is, our society has temporarily proven Malthus wrong, because 'the American farmer has adopted science and technology as rapidly as it has become available, allowing farm production to outpace population growth'. Consequently, 'Our existence is now dependent upon fewer than 20 species of plants; we must use all available resources to assure that [those] species are genetically fit to survive under the wide range of environmental extremes' (Calder 1991: 71). In other words, industry has promoted a genetic uniformity which makes agriculture more vulnerable to the vicissitudes of nature; this vulnerability must now be overcome by fixing the genes.

Such arguments extend familiar neo-Malthusian ones: that is, agricultural yield must keep pace with the Third World's growing population in order to avert more famines. According to Britain's single largest seeds merchant, ICI Seeds, 'biotechnology will be the most reliable and environmentally acceptable way to secure the world's food supplies'; it can provide essential tools for 'feeding the world' (for references see Levidow and Tait 1991). In this vein, an advertisement from Monsanto depicts maize growing in the desert: 'Will it take a miracle to solve the world's hunger problems?' (See Figure 4.1)

Moreover, it is suggested that food shortages in the third world threaten the security of the West. As one publicist argues, 'We will need dramatic progress in the productivity of agriculture to limit starvation and the social chaos which over-population will bring' (Taverne 1990: 5). Thus, by

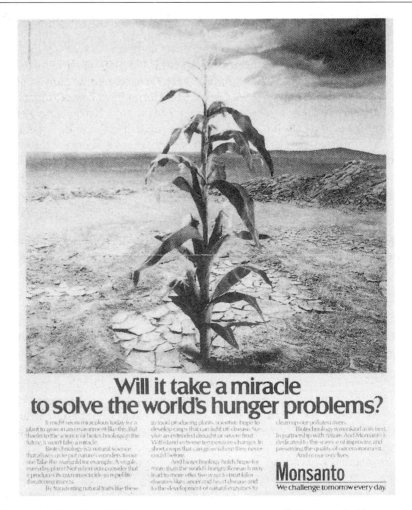

Figure 4.1 Genetic deficiencies of current crops, unable to grow in the desert, require remedies from biotechnical wizards, who will thereby prevent the Third World from starving

Source: Monsanto Company, St Louis, Missouri

helping the Third World to increase agricultural yields, the West can protect itself from immigrant hordes and other environmental threats.

When invoking a demographic threat, however, industry publicists conveniently ignore the appropriation of Third World resources for producing cash-crop exports. In their account, the problem instead appears as overpopulation and inefficient agriculture. A similar diagnosis under-lies structural adjustment programmes (World Bank 1992), which have

further dispossessed and impoverished third world populations in the name of modernizing their countries.

The pretence of increasing food production, much less of 'feeding the world' is belied by the R&D priorities of the biotechnology industry. Its own house journal, *Agro-Food-Industry Hi-Tech*, has a revealing subtitle: *International Journal for Food, Chemicals, Pharmaceuticals, Cosmetics as Linked to Agriculture through Advanced Technology.* This acknowledges the priority of making biological materials more plastic and interchangeable. The journal emphasizes the political context of reduced farm subsidies, which will make productivity less important in the future: 'Agriculture is bound to go for more [high] value-added products, better adapted to demand from downstream industry and the consumer. Hence it is going irresistibly towards a global system where contents matter more than quantities' (Anon 1990). Such contents are stamped with the commodity-form of value, as graphically illustrated in a British government publication, which portrays the DNA double-helix as a money tree sprouting £5 banknotes (Dept of Trade and Industry/Laboratory of Government Chemist 1991: 26).

In our society, what defines 'value added'? According to US Tobacco's vice-president, 'value-added genetics determines the processability, nutrition, convenience and quality of our raw materials and food products' (Lawrence 1988: 32). More specifically, some biotechnology companies are developing substitutes for crops or materials hitherto imported from Third World countries (Walgate 1990: 57; Hobbelink 1991: 93; Panos 1993: 12–14); for example, oilseed rape is being altered to produce oils which could substitute for those hitherto imported from tropical countries. If technically successful, these new products would undermine the livelihoods of entire Third World communities, just as European sugar beet has devastated sugar-cane production elsewhere.

The biotechnology industry euphemistically portrays its disruptive power as democratic progress: 'Let there be no illusions: as with any innovative technology, biotechnology will change economic and competitive conditions in the market. Indeed, economic renewal through innovation is the motor force of democratic societies' (SAGB 1990: 15).

These competitive conditions demand more flexible investment strategies in the face of an insecure commercial environment. 'Value-added genetics' directs R&D towards accommodating and aggravating commercial insecurities.

CLEANER DEFENCE

In the recent stages of industrializing agriculture, investment strategies have redefined the type of 'clean' nature which will protect agriculture from pests. Let us examine the conceptual and investment shift.

In the chemical-intensive agriculture which prevailed after the Second World War, plant breeders could select crop strains mainly for high yield, shielded by the 'pesticide umbrella'; chemicals protected crops from insects, weeds and disease. Farmland was kept 'clean' of intruders – indeed, of all other life. The soil became less able to regenerate itself; its fertility came to depend upon applying chemical fertilizer rather than recycling vegetation or manure. As a cultural critic has observed, 'That ultimate simulacrum of our times – artificial shit – is surely the sign of a culture obsessed with what Baudrillard calls "deadly cleanliness"'' (Nelson 1990).

Since the 1960s, the chemicals have been losing both their clean image and agronomic effectiveness. Genetic uniformity leaves crops more vulnerable to pests and disease. Pesticides eliminate the natural predators of pests and/or generate selection pressure for insect pests resistant to the chemicals. Agriculture faces a 'chemical treadmill', needing new pesticides to keep up with new pest resistance.

Despite applying more and newer pesticides, agriculture has suffered even greater crop losses – widely attributed to intensive monoculture methods, which abandoned such practices as crop rotation (e.g. Pimentel 1989: 70). More and more fertilizer has been needed to sustain crop yields, yet fertilizers assist weeds. Political protest has cited threats to human and environmental safety from chemical residues or run-off, in turn leading governments to restrict pesticide use.

Recently agronomists have been acknowledging the limits of overcoming pest problems through better chemicals alone. However, industry now tends to locate the problem within genetic deficiencies, which can be corrected by inserting extra genetic defences into crops or biopesticides. In this way, biotechnological methods are accorded a natural legitimacy. 'What is new is our growing ability to simulate nature in ways that can offer enormous benefits', declares the president of Mycogen Corporation (Goodman 1989: 49; Calder 1991: 75).

Within agricultural biotechnology, the greatest R&D efforts are directed at developing herbicide-resistant crops. Their inserted gene protects the crop from broad-spectrum herbicides, which in turn kill all other vegetation. Previously agronomists had to find herbicides which would selectively spare the crop from damage; now the inserted gene provides the selective protection.

By inserting a gene which offers resistance to a less persistent herbicide, industry can describe the product as cleaner, in the dual sense of combining a precise defence with a less-polluting chemical. According to ICI Seeds, herbicide-resistant crops will reduce dependence upon chemical inputs, by reducing quantities of their use; such crops will offer greater choice to farmers, who can thereby defer herbicide applications until the post-emergence phase (e.g. Bartle 1991). These products have even been celebrated as the ultimate solution to the problem of weeds resistant

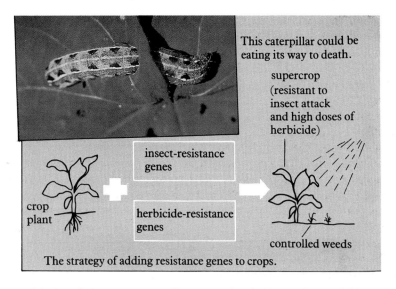

Figure 4.2 Imaginary supercrop illustrates the fantasy of exercising a bio-technological omnipotence over the forces of unruly nature

Source: reproduced by kind permission of Hobsons Publishing from *Biotechnology . . . in Perspective* by David Satelle (Cambridge, 1988)

to herbicides, even as a 'moral imperative' for feeding the third world (Gressel 1992, 1993).

Critics regard this R&D priority as perpetuating dependence upon chemical herbicides, regardless of whether quantities are reduced (BWG 1990). Ecologists remind us that some herbicides have already weakened crops' natural defences and so necessitated additional chemical treatments (Pimentel 1987). In various ways, herbicide-resistant crops could extend the use of agrochemicals, across time and space.

In this vein, imagine a 'supercrop' which has been genetically modified for resistance to both insect attack and high doses of herbicide. Such an imaginary crop is depicted in a textbook for schoolchildren, sponsored by Britain's Department of Trade and Industry (Satelle 1988: 31). (See Figure 4.2.) This image exemplifies the declaration by an industry publicist: 'if we have the imagination and resources, there is almost no biological problem we cannot solve' (Taverne 1990: 4).

Not merely rhetorical, such fantasy has roots in the conceptual frame-work of biotechnology: reprogramming nature for total environmental control. In the 1930s, the new science of molecular biology treated genetic material as interchangeable, universal coded 'information', which would permit the ultimate human control over the 'essence of life' (Yoxen 1983). With the cell now conceptualized as a natural factory, the 'factory farm'

also becomes more than a metaphor (Krimsky 1991: 10). Biotechnology invests nature with metaphors, for example, of industry efficiency, which in turn lend a natural status to its products.

Such metaphors are accompanied by an evolutionary account of genetic improvement. Emphasizing the universal genetic code in nature. Monsanto presents genetic engineering as a 'natural science'. Paradoxically, biotechnology does what nature does – but does so more safely and efficiently (Kleinmann and Kloppenburg 1991).

In a similar vein, official language has shifted from genetically engineered to genetically *modified* organisms (GMOs), the new term denoting a modest improvement upon nature. Genetic modification precisely enhances natural characteristics – for example, by 'giving nature a little nudge towards greater efficiency', according to ICI. Akin to nature, and protective of nature, GMOs can appear to provide an enhanced natural efficiency through 'environment-friendly products' (Levidow and Tait 1991). Through this rhetorical greening, biotechnology can be promoted as 'clean technology'.

Just as biotechnology finds an evolutionary *ex-post* legitimation, so did the eighteenth-century advent of capitalist agriculture. As the brutal enclosures transformed the social meaning of agricultural land, 'any positive conception of a just society . . . was replaced by new and ratifying concepts of a mechanism and market' (Williams 1980: 73, 79). Similarly biotechnology recasts nature in terms of computer codes and commodities. Its R&D seeks a total biosystems control by manipulating a few genetic and/or chemical parameters (Kloppenburg 1991). Like the strategy of purely chemical control, this genetic-level control treats the systemic instabilities of intensive monoculture as external natural threats. Deploying a precise genetic defence, possibly combined with a broad-spectrum chemical offence, biotechnology offers a clean surgical strike against unruly nature.

BIOPESTICIDE STRATEGIES

The material investment of social metaphors can be illustrated by analysing R&D which attempts to replace agrochemicals with new biopesticides. A gene for a toxin can be transferred from a microbe to another organism which will persist longer or target the pest more effectively. Some R&D even combines genes for different toxins in the same microbe, thus killing a broader range of insect pests.

What problem is this solving? Traditional biopesticides have a narrow host-range, which limits their commercial potential. The specialist Sheldon Murphy laments, 'It is like a rifle shot rather than a shotgun shot into a pest group' (quoted in Kloppenburg 1988: 251). Microbial pesticides occupy only about 1 per cent of the pesticide market, the small share due to their 'lack

of environmental persistence, narrow host range, limited virulence, and high production costs' (McManus 1989: 65; Cook and Granados 1991: 217).

Those features, which make biopesticides so attractive ecologically, also make them unattractive economically to companies, regardless of whether the products would be attractive to farmers. As the solution, a genetic redesign can make the biopesticide less specific, more persistent and/or more deadly. In those ways, biotechnology may overcome the economic limitations of traditional biopesticides. Thus 'value-added genetics' pre-defines the pestilential insecurity to be overcome. Moreover, this R&D manifests a self-perpetuating logic of genetic defences.

A traditional biopesticide, *Bacillus thuringiensis* (*Bt.*), has been widely used in agriculture. Commercialization expanded in the late 1960s, after isolating a *B.t.* strain particularly effective against lepidopteran pests (McManus 1989: 62–3). *B.t.* is also the potential basis for new biopesticides, as it has numerous varieties, each of which produces a toxin specific to certain insects. The corresponding genes are being identified and transferred into more persistent organisms, be they other micro-organisms or even plants. For the Monsanto Company, such pesticidal plants extend natural methods in order to reap their cornucopian bounty (Camp and Altemus, 1994).

Although one entomologist has been sceptical of simple solutions, he speaks in military metaphor: each *B.t.* toxin is 'like a surgical tool for taking out the pest' (Froud Gould in Holmes 1993: 34). Emphasizing the selective precision, one biotechnologist notes that genetic modification provides the plant breeder with 'more ammunition to help him hit his target' (Lindsay 1991: 9). According to a former vice-president of Calgene, biotechnology attempts 'to do better than mother nature in designing improved, more efficacious toxins' (Goodman 1989: 52). Novo Nordisk, another leading company in biopesticides, portrays their benign surgical precision with the visual metaphor of a green bow-and-arrow: 'Fighting for a better world, naturally'. (See Figure 4.3.)

Regardless of their precision and genetic origin, the new biopesticides pose a familiar hazard: generating selection pressure for resistant pests. If such resistance weakens the effectiveness of traditional biopesticides as well as the new one, then it will eliminate a relatively safe alternative to chemicals, as some environmentalists have warned. Such warnings have been strengthened by scientific reports that some pests are developing resistance to *B.t.* in stored grain and even to *B.t.* in the field. As a journalist noted, 'Mother Nature has startled the genetic scientists . . .' (Connor 1991), though they were startled only because they had tunnel vision.

To avoid pest resistance, scientists have been discussing strategies for integrated pest management (IPM). In the case of chemical pesticides, even a leading advocate of IPM has suggested that it 'will only slow the pesticide treadmill, thereby extending the usefulness of available

Fighting for a better world.
Naturally!

Economy. Efficacy. Environ-mental impact. These are the key criteria in Novo Nordisk's drive to pioneer a new range of safer pesticides.
We realise that to compete with their alternatives, products must be viable. But as the 90's progress, products also require an acceptable balance between their field performance and total environmental impact to pass the ever stricter standards of regulators, users and the public at large.

Novo Nordisk's strength lies in the depth of its expertise in biotechnology and the extent of its fermentation production capacity. And since fermentation processes utilise renewable agricultural products , rather than petro-chemicals as a feedstock, our products come from the farmer - to the farmer. As one of the largest indus-trial fermentation compa-nies in the world, we have the resources to transform our discoveries into reality.

Our current range of products based on Bacillus thuringiensis - the widest offered by any company - secures Novo Nordisk with a solid foothold in the field of plant protec-tion.
If you are looking for products that will meet the increasingly demanding crite-ria for both users and regula-tors of pesticides, you need look no further than Novo Nordisk. Naturally.

Figure 4.3 A green bow-and-arrow symbolizes the clean surgical strike offered by environment-friendly biopesticides
Source: Novo Nordisk, Denmark

chemicals' (Hammock and Soderlund 1986: 113). By analogy, can genet-ically modified biopesticides be designed to avoid a 'genetic treadmill', or at least to slow it down?

Many scientists warn that a genetic treadmill will result from any attempt at totally exterminating a pest. They seek alternative strategies

which can 'outwit evolution', i.e. by minimizing selection pressure for resistant pests. Early in the *B.t.* debate, a Calgene official suggested using genetically modified *B.t.* 'to control [insect] populations rather than kill insects outright' (Goodman 1989: 52).

Some strategies, amenable to IPM, have been proposed by entomologists (e.g. Gould 1988) and endorsed by some industrialists (Goodman 1989; Cutler 1991). On the military analogy of a 'safe haven', farmers could provide refugia, that is, patches of toxin-free plants, so that the less resistant insects can survive and pass on their genes; and/or farmers could vary the choice of toxin in space and time. Yet even proponents of the refugia strategy acknowledge great difficulties in designing and implementing it, partly because the necessary measures would impose commercial disadvantages upon farmers and/or seed vendors (Holmes 1993). The strategy assumes a willingness to sacrifice economic benefits, in favour of the longer-term common good.

These attempts at IPM may benefit from new genetic knowledge. At Plant Genetic Systems (PGS), laboratory research has clarified that pest resistance to the different *B.t.* toxins is controlled independently, by different genes (van Rie 1991; Peferoen 1992). Such knowledge implies that varying the toxin over time could help prevent pest resistance. However, one PGS researcher downplays IPM strategies, instead arguing that 'insecticide mixtures would be more effective' for making plants 'resistance proof': this strategy assumes that no insects would be resistant to more than one toxin. He concludes that 'the optimal strategy for pest management will depend upon the genetic basis for resistance' (van Rie 1991: 179).

His more cautious colleagues at PGS foresee new biopesticides bringing a massive introduction of *B.t.* in soils; they warn that 'we know almost nothing about its ecology' (Lambert and Peferoen 1992: 120–1). Moreover, the strategy of mixing toxins would have to be executed perfectly in order to succeed; otherwise it would generate multiply resistant pests – a 'superpest', as a Du Pont scientist warns (Holmes 1993: 36). Additional field testing has shown that moderately resistant insects can evolve resistance to *B.t.* mixtures (Tabashnik *et al.* 1991); thus such a product seems likely to generate a genetic treadmill.

Nevertheless, the prevalent R&D treats genes as chemical bullets for a total extermination strategy; this conceptualizes crop vulnerability as an external problem of pest genetics. For example, biotechnologists develop 'cassettes' for inserting several defence genes at once into a plant or microorganism (Day 1993: 39). This technique happens to coincide with commercial pressures for mixing different toxins in the same product. According to United States Department of Agriculture (USDA) scientists, a refugia strategy is probably better for avoiding resistance, but simpler strategies – such as toxin mixtures – would be more profitable for industry (McGaughey and Whalon 1992: 1455).

And what if a 'genetic treadmill' ensues? According to Jerry Caulder, president of Mycogen Corporation, insects have understandably acquired resistance to the one strain of *B.t.* which has been used for thirty years, but 'We have other bullets in the gun we call Bt' (Cutler 1991). From this cornucopian perspective, any one toxin is dispensable, because scientists will always find another one to kill the same pest. Indeed, some researchers are already planning how to add new toxins faster than the insect pests can develop resistance to the previous ones (Wilson *et al* 1992). Thus a prospective 'genetic treadmill' is treated not as a hazard, but rather as a challenge for technical advance and commercial advantage. (By analogy to the New World Order, a global control system manages and intensifies its own endemic instabilities, while attributing these to an external enemy, from which we need perpetual protection; see Levidow 1994.)

SUSTAINING WHICH AGRICULTURE?

Biotechnology presents itself as a naturally based alternative to agro-chemicals, yet its dominant paradigm conceptualizes DNA as the ultimate chemical weapon. As an historical precedent, medicine too has appropri-ated military metaphors in developing new antibiotic weapons which can seek and destroy invading pathogens (Montgomery 1991). Both the medical and military metaphors converge in biotechnology: here DNA becomes a magic bullet for 'cleaning up on the farm', in both senses of that verb (Levidow 1991a).

The term 'biodiversity' comes to mean new combinations of special protective genes in crop strains. Traditionally, diverse cultivars (and biopesticides) provided a systemic defence against unanticipated pests or disease. This biodiversity now becomes a resource for genetic prospecting, for extracting a few magic bullets which can provide high value-added commodities.

An organic farmers' organization has warned that 'supercrops' may encourage farmers to buy new seed each season rather than sow seed harvested from the previous year's crop. The resulting 'global mono-culture' will become all the more vulnerable to pests and disease (Bill Duesing, quoted in Day 1993). These problems derive from our intensive monocultural system, driven by imperatives of profitability, as newly embodied in biotechnology R&D agendas (e.g. Kloppenburg 1988; Hobbelink, 1991).

Towards a sustainable agriculture, critics counterpose 'holistic' methods of crop protection, such as those which have traditionally helped to avoid weeds, pests and disease: 'It is widely agreed that systems approaches – for example, crop rotation and other methods – could avoid the need for the majority of pesticides, both chemical and biological, now and into the future' (Mellon 1991: 67).

Some alternatives idealize traditional methods as proximate to nature: 'The closer a farming system comes to a natural ecosystem, the most likely it is to be sustainable' (Hobbelink 1991: 140). On this model, society can appropriate benign ecological processes and so keep the agricultural system clean of artificial contaminants, that is, high-tech inputs.

In contending versions of 'clean' agriculture, protagonists tend to idealize or demonise some external nature; they split nature into 'good/ bad' parts, in opposite ways. At the same time, such concepts mediate a struggle over farmers' social power. Industry emphasizes that modern pest-control methods can reduce farm management time (e.g. Goodman 1989: 84–6). Yet critics foresee biotechnological methods dispossessing farmers of their knowledge and skills, which alternative methods could strengthen (Hassebrook 1989). In pest control, for example, a total extermination strategy would initially spare too few insects to warrant monitoring them, thus discouraging the skills associated with IPM.

Also at issue is the meaning of 'sustainable agriculture', which concerns more than simply quantitative yields. For example, does 'sustainable agriculture' signify only an environmental equilibrium or also a way of life? (See MacDonald 1989: 20; Hamlin 1991.) The question could be extended, by asking how any model – for example, of equilibrium or 'clean' agriculture – tends to favour one way of life over another.

Amid these debates, alternative approaches have obtained little research funding. US government funds have been shifting towards 'biotechnological product development, rather than biological process understanding' (Doyle 1990: 191). As a leading biotechnologist proclaimed, 'This is the era of biology, and we are the biologists' – meaning not ecologists or even agronomists (cited in Levidow 1991b).

THE FUTURE OF NATURE

Controversy over biotechnology arises from its project of further industrializing agriculture. In the name of simulating mother nature, it invests nature with metaphors of chemicals and combat, of computer codes and commodities. These concepts extend the earlier ones which served historically to recast agricultural land as capital.

Not merely rhetorical, capitalist metaphors guide the R&D agendas of agricultural biotechnology. In the name of discovering 'natural' defences, such research attributes socio-agronomic problems to genetic deficiencies, which must be identified and precisely corrected at the molecular level. In the name of overcoming environmental insecurities and enhancing human choice, its R&D accommodates and intensifies commercial insecurities. Its problem-definition complements the tendency to commoditize and reify biological properties as things, for example, in the form of 'value-added genetics' and 'environment-friendly products'.

Indeed, biotechnology promises to overcome the limits of chemical-intensive agriculture in a benign way; like other contentious innovations, it offers a diagnosis and remedy for 'industrially exhausted ex-nature'. Moreover, it constructs a good biotechnologized nature, whose clean surgical strikes can protect agriculture from a wild bad nature. Through this splitting, the inherent instabilities of intensive monoculture are denied and projected onto external environmental threats.

Biotechnology recasts 'sustainable agriculture' in its own image. Improved yields, in terms of quality or quantity, are to be sustained by genetic techniques which promote less harmful chemicals or which replace chemicals with biological agents, in turn reduced to the chemical terms of DNA. In effect, this project eternalizes the project of intensive monoculture, as if its criteria of industrial efficiency were somehow given by nature. It also tends to substitute laboratory expertise for farmers' knowledge of local resources, or even to intensify class divisions within agriculture.

Although its fantasy of technological omnipotence cannot be stably fulfilled, the biotechnological project establishes a prior conceptual framework for interpreting the limits which will be encountered. Through its self-perpetuating logic, any future problems will warrant more of the solutions which created them, for example, even more precise genetic remedies. Despite its practical limits, biotechnology forecloses the future by diverting resources from alternative natures (and human natures) which might be cultivated.

Some alternatives may already exist, in various embryonic forms, but they face great obstacles. Perhaps most obvious is that state policy and funding accept the dominant problem-definition of biotechnology. Given the promised 'benefits', critics have had difficulty in opposing apparently 'clean products' or in shifting the R&D priorities.

Moreover, biotechnology critics have tended to marginalize themselves by rhetorically idealizing pre-industrial forms of nature, as a reference point for evaluating agricultural models. Such appeals serve as a mirror-image of biotechnologists who idealize their own laboratory simulations as enhancing natural qualities such as efficiency and biodiversity. Each in their own way, most protagonists split nature into good and bad parts, while denying the social character of those parts and their inner connection.

As biotechnology R&D aims at further industrializing agriculture, which future of nature will prevail? Any viable alternative needs some understanding of how the agriculture/nature split is already a social construct, and some way of overcoming the split, somehow re-integrating the 'good/bad' parts.

In conclusion, the present R&D agenda of agricultural biotechnology aims at solving the wrong problems, invests nature with capitalist metaphors, and encounters environmental limits. However, alternatives

will not naturally follow. For cultivating a different nature, we will need answers to such questions as these:

- How shall the right problems be defined, and who shall carry out this problem-redefinition?
- How shall agriculture be reconstituted according to different social metaphors?
- How shall laboratory science be appropriated for enhancing a wider social knowledge about environmental resources, rather than colonize or displace such knowledge?
- How shall agriculture itself be recast as part of the environment, yet without commoditizing and reifying nature?

ACKNOWLEDGMENTS

This essay arises from two studies, 'Regulating the risks of biotechnology' (project number R000 23 1611), and 'From precautionary to risk-based regulation: the case of GMO releases' (project number L211 25 2032), both funded by Britain's Economic and Social Research Council. The essay was developed from a talk at the *BLOCK* conference on 'The Future of Nature' in November 1994, where I received helpful suggestions from Lisa Tickner and Slavoj Žižek.

REFERENCES

Anon (1990) 'Editorial' *Agro-Food-Industry High-Tech* 1(1): 3–4, Teknoscienze, Milan.

Bartle, I. (1991) *Herbicide-tolerant Plants: Weed Control with the Environment in Mind*, Haslemere, Surrey: ICI Seeds.

Beck, U. (1992) *Risk Society: Towards a New Modernity*, London: Sage.

Biotechnology Working Group (1990) *Biotechnology's Bitter Harvest: Herbicide Tolerant Crops and the Threat to Sustainable Agriculture*, Biotechnology Working Group. Available from Environmental Defense Fund, 257 Park Avenue South, New York, NY 10010 (Price $10).

Calder, J. (1991) 'Biotechnology at the forefront of agriculture', in J.F. MacDonald, (ed.) *Agricultural Biotechnology at the Crossroads: Biological Social and Institutional Concerns*, NABC, 211 Boyce Thompson Institute, Tower Road, Ithaca, NY 14853–1801: pp. 71–5.

Camp, N. and Altemus, N. (1994) *Helping Nature's Bounty: A Discussion of Insect-control Potato Plants*, St Louis, Mo: Monsanto.

Connor, S. (1991) 'Mother Nature thwarts hopes of supercrops', *Independent on Sunday*, 17 November.

Cook, R. and Granados, R. (1991) 'Biological control: making it work', in J.F. MacDonald (ed.) *Agricultural Biotechnology at the Crossroads: Biological Social and Institutional Concerns*, NABC, 211 Boyce Thompson Institute, Tower Road, Ithaca, NY 14853–1801: pp. 213–27.

Cutler, K. (1991) 'Bt resistance: a cause for concern?', *Ag Biotech News*, January/February: 7.

Dart, E. (1988) *Development of Biotechnology in a Large Company,* London: ICI External Relations Department [now Zeneca].

Day, S. (1993) 'A shot in the arm for plants', *New Scientist,* 9 January: 36–40.

DTI/LGC (1991) *Biotechnology: A Plain Man's Guide to the Support and Regulations in the UK,* Hobsons/Laboratory of the Government Chemist, Dept of Trade and Industry.

Doyle, J. (1990) 'Who will gain from biotechnology?' in S. Gendel, A. Kline, D. Warren, F. Yates (eds) *Agricultural Bioethics: Implications of Agricultural Biotechnology,* Ames: Iowa: Iowa State University: 177–93.

Goodman, R.M. (1989) 'Biotechnology and sustainable agriculture: policy alternatives', in J.F. MacDonald (ed.) *Biotechnology and Sustainable Agriculture: Policy Alternatives,* NABC, 211 Boyce Thompson Institute, Tower Road, Ithaca, NY 14853–1801: 48–57.

Gould, F. (1988) 'Genetic engineering, integrated pest management and the evolution of pests', in Hodgson, J. and Sugden, A.M. (eds) *Planned Release of Genetically Engineered Organisms (TREE/Tibtech),* Elseviel, Cambridge: S15–18.

Gressel, J. (1992) 'Genetically-engineered herbicide-resistant crops: a moral imperative for world food production', *Agro-Food-Industry Hi-Tech,* Teknoscienze, Milan, 3(6): 3–7.

—— (1993) 'Herbicide resistance threatens wheat supply', *Agro-Industry Hi-Tech,* Teknoscienze, Milan, 4(2): 36.

Hamlin, C. (1991) 'Green meanings: what is sustained by sustainable agriculture?', *Science as Culture,* London: Process Press (with Guilford publishers, New York), 2(4): 507–37.

Hammock, B. and Soderlund, D. (1986) 'Chemical strategies for resistance management', in National Research Council, *Pesticide Resistance: Strategies and Tactics for Management,* Washington, DC: National Academy Press: 11–29.

Hassebrook, C. (1989) 'Biotechnology, sustainable agriculture and the family farm', in J.F. MacDonald (ed.) *Biotechnology and Sustainable Agriculture: Policy Alternatives,* NABC, 211 Boyce Thompson Institute, Tower Road, Ithaca, NY 14853–1801: 38–47.

Hobbelink, H. (1991) *Biotechnology and the Future of World Agriculture,* London: Zed Books.

Holmes, B. (1993) 'The perils of planting pesticides', *New Scientist,* 28 August: 34–7.

Klein, M. (1975) *Writings III: Envy and Gratitude and Other Works,* London: Hogarth Press: 1–24.

Kleinman, D.L. and Kloppenburg, J. (1991) 'Aiming for the discursive high ground: monsanto and the biotechnology controversy', *Sociological Forum,* 6(3).

Kloppenburg, J. (1988) *First the Seed: The Political Economy of Plant Biotechnology 1492–2000,* Cambridge: Cambridge University Press.

—— (1991) 'Alternative agriculture and the new biotechnologies', *Science as Culture* 2(4): 482–506.

Krimsky, S. (1991) *Biotechnics and Society: The Rise of Industrial Genetics,* London: Praeger.

Lambert, G. and Preferoen, M. (1992) 'Insecticidal promise of *Bacillus thuringiensis*', *BioScience* 42(2): 113–21.

Lawrence, R.H. (1988) 'New applications of biotechnology in the food industry', in *Biotechnology and the Food Supply,* Washington, DC: National Academy Press: 19–45.

Levidow, L. (1991a) 'Cleaning up on the farm', *Science as Culture* 2(4): 538–68.

—— (1991b) 'Biotechnology at the amber crossing', *Project Appraisal* 6(4): 234–8.

—— (1994) 'The Gulf massacre as paranoid rationality', in G. Bender and T. Druckrey (eds) *Culture on the Brink: Ideologies of Technology,* Seattle: Bay Press, 317–28.

Levidow, L. and Tait, J. (1991) 'The greening of biotechnology: GMOs as environment-friendly products', *Science and Public Policy* 18(5): 271–80.

Lindsey, K. (1991) 'Crop improvement through biotechnology', *Agro-Food-Industry Hi-Tech* 2(4): 9–16.

MacDonald, J.F. (ed.) (1989) *Biotechnology and Sustainable Agriculture: Policy Alternatives,* NABC, 211 Boyce Thompson Institute, Tower Road, Ithaca, NY 14853–1801.

McGaughey, W. and Whalon, M. (1992) 'Managing insect resistance to *Bacillus thuringiensis* toxins', *Science* 258: 1451–5.

McManus, M. (1989) 'Biopesticides: an overview', in J.F. MacDonald (ed.) *Biotechnology and Sustainable Agriculture: Policy Alternatives*, NABC, 211 Boyce Thompson Institute, Tower Road, Ithaca, NY 14853–1801: 60–68.

Mellon, M. (1991) 'Codes and combat in biomedical discourse', *Science as Culture* 2(3): 341–90.

Nelson, J. (1990) 'Culture and agriculture: the ultimate simulacrum', *Border/Lines* (spring) Bethune College, North York, Ontario: 34–8.

Panos (1993) 'Genetic engineers target third world crops', *Media Briefing* 7 (December), Panos Institute, London.

Peferoen, M. (1992) '*Bacillus thuringiensis* in crop protection', *Agro-Industry Hi-Tech* 2(6): 5–10.

Pimentel, D. (1987) 'Down on the farm: genetic engineering meets ecology', *Technology Review* (January): 24–30.

Pimentel, D. (1989) 'Biopesticides and the environment', in J.F. MacDonald (ed.) *Biotechnology and Sustainable Agriculture: Policy Alternatives*, NABC, 211 Boyce Thompson Institute, Tower Road, Ithaca, NY 14853–1801: 69–74.

SAGB (1990) *Community Policy for Biotechnology: Priorities and Actions*, Senior Advisory Group on Biotechnology/CEFIC, Brussels.

Satelle, D. (1988) *Biotechnology . . . in Perspective*, Cambridge: Hobsons.

Tabashnik, B., Finson, N. and Johnson, M. (1991) 'Managing resistance to *Bacillus thuringiensis*: lessons from the Diamondback moth (Lepidoptera: Plutellidae)', *Journal Economic Entomology* 84(1): 49–55.

Taverne, D. (1990) *The Case of Biotechnology*, London: Prima.

van Rie, J. (1991) 'Insect control with transgenic plants: resistance proof?', *Tibtech*, 9: 177–9.

Walgate, R. (1990) *Miracle or Menace? Biotechnology and the Third World*, London: Panos.

Williams, R. (1980) 'Ideas of nature', in Williams, R. (ed.) *Problems in Materialism and Culture*, London: Verso: 67–85.

World Bank (1992) *Development and the Environment*, Washington, DC.

Yoxen, Edward (1983) *The Gene Business: Who Should Control Biotechnology?*, London: Pan; reissued London: Free Association Books (1986).

Chapter 5

Knowing, loving and hating nature
A psychoanalytic view

Karl Figlio

Some time ago, while driving through a heavily forested region of northern Wisconsin, I came into a huge area that had been laid waste by logging in the ninteenth century. It was nearly a century later, yet all that remained inside this mighty forest were countless stumps. The image was vivid: nature was wounded and the wound could not heal.

This image, and my reaction, still stick in my mind: here was nature cut down, held down, killed. Reflecting on it now, I find myself wondering: in the face of such devastation, do we always invest nature with phantasies, say, of an injured mother? Do we always destroy, repair, thieve, live from mother nature? Do we need these phantasies, both to exploit nature and to moderate our incursions? Can we engage with an inanimate nature as plain pragmatists? Can we know nature without anthropomorphism and yet with respect?[1]

The loggers were spared a critical awareness of such phantasies by the vastness and apparently infinite regenerative capacity of nature, and by a primitive technology that damaged, but could not fundamentally alter the natural environment. Today, science is the principal cultural form through which we relate to nature. The main forms of destructiveness, such as pollution, and of regeneration, such as trapping 'greenhouse gasses', are technological.

Scientific thinking is itself a technology, in that it encompasses and formulates nature in the process of representing it. Science aims to predict, and predictability implies a nature that is inanimate or without autonomy. But a paradox surfaces at this point: the more nature is experienced as inanimate, the more it has been, in phantasy, killed. Nature killed is nature in a vengeful mood, a primitive retaliatory phantasy that fuels apocalyptic forebodings. The more scientific the culture, the more it is at the mercy of irrational fears, and the more it is dependent on scientific protection from them.

There is, therefore, a contradiction inside the rational core of western naturalism. Scientific knowledge itself promotes this contradiction, and stirs up a countervailing force outside scientific discourse, which aims to

limit the scope of its inquiry. This form of scepticism rests on the assumption that nature is alive and on the hidden anthropomorphism that humanity should respect it as one would respect a neighbour. But any movement that is based on the premise of an animate nature will add to the contradiction by identifying with the phantasy of an injured nature, retaliating against an aggressive science. These reactions are hived off into anti-scientific movements that are not contained within scientific discourse; and they exacerbate the oppressiveness of rationalism, on the one hand, and the irrationality of oppositional movements, on the other.

A brief example will have to suffice to ground the argument. Gustav Bovensiepen, a Jungian analyst, carried out a detailed linguistic study of the German parliament, and found that the debates on green and peace issues contained high levels of unconscious aggression. He argues that the parliamentarians – mainly men – had formed a male band to suppress the retaliation of a suppressed mother nature, and the aggression between her and this band surfaced in the face of their conscious goodwill (Bovensiepen 1986; on unconscious aggression in pacifism, see Richards 1986). Typically, such a contradiction will be split into a destructive attitude towards nature, carried by science, technology or industry, and a benevolent attitude, carried by a green or religious group.

In this example, parliament encapsulates a cultural problematic, and works it over for the culture, aiming to distil its work into legislation. The idea of culture as a group that works over an originary problematic follows from Freud's analysis of totemism and religion (Freud 1912–13). Totemism substitutes a sacred animal for the custom of elevating a tribe member to a deity as a representative of the tribal father. The totemic sacrifice repeats the killing of the father, and struggles to resolve the unconscious problem that it set in motion. This cultural work is repetitive because, like a symptom, it is generated in the unconscious, which can condense the contradictory impulses of prohibition and fulfilment of a wish. In the case of totemic celebration, the murder and eating of the father is repeated and prohibited, and the guilt is both acknowledged and denied.

In Christian culture, this originary cultural problematic is carried in a monotheistic religion, in which both parricide and deference to the father are reaffirmed in the process of ritual killing and eating. In the Eucharist, this ritual appropriation of, and deference to, the father has been concealed from consciousness by attributing the sacrifice to the father himself and substituting the son for the father as the object of sacrifice.

Does the idea of a cultural working over of an originary problematic give us a way of understanding the relationship of science to nature? The argument would be as follows: science is the sector of western culture that works over an originary problematic – in this case the encompassing of nature. It encompasses nature by representing nature; it represents nature as visualizable or as presentable in a non-contradictory complete form, as

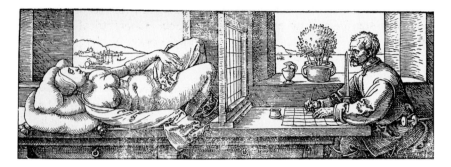

Figure 5.1 Albrecht Dürer: *Draftsman drawing a nude* (woodcut)
Source: Unterweysung der Messung (Nuremberg, 1538)

if it could be mapped into a space of finite dimensions; in doing so, it both repeats and repudiates a repressed impulse, as in the parricide in the mass.[2]

The objectness of nature is itself a feature of this mapping. A common example of this mapping was the discovery, in the sixteenth century, of the principles of perspective, which established the possibility of picturing an objective world (Figure 5.1). The mapping of a three-dimensional world onto a two-dimensional space, according to certain principles, elicited a compelling picture of reality from marks on a surface

This calling forth of a picture from what is around us is an act of con-stituting or encompassing what is present. It presents it and annuls it at the same time. It causes what is around to come into view within the dimensional world of a naturalistic quest.[3]

Science meets what is present with a form of representation in which the notion of nature as a picture of objects arises. We could ask, with Bion, what was mapped onto a dimensional space, and whether it is possible to restore a meaning lost in the mapping.

> I shall now use the geometrical concepts of lines, points, and space (as derived originally not from a realization of three-dimensional space but from the realizations of the emotional mental life) as returnable to the realm from which they appear to me to spring. That is, if the geometer's concept of space derives from an experience of 'the place where some-thing was' it is to be returned to illuminate the domain where it is in my experience meaningful to say that 'a feeling of depression' is 'the place where a breast or other lost object was' and that 'space' is 'where depression, or some other emotion, used to be'.
>
> (Bion, 1970: 10)

A patient spoke fondly of his dog, which always jumped onto his armchair when he left it. His dog went to where he had been, and retrieved his

absence as a place. The idea of place is charged with the search for love objects, in the form of an experience of absence. Geometrical space is a representation of absence. It is that emotional notion of place that Bion says underlies the geometrical notion of space, which can then be located by coordinates.

Every mapping into geometrical space – every act of picturing – leaves a gap between what was present in emotional space (which might be an absence) and what appears in the mapped space; and the finitude of geometrical space cannot encompass the infinitude of emotion. It requires emotional work to tolerate the painfulness of this gap and to rehabilitate the displaced emotional space that has been mapped.[4] Bearing the reduction in dimensionality and repairing lost meaning makes an open, generous relationship to nature possible; not bearing it makes nature the object of frustration-driven yearning or attack.

What is lost in mapping is equivalent to repression. The process of picturing constitutes repression and builds up unconscious material that will seek expression and will provide a vehicle for other unconscious material to seek expression as well. Picturing nature carries the weight of a destruction of emotional dimensionality and, therefore, of a triumph that is opposed by pressure from the unconscious.

The extreme example of scientific mapping that calls forth revenge from nature is Mary Shelley's Frankenstein. Frankenstein hates his creation as soon as the thrill of his achievement passes its peak. He finds it repulsive and turns against it, forcing it into living in the shadow of human life in which it can never take part. The monster takes revenge upon human happiness, acting out the disowned dark side of that humanity.

Frankenstein, like Faust, has become a legend of modern western culture. The Faustian theme has an unconscious dimension, and psychoanalytic discourse on the unconscious diverts our investigation into the territories of primitive anxieties and defences that remain unchanged by conscious plans.

Two unconscious themes are relevant to the phantasy of the revenge of nature. First, Frankenstein's monster was fabricated from parts taken from more than one body. Second, the parts from which he had been made were already dead, and normally would have stayed dead. In making a creature from parts that have various origins and that are dead, Frankenstein seeks omnipotently to master two anxieties: First, there is the anxiety from what Melanie Klein called the phantasy of the 'combined parent figure', in which mother and father are confused by the child into a bizarre and terrifying figure that mirrors the child's intrusive impulses.[5] Second, there is the anxiety from the confusion of death with a shadow existence in an underworld into which the dead have been pushed by the living. Death is a defeat; life is a triumph. Thus, to be alive is to be prey to revenge by the dead. In a more primitive form, less amenable to

picturing, the concoction of the monster from parts represents an omnipotent defence against phantasies of dismemberment, and therefore against psychotic anxieties of loss of self into a world inhabited by bizarre animate fragments. This form of torment by dead bodies can be put more generally as a torment by thoughts that cannot enter the mental world (see Bion's concept of beta elements, Hinshelwood 1989–91: 229–30).

The dilemma of science is this: scientific thinking concocts nature, representing nature as made up in scientific discourse. Representation reduces the dimensionality of nature and displays it in a non-contradictory form, just as a military map displays the deployment of troops as a logic of confrontation. That project, which is also the project of visualization, is built on repression. It stirs up the unconscious, just as military confrontation stirs it up by the very attempt to impose a single-minded solution in the face of uncontrollable discord.

There is no threshold beneath which the scientific enterprise harmonizes with nature and there is no observational vantage point from which it can be judged to have overstepped a legitimate concern and to have violated a moral, religious, social or political principle. We try to gain such a vantage point, but it only adds to the problem. This dilemma was brought home to me by a recent religious reaction to using vaccines produced from a cell line taken from an aborted foetus. A foetus is a baby and an abortion is an infanticide, so although the abortion was done on grounds of severe deformity and the foetus was not a self-sustaining child, the foetal tissue remained living tissue taken without consent.[6]

Resistance has built up from outside science. A mode of scientific enquiry – in this case, experimentation on foetal tissue – is called into question. It seems attractive to sidestep a moral quagmire by applying external criteria, without ever getting to the heart of anti-scientific sentiment. The momentum of scientific inquiry necessarily evokes resistance because its reduction of dimensionality evokes the unconscious phantasy that the world that has not been encompassed by scientific knowledge is an alien world filled with dangerous objects. These dangerous objects do not roam freely in a culture; they are collected into various sub-groups, to become, for example, the special concern of religion, moral philosophy or the law.

Let us look at one dangerous object more closely: the phantasized unborn or annihilated sibling. There is a well-known condition, called survivor syndrome, in which people who have survived a catastrophe, which others have not, feel intense guilt. This response to remaining alive is a particular form of a more general guilt at being alive. Patients in psychoanalytic psychotherapy sometimes report material suggesting that their mothers suffered a miscarriage at a time near to their birth. In one case, I speculated to a patient that there had been a miscarriage, and it brought a conscious confirmation; in other cases, it fits the patient's psychic reality, if not the material reality.

A woman – an only child – felt intensely guilty, whenever she thought she might accrue any material or psychological wealth, unless it followed an angry attack aimed at driving home the point that she was owed this wealth as compensation for mistreatment, especially from her father, who seemed to turn away from her when she was a child. She brought material of this sort over a long period, in the midst of which she spoke of an illegitimate sister of her mother's, who had been hidden away and eventually died in an institution. Much later, she spoke of a cousin who had begun to visit her parents regularly, as if he were a long-lost child, other than herself, who had returned. Later still, she said she had always had the fantasy that she was her aunt's second child, and had been adopted by her parents when her uncle, a kind man, died. The first child, a child of her aunt's first marriage, to an abusive man, had been aborted.

Child analysis provides a vivid example of surviving a sibling. Here is an extract from a consultation with an eighteen-month-old child:

> Jacob ... seemed to move about restlessly almost [as] if obsessed by ... looking for something he never seemed able to find. ... [He] also tried to shake ... objects ..., as if trying to bring them back to life. His parents then told me that any milestone in his development ... seemed to be accompanied by intense anxiety and pain as if he were afraid ... 'to leave something behind him'. When I said very simply to him that he seemed to be looking for something that he lost and could not find anywhere, Jacob stopped and looked at me very intently. I then commented on his trying to shake all the objects to life as if he were afraid that their stillness meant death. His parents almost burst into tears and told me that Jacob was, in fact, a twin, but that his co-twin ... had died two weeks before birth. Jacob, therefore, had spent almost two weeks *in utero* with his dead and consequently unresponsive co-twin. The simple realization of this, as well as the verbalization of his fears that each step forward in his development, starting from the first warning signs of his imminent birth, might have been accompanied by the death of a loved one for whom he felt himself to be responsible, brought about an almost incredible change in his behaviour.
>
> (Piontelli 1992: 17–18)

Eric Rhode (1994) argues that birth, in phantasy, is accomplished through a double annihilation – of mother and a twin – and that the placenta and cord, as the lifeline to the pre-birth mother, incarnate the annihilated pair for the post-birth baby. The cutting of the cord and the birth of the placenta represent the caesura, upon which mother and twin are banished to the underworld in order that the baby live. Jacob's anxiety, though more intense and more focused upon an experience available to consciousness, points to the psychic background against which the birth of self is highlighted.

Life is shadowed by death. Being alive and, in particular, the experience of selfhood, is built on the phantasy that another self remains unborn or was killed. A young man presented with debilitating tension in his body. Over time, we discovered that it radiated from tension in his throat, which he at first associated with glandular fever following the break-up of a relationship and the deaths of two friends in close succession. He suffered guilt at having survived these deaths, but it also emerged that, years before, he had the thought that there could be a road accident outside his home, after which an accident occurred; and before that, his grandmother went against his doctor's reassurance, and took him to hospital, where an emergency appendectomy saved his life in the nick of time.

In each case, he survived, and he experienced his survivals as triumphs. Ultimately, the triumph was consciousness itself, in being built on repressing a primal relationship with mother, which was denigrated but also envied for its unique rootedness in the source of life. His mother was deaf, and he (incorrectly) dated her deafness from the time of her pregnancy with him. In phantasy, he caused and survived her deafness. It was also likely that, along with triumph, he experienced her as enigmatic because, as a baby, he had to fill in for the disjunction between the sound of her voice and her facial gestures. It was also likely that he experienced an unconscious part of himself to be in a special pre-verbal harmony with mother, created by her deafness and cemented by identification. She had to substitute muscular sensations in her throat for sound, to guide her speaking; and he identified with the tension in her throat by suffering tension in his throat, which was the basis of the bodily tension with which he originally presented. The underworld, into which mother and his twin were banished, was also a special world beyond encompassing by consciousness.

This shadowing by the unborn twin in the displaced womb gives an additional significance to Freud's notion of the uncanny (Freud, 1919). The uncanny is a special kind of anxiety, related to feeling stalked by something familiar. If we said that person A bore an uncanny likeness to person B, we would imply, though we knew it not to be the case, that person B was, in some undefinable way, present in person A. The uncanny would lie, not in the likeness, but in the revealing of person B in person A, as if by having seized person A from inside, in order to push into view. For Freud, this seizing would be the repetition compulsion, whereby repressed ideas make use of conscious situations to break through their repression.

Naturalism, including scientific naturalism, is stalked by the uncanny. Freud gives an example of the way repressed ideas can use conscious ideas as a vehicle for their release, in a naturalistic yet uncanny form. Some patients have:

lively recollections called up in them – which they themselves have described as 'ultra-clear' – but what they have recollected has not been the event that was the subject of the [analytic] construction but details relating to that subject. For instance, they have recollected with abnormal sharpness the faces of the people involved in the construction or the rooms in which something of the sort might have happened, or, a step further away, the furniture in such rooms – on the subject of which the construction had naturally no possibility of any knowledge.

(Freud 1937: 266)[7]

The dynamic relationship between the conscious and the unconscious offers a new look at naturalism and at science. From a conscious point of view, naturalism – and scientific naturalism in particular – suggests the recording of nature as it is. It implies that nature is an arena of objects and processes undisturbed by human intention. A model of naturalism would be the detailed fine drawing of the Renaissance, as in Leonardo da Vinci or Dutch genre painting; or it would be in descriptive science, such as taxonomy or anatomy; or in theoretical science, such as the planetary model of the atom or the theory of evolution.

With the unconscious in mind, on the other hand, naturalism suggests an attention to detail that expresses, not the geometry of objects and their relationships, but a displacement and binding of repressed thoughts, which allows them to make their way to consciousness. The anatomical drawings of Leonardo da Vinci are masterpieces of fine detail that creates a sense of objective reality. Two drawings of women, when looked at closely, however, show that the detail can be in the service of illusion. One portrays sexual intercourse, with both man and woman sectioned down the middle, so that their internal organs are visible (Figure 5.2). The other shows the internal organs from the front (Figure 5.3). What emerges upon close inspection is that the female reproductive organs are either uncharacteristically indistinct or fanciful. One has to look several times to see the departure in representation from what surrounds the reproductive area; otherwise it is the crispness and clarity of portrayal that imprints the sense of objectivity on the viewer.[8]

A similar point could be made about the incredibly precise and clear Dutch genre and still-life paintings of the sixteenth to eighteenth centuries. A piece of fruit looks so real, so ripe, so fresh, with transparent drops of moisture heightening its lusciousness. And yet these paintings can be seen as *vanitas* paintings: the very peak of natural beauty stands at the moment of turning, and carries an uncanny reminder of mortality and imminent decay (Hall 1974–79).

And of course, what of surrealism? Dali and Tanguy portray objects that seem recognizable, but are not. They seem recogizable, not just because of the familiarity of their shapes, but because of the precision of their detail. The perception of an object that is simultaneously familiar

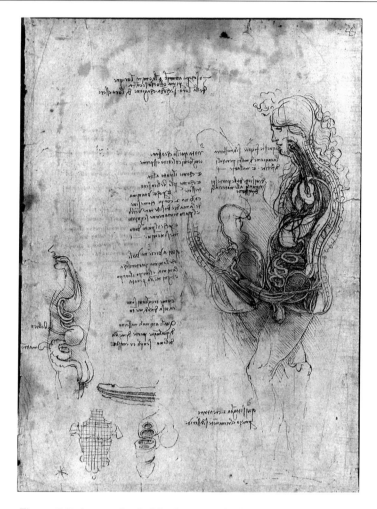

Figure 5.2 Leonardo da Vinci: anatomical drawing
Source: The Royal Collection, Her Majesty the Queen

and strange creates an elusiveness that is uncanny. Indeed, that is Freud's definition of the uncanny.[9]

These examples are meant to show that there is an underworld beneath naturalism. The more realistic the surface, the more uncanny the depths. Scientific naturalism creates an irrational underworld beneath its rational surface. It means that the systematic treatment of nature as inanimate and subject to an ever-expanding non-contradictory representation creates an animistic underworld, which surfaces in mythic forms that reveal unconscious phantasies.

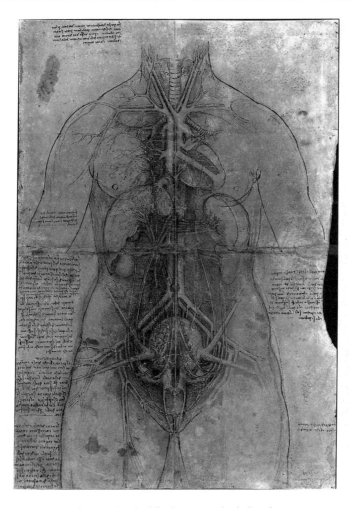

Figure 5.3 Leonardo da Vinci: anatomical drawing
Source: The Royal Collection, Her Majesty the Queen

Scientific rationality intensifies the phantasy of the unborn child, banished with its mother into the underworld. The growth of science paradoxically leaves in its wake, not just a more reasoned attitude towards nature, but a reaction on her behalf against science and a fear that takes on tones of the uncanny. In identifying with its conscious rationality and institutionalizing it in a scientific culture, modern western culture displaces the unconscious phantasies on which its conscious identity is built. When Thebes suffered an unrelenting epidemic and crop failures, the citizens sought the man who had killed his father and married his

mother: the cause fit the consequences. In the early modern period, under transformation into capitalist rationality, social unease found a resolution in hunting down witches (Roper 1994).[10]

There was a similarity between the social reaction to threatening events in ancient Greece and that in early modern Europe, but there was an emerging difference: in the early modern period, a culture of rationality added to the forces of repression, producing a greater disjunction between reason and unreason. Material reality was shaded by the return of the repressed, and a threat that could not be subdued became uncanny as well as frightening.

The future of nature lies mainly in the future of science. There is no limit to either the new territories or the depth of scientific inquiry. The reaction of nature has become the return of the repressed, and the cultural formation in relation to nature will depend on whether the irrationality can be contained within, or near to, scientifc discourse, or whether it will be split off into cultural sectors that identify with the irrationality and promote the return of the repressed.

Examples of this advocacy are ready to hand, both in anti-scientific moralism and in fundamentalist religious sects. The banning of measles innoculation because the vaccine was originally cultured on tissue from an aborted foetus sets an advocacy for unborn children in opposition to scientific rationality. In a more extreme form, the pro-life campaigns against abortion become violent; and animal rights campaigners have even threatened to kill scientists who experiment on animals.

As these movements become more extreme, unborn children and animals come to represent the mythic twin and its mother, banished into the under-world in the interest of the conscious self and its rational culture. Their reaction carries the force and the ominousness of the repressed. They do not see that there must be unborn children, not just biologically, but psychologically. By arrogating to themselves the role of advocate, they perform the psychic function of separating the rationality of science from an irrational shadow. Contrary to conscious intention, this splitting actually promotes science through externalizing an inherent source of anxiety that otherwise would inhibit scientifc inquiry or press for inclusion within scientific discourse. It also promotes irrationality outside science because its advocacy for the unborn child is untempered by scientific rationality. By identifying nature with the annihilated mother/twin, this advocacy unconsciously promotes the retaliation of the unborn child towards those who have been born and towards their conscious aims, including rational inquiry.

Although it is dangerous, this process of splitting and externalization of unconscious parts of self and objects is inherent in all social forma-tions. I close with a question: how might reflection on this process be promoted, and how might it work its way into scientific discourse, so that naturalism embodies a generous relationship with nature? It is part of the

broader question of how psychoanalytic thinking enters social imagination and informs thinking, behaviour and social and political processes.

NOTES

1 I am aware that the unspecific use of 'we' begs many questions about who 'we' are. Society is heterogeneous, with sectional identifications and interests that often conflict. Here, 'we' simply refers to the subject of a collective phantasy. The argument will make clear when that colllective 'we' needs to be divided into sub-groups.

2 I am baseing my argument on an analogy to the parricide, which, according to Freud, is worked over in a monotheistic religion, specifically in the Christian mass. One could ask what the analogous impulse might be, which I am subsuming under 'encompassing nature', and which is worked over in scientific naturalism. Is it, for example, the murder of 'mother' nature? Bovensiepen's study (1986) suggests something of this sort, in that parliamentary debates give vent to aggression as well as contrition and reparative efforts, in attempts to arrive at rational policy towards the environment. I don't want to push the analogy too far, but to claim, for the purposes of this paper, only that it shows the perpetuation of an unconscious theme within the conscious workings of a social institution. A more detailed examination of the maternal or feminine form of nature in western culture is the theme of another study.

3 In this formulation, I am following Heidegger's notion of scientific theory. Heidegger develops a language that captures the subtlety of the encompassing character of science in relation to the objective world and avoids the dichotomy between a pre-existent nature and a nature mastered by technology as the instrument of science.

> The real is what presences as self-exhibiting. But what presences shows itself in the modern age in such a way as to bring its presencing to stand in objectness. Science corresponds to this holding-sway of presencing in terms of objects, inasmuch as it for its part, as theory, challenges forth the real specifically through aiming its objectness. Science sets upon the real. It orders it into place to the end that at any given time the real will exhibit itself as an interacting network, ie., in surveyable series of related causes. . . . The fact that what presences – eg., nature, man, history, language – sets itself forth as the real in its objectness, the fact that as a complement to this science is transformed into theory that entraps the real and secures it in objectness, would have been as strange to medieval man as it would have been dismaying to Greek thought.
>
> (Heidegger 1954: 167–8)

4 Photographs – the ultimate picturing of nature – often create a nostalgic mood that is absent in paintings. The photographer dissolves into the picture, leaving a sense of loss in the viewer, who has no subject with whose emotional work he or she can can identify. The surface of a painting, on the other hand, shows the work of the painter, and provides a focus for identification with a subject that has laboured over emotional expression. On the importance of the painted surface, see Wollheim 1987.

5 The 'combined parent figure' was a concept introduced by Melanie Klein to describe a sadistic unconscious phantasy of parental intercourse, in which the parents were not whole beings but parts locked together in violent copulation. Part objects are not anatomical structures, but the objects of primitive

phantasies such as oral, anal or urethral attack. The combined parent object is therefore not parental, since parental creativity has been attacked; it is a collation of part objects, having no quality of integration or vitality. It is both the result of envious attacks upon parental creativity and a defence against envy (Hinshelwood 1989–91: 242–3; Klein 1932: 132–3).

I am comparing this part-object character, including its antithesis to life, with Frankenstein's production. Frankenstein's monster was made up of parts, perhaps as a defence against envious attacks on natural creativity. Stephen Bann (1994) puts the monster's collated structure in the context of nineteenth-century ideas of creation *v.* monstrosity. Monstrosities had no intrinsic integration, which was why a super-added mysterious life force had to be introduced.

In Kleinian thinking, the emergence of mother as a whole object is an achievement of working through these primitive destructive phantasies, as well as the depressive anxiety of having irreparably damaged an internal good and loved object. Frankenstein's attack on creativity could not allow this transformation, so the monster remained a collated object and a persecuting threat.

6 This is my version, not a report on the views expressed by opponents of the vaccine.

7 The translation of the *Standard Edition*, which I have used, differs from the earlier translation of the collected papers in the rendering of one word only: *überdeutlich*, which is translated here as 'ultra-clear', appears in the collected papers as 'unnaturally distinct'. In a sense, the earlier version is preferable, in that it conveys the idea that the special clarity of detail indicates that it is not just unusual, but misleading and unnatural. For Freud, the sharp detail signifies repression: the exaggeration of some features both consolidates the repression and allows it an expression in a displaced form. It has a quality that Freud compared to a hallucination further along in the text quoted, and that he also associates with an experience of *déjà vu* (1901: 266–7). Thus, detail calls forth a psychic reality, not a material reality (Freud discusses this difference in 1939, III.II.G: 'Historical truth'). I am further arguing that this psychic reality stalks scientific naturalism with a sense of the uncanny.

8 Freud (1910: 159, n. 2) noted the indistinctness and errors in the representation of the female reproductive organs, compared to that of the male, in Leonardo's drawing of sexual intercourse. He included a copy of the drawing and a lengthy commentary upon it by Reitler (1917). The drawing of the internal organs of a woman is in Popham, 1946: 142, 247.

9 The relationship between the surrealist project of disorientation of a stable sense of reality and Freud's understanding of the uncanny as the breaking through of primitive animistic thinking has been a theme in art history. For a treatment of it, which focuses on the surrealist use of photography to portray these processes, see Krauss, 1985.

10 There is a similarity between the dread of the undead, the Frankenstein theme, in which a bizarre form of the undead emerges, and the vampire folklore, in which the undead stalk the living and attack them. Interestingly, vampire folklore became important in a region of Serbia, previously held by the Turks, at the time it was occupied by the Austrians in the early eighteenth century. The occupying force began to file reports on a local custom of exhuming bodies and 'killing' them (Barber 1988: 5). The Balkans, where vampire legends flourished, were a buffer zone between Byzantium and Rome, and the conflict centred on a dispute about the Roman Catholic doctrine of the reality of the body and blood of Christ in the Eucharist, which was rejected by the Greek Orthodox church. This assertion of the real presence of Christ also carried the

politcal, cultural and doctrinal significance of the reassertion of the Catholic church and of Christian statehood. The legends of bodies that remained uncorrupted and that fed on blood was seen as an attack, promulgated in Greek Orthodox territories, on the presence of the uncorrupted body and blood of Christ in the bread and wine of the Eucharist (Schefer 1994). The dread of the undead can be seen as a dread of the return of the repressed, in the form of a retaliatory unconscious phantasy reinforced by the suppression of unorthodox views and the imposition of a single orthodoxy.

REFERENCES

Bann, S. (1994) 'Introduction', in S. Bann (ed.) *Frankenstein, Creation and Monstrosity*, London: Reaktion Books.

Barber, P. (1988) *Vampires, Burial, and Death: Folklore and Reality*, New Haven and London: Yale University Press.

Bion, W. (1970) *Attention and Interpretation*, London: Tavistock and Karnac Books, 1984.

Bovensiepen, G. (1986) 'Thoughts on the mythical structure of consciousness of the West German power elite', unpublished manuscript.

Freud, S. (1901) *The Psychopathology of Everyday Life*, Vol. 6 in *The Standard Edition of the Complete Psychological Works of Sigmund Freud*, London: Hogarth and the Institute of Psycho-Analysis.

—— (1910) *Leonardo da Vinci*, Standard Edition 11: 57–137.

—— (1912-13) *Totem and Taboo*, Standard Edition 13: xv, 1–161.

—— (1919) 'The uncanny', Standard Edition 17: 217–52.

—— (1937) 'Constructions in analysis', Standard Edition 23: 255–70.

—— (1939) *Moses and Monotheism: Three Essays*, Standard Edition 23: 1–137.

Hall, J. (1974–79) *Dictionary of the Subjects and Symbols of Art*, London: John Murray.

Heidegger, M. (1954) 'Science and reflection', in *The Question Concerning Technology and Other Essays*, New York: Harper & Row, 1977.

Hinshelwood, R. (1989–91) *A Dictionary of Kleinian Thought*, London: Free Association Books.

Klein, M. (1932) *The Psycho-Analysis of Children*, London: Hogarth and the Institute of Psycho-Analysis, 1975.

Krauss, R. (1985) '*Corpus delicti*', in R. Krauss and J. Livingston (1985) *L'Amour Fou: Photography and Surrealism (Hayward Gallery, London, July to September, 1986)*, New York: Abbeville Press/London: Arts Council of Great Britain, 1986.

Piontelli, A. (1992) *From Fetus to Child: An Observational and Psychoanalytic Study*, London/New York: Tavistock/Routledge.

Popham, A. (1946) *The Drawings of Leonardo da Vinci*, London: Reprint Society.

Reitler, R. (1917) 'Eine anatomisch-künstlerische Fehlleistuing Leonardos da Vinci', *Internationale Zeitschrift für ärztliche Psychoanalyse* 4: 205.

Rhode, E. (1994) *Psychotic Metaphysics*, London: Karnac Books.

Richards, B. (1986) 'Military mobilizations of the unconscious', *Free Associations* 7: 11–26.

Roper, L. (1994) *Oedipus and the Devil: Witchcraft, Sexuality and Religion in Early Modern Europe*, London and New York: Routledge.

Schefer, J.-L. (1994) 'The bread and the blood', in S. Bann (ed.) *Frankenstein, Creation and Monstrosity*, London: Reaktion Books: 177–92.

Wollheim, R. (1987) *Painting as an Art*, London: Thames & Hudson.

Chapter 6

Nature's *r*
A musical swoon

Trinh T. Minh-ha

Nature. Make it a small, not a capital N, and nature applies to almost everything that is nameable. Take off both capital N and small *n*, and what remains is an *ature*-fragment whose music and meaning change radically with the substitution of a single opening consonant. M, for example: *mature*. Or, as in French: *mature, rature, sature*. Now delete the *r,* and the sound, incomplete, would have to remain suspended, *na-tu. . . ,* unable to carry through its musical term. For a sign to unsettle itself and to break lose from its fixed representations, duration is made audible, space between syllables is spelled out, and time, deferred. Delete, replace, return, then let be. The *r* in nature is the grey zone between sound and sense. To leave both the *n* and the *r* in, therefore, is not to revert to nature in its 'original', non-dismembered state, but rather, to listen again carefully, critically, ec-static-ally, to its musical intervals.

Perceptible to the ear and yet hardly articulated, the *r* in nature is always half-muted, half pronounced. It is the very phoneme whose pronunciation remains in parenthesis [nache(r)] – that is, somewhere between a sound and a silence. In listening to a song, a poem, a phrase, or even a single word, one listens to both their marked and non-marked beats. What retains one's attention is the way meaning and sound come together and move apart from one another, ceaselessly closing the gaps while producing new gaps between themselves, finding thereby their beginnings and endings in creative rhythm. More than the use of pauses and interruptions, the boundary event that makes one hold one's breath is here the dying fall – the fragile moment when in the shift to a lower note, sound becomes sigh and word fades to breath. The musical swoon (in nature's *r*) has the potential both to free the listener from the weight of the word(s), and to interrupt the aural landscapes built with washes of captivating sounds. The Persian mystic Jalaluddin Rumi (1207–1273) wrote: 'Enough talking. If we eat too much greenery,/we are going to smell like vegetables'.[1]

Enough talking; and yet we go on talking and falling in love with green. We just can't stop. And I can't stop here, can I? With the media

promotions of 'natural' products and imagery that saturate life in modern societies, it is difficult to continue putting nature back into discourse, without contributing to further denature nature by partaking in the production of its so-called 'crisis' – or what an European critic views as a form of 'intellectual blackmail[ing]' associated with that 'epidemic of visibility menacing our entire culture'.[2] As the end of the century approaches, discourses on and images of nature seem to have taken on a new lease of life. With their proliferation, the concept of nature has at once regained its full importance and become so destabilized as to raise anew the question of its viability as a discursive category. In an attempt to introduce difference into practices that inform the theorizing of nature and to talk while not overeating greenery, a space is thus opened up here, in which reflections on nature necessarily shuttle between the arbitrary reality of the sign (word as word) and the multiple realities it speaks to or represents in the posthumanist landscapes of 'denaturalized' discourses.

Over four decades ago, Simone de Beauvoir wrote:

> Nature is one of the realms [women] have most lovingly explored. For the young girl, ... nature represents what woman herself represents for man: herself and her negation, a kingdom and a place of exile; the whole in the guise of the other. ... Few indeed there are who face nature in its nonhuman freedom, who attempt to decipher its foreign meanings, and who lose themselves in order to make union with this other presence.[3]

Herself and her negation. The link between woman and nature is one that is both constructed, capitalized on and lovingly assumed. A look at the thinking conveyed in summer advertisments promoting feminine products and the new fragrances put out on the market in the 1990s, suffices to confirm how thoroughly such a link continues to encode the natural. In the realm of the senses, for example, it is affirmed that the passion-driven imagery and the lusty scents of the 1980s are definitely outdated. Today women are quoted saying they want to wear a scent for themselves, not necessarily for some man whom they want to attract or seduce. The focus is all on green. On the great outdoors, on fresh florals and on fruity scents. Green is definitely selling, and as remarked in a women's magazine, 'the beauty biz has seen the future – and it's green, the very shade of a million-dollar bill!'

The world of media sensationalism has always proved to be very effective in its power of co-optation. It translates subversiveness into marketable pleasures and invests in the critical discourses that address the destruction of nature only so as to further work at raising up the green event for its mercantile purposes. Thus, partaking in the same historical network are both the discourses on nature that have been depicting it in terms of environmental crises and catastrophes, and those that continue to crown it

in terms familiar to the tradition of taming and appropriating nature for the productions of culture. The slogan 'green and clean', for example, has been readapted, as quoted earlier, to feminized contexts of pleasure, liberation and success, where images of the garden of Eden, of the lost paradise, or of the forbidden fruit happily flourish. Like other cultural constructs, the concept of crisis is thereby always twofold: it constitutes a contestation of the despoiling of nature, at the same time as it gives a boost to the consumption of 'natural' products and of the environment. As a cultural critic cynically puts it, 'together with mundane and operational eclecticism, crisis promotes all nostalgic and sentimental remakes from those of love to those of human rights, from those of fashion revivals to socialism in politics, and discourages everything regarded as adventurous'.[4] *A kingdom and a place of exile.* The common tendency to oppose nature to culture, to feminize and primitivize it within the escalating logics of confine-and-conquer, or expropriate-and-dispossess systems fundamental to ideologies of expansionism, has been widely analysed by feminists and postcolonial critics as part of a process of questioning the concepts of woman, otherness, and nature in relation to the globalizing projects of domination via (economic and cultural) modernization. Nature, the feminine and the primitive represented as the 'no man's land' or the limit-zone of man's symbolization, has undergone thorough scrutiny, and the critical debate has moved past the phases of assimilation and rejection to that of struggle (to use Franz Fanon's terms), where affirmations and negations are diversely reappropriated as strategies and tactics toward the emergence of new subjectivities. Today, to come back to De Beauvoir's pessimistic statement, one would then have to turn its affirmation into a question: Have there been, are there, indeed, so *few* – and who are they? – 'who face nature in its nonhuman freedom, . . . and lose themselves in order to make union with this other presence'?

LOOKING BACK TO THE CITY OF THE FUTURE

As long as there is a future, all truth will be partial.

Cheikh Hamidou Kane

all time is a now-time. . . . The past is the future.

Patricia Grace

We sense the fatal taste of material paradise. It drives one to despair, but what should one do? *No future.*

Jean Baudrillard

The mind lags behind nature.

Gilles Deleuze and Felix Guattari

In Cheikh Hamidou Kane's *Ambiguous Adventure*, the confrontation of a Frenchman (Paul Lacroix) and an African man of tradition ('the knight', or Samba Diallo's father) in the country of the Diallobe provides the reader with one of the novel's most remarkable scenes. Set at a time of the day when, 'on the horizon, it seemed as if the earth were poised on the edge of an abyss' above which 'the sun was dangerously suspended', the scene invites reflection on the men's relationship with nature, as well as on the gap displayed between East and West, tradition and modernity, past and future. (After much resistance, Samba Diallo's father has here, finally come to term with the fact that his son will be sent to the new school and taught the values of the West, as required in the new system of government.)

[Paul Lacroix] turned and spoke to him:
'Does this twilight not trouble you? Myself I am upset by it. At this moment it seems to me that we are closer to the end of the world than we are to nightfall.'
The knight smiled.
'Reassure yourself. I predict for you a peaceful night.'
'You do not believe in the end of the world?'
'On the contrary, I even hope for it, firmly. . . . Our world is that which believes in the end of the world: which at the same time hopes for it and fears it . . . from the bottom of my heart I wish for you to redis- cover the feeling of anguish in the face of the dying sun. I ardently wish that for the West. When the sun dies, no scientific certainty should keep us from weeping for it, no rational evidence should keep us from asking that it be reborn. You are slowly dying under the weight of evidence. . . . [Your science] makes you the masters of the external, but at the same time it exiles you there, more and more. . . . M. Lacroix, I know that you do not believe in the shade; nor in the end of the world. What you do not see does not exist. . . . The future citadel, thanks to my son, will open its wide windows on the abyss, from which will come great gusts of shadow upon our shrivelled bodies, our haggard brows. With all my soul I wish for this opening. In the city which is being born such should be our work – all of us, Hindus, Chinese, South Americans, Negroes, Arabs, all of us.'[5]

The fragile moment is that of a multiple encounter between day and night. As the sun goes dying in the west, the man of the East lets go of his mourning for the Diallobe that will go dying in his son's heart, and looks forward to the city of the future. In this moment, when ending and begin- ning mingle, and nothing seems evident to the eye and the ear, questions that arise remain dangerously suspended: Is it the East or the West that is dying? What, exactly, is dying? As the tradition of the East gives way to the progress of the West, and as the West heads towards its own

extinction under the weight of evidence, the world itself is coming to an end – the world as a concept for (implementing) a global society. The city of the future, as the African man has envisioned, is a city that is radically multiple as it can only survive in hope and fear, with its windows wide open onto the abyss.

'In the beginning was, *yesterday*, after which there have been many tomorrows',[6] wrote Boubou Hama. The sight of the sunset in its full and dying splendour has never suscitated a uniform feeling among those whose relationship with nature is that of an intimate participant, rather than that of a spectator. The filmmaker Peter Kubelka, for whom it took a trip to a remote village in Africa to fully experience what he was trying for years to create in his films, has for example, the following event to relate back to his audience. When 'it became evening', he wrote,

> all attention was focused on the open plain. There was nothing to see but the people gathered to watch the plain and the horizon ... then suddenly the drummers came and the excitement started to grow ... the sun started to set, very fast ... then exactly when the sun reached the horizon the chief made one bang on his drum. I was moved to tears because I saw my own motive right there. ... What I wanted to do with sound and light, they did too. This was a fantastic, beautiful sound sync event. ... This comparison of their sync event and mine exactly describes the situation of our civilization. Much less sensual substance and beauty, more speed. They had one day, I had every 24th of a second.[7]

Visual and aural, external and internal, passive and active at the same time, the sync event is evoked in Kubelka's context as a form of ecstasy, which he defines as a refusal to merely 'serve time', to be a slave of nature, or to conform to the idealized cycle of life (birth, youth, age). Such an interpretation denotes a desire to defy the laws of nature – a desire particularly suited to the cinematic medium – but it also has the potential to introduce a break into the more familiar discourses of the West on its others, whose close relationship with nature continues to be depicted in terms of passive identification and submissive reverence. *There have been many tomorrows. Here been.* Here, the sync event is also a boundary event, for the moment when sight and sound meet is the very moment when the sun reaches the horizon – that is, when the curve and the straight line, the round and the flat, the circular and the linear seem to come into contact, and light starts mingling with darkness. 'Every time the sun capsizes', wrote poet Jean-Joseph Rabearivelo, 'he begins to suffer anew'.[8] Anguish and ecstasy in the face of the dying sun. The feeling of the end of the world experienced anew every evening is widely conveyed in African literatures. A sunset is lived not necessarily and literally as the death of the sun, but as a rupture with and a continuation of the cycle of

departing and returning. No real crisis. The 'ambiguous adventure' is one in which the invasion of the evening awakens both fear and hope, and past and future are grasped in that moment of passage when 'the known world was enriching itself by a birth that took place in mire and blood'.[9] *Everything* is in the transition. (Or, there is no transition as suturing device.) Looking forward to the end of the world is also looking forward to a strange and terrible new dawn.

BOUNDARY EVENT

In many Asian and African traditions the western notion of 'evil' as opposed to that of 'good' remains largely unknown. For example, whenever the term devil is borrowed in the translation of *Kaydara*, an initiation text of the Fulani of the Niger Loop, it is said that it simply refers to one of the genii who work for the 'supernatural spirits' and exercise their wits either to assist or to harass humans. They constitute a crowded population, which resides in what Amadou Hampate Ba calls 'the country of semi-darkness', and are subject to all kinds of incarnation. Such a country exists as an intermediary between 'the country of light' where all species of the visible live, and 'the country of profound night' where the souls of the dead and of those to be born from the human, the animal and the vegetal worlds are to be found.[10]

In western cultures, the supernatural seems more easily locatable as it used to be confined to a genre known as the twilight tales. Associated with the world of ghosts and phantoms, of demonic and otherworldly being, the supernatural is said to be always just around the corner. The mind that sees this other world as quite as real as, if not more so than, this world is called a 'haunted mind'. The technique, as a master of supernatural fiction writes, is to use the familiar and to 'put the reader into the position of saying to himself, "If I'm not very careful, something of this kind may happen to me"'.[11] Thus, unlike in African literatures, where contact with the inhabitants of the countries of semi-darkness and of profound night is most likely initiated during a journey into the bush or beyond the boundaries of a settlement (of village life, of normal life), in many western twilight tales the stage for the encounter with the supernatural is more often the haunted, abandoned house. Such a house, by 'its apparent domesticity, its residue of family history and nostalgia, its role as the last and most intimate shelter of private comfort' which sharpens 'by contrast the terror of invasion by alien spirits', has proven to be, since the nineteenth century, the most popular and 'favored site for uncanny disturbances'.[12]

On the one hand, reality is dichotomized, set into binary opposition, and dramatized in their contrast: domesticity family private comfort versus the invasion by demonic alien spirits; the invisible threatening to become

visible; or the unfamiliar lurking in the midst of the most evidently familiar. On the other hand, reality is *set into motion* as it travels between the countries of light and of night, and shifts its boundaries as it moves from one marking, one territory, one light to another. Such a multi-dimensional fluidity has been hierarchized and explained by an observer of the West, Claude Lévi-Strauss, as follows:

> Among the peoples called 'primitive', . . . the notion of nature always offers an ambiguous character. Nature is preculture and it is also sub-culture. But it is by and large the means through which man may hope to enter into contact with ancestors, spirits and gods. Thus, there is in the notion of nature a 'supernatural' component, and this 'supernature' is as undeniably above culture as nature itself is below it.[13]

Here, ambiguity offers a site where nature continues to resist hierarchized and linear categories. The prefixes pre-, sub- and super- seem 'hopelessly' irrelevant; so does the tendency incessantly to recentre 'culture' and to revert to it as an organizing concept. After all, 'If a ghost is seen . . . what sees it?' asked Algernon Blackwood, for whom our so-called normal waking consciousness is but one type of consciousness, by which only one person in a hundred is seen as 'real'.[14] What is unclear for the logic of rational of knowledge may be crystal-clear for other forms of knowledge, and the 'ambiguous character' of (the notion of) nature appears ambiguous only to those who refuse to participate in it. The haunted mind, the haunted house, the 'real' person. Even when conscious-ness is extended to its outer limits, everything here seems to be confined to the precincts of humanist tradition. The anthropocentric overcast can seriously limit one's vision of things. Thus, returning to the West its own ethnocentric classifications, Boubou Hama clears the field by specifying:

> Nothing is the universe is supernatural. Everything is natural. The supernatural is an anti-scientific invention of the West, its inability to grasp the spirit of matter and the soul of beings, and to distinguish the one and the other from the energy of matter.[15]

Twilight; two lights. Two countries; two worlds. It has always been dif-ficult to determine where nature begins and where it ends. Especially when one recognizes oneself as being part of it. *Everything is natural. Spirit, soul, energy.* Realities change, for example, according to the shift of light, and meanings given to the same symbol may differ radically during daytime or night-time. Again, in *Kaydara*, A. Hampate Ba refers to knowledge of both cosmic order and disorder, of the annihilation of beings by other beings, and hence to the diurnal and nocturnal meanings encountered with each symbol. For example, among the seven attributes of the chameleon, 'changing color, in the diurnal sense, is to be a sociable person . . .

capable of maintaining good exchange with everyone, of adapting himself
or herself to all circumstances. ... While in the nocturnal sense, the
chameleon symbolizes hypocrisy ... lack of originality and of personal-
ity'.[16] Knowledge is, however, referred to here as being 'far away and near
by'; it is formless but does not hesitate to take on an adequate form when
necessary, and the complexity of life is grasped, both in its binary and
ternary symbols. Between the diurnal and the nocturnal, then, there is the
third term; and there is a wide range of possible shades of meaning in
the country of semi-darkness where all kind of incarnation are possible.

Indicative of the two extremes of a thing or an event, the third term
carries with it the potential to change the term of every duality. In other
words, it enables one to displace duality and reinscribe it as difference.
An excerpt from Boubou Hama's novel, significantly titled *Le Double
d'hier rencontre demain* (Yesterday's Double Meets Tomorrow), plays
on the notion of 'double' over that of duality in the following manner:
'The dying evening marks the end of the world of he who is conditioned
to live in full daylight; it is Souba's world in decline, while from its
deepening shadow, emerges luminescent, the bright daylight of another
world, the world of Bi Bio. . . . Night, for him, is a "blinding lighthouse"'.[17]
If supernature is contained within nature, if it only constitutes a site
in which the forces of nature are humanized, if it is apprehended
both within and beyond the boundaries of village life or culture; in
other words, if night is lived within day, and day within night, then what
is 'natural' may be said to situate itself nowhere else than at the boundary
of nature.

NATURE'S BECOMINGNESS

The natural *lies* at the edge of nature and culture. Shifting from one realm,
one context, one situation to another, its boundary challenges every
definition of the 'natural' arrived at. Should writing be qualified as natural,
then nature certainly proves to be writerly. 'Music, as I conceive it, is
ecological. . . . It IS ecology', wrote John Cage, who spoke of nature as a
'together-work' of water, air, sky and earth – the separation of which (by
humans) has put nature to danger.[18] Such a together-work is what makes
the difference between an art which *imitates* nature and one, as defined
by Ananda K. Coomaraswamy, which 'is like Nature, not in appearance,
but in operation'.[19] Realist art is here regarded as 'decadent', for it is said
to fall short of 'what is proper to man as man, to whom not merely
sensible, but also intelligible worlds are accessible', and hence, 'the more
an image is "true to nature", the more it *lies*'.[20]

In the tradition of Asian arts, nature is always given a prominent role,
but as a witness of events, or as a reality of its own, it is often not resorted
to in mere metaphorical or symbolical terms. Rather than simply reflecting

the moods, the feelings or the states of mind of the writer or the onlooker, its function is more likely to *elicit* (these feelings and states) rather than to illustrate. It is known from the Sumiye school of painting, for example, that there could be no retouching whatsoever on a work, for the precise, swift and decisive brush strokes were effected on paper so thin that the slightest hesitancy would cause it to wrinkle and rend. Here the traces and gestures of painting are irrevocable, and the artistic work material- izes a movement that depicts the becomingness of both nature and the human action–emotion–idea.

A boundary event. As such, painting is a form of comm-union with nature – or of natural responsibility/respond-ability – in the realm of no-knowledge. Born from silence, no-knowledge like no-thingness differs substantially from no knowledge and nothingness. The hyphen makes all the difference. Without it, the state of 'infinite' sensibilities is both confused with the state of ignorance and reduced by narrow-minded rationalists to that of mystification. Nature *elicits* no-knowledge from the painter, and as R.G.H. Siu put it, 'Creation in research is the fluorescence [/florescence] of no-knowledge'.[21] In the state of becoming and un-becoming the thing known, a painting captures 'the tigerishness of the tiger' and imparts what Siu considered to be 'a feeling of nature that is rarely equaled in Occidental paintings with their anthropocentric overcast'.[22] Su Tung-Po (1035–1101), whose influence among painters was widespread, suggested that in their works, emphasis be given not to exterior and fixed forms, but to grasping things in their becoming. What is thereby affirmed is the necessity to integrate vital Duration in painting. Li Jih-hua (1565–1635) further stressed the idea of such an internal transformation in theorizing the work of brush and ink as follows:

> In painting, it is important to know how to retain, but also how to let go. ... In the tracing of forms, although the goal is to fully reach a result, the entire art of execution resides in the intervals and the frag- mentary suggestions. Hence the necessity to know how to let go. This implies that the painter's brush strokes interrupt themselves (without interruption of the breath that animates them) to better fill themselves with 'surplus meaning'. Thus, a mountain can comprise unpainted sections and a tree can do without parts of its branches in such a manner that these remain, in this state of becoming, between being and non- being.[23]

A duration event. Partaking in nature's manner of operation, the painting can be said to be a becoming-nature/becoming-culture/becoming-human. What breathes through Li Ji-hua's intervals, what governs the absences- presences or centres-absences, what moves in the space-between is not the missed, hidden or impenetrable thing, but rather, the no-thing

becoming (the thing) not-quite-not-yet known. Shen-Hao (seventeenth century), whose treatise on painting insisted on the necessity of taking inspiration directly from nature, related that after having been inspired one night to paint bamboo according to the *i* (translated as idea, desire, intention, acting conscience, accurate vision), the painter Ni Yu discovered upon waking up the next morning that his painted bamboo differed wildly from the real ones, and exclaimed laughingly: 'To resemble nothing, but that's exactly what's most difficult!'[24] Night-into-day realizations, like all work carried out in frontier realms, have at all times been a challenge to artists and writers. As Ch'ien Wen-shih (from the Sung Dynasty, 960–1279) had specifically noted:

> It is easy to paint a mountain in clear or rainy weather. But how far more difficult it is to grasp this state between being and non-being, when the fine weather is about to give way to the rain, or inversely, when the rain begins to clear and to yield to the fine weather. Or else, when bathed in the morning mists or in the sunset smokes, things immersed in semi-darkness are still distinct, but they are already nimbed by an invisible halo that unites them all.[25]

At the edge of. Rather than being a spectator of nature, the painting subject enters becomings-nature. The first of the six canons formulated by Hsieh Ho (sixth century) asserted that the work of art must reveal 'the operation of the [breath/]spirit (*ch'i*) in life movement'.[26] In a painting without *ch'i*, the forms are, indeed, said to be lifeless. Wang Wei (699–759) held that, as with the *I-Ching* and its ever-moving lines, paintings, in their language of brush, form and symbol, should inscribe the ever-changing processes of nature. Shih T'ao (1641 – after 1710) further advocated the art of probing the 'unforeseeable mutations' of the landscape, while Pu Yen-t'u (eighteenth century) wrote about the necessity of integrating the infinite in the finite, the invisible in the visible, for 'all elements of nature which appear finite are in reality linked to the infinite'.[27] A multitude of examples could be cited here of other traditional Asian painters whose practices, rather than seeking resemblance with nature's outward appearance (*hsing*), involve the movement of its becomingness.

Of no less relevance in the leap from tradition to postmodernity, and from East to West, are the works of contemporary theorists like Gilles Deleuze and Felix Guattari. The latter may be said to have come very close to 'Oriental mysticism' and to have been particularly stimulated by the so-called inscrutable Asian aesthetic experience of 'union with nature', when they expand on the rhizome as 'all manner of "becomings"'. On binary logic and the one-becomes-two law that dominates western classical thought, Deleuze and Guattari remark: 'Nature doesn't work that way; in nature, roots are taproots with a more multiple, lateral, and circular system of ramification, rather than a dichotomous one'. To the

western model of the tree-root and its centralized, hierarchical arborescent systems, they oppose the eastern model of the rhizome, which cannot be reduced either to the One or to the multiple derived from the One, and 'is composed not of units but of . . . *directions in motions*'.[28]

A becoming is not a resemblance, an imitation, an identification or an evolution by descent. It creates nothing other than itself since its order is never that of filiation but of alliance. Thus, becoming always involves at least a double movement, for what one becomes also becomes: 'The painter and musician do not imitate the animal, they become-animal at the same time as the animal becomes what they willed, at the deepest level of their concord with Nature'.[29] Deleuze and Guattari further designate the rhizome as being made of plateaus and located 'in the middle, between things, interbeing, *intermezzo*': having no culmination or termination points, its movement is that of coming and going, rather than of starting and finishing. The middle is 'by no means an average. . . . *Between* things does not designate a localizable relation going from one thing to the other and back again, but . . . a stream without beginning or end that undermines its banks and picks up speed in the middle'.[30]

Here, one is easily reminded of the concept of the Middle Ground or the Median Way in Chinese theories of art and knowledge. Middleness in this context does not refer to a static center, nor does it imply any compromise or lack of determination. A median position, on the contrary, is where extremes lose their power; where all directions are (still) possible; and hence, where one can assume with intensity one's freedom of movement. As such, it is a place of decentralization that gives in to neither side, takes into its realm the vibrations of both, requiring thereby constant acknowledgement of and transformation in shifting conditions. Middleness (*Chung*) is usually paired with (what has been translated as) Harmony (*Ho*). Here again, harmony does not connote uniformity: it is 'a multitude and diversity of notes and motions. . . . Harmony is not only compatible with differences but without them there can be no harmony'.[31] Difference is thus paired with harmony, rather than with conflict. (Difference has too often been pointed to as the cause and the source of conflict, whereas difference may be said to exist without, within and alongside conflict.) A harmony-difference-middleness. To return to Deleuze's and Guattari's terms, what is designated in this space between the extremes is not a localizable relation or a mere shuttling between two recognizable points, but 'a perpendicular direction, a transversal movement that sweeps one *and* the other way'.[32]

TWILIGHT GREY, MIDDLE GREY

It is known that the western notion of *nature morte* in art does not really exist in the traditional conception of painting in the Far East. Indeed, it

matters little whether a flower, a fruit or a whole landscape is drawn, for even when a single bamboo is materialized, what is depicted and seen by the beholder is a grove of bamboos in its density, or further still, nature itself in its vastness.[33] To seize the *ch'i* (life breath/spirit) which animates the bamboo and to let it draw its own inner form on paper or on silk is to actualize a whole landscape in its motions, multiplicities and alliances. Awareness of the becoming space between being and non-being and of the principle of expression through non-expression prevails in the aesthetic and spiritual consciousness of the East. As R.G.H. Siu noted, 'The Indian Samkara maintains that in observing things we not only perceive our perceptions but something which is neither ourselves nor our perceptions'.[34]

In classic Japanese literature, nature is often equated with colour. To go toward nature is to encounter colour. Nature's infinitely varied colours can intoxicate one's aesthetic sense. Widely referred to as a place of spiritual repose, it offers the contemplative onlooker a beauty both to be dazzled by and to meditate upon – in other words, a beauty that inevitably goes on changing with the moments of the day and the seasons of the year, whether it is cherished in its sumptuous tones or in its subdued shades. The ancient word for 'colour', *iro*, is thus said to evoke 'the idea of time passing, of change with its multifold meanings. ... In its nuance of "beautiful" hues *iro* instantly suggests beauty that fades or feelings that are inconstant'. It came to mean 'woman, prostitute, or lover as the [passing] object of [man's] desire'.[35] Nature, colour(s), woman, sex. Nature, spirit, shade(s), repose. Conjuring up a familiar image of nature, these two sets of combined realities do not really stand in opposition to one another; they are simply two of the possible and existing multiplicities woven here by a thread that links the process of 'reviving' to that of 'killing' colour/nature.

Nature: the feminine, the sexual, but also the supernatural, the spiritual. The Rest. A poem (by Teika Fugiwara, 1162–1241) constantly quoted by the tea-men as their motto reads:

> All around, no flowers in bloom are seen,
> Nor blazing maple leaves I see,
> Only a solitary fisherman's hut I see,
> On the sea beach, in the twilight of this autumn eve.[36]

A beauty that fades; a feeling that wavers between nostalgia and unqualifiable lucidity (*not seen/I see*); a reaching out in unforeseen directions toward outer circles named 'past', 'future', or 'unspecified present'; or else, a situating at the boundary of natural and supernatural thought, apparent and real in-existences. The end-of-the-world image offered above is again that of a twilight moment – a becoming–no-thing moment – in which the play on the visible and the invisible creates a sense of intense ephemeral reality approaching spiritual absoluteness. The supernatural is

always right around the corner. It is the all-too-tangible presence of an absence within the natural. Faithful to the tradition of Far-Eastern aesthetic, the poem offers a perception of nature *in the course of change*. It depicts the interstate of being and non-being via the presence and absence of color/nature. What is explicitly pointed to in the verses as a lack or a deficiency is actually what allows the monochrome landscape to reach its 'supreme beauty'. Brilliant colors are thus positively presenced in the negative (*no, nor*), via a chromatic restraint. They are brought to the reader's vision only to lead the latter to the colourless colour of the fisherman's hut standing by itself on the sea beach in the twilight grey of the autumn evening.

The teamen's poem is an example of 'artistic asceticism', 'chromatic reticence' and 'remarkable natural inclination ... toward the subdual or suppression of color' that Toshihiko Izutsu considers to be revealing of 'one of the most fundamental aspects of Far Eastern culture'.[37] Such an 'aesthetic consciousness' does not result from a lack of appreciation for colour; on the contrary, it has grown out of a context of highly refined sensibility for colour and for the infinite subtleties of its hues. For example, the writings of court women that constituted the prose of the Heian period (794–1185) mentioned the names of more than one hundred and seventy different colours, all to be elaborately combined into colour harmonies (such as in the art of clothing and costuming). Differentiated from this period of aristocratic aesthetic refinement that is said to verge on 'effeminacy' is the Momoyama period (1573–1615), permeated with 'virile vitality', a period during which the Japanese taste for dazzlingly brilliant colours and exuberant decorations reached its second peak. Yet, alongside the world of refined and vivid colours of these periods also existed the totally different world of black-and-white painting, or rather, of vaporous-grey and spared-ink painting attributed to the impact of Zen Buddhism (which thrived during the Kamakura period [1192–1333] and produced masterpieces of monochrome painting during the Muromachi period [1392–1573]). Thus, the taste for the extravagant display of colour during the Momoyama Period went hand in hand with the distaste for colourful show – an aesthetic chromatic reticence that linked the pictorial art to the art of tea, via the teaching of Tea-Master Sen no Rikyu, also known as Soeki (1521–1591). [38]

Among the instructions Soeki gave to practitioners of the art of tea was that of wearing 'cotton kimono dyed with ash to a neutral hue'. As is well known, the master's advocation of simplicity and restraint achieved a widespread following, and with the art of tea gaining ground, the colour grey grew so popular among the people that Japan came to be culturally associated with the 'ash-dyed neutral hue', the 'rat colour', or twilight colour of Rikyu grey. A wide range of shades of grey obtained through the matting and subduing of colours dominated Japanese aesthetic sensibility from the

Genroku era (1688–1704) to the Tenmei era (1781–89) and beyond. The contemporary architect and theorist Kisho Kurokawa, for example, does not hesitate to refer to all of Japanese culture as to 'a culture of greys' when he proceeds to define its spatial character and open-ended aesthetic. Seeing in Rikyu grey a colourless colour of numerous hues that collide, neutralize and hence cancel each other out, Kurokawa further claims it as his personal label for the multiple meanings and simultaneous possibilities of things. He writes:

> Rikyu grey works to transform volumetric, sculptural, physical space into planar, pictorial space. The streets of Tokyo, and indeed of all traditional Japanese towns in general, take on a special beauty in the greying light of dusk. There is a fusing of perspectives as the slate-colored tiles and white plaster walls dissolve into grey, flattening all sense of distance and volume; a drama of transition from three-dimensions down to two which is not often seen in Western cities.[39]

Such a sense of two-dimensionality is said to lie at the heart of all creative manifestations of traditional Japanese culture, whether in painting, theatre, music, architecture or city design. Kurokawa further calls 'grey space', the intervening area between inside and outside and a realm where both the interior and the exterior merge. He describes as the 'grey zone in time' the concept of *senuhima* or 'undone interval' of pause, which was developed by Zeami Motokiyo (1364?–1443) to designate the moment of suspended action and of 'no mind' in the art of Noh drama. Among the many other terms that speak of the temporal, physical or spiritual 'grey' quality of Japanese culture, he also mentions the word *ne* which is used for musical sounds created both by man and in nature. 'It stands,' he remarks, 'midway between sound and music – representing the grey space between these two realms. Again the concept of *ne* embodies the Japanese inclination to recognize, live with and preserve continuity with nature'.[40]

THE FADED CHARM OF THE WOLF

A drama of transition. A beauty that fades. The lures of decline, of passing things and of the past. Nature is never static, and *music is ecology*. In colour genetics, grey is said to be at the centre of humans' sphere of colours. A human is thus grey in the midst of the chromatic world. But plain grey as defined earlier in Japanese aesthetics is not so much the result of a mixing of equal parts of black and white as it is 'the colour of no colour' in which all colours are canceling each other out. The new hue is a distinct colour of its own, neither black nor white, but somewhere in between – *in the middle* where possibilities are boundless. *Intermezzo.* A midway-between-colour, grey is composed of multiplicities, or to borrow

Deleuze and Guattari's terms, of 'directions in motions'. As Kurokawa specifies, 'in contrast to grey in the West, which is a combination of white and black, Rikyu grey was a combination of four opposing colors: red, blue, yellow and white'.[41]

Rikyu grey is a manner of becoming. A becoming-no/colour. The temporal, physical and mental interval between two phenomena takes on here a compelling visual (pictorial, painterly, non-realist-two-dimensional), musical and spiritual dimension. Without this dimension, grey remains largely (in Japanese as well as in many western contexts) a dull colour within culture's boundaries: one that usually implies a lack of brightness; an unfinished state; a dreary and spiritless outlook (the grey prospects, the grey office routine); a negative intermediate condition or position (that evades for example the spirit of moral and legal control without being overtly immoral and illegal); sadness, melancholia, boredom, unpleasantness (grey weather, *faire grise mine*); and last but not least, the polluting of the natural world by ecologically destructive technology (in which modern Japan partakes as one of the most powerful producers). *Much less sensual substance and beauty, more speed.* Developing a relationship to nature mediated through machines made to dominate nature paradoxically means nuturing a nostalgia for nature not yet tamed for humans' utilitarian purposes. *Nature, colour, woman, sex.*

The ecofeminist critique of the natural and social sciences has shown that fulfilment of this modernized desire for wilderness is often satisfied by adventure tourism and sex tourism (such as in Thailand, Kenya, the Dominican Republic). American, European and Japanese businessmen travel around the globe to have sexual experience with, if not to acquire, an exotic 'passing beauty' – a temporary and 'inconstant' object of desire – that resides in or comes from the remote parts of the under- or non-industrialized world. The further from the (men's) mind and the closer to nature the object of desire acquired abroad is, the more likely it is to provide compensation for these men's alienation from nature in their culture. It is as if the sexual act has become virtually the only direct contact to nature available to the man of modern technology; 'a sexual act which becomes itself entangled in the net of consumption and economic exploitation, or which becomes the sacred refuge, outside ordinary life'.[42]

A becoming-exploitation, a becoming-refuge. The sexual and the spiritual both have their share in nature. *Between the extremes is a perpendicular direction, a transversal movement that sweeps one* and *the other way.* Between the countries of light and of night is the country of semi-darkness whose inhabitants travel in the diurnal *and* nocturnal meanings of things, passing from one incarnation to another, turning into. . . . In Christian symbolics, grey designates the *resurrection of the dead.* Artists in the Middle Ages painted Christ's coat grey – the colour of ash and of fog – when he presided at the Last Judgement. Here, to cover oneself

with ashes is to express intense pain, for ash-grey is the colour of half-mourning. Evoking dreams that appear in greyish fog is also to situate them in the layers of the unconscious, in the process of emerging into consciousness (doesn't the French expression *se griser*, or to be half drunk, resort to grey as a colour of semi-consciousness?). One can say that the fog is a transcultural symbol of that which is indeterminate ('the grey area'); it indicates a phase of (r)evolution, between form and formlessness, when old forms are disappearing while new ones coming into view are not yet distinguishable. In Far Eastern paintings, for example, horizontal and vertical fogs constitute a disturbance in the unfolding of the narrative, a transition in time, a passage to the supernatural, a transitory period between two states of things and a prelude to manifestation.[43]

The delicate, diffused, ephemeral and transitory lights of dawn and dusk have always been the lights most sought after in colour photography. It is, indeed, during the 'magic hours' of sunrise and sunset that photographers fully capture the muted hues and subtleties of tone that appear with the gradual deepening and fading of colours. Just as poets are attracted to changeability and to the recurring act of becoming, photographers are drawn to the swift transformations effected with the shifting early morning and evening lights. Fascinated by the frail sunlight that penetrates the morning mist, John Hedgecoe for example remarks: 'Minute by minute, a world composed entirely of tones of grey is tinted until colors intensify and glow even in the angular shadows'.[44] He further notes that the dimmer light of dusk is best for photography of wildlife, for not only saturated colours are achievable in late light, but nocturnal animals begin to emerge in search for food. ... *Dissolve into grey, flattening all sense of distance and volume.* Dusk is also the spatio-temporal image of the suspended instant, 'a drama of transition' in which maintaining definition over the whole of the subject is quasi impossible, for the low light demands a wide aperture which means a shallow depth of field. *Every time the sun capsizes, he begins to suffer anew.* Twilight: the hours of melancholia, loss and nostalgia; but also of preparation for a renewal, when the sun sets in the west, the moon rises in the east, and the ending passes into the beginning. The journey to the west is, no doubt, the journey toward the future, through dark transformations.

Needless to say, the hope for and the fear of the end of the world, the powerful and peaceful experience of twilight as the coming and going of colour, the waning and waxing of desire, or the ability to open wide into the abyss of the world of shadows, constitute a site where East and West both depart and meet – literally, literarily. One of the most striking passages in *Un Captif amoureux* is, for example, the passage in which Jean Genet related his erotic and political relationship with Palestinian soldiers while casting what he saw as the *flamboyance* of their struggle and physical appeal in the *grey* tones of twilight:

the expression *entre chien et loup* (literally, between dog and wolf, that is dusk, when the two can't be distinguished from each another) suggests a lot of other things besides the time of the day. The colour grey, for instance, and the hour when night approaches as inexorably as sleep, whether daily or eternal. The hour when street lamps are lit in the city. . . . The hour in which – and it's a space rather than a time – every being becomes his own shadow, and thus something other than himself. The hour of metamorphoses, when people half hope, half fear that a dog will become a wolf. The hour that comes down to us from at least as far back as the Middles Ages, when country people believed that transformation might happen at any moment.[45]

Genet's description of dusk uncanningly reminds one of the previously quoted conversation between the African man of tradition and the French man of modernity in Cheikh Hamidou Kane's *Ambiguous Adventure*. Similar terms are used to depict the 'inconstant feeling' (half hope, half fear; becoming-shadow; the peacefulness of sleep and the anxiety of transfomation) that arises when the sun capsizes. For contemporary westerners and city-dwellers, Genet specified: the expression *entre chien et loup* 'has a certain faded charm, because . . . we don't know much about wolves now, and no one believes any more that a dog might turn into one'. But for Genet himself, in the Middle East, rather than connoting twilight, the expression 'describes any, perhaps all, of the moments of a fedayee's life'.[46]

In today's need to return to nature and to theorize it anew, one can say that the rejection of all that is romantic and nostalgic strives with a strong attraction to all that is declining and ending, and their strange ecstasies. The 'adventure' is an 'ambiguous' (one whose effortless radiance is at once sweet and strong, hopeful in its hopelessness. It is by listening to the evening, to the fading sounds of this moment of multiplicities, transformations and metamorphoses that one's ears open up to the sight of two worlds wavering across the sky. Such a sight has its own becoming-sound story; one which Kubelka, moved to tears and in ecstasy, calls a one-day sound sync event; and one also in which nature's *r* is here read specifically as a middle ground and . . . *a musical swoon*. For between sound and sense, if rhythm isn't, then writing/nature isn't either. One never stops listening to the tone, timbre and rhythm of words. And when nature is heard as nonsense, (its) music will sound through, unhampered. Again, nature will be heard.

NOTES

Thanks to Jasbir Puar for her research assistance. All translations from the French are mine, unless otherwise indicated.

1 Quoted from memory.
2 Jean Baudrillard, 'The anorexic ruins', in *Looking Back on the End of the*

World, D. Kamper and C. Wulf (eds), trans. D. Antal, New York: Semiotext(e), 1989, 45.

3 Simone de Beauvoir, *The Second Sex*, trans. H.M. Parshley, New York: Bantam, 1952 669.

4 Baudrillard, op. cit.

5 Cheikh Hamidou Kane, *Ambiguous Adventure*, trans. K. Woods, New York: Walker & Company, 1963 75–80.

6 Boubou Hama, *Le Double d'hier rencontre demain*, Paris: Union Générale d'Edition, 1973 29.

7 Peter Kubelka, 'The theory of metrical film', in *The Avant-Garde Film*, P. A. Sitney (ed.), New York: New York University Press, 1978, 158.

8 Jean-Joseph Rabearivelo: 'Le vitrier nègre', in A. Gérard (ed.) *Etudes de littérature africaine francophone*, Dakar: Les Nouvelles Editions africaines, 1977: 83.

9 Cheikh Hamidou Kane, op. cit., p.48.

10 A. Hampate Ba, *Kaydara*, Dakar: Nouvelles Editions Africaines, 1978, 10.

11 M.R. James, as quoted in Edward Wagenknecht, *Seven Masters of Supernatural Fiction*, New York: Greenwood Press, 1991, 51.

12 Anthony Vidler, *The Architectural Uncanny*, Cambridge, MA: MIT Press, 1992, 17.

13 Claude Lévi-Strauss, *Structural Anthropology*, II., trans. M. Layton, New York: Basic Books, 1976, 320.

14 M. R. James, op. cit., p.71.

15 Boubou Hama, op. cit., p.409.

16 A. Hampate Ba, op. cit., p.83.

17 Boubou Hama, op. cit., p.203

18 John Cage, *Pour les oiseaux*, Paris: Pierre Belfond, 1976, 231.

19 Ananda K. Coomaraswamy, *The Transformation of Nature in Art*, New York: Dover, 1934, 11.

20 Ibid.: 128, 129 (my italics).

21 R.G.H. Siu, *The Tao of Science*, Cambridge, MA: MIT Press, 1957, 78.

22 Ibid., 76.

23 In François Cheng, *Souffle-esprit*, Paris: Editions du Seuil, 1989, 33–4.

24 Ibid.: 56.

25 Ibid.: 114–15.

26 Quoted in Coomaraswamy, op. cit., p.15.

27 François Cheng, *Souffle-esprit*: 30: 46–7.

28 Gilles Deleuze and Felix Guattari, *A Thousand Plateaus*, trans. B. Massumi, Minneapolis: University of Minnesota Press, 1987, 25 (my italics).

29 Ibid.: 305.

30 Ibid.: 25.

31 Siu, op. cit., p.127.

32 Gilles Deleuze and Flelix Guattari, op. cit., p.25.

33 See Toshihiko Izutsu, 'The elimination of colour in Far Eastern art and philosophy', in *Color Symbolism*, Dallas, Texas: Spring Publications, 1977, 185–9.

34 Siu, op. cit., p.71.

35 Ooka Makoto, *The Colors of Poetry: Essays in Classic Japanese Verse*, trans. Takato U. Lento and Thomas. V. Lento, Michigan: Katydid Books, 1991, 37, 39.

36 Quoted in Izutsu: 176.

37 Ibid.: 168-9.

38 Information largely given in Izutsu, op. cit., pp.170–4.

39 Kisho Kurokawa, *Rediscovering Japanese Space*, New York: Weatherhill, 1988, 405. Previous information on Rikyu grey is largely taken from Kurokawa:

53–70. See also Kurokawa's *Intercultural Architecture: The Philosophy of Symbiosis*, Washington, DC: American Institute of Architects Press, 1991.

40 Kisho Kurokawa, op. cit., 1988, p.58.

41 Kisho Kurokawa, op. cit., 1991, p.70.

42 Roger Garaudy quoted in Maria Mies and Vandana Shiva, *Ecofeminism*, London: Zed Books, 1993, 137.

43 Information gathered in J. Chevalier and A. Gheerbrant, *Dictionnaire des symboles,* Paris: Editions R. Laffont & Editions Jupiter, 1969.

44 John Hedgecoe, *The Art of Color Photography*, New York: Simon & Schuster, 1978, 126.

45 Jean Genet, *Prisoner of Love*, trans. B. Bray, Hanover, New Hampton: Wesleyan University Press, 1992, 220.

46 Ibid.: 221.

Part II

Human nature

Chapter 7

The biological gaze

Evelyn Fox Keller

The film version of *The Race to the Double Helix* shows Rosalind Franklin gazing down, admiring the evidence of her latest experiment, and murmuring beatifically, 'I just want to look, I don't want to touch'. This is a twist on the association of vision with distance and aggression, and touching with erotic engagement that is so familiar to feminist scholars. Franklin reverses these. Yet, by appealing to a different association, most familiar to scientists, she is saved the feminine-subject position. In scientific discourse, looking is associated with innocence, with the desire to understand, while touching implies intervention, manipulation, and control.

But what in fact does it mean to look without touching? Doesn't looking always imply some effect, some impact? Even looking at the stars touches something – if not the stars, then surely us. Looking always touches us, at least metaphorically. But I am more interested in the ways in which looking touches the object, the material entity we seem to be looking at. Thus I will not talk about star-gazing, about telescopes and the technologies of looking at large and distant objects that we cannot even hope to touch, but rather about the forms of looking scientists have developed to peer at, and into, the very small. Also, I am less concerned here with the gaze as metaphoric rape than as itself a form of literal, material transgression. Or, if not itself transgressive, as preparatory to the act of transgressing (or penetrating) – much in the sense in which Freud described the function of looking as '*preparatory* to the normal sexual aim' (1962: 23).

Especially, I am interested in the technologies developed in biology for peering into the secrets of life, into the fundamental processes of generation – a domain in which we can and do aspire (indeed may have always aspired) to intervene. In short, I take this occasion as a chance to meditate on the particular character of the biological gaze, once, but no longer, possible to think of as the natural counterpart of star-gazing.

As Scott Gilbert (1994) reminds us, the tradition of invoking the heavenly gaze as a metaphor for the study of embryology extends back to ancient times, and continues into the twentieth century. In 1939, for example, the American embryologist E. E. Just writes:

The egg cell also is a universe. ... The lone watcher of the sky who in some distant tower saw a new planet floating before his lens could not have been more entralled than the first student who saw the spermatozoon preceded by a streaming bubble moving toward the egg-centre. And as every novitiate in astronomy must thrill at his first glance into the world of the stars, so does the student today who first beholds this microcosm, the egg-cell.

<div align="right">(Just 1939: 369)</div>

It would seem that these scientists, like Franklin, also just wanted to look, not to touch. But I suggest that star-gazing has always been a somewhat disingenuous metaphor for biology; certainly, it has no place in the biology of today.

This essay, then, is a meditation; an attempt to explore – tentatively and even a bit quixotically – the history of the biological gaze, focusing in particular on the different ways in which that gaze has become increasingly and seemingly inevitably enmeshed in actual touching, in taking the object into hand, in trespassing on and transforming the very thing we look at.

Let us return to Rosalind Franklin. Rosalind Franklin is a scientist of the grand tradition of innocent inquiry. She is a pure scientist. Like Barbara McClintock, she has no interest whatsoever in the use value of the objects she studies. She is not after control, only understanding. But what exactly is she looking at as she utters this seraphic line?

Despite the crucial (and somewhat infamous) role the photograph (Figure 7.1) turned out to play in Watson and Crick's race to the double helix, in leading them to their discovery of the secret of life, it is not, in fact, an image of a cell or of any other living object. It is an X-ray photograph of a crystalline structure composed from cell extracts – that is, from extensive preparations and purifications (or, manipulations) of the homogenized contents of a vast number of cells. No living object could possibly survive these preparations. Indeed, no living object could even survive the process of imaging. To obtain this image, one needs to bombard the object at issue with a barrage of X-rays that would quickly destroy the vital functions of any living thing. X-ray crystallography is thus too transgressive to enable us to see an animate entity in its living state.

But perhaps this is a bad example. If X-rays are too powerful – and too intrusive – for an innocent gaze, perhaps we should be considering ordinary light rays, the more conventional vehicle for a non-intrusive looking. Indeed, I am prompted by the spirit of Rosalind Franklin's remark to turn back in time as well, to the Edenic days before the study of vital phenomena became an experimental science. To a time when natural historians pursued their investigations by simply observing with the naked eye (or perhaps with a magnifying glass) the wonders around them. Surely, if there ever was a non-intrusive, non-transgressive, biology,

Figure 7.1 An X-ray photograph of DNA in the B form, taken by Rosalind Franklin late in 1952

Source: Watson 1968: 116

that was it. Innocence may be too much to claim, for we know that even the unaided eye does not see innocently. Observation always requires experience, skill, at least some kind of theory or organized expectation – but presumably, not yet intervention. Or is this wrong? Does not the naturalist in fact have to cut or otherwise uproot his or her specimens from the field, and preserve them for future study in the cabinet or museum? And are not his or her excursions into the field forays that alter that field, often mapping it for future, more massive incursions? So, even natural history intrudes – not actually by the act of looking, but in all the peripheral activities contiguous with that act. Perhaps therefore we should better say that the methods of natural history were relatively non-interventionist, certainly less intrusive of the organism *per se* than the work of early anatomists, or, in our own time, of Rosalind Franklin's crystallograph. But then we must also note that natural history was at the same time relatively ineffective for seeing into the secrets of life. The naked eye, with the relatively gentle ways of touching that went with the scientific study of biological form, left the mysteries of vital phenomena unexplored. Above all, it left the mysteries of embryogenesis – of reproduction and development – intact.

There was of course the microscope, one of the great developments of the seventeenth century. Long before biologists came to agree about the need for an experimental science, an instrument had appeared that

Figure 7.2 'Biological research', from Compte de Buffon, *Histoire naturelle* (1749–1804), II (1750), 1

Source: Wellcome Institute Library, London

promised to do for the living form what the telescope was already doing for cosmic form, namely that would vastly enhance the power of the naked eye to peer at, and even into, the secrets of life. But even from the start, there was a crucial difference. The preparation of an object required for microscopic examination was necessarily more intrusive than that required by the naturalist. Before looking at an animate being, it was necessary to first cut and fix it, in a word, to de-animate it. As a tool for probing the inner processes of life, the microscope thus had obvious limitations. The gaze itself may have been innocent enough, requiring only the eye and not the hand, but immediately antecedent to the work of looking lay the work of the cutting. Consider, for example, the classic image of early microscopy from Buffon's *Natural History* (Figure 7.2). Note here the spatial distance here between the acts of touching and seeing – to be sure, closer than that for the natural historian – both acts are in the same frame, but still kept clearly apart. The hands of the microscopist are at his side.

 And there were also other, yet more serious, problems with the new microscope. Along with its promise to make at least the once animate subvisible visible, it raised new problems for the very meaning of 'seeing'. What does it mean to see through a microscope? What in fact *can* one see? For most of us, even with a modern-day microscope, the answer is precious little – apart, that is, from one's own eyeball. Only with a great deal of practice, fiddling with the focusing knob, does one learn to see

Figure 7.3 Nicolaas Hartsoeker: woodcut illustration of spermatozoon, from his *Essay de dioptrique*, Paris: J. Anisson (1649)
Source: Wellcome Institute Library, London

anything at all through a microscope. And once one does, the question arises, is it a real thing one sees? Is it an object on the slide, or a spot on the lens? And if on the slide, is it a shadow or a ridge? Robert Hooke, founding member of the Royal Society and often regarded as the founder of modern microscopy, himself admitted how 'exceedingly difficult' it often is to distinguish between the real properties of an object and the artifacts of microscopic viewing. Such distinctions were left to the solitary microscopist to make, and to painstakingly transcribe his impressions into a freely hand-drawn sketch. And the public at large – the community of virtual witnesses – saw, of course, only prints from the engraving that ensued.

Not surprisingly, these engravings evoked tremendous curiosity. But perhaps more so among the general public than among working scientists, whose interest in the new instruments, while initially quite strong, had already subsided by the end of the seventeenth century. While useful for creating the impression of evidence, the evidence produced by the early microscope proved to be extraordinarily unstable. In Bachelard's view, it 'was an instrument for dreamers, an instrument whose optical shortcomings produced more artefacts' than facts (quoted in Luthy 1994: 2) Often as not, they made visible the invisible rather than the subvisible (Figure 7.3).

The problem for scientists was obviously a serious one. Of course they understood that the images they drew were also artefacts, or, as we now might say, constructions. But then as now, their job as scientists was to ensure that these artefacts corresponded, in some sense at least, to the real. To quote Elaine Scarry, they needed not only to 'make up' but also to 'make real' (Scarry 1994). How was one to do this? How could one be certain that the image one saw was not an illusion? Indeed, how do we know that looking through a microscope actually gives rise to seeing at all?

Today, this problem – the question, are microscopic objects real? – has long ceased to trouble scientists, but it does continue to trouble

philosophers. We believe in the reality of the things we see with the naked eye, philosophers argue, because we can walk up to them and touch them. And with things of microscopic size, we cannot do that. Perhaps then they are merely theoretical entities, not real at all. Gustav Bergman, for example, wrote that:

> microscopic objects are not physical things in a literal sense, but merely by courtesy of language and a pictorial imagination. ... When I look through a microscope, all I see is a patch of color which creeps through the field like a shadow over a wall.

> (quoted in Hacking 1983: 187–8).

Indeed, to this day, some philosophers of science claim that we do not actually *see* anything at all through a microscope. Of course, practicing scientists merely laugh at such quibbles – maybe philosophers can't see through a microscope, but they have no problem at all.

The reason that this problem troubles only philosophers and no longer scientists is simple. Philosophers do not understand the nature of the activity of modern microscopic observation. The fact is that scientists *have* found a way to walk up to the object and touch it; no longer do they peer through the microscope with their hands behind their backs. This, in fact, was the great contribution the rise of an experimental ethos brought to nineteenth century biology: the desire – and increasingly, the skill – to reach in and touch the object under the microscope, and to thereby 'make it real'. In other words, once the microscope was joined with the manual manipulations of an experimental biology – marking, cutting and dissecting *under* the scope – and the interdependency of hand and eye previously reserved for the naked eye was extended into the microscopic realm, the microscope became a reliable tool for veridical knowledge. By the close of the nineteenth century, hand and eye had begun to converge. In turn, and because of this rapprochement, the microscope provided an incalculable boon to the further advancement of experimental biology – perhaps especially, to experimental embryology.

At first with relatively crude instruments – perhaps a glass rod drawn very finely, or a hair from a baby's head – and later, in the twentieth century, with the carefully machined microtomes and micromanipulators – researchers could not only represent but actually intervene in the choreography of the minute primal stages of life. They could isolate the fertilized egg, watch it divide, gently mark one of the cells with a dab of dye and follow it as it continued to divide and ultimately became incorporated into the larger whole as a particular body part, or they could carefully separate the cells after the first or second division to see if the two halves of the young embryo could independently form whole bodies (Figure 7.4).

Still later, after the arrival of micromanipulators, researchers learned to get inside the cell – much as their predecessors had got inside the

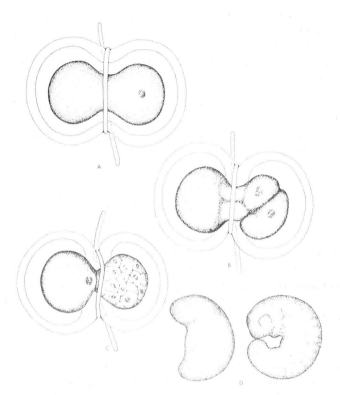

Figure 7.4 Summary of Hans Spemann's constriction experiment on newt eggs
Source: B.M. Carlson (1981) *Patten's Foundations of Embryology*, McGraw-Hill (from Spemann 1938)

organism – and manipulate the microstructure of the cell itself. By the 1950s and 1960s, for example, they learned how to exchange nuclei – or parts of the cytoplasm – between cells. Ian Hacking is one of the few philosophers of science to understand the indispensable role the hand has come to play in modern biological microscopy. He writes:

> you learn to see through a microscope by doing, not just by looking. ... The conviction that a particular part of a cell is there as imaged is, to say the least, reinforced when, using straightforward physical means, you microinject a fluid into just that part of the cell. We see the tiny glass needle – a tool that we have ourselves hand crafted under the microscope – jerk through the cell wall. We see the lipid oozing out of the end of the needle as we gently turn the micrometer screw on a large, thoroughly macroscopic, plunger.
>
> (Hacking 1983: 189–90)

So, now we know that the cell *is* real. And not only real, but also alive. Indeed, after the great microscopical investigations of Schwann and Schleiden, the cell – a word Robert had earlier used to describe the cavities he observed in dead cork – came to be thought of as the atomic unit of vitality, displacing the organism from its prior position as the most basic unit of life. As François Jacob has aptly written, 'For the eye armed with a microscope, every living organism was finally resolved into a collection of juxtaposed units' (Jacob, 1976: 117).

But there is a lot more going on here than simply 'making real' through touching. Already, even in Jacob's statement, we can read another agenda in the experimental attitude – an agenda we might describe as 'making real' through causal efficacy, or, making things real by using them to effect change in other things that we *know* are real. Here, by this reasoning, we know something is really real not simply by touching it, but, after touching it, by grasping it and hurling it at something else. (As Hacking says of electrons, 'if I can spray them, they're real' [see Hacking 1983].) In this context, Jacob's choice of words is revealing, for an arm is indeed more than a hand. An 'eye armed with a microscope' is an eye equipped not merely with fingers but with arms, that is, with the potential for projectile force.

For a microscope to acquire this potential for projectile force, it must be employed not simply to describe, but to search out and identify the units which presumably will, in the right hands, maximize causal efficacy. Thus, for the experimental biologist, the function of the microscope is not simply to enhance looking, or even to validate the tangibility of that which we are gazing at, but to employ that gaze as a probe in anticipation of action. A unit is fundamental if, and only if, it is a unit to which one can attribute primary cause. Once identified as the locus of primary cause, it becomes the fulcrum through or with which one may hope to leverage maximal effect. This is the meaning in Jacob's remark of the word 'resolved', implying, as it is does, a resolution of the organism into the 'fundamental units' of life, entities which can hopefully be harnessed to bring about effective change – that is, can serve as agents of control.

Indeed the major arguments for experimental biology given in the nineteenth century were explicit on this point. Without experiment, it was argued, one could never find the underlying causes of a phenomenon, and without cause, one could not hope to effect change. One of the most articulate advocates for an experimental biology, Claude Bernard, had this to say in regard the need for an experimental approach to medicine:

> [M]en have actually maintained that life is indivisible and that we should limit ourselves to observing the phenomena presented to us as a whole by living organisms. . . . But if we admit that we must so limit ourselves, and if we posit as a principle that medicine is only a passive

science of observation, then physicians should no more touch the human body than astronomers touch the planets. ... Medicine so conceived can lead only to prognosis and to hygienic prescriptions of doubtful utility; it is the negation of active medicine, i.e., of real and scientific therapeutics.

(Bernard 1947: 19)

It was through experiment that we found the real, underlying causes of natural phenomena, in living bodies as well as in inorganic bodies, and hence the means to alter – to induce a change in – the course of natural phenomena.

In the early part of the twentieth century, the great experimental embryologist, Hans Spemann, thought that he (together with his student, Hilde Mangold) had found the fundamental locus of causal agency for the developing embryo. He called it the 'organizer'. The 'organizer' was not a single cell, but a group of cells, found in the dorsal lip of the frog embryo, and deriving from a particular region of the fertilized egg. When excised from one frog embryo and inserted into another, in a different location, it induced the formation of a second developmental axis – initiating the growth of something like a Siamese twin (Figure 7.5). Here Spemann thought he had found the head (or 'führer', as he once called it) of the growing embryo – that which organized and commanded the growth of the subsidiary cells. He wrote:

The designation 'organizer' ... is supposed to express the idea that the effect emanating from these preferential regions is not only determinative in a definite restrictive direction, but that it possesses all those enigmatic peculiarities which are known to us only from living organisms.

(Spemann 1938: 182–3)

The discovery of the 'organizer' in 1924 marked the high point of what is now referred to as classical embryology; it provided the cornerstone of a research tradition that flourished and in fact dominated experimental embryology, at least until the late 1930s. By the 1940s, most biologists had lost interest in the organizer. Why? The usual answer given is that interest faded because it had been shown that any number of things – for example, a piece of dead tissue, even certain ordinary, off-the-shelf chemicals – could induce the formation of a second axis. This meant that the specific motive force was not in the organizer itself, but at least partially in the surrounding tissue. As Spemann himself wrote, 'A "dead organizer" is a contradiction in itself' (1938: 369).

Clearly, if biologists were to find the units which carried the motive force, or primary cause, behind embryonic development, that is, if they were to find the agents truly responsible for the secret of life, they would

Brief signals from a cascade of genes then split the fly embryo into ever smaller and more specialized regions. In this photograph the embryo is divided into large blocks by proteins from so-called gap genes—Krüppel (red) and hunchback (green), which is turned on by bicoid 2 1/2 hours after fertilization. The region where the two proteins overlap is yellow. The colors come from fluorescent dyes in antibodies that bind to these proteins.

About half an hour later, hairy, a "pair-rule" gene that is regulated by the gap genes, switches on and produces seven transient stripes. As Francis Crick, who shared a Nobel Prize for the discovery of the double helix structure of DNA, once remarked, "embryos are very fond of stripes." These stripes act like boundaries, dividing the embryo into seven segments.

Finally the engrailed gene, a "segment-polarity" gene, divides each of the previous units into anterior and posterior compartments. The fourteen narrow compartments shown here correspond to specific segments of the embryo. There are three head segments (H, top left), three thoracic segments (T, lower left), and eight abdominal segments (A, from bottom left to upper right).

Figure 7.5 Colour photograph, in 'A Report from the Howard Hughes Medical Institute', *From Egg to Adult*, 1992

have to look elsewhere. Some biologists thought they already knew where to look. H.J. Muller, for example, a classical geneticist from the laboratory of T.H. Morgan, was convinced that the right place to look was at the gene. To Muller, it was the gene, not the cell, and certainly not the organism, that was the biologist's atom. Analogizing the problem of mutation of the gene to that of transmutation of the elements, he argued, as early as 1916, that just as control of transmutation 'would render possible any achievement with inanimate things', so too would the control of mutation. It could 'place the process of evolution in our hands'. 'Mutation and transmutation' he wrote, are 'the two keystones of our rainbow bridges to power.' And just a few years later, in an essay entitled, 'The Gene as the Basis of Life', he rhapsodized:

The secret of [the gene] may perhaps be reached first by an upward thrust of pure physical chemistry, or perhaps by biologists reaching down with physico-chemical tools. . . .

We cannot leave forever inviolate in their recondite recesses those invisibly small yet fundamental particles, the genes, for from these genes, . . . there radiate continually those forces, far-reaching, orderly, but elusive, that make and unmake our living worlds.

(quoted in Keller 1992: 99–100)

The gene was elusive indeed. A great deal of progress had been made in mapping out the microscopic substructure of the cell – the microtome appeared in 1870, permitting the cutting of exceedingly fine slices of tissue; new stains appeared every few years. By Muller's time, one could see the nucleus, one could even see the chromosomes (colored bodies). One could not however *see* genes. And despite Muller's success with X-rays, one could certainly not (at least not yet) reach down into their 'recondite recesses' and grab hold of them. It is sometimes even argued as a virtue of genetics (relative to, for example, experimental embryology) that it is non-intrusive: It does not require cutting into the organism, manually manipulating its parts. Experiment, for geneticists, is rooted in the practice of genetic crosses – that is, controlled mating of organisms with particular properties – followed by close observation of the resulting progeny. Apart from the intrusion required in mutagenesis, what is manipulated is the environment in which the organism finds itself, not the organism *per se*. For Muller, as for all other classical geneticists, the existence of genes had to be inferred from the gross phenotypical properties they were presumed responsible for. Indeed, because of its abstractness, many wondered whether the gene is real at all; perhaps it was just a hypothetical construct.

Furthermore, not everyone was convinced, even in principle, of the possibility of ever achieving Muller's goal of complete control of living processes – of extending the eye or hand so far that one could actually lay claim on the secret of life. Against Muller, Niels Bohr argued that the science of animate matter is not, after all, just like that of inanimate matter. If we have learned anything from physics at all, it is of the impossibility, even in the physical domain, of looking without touching: the very light we shine disturbs the object at which we gaze. Intuiting here a principle of profound epistemological importance, perhaps even more so for biology than for physics, in 1932 Bohr suggested a generalization of his principle of complementarity for the biological sciences. He wrote:

The conditions in biological and physical research are not directly comparable, since the necessity of keeping the object of investigation alive imposes a restriction on the former which finds no counterpart in the latter. Thus, we should doubtless kill an animal if we tried to carry

the investigation of its organs so far that we could tell the part played by the single atoms in vital functions. In every experiment on living organisms there must remain some uncertainty . . . and the idea suggests itself that the minimal freedom we must allow the organism will be just large enough to permit it, so to say, to hide its ultimate secrets from us.

(Bohr 1932: 9)

But as we know, the story does not end here. The motive force of scientific inquiry was too strong, the desire to extend the biological gaze too great. And with the resounding success of atomic physics at the end of the Second World War, an entire generation of biologists (or physicists turned biologists) were ready to take up Muller's call, to prove Bohr wrong. Which they did.

In 1953, with the help of the X-ray crystallograph discussed above (Figure 7.1), Watson and Crick found the structure of DNA, and in that structure they saw the secret of life: a Rosetta Stone written in the alphabet of nucleic acid bases. This event was of immense importance to the history of biology, abruptly and dramatically transforming the pace, and also the course, of biological science. Even Bohr was obliged to recant, in a way. In his eminently cryptic fashion, he wrote: 'Life will always be a wonder, but what changes is the balance between the feeling of wonder and the courage to try to understand' (1962, p.26). Presumably, Watson and Crick had displayed a most remarkable courage. Of course, a DNA crystal is not itself a living thing, but the logic of its molecular structure left no doubt in most minds about its role in living cells. It provided an answer to at least one of what Spemann called 'the enigmatic peculiarities which are known to us only from living organisms': it revealed a mechanism for replication, a way in which like could be produced from like. Never mind that it told us virtually nothing about how genes might orchestrate the development of actual organisms, the differential specification of body parts, their formation, the design of their structure, their actual functioning. What we were now able to do, despite these shortcomings, was to give real content to the notion of 'gene action' – a notion that classical genetics, as if anticipating the dramatic successes of molecular biology, had earlier made so popular: DNA makes RNA, RNA makes protein, and proteins make us.

But what, you may ask, do the successes of either genetics or molecular biology have to do with the connection I have been trying to map between looking and touching? Muller's vision did not in fact depend on the possibility of literally seeing genes; and insofar as one might speak of a gaze specific to genetics, it has to be said that that gaze – at least as far as classical genetics went – no more intruded on the organism than did the gaze of the natural historian. Muller's vision depended on training the

mind's eye, not the visceral eye, on these entities so deeply esconced in innermost parts of the cell. Nor was any literal hand (certainly not any human hand) involved in the upward thrust, or downward reach, which he advocated; to make even the crudest contact with the gene, Muller had had to settle for an unfocused barrage of X-rays. Of course, other (more focused) techniques – both for looking and for touching – did soon become available.

The electron microscope produced one such technique. With this instrument, it *was* possible to see something one could call a gene, but even so, it was hardly a gene in action. Electron microscopes damage the object in view even more than do X-rays. If one were to see genes through an electron microscope, one would first need to isolate and freeze them. Like the DNA in Rosalind Franklin's X-ray crystallograph, they would have to be completely extracted from their cellular environment and inactivated – as if visibility and activity obeyed a kind of complementarity principle.

Indeed, one of the great strengths of molecular biology in its early days was its disavowal of the very term *life*, and its choice of a model system that resided midway between an inert molecule and a living organism, namely the bacteriophage, or virus. Viruses are little more than naked DNA; they cannot be seen through a light microscope, and, as already mentioned, by some standards they are not even alive, but they proved their worth as a simple tool for effecting genetic changes in their more conventionally living hosts. The hosts for bacteriophage were independently growing and reproducing bacteria. These more bona-fide organisms could, in turn, be cultivated and studied in the laboratory with astonishing ease, and with a complete lack of skill. Anyone could do it, even newcomers from physics or chemistry who had never studied biology. Generations of molecular biologists made their careers trafficking back and forth between bacteriophage and bacteria and the truly naked DNA they could extract from these rudimentary creatures.

During this period, however – for roughly two decades – some biologists (those who were more conventionally trained and more organismically minded) complained bitterly that the enthusiasm for molecular biology was excessive if not actually misguided; at the very least, its claims were overblown. The very essence of life as they knew it was its complexity. Surely, it was too simplistic to claim that single-celled bacteria, or even worse, bacteriophage, could speak to the wonders of the living forms we see around us, and even less to the miracle of our own vitality. Little did anyone in those days realize – not even molecular biologists themselves – that the virus, itself only a quasi-vital entity, was already being fashioned into a vehicle for extending both eye and hand into the deepest recesses of the cell. There is even a technical term for the virus that serves this function: it is called a *vector*.

The breakthrough came in the 1970s with the development of techniques for isolating a particular genetic fragment from one organism, and attaching this fragment to a viral or plasmid 'vector'. We can inject this mixture into the cell nucleus of another organism with a micropipette, and the viral 'vector' will do the rest of our work, inserting the fragment directly into the host genome. Such techniques led not only to the production of transgenic organisms; they also enabled the introduction of specific probes which could visually 'report' on the activity of particular genes. For example, the gene for *luciferinase* could be isolated from the firefly, attached to a gene normally found in the host, and, by way of the viral or plasmid vector, the composite construct could be incorporated into its normal position in the host genome. Now, whenever the host gene is activated, the firefly gene will also be activated, and its location in the cell will literally 'light up'. Here, a visual signalling device, able to reveal a level (and kind) of detail which the microscope never could achieve, has been introduced into the interior of the cell nucleus. In much the same way, other combinations of genes can be also be constructed, introducing different visual markers; alternatively, tagged constructs can be introduced to bind to specific pieces of messenger RNA, which, once bound, can be 'lit up' by the addition of appropriate antibodies. Or, antibodies can be used directly to target the proteins themselves. By such techniques, it has become possible visually to identify and to track – *in situ* – many of the particular RNA or protein molecules required to activate or deactivate (turn on or off) those genes involved in the developmental process. (Figure 13 shows the early developmental stages of the *Drosophila* embryo, as they can now be seen with the aid of new techniques of gene marking.) Needless to say, such techniques have revolutionized the study of embryology. They have made it possible – in ways that would have been utterly unimaginable to the great embryologists of even the recent past – directly to observe the generation of life, as it were, *in flagrante delicto*.

What does this say about looking and touching? To recapitulate: Once, it might have been possible to think of the eye as a purely passive instrument for the study of pristine nature, entirely separate from any intrusive act of touching, but, 'armed with the microscope', the interdependence of hand and eye grew ever more intricate. Here, in the most current life sciences, is a technology which merges looking and touching into an undifferentiable and unified act. What we see in these slides are the fingerprints left by the genes or gene fragments which, with the aid of viral vectors acting as prosthetic fingers, we have manually inserted into the cell's nucleus. Thus, what we see as we gaze at the secret of life is life already, and necessarily, transformed by the very technology of our gaze. And conversely, and simultaneously, that gaze provides the means of further transformation. Muller was right – by 'reaching down with physico-chemical tools'... into the 'recondite recesses of those ... small

yet fundamental particles' we do secure a handle on the 'forces ... that make and unmake our living worlds.' But Bohr was also right: there is a principle of complementarity operating here. The 'secret of life' to which we have so ingeniously gained access is no pristine point of origin, but already a construct at least partially of our own making.

REFERENCES

Bernard, C. (1947) *Introduction to the Study of Experimental Medicine*, New York: Schuman.

Bohr, N. (1932) 'Light and life', reprinted in *The Philosophical Writings of Niels Bohr*, II, Woodbridge, Conn.: Ox Bow Press, 1987: 3–12.

—— (1962) 'Light and life revisited', reprinted in *The Philosophical Writings of Niels Bohr*, III, Woodbridge, Conn.: Ox Bow Press, 1987: 23–9.

Buffon, G.L.L., Comte de, (1750) *Histoire naturelle,* II, Paris: Imprimeric Royale.

Freud, S. (1962) 'The Sexual Aberrations', in *Three Essays on the Theory of Sexuality*, New York: Basic Books: 23.

Gilbert, S. (1994) 'Looking at embryos: the visual and conceptual aesthetics of emerging form', presented at Boston University, 1994.

Hacking, I. (1983) *Representing and Intervening*, Cambridge: Cambridge University Press.

Jacob, F. (1976) *The Logic of Life*, New York: Vantage Books.

Just, E.E. (1939) *Biology of the Cell Surface*, Philadelphia: Garland, 1988.

Keller, E.F. (1992) *Secrets of Life, Secrets of Death*, New York: Routledge.

Luthy, C.H. (1994) 'The expected and the observed: microscopy and the establishment of the corpuscularian philosophy', presented at the History of Science Society Conference, 15 October, 1994.

Scarry, E. (1992) 'The made-up and made-real', *Yale Journal of Criticism* 5 (2): 239–49.

Spemann, Hans (1938) *Embryonic Development and Induction*, New York: Hafner Press.

Watson, J.D. (1968) *The Double Helix*, New York: Atheneum Press.

A natural order of things?

Reproductive sciences and the politics of othering

Nelly Oudshoorn

> However natural categories are, we need to search whether and by
> what means they find their existence as natural categories.
>
> (Coupland 1988: 14)

Once upon a time life was rather simple, at least for philosophers of
science. Since the Enlightenment it was generally assumed that 'a progres-
sive growth of scientific knowledge will uncover the natural order of
things' (Smart 1992). In this modernist philosophy the interfaces between
science and nature were straightforward: scientists simply discovered the
truth of nature, whereas nature was perceived as timeless and universal,
as something 'out there'. Science was granted the elite status of providing
objective knowledge about nature. Since Kuhn, life has become more
complicated. Philosophers and sociologists of science gradually rejected
the notion that there exists an unmediated truth of nature that can be
discovered by science. Instead, they introduced the idea that the natural-
istic reality of phenomena as such does not exist, but is created by
scientists as the object of scientific investigation (Duden 1991: 22).[1]
This implies a totally different perspective on what scientists are doing:
scientists are actively constructing reality, rather than discovering
reality. This challenging idea created a problem for scholars interested
in the interfaces between science and nature. How can we deal with
natural facts if we abandon the idea that science reveals the truth about
nature?

One powerful way to go beyond this traditional image of science is to
set ourselves the task of exposing the concrete, often very mundane,
human activities that go into discourse-building in order to explore the
processes through which scientific claims achieve the status of universal,
natural facts. Such stories may reveal that scientific facts do not suddenly
leap into existence as the result of observations by clever scientists, who
simply read the book of nature. The myth of scientific heroes discovering
the secrets of nature needs to be replaced by another image of science,
one which enables us to study how scientific facts are deeply embedded

in society and culture, not just in the sense that scientific facts shape society, but even to the extent that a scientific fact may only exist by virtue of its social embeddedness. In this epistemological view, knowledge claims acquire the status of universal facts by virtue of the extent to which they become interwoven with the institutional settings and practices of scientists and their audiences. This social constructivist portrait of the interfaces between science and nature provides us with a model to explore the multiple ways in which scientists create knowledge with the status of universal and timeless truth.

As a feminist scholar, I am particularly interested in the question of how scientists have constructed 'woman' as a natural category. Twentieth-century biomedical sciences have transformed our world into a culture in which the female body has become increasingly understood in medical terms. Feminists have tended to explain the medicalization of the female body in terms of a male conspiracy, whereas biomedical scientists have encouraged us to assume that women's bodies are simply closer to nature and consequently easier to incorporate into biomedical practice. This chapter is concerned with finding an alternative explanation for the idea that the emphasis on the female body in the biomedical sciences simply reflects male bias or a natural order of things. Drawing from my book on the archaeology of the hormonal body, the chapter discusses two problematic consequences of naturalizing phenomena: the creation of subject–object dichotomies and the development of universal technologies (Oudshoorn 1994a). It concludes by reflecting on my hopes for the future, not the future of nature but the future of what we have constructed as the major embodiments of nature: the biomedical sciences.

PROCESSES OF OTHERING

The very act of classifying phenomena as natural is not without consequences. Natural phenomena are accorded the ambivalent status of objects of scientific inquiry: only those phenomena identified as natural will be included in the research agenda of natural scientists. This is clearly exemplified by the history of the biomedical sciences. In the late nineteenth and early twentieth centuries the view that sex and reproduction are 'more fundamental to Woman's than Man's Nature' (Moscucci 1990) resulted in the creation of a new specialty in the biomedical sciences: gynaecology. In her fascinating account of the rise of the 'Science of Woman', Moscucci has described how 'the belief that the female body is finalised for reproduction defined the study of "natural woman" as a separate branch of medicine'. With the emergence of gynaecology women became identified as 'a special group of patients' (Moscucci 1990: 2). This period witnessed the founding of societies, journals and hospitals specifically devoted to the diagnosis and treatment of the female body.

'Woman' thus became reified in the discursive and institutional practices of the biomedical sciences.

Consequently, 'Woman' became conceptualized as an ontologically distinct category which firmly established the view of Woman as the Other. This meant a definitive rejection of what Thomas Laqueur has characterized as the 'one-sex-model', a medical practice in which the female body was understood as a lesser version of the male body, rather than a different sex (Laqueur 1990: viii, 4). The most striking feature of these discursive and institutional processes of othering is the establishment of gendered subject – object relations in which men possess the subject position and women are considered as objects of scientific inquiry. This institutional process of othering was continued and reinforced by the rise of sex endocrinology, a discipline devoted to the study of sex hormones that emerged in the 1920s and 1930s. In *Beyond the Natural Body* I have described how the theory of sex hormones, initially symmetrical with respect to the sexes, increasingly focused on the female body (Oudshoorn 1994a).

In the pre-Kuhnian tradition, philosophers of science would have explained this emphasis on the female body as a reflection of the natural order of things. The social constructivist turn in science and technology studies enables us to go beyond the view that what we perceive as natural is simply dictated by nature. The epistemological view that phenomena assume the appearance of natural categories by virtue of the activities of scientists enables us to explore what exactly is required to transform a scientific concept into a natural phenomenon. I suggest that an answer to this question can be found in one of the distinctive features of science and technology: its striving for universal, decontextualized knowledge. Scientific concepts attain the status of natural facts in a twofold process. First, scientists create the contexts in which their knowledge claims are accepted as scientific facts and in which their technologies can work. Scientists adopt what I would call a '(re)contextualization strategy' in which their knowledge claims can gain momentum. Second, scientists then conceal the contexts from which scientific facts and artefacts arise, in a process which I will refer to as a 'decontextualization strategy'.[2] One of the reasons why science succeeds in convincing us that it reveals the truth about nature is that the social contexts in which knowledge claims are transformed into scientific facts and artefacts are made invisible. Science makes us believe that its knowledge claims are not dependent on any social context. During the development of science and technology the established links with the worlds outside the laboratory are naturalized. 'There was, or so it seems, never any possibility that it could have been otherwise' (Akrich 1992: 222).

Let us first look more closely at how scientists have tried to create contexts in which their knowledge claims about sex hormones could be transformed into natural facts. The history of sex endocrinology shows

both successes and failures, which can best be understood in terms of the notion of networks of knowledge. In this perspective, knowledge:

> never extends beyond and outside practices. It is always precisely as local or universal as the network in which it exists. The boundaries of the network of practices define, so to say, the boundaries of the universality of medical knowledge.
>
> (Pasveer 1992: 174)

The successes and failures in scientists' striving for universal knowledge are thus related to the extent to which they are successful in creating networks. Bruno Latour's metaphor of the railroads exemplifies this point:

> When people say that knowledge is 'universally true', we must understand that it is like railroads, which are found everywhere in the world but only to a limited extent. To shift to claiming that locomotives can move beyond their narrow and expensive rails is another matter. Yet magicians try to dazzle us with 'universal laws' which they claim to be valid even in the gaps between the networks.
>
> (Latour 1988: 226)

In terms of this network perspective, the concept of sex hormones was a strong concept because of its pronounced connotations for sex and the body. Female sex hormones could be linked with 'female diseases' and related medical institutions, and male sex hormones to 'male diseases' and related medical professions. The concept of sex hormones simultaneously summarized and simplified the interests of specific groups. At this point, however, there existed vast differences between knowledge claims about female sex hormones and male sex hormones: the networks that evolved around statements about female sex hormones were much more extensive and substantial than the networks around male sex hormones. What is important here is that some networks are easier to create than others. Negotiations to establish networks take place in 'a highly prestructured reality in which earlier choices delineate the space of further choices' (Berg 1992: 2). In the case of female sex hormones, laboratory scientists and pharmaceutical companies did not have to start from scratch. They could rely on an already organized medical practice that could easily be transformed into an organized market for their products. The gynaecological clinic functioned as a powerful institutional context that provided an available and established clientele with a broad range of diseases that could be treated with hormones.

Knowledge claims about male sex hormones were more difficult to link with relevant groups outside the laboratory. The production as well as the marketing of male sex hormones was rather constrained by the lack of an institutional context comparable with the gynaecological clinic: men's clinics specializing in the study of the male reproductive system did not

exist in the 1920s. Although there existed a potential audience for the promotion of male sex hormones, this audience was not embedded in any organized market or resource network. It was this asymmetry in organizational structure that made the female body into the central focus of the hormonal enterprise. Sex endocrinologists depended on these organizational structures to provide them with the necessary tools and materials. These differences in institutionalization between the female and the male body constituted a crucial factor in shaping the extent to which knowledge claims could be made into universal facts. The institutionalization of practices concerning the female body in a medical speciality transforms the female body into an easily accessible supplier of research materials, a convenient guinea pig for tests, and an organized audience for the products of science. These established practices facilitated a situation in which the hormonally-constructed female body concept acquired its status as a universal, natural phenomenon.

THE QUEST FOR UNIVERSAL TECHNOLOGIES

As indicated above, the transformation of scientific concepts into natural phenomena requires a second activity: the concealment of contexts. However, scientists are not always successful in decontextualizing knowledge claims. There exists a basic tension between scientists' striving for universal, decontextualized knowledge and the notion that science is shaped in its local contexts,[3] and this tension has important practical consequences particularly with respect to the development of (medical) technologies. The decontextualization strategy suggests that technologies can be made to work everywhere, but this is not always so. Scientific artefacts require a specific context in which they can work, one similar to the context from which they arose. If this context is not available, scientists have to create it. Or to use Latour's railroad metaphor again: scientists first have to construct the railroads before the locomotives can move in the envisioned directions. The problem is that for (medical) technologies the railroads are chiefly constructed in the western industrialized world. Most technologies are made in industrialized countries and therefore bear the fingerprints of western producers, including locally and culturally specific ideas about how the ideal technology should look. Every technology contains, so to say, a configured user.[4] Consequently, technologies cannot simply be transported elsewhere.

The case of the contraceptive pill illustrates the complications that emerge when western technologies are introduced into developing countries. Although pill researchers claimed that the pill was a universal, context-independent contraceptive, it nevertheless implied a specific user: a woman disciplined enough to take medication regularly, who is used to gynaecological examinations and regular visits to the physician, and who

does not have to hide contraception from her partner. It goes without saying that this portrait of the ideal pill-user is highly culturally specific (with variation even within one culture). This user is more likely to be found in western industrialized countries with well-developed health care systems. From this perspective it can be understood that the pill has not found universal acceptance. The main acceptance of the pill has been among middle- and upper-class women in the western industrialized world, with one major exception: China. Most women in southern countries have adopted sterilization and intrauterine devices as means of contraception (Seaman and Seaman 1978: 76).

Actually, the user-specificity of the envisioned universal contraceptive pill was already manifest during its clinical testing in Puerto Rico. The early trials experienced a high percentage of dropouts. In *Beyond the Natural Body* I have described how disciplining women to the conditions of the tests was not always successful. Many women did not participate in the gynaecological examinations or simply quit the programme because they preferred other contraceptive methods, particularly sterilization. The Puerto Rican trials provided the pill researchers with information indicating that the pill did not meet with universal acceptance. These test conditions were, of course, a much heavier burden than the conditions of using the pill after it had been approved by the US Food and Drug Administration. Two conditions remained, however, the same: frequent visits to a physician (the pill was only available on prescription) and regular gynaecological examinations (women using the pill had to undergo regular gynaecological examinations, including blood-pressure tests and vaginal smears to check for adverse health effects).[5]

The making of the pill into a successful contraceptive technology thus required a specific context, one in which:

1 there exists an easy accessible, well-developed health care infrastructure;
2 people are accustomed to taking prescription drugs (many developing countries mainly use 'over the counter' drugs, which people can buy in shops);
3 women are accustomed to regular medical controls;
4 women and men are free to negotiate the use of contraceptives.

The pill could only be made into a universal contraceptive if its producers put great effort into mobilizing and disciplining people and institutions to meet the specific requirements of the new technology. Needless to say, many of the required transformations were beyond the power of the inventors of the pill.

The quest for universal contraceptives can be considered as an ultimate consequence of the processes of naturalization and othering. Classifying woman as a natural category, as the other, directs the attention to similarities rather than differences among women. Consequently, scientists

assumed that in designing medical technologies they would not have to consider the diversity of users. The sad conclusion therefore is that, although new contraceptive technologies such as the pill are often tested in southern countries, the local needs of their potential users are rarely taken into account. During the tests the technologies are more or less sucessful because scientists make the contexts fit the demands of the testing, for example, by enrolling trained medical staff and by selecting trial partici- pants who may be made into ideal test subjects but who are not necessar- ily representative of the whole population. It is by creating such controlled settings that scientists are able to make the technology work. These con- trolled settings, however, no longer exist when the trials are over and the technologies are put on the market.

This situation often leads to health risks among the users of the new technologies. Since the 1980s, feminist health organizations seeking safe and reliable contraceptives have reported women's complaints about serious side effects from using contraceptives such as implants and injecta- bles, particularly in developing countries (Anonymous 1985; Ward 1986; Mintzes 1992). Many of these adverse health effects seem to be related to insufficient medical follow-up. These contraceptive technologies all require a health care infrastructure that can provide medical controls for their administration and removal.[6] In many southern countries, such an infrastructure simply does not exist, particularly in rural areas. To avoid potential health risks, women's health advocates campaign for the devel- opment of contraceptives that require less dependency and interaction with health-care providers. They prefer the so-called user-controlled tech- nologies and stress that users' views should be taken into account in assessing acceptibility (Pollock 1984; Bruce 1987).[7]

The case of the pill exemplifies the point that scientific artefacts are not in themselves universal and context-independent. They have to be made into universal technologies by a whole variety of different activities. The introduction of contraceptive technologies shows that science is not always successful in its quest for universal, context-independent knowledge.

TOWARDS SITUATED TECHNOLOGIES

This conclusion about the limitations of the universality of science and technology is in line with the postmodern feminist perspective that acknowledges the differences among women's experiences in different cultural and social settings. Donna Haraway has introduced the notion of 'situated knowledges' to argue for 'politics and epistemologies of location, positioning, and situating, where partiality and not universality is the condition of being heard to make rational knowledge claims' (Haraway 1989: 589). Haraway's plea for situated knowledges also bears relevance for (contraceptive) technologies.

For the future in the biomedical sciences, I would like to see more chal-
lenges to the processes of othering and universalization. On the one hand,
the future seems favourable. The more recent history of the reproductive
sciences shows a growing awareness of the problematic sides of devel-
oping universal technologies. In the late 1970s we saw the emergence of
a different type of discourse which acknowledges the diversity of users
of contraceptive technologies. Reproductive scientists gradually seem to
acknowledge the need to design contraceptive technologies to fit people,
rather than modifying people to fit technologies.

This drastic shift in the reproductive paradigm coincided with broader
cultural changes in the late 1970s. The declining belief in grand theories
and ideologies to understand and control the world led to a situation in
which locality and individuality became a central concern in western
culture. The notion of differences became an important theme. The crisis
in modernity eroded the belief in one technological fix to improve the
human condition (Smart 1992). Reproductive scientists readily adopted
the postmodern acknowledgement of differences, not least because it
enabled them to expand their research programmes. They used the voiced
need for a wider variety of contraceptive methods to negotiate an increase
in financial support for fundamental research in the reproductive sciences.
To industry, the recognition of diversity among users indicated a variety
of new markets.[8] Or to quote Adele Clarke's felicitous phrase: 'in post-
modernity, capital has fallen in love with difference' (Clarke 1995: 10).
Most remarkably, the acknowledgement of diversity broadened biomed-
ical research to include a new group: men. The late 1970s witnessed the
establishment of a medical speciality devoted to the study of male repro-
ductive functions: andrology (Niemi 1987). Although andrology is still a
cinderella profession compared to its bigger sister gynaecology, the male
body has thus finally been put on the reproductive agenda.[9] Issues such
as male infertility and the development of male oral contraceptives are
gradually included in research programmes and clinical practices. These
developments give grounds for hope, because they mean a challenge to
the practices of othering that have dominated the reproductive sciences
since the nineteenth century. The shift in the reproductive paradigm
towards acknowledging differences among users has thus resulted in
eroding the gendered subject – object relations in which men tradition-
ally possessed the subject position and women were the target. For the
first time in the history of the reproductive sciences, male scientists are
testing contraceptive compounds on their own sex, and I am still enough
of a feminist to find pleasure in this.[10] The reverse has also happened:
women have increasingly adopted the subject position. Since the 1980s
women are represented in substantial numbers in decision-making bodies
dealing with contraception, and the number of women scientists has
increased as well (Djerassi 1989).[11]

However, the politics of othering are still very much alive. Although the acknowledgement of diversity has challenged the gendered subject–object relations in the reproductive sciences, it has reinforced the othering of people of color. Recent reproductive discourses show how the focus on woman as the sex responsible for reproduction has been replaced with a focus on a specific category of women and men, most notably people in developing countries (Hartmann 1987). In the present political climate in which population control in southern countries is deemed a precondition for the solution of environmental problems, this politics of othering will remain at the heart of the biomedical sciences.

NOTES

1 See, for example, Latour and Woolgar (1979), Gilbert and Mulkay (1984), Bijker *et al.* (1987), Latour (1987) and Bijker and Law (1992).
2 I draw here specifically on the conceptual work of social constructivist studies of science and technology. See, for instance, Latour (1987), Pinch and Bijker (1987). The terms 'recontextualization' and 'decontextualization' are used, amongst others, by Knorr-Cetina 1981a and 1981b.
3 The theme of local versus universal knowledge has been addressed by, among others, Star (1989)
4 The concept of the configured user has been introduced by Woolgar (1991).
5 Such regular medical examinations of pill-users were normal medical practice in all countries in which the pill was introduced until the mid-1980s.
6 Contraceptive injectables (like Depo Provera) have an efficacy period of at least three months, and consequently have to be repeated at least every three months. Most of its users live in developing countries (Hardon 1992: 12). Contraceptive implants (like Norplant) are long-acting methods (five years) which must be inserted under the skin of a woman's upper arm and removed by a health-care worker. The introduction of this contraceptive method in developing countries is highly controversial (Mintzes 1992).
7 This emphasis on user-controlled contraceptive technologies is not unproblematic. From this perspective, feminist health activists tend to reject injectable or subdermal techniques, although these same techniques are favored by women in Indonesia, for example. This preference is apparently related to the fact that these methods can more easily be kept hidden from partners, who do not agree with their decision to practice birth control (Hardon and Claudio-Estrada 1991: 12).
8 The role of industry in the development of new contraceptives remained, however, very restricted due to a number of constraints that I have described elsewhere (Oudshoorn 1994b).
9 Although the need for the establishment of a separate and distinct speciality for the study of the male reproductive system was suggested as early as 1891, not until the late 1960s was andrology institutionalized as a medical specialty. The first andrological journal (*Andrologie*) was founded in 1969. The first andrological society is either the *Nordic Association for Andrology* or the *American Association of Andrology*, both of which were established in 1973: see Niemi (1987). Clinics focused on male reproductive functions are at present still very rare. Andrology is usually still part of urology departments.
10 With one exception: one of the first clinical trials that Pincus performed to

investigate the contraceptive activity of hormones included eight men, all patients from a mental institution. Despite the fact that the hormone preparations had a definite contraceptive effect in these male patients, men were not included in later trials due to the occurrence of side-effects (Oudshoorn 1994a).

11 For a more extended analysis of the shift in the reproductive paradigm towards acknowledging differences among users, see Oudshoorn 1994c.

REFERENCES

Akrich, M. (1992) 'The de-scription of technological objects', in W.E. Bijker and L. Law (eds) *Shaping Technology – Building Society,* Cambridge, Mass.: MIT Press.

Anonymous (1985) *The Depo-Provera Debate: A Report by the National Women's Health Network*, Washington, DC: National Women's Health Network.

Berg, M. (1992) 'The construction of medical disposals: medical sociology and medical problem solving in clinical practice', *Sociology of Health and Illness* 14: 151–80.

Bijker, W.E. and Law, J. (1992) *Shaping Technology – Building Society*, Cambridge, Mass.: MIT Press.

Bijker, W.E., Hughes, T.P. and Pinch, T.J. (1987) *The Social Construction of Technological Systems*, Cambridge, Mass.: MIT Press.

Clarke, A. (1995) 'Modernity, postmodernity and reproductive processes, c. 1890–1990 or, "Mommy, where do cyborgs come from anyway?" ', in C.H. Gray, J. Figueroa-Sarriera and S. Mentor (eds), *The Cyborg Handbook,* New York: Routledge.

Coupland, N. (ed.) (1988) *Styles of Discourse*, London: Croom Helm.

Djerassi, C. (1989) 'The Bitter Pill', *Science* 245: 356–61.

Duden, B. (1991) *The Woman Beneath the Skin: A Doctor's Patients in Eighteenth-century Germany*, Cambridge, Mass. and London: Harvard University Press.

Gilbert, G.N. and Mulkay, M. (1984) *Opening Pandora's Box: A Sociological Analysis of Scientific Discourse*, Cambridge: Cambridge University Press.

Haraway, D. (1989) 'Situated knowledges: the science question in feminism and the privilege of partial perspective', *Feminist Studies* 14 (3): 575–99.

Hardon, A. (1992) 'Development of contraceptives: general concerns', in B. Mintzes (ed.) *A Question of Control: Women's Perspectives on the Development and Use of Contraceptive Technologies*, Report of an International Conference held in Woudschoten, The Netherlands, April 1991. Amsterdam: WEMOS Women and Pharmaceuticals Project and Health Action International.

Hardon, A. and Claudio-Estrada, S. (1991) 'Contraceptive technologies, family planning services, and reproductive rights', *VENA Journal* 3: 10–15.

Hartmann, B. (1987) *Reproductive Rights and Wrongs: The Global Politics of Population Control and Contraceptive Choice*, New York: Harper & Row.

Knorr-Cetina, K.D. (1981a) *The Manufacture of Knowledge: An Essay on the Constructivist and Contextual Nature of Science*, Oxford: Pergamon Press.

—— (1981b) 'The micro-sociological challenge of macro-sociology: towards a reconstruction of social theory and methodology', in K. Knorr-Cenina and A.V. Cicourel (eds) *Advances in Social Theory and Methodology: Toward an Integration of Micro and Macro-Sociologies*, Boston: Routledge & Kegan Paul: 1–49.

Kuhn, T. (1970) *The Structure of Scientific Revolutions*, 2nd edn, Chicago: University of Chicago Press.

Laqueur, T. (1990) *Making Sex: Body and Gender from the Greeks to Freud*, Cambridge, Mass. and London: Harvard University Press.

Latour, B. (1987) *Science in Action: How to Follow Scientists and Engineers through Society*, Milton Keynes: Open University Press.

Latour, B. (1988) *The Pasteurization of France*, Cambridge, London: Harvard University Press.

Latour, B. and Woolgar, S. (1979) *Laboratory Life: The Social Construction of Scientific Facts*, Beverly Hills and London: Sage Publications.

Mintzes, B. (ed.) (1992) *A Question of Control: Women's Perspectives on the Development and Use of Contraceptive Technologies*, Report of an International Conference held in Woudschoten, The Netherlands, April 1991. Amsterdam: WEMOS Women and Pharmaceuticals Project and Health Action International.

Moscucci, O. (1990) *The Science of Woman. Gynaecology and Gender in England, 1800–1929*, Cambridge: Cambridge University Press.

Niemi, S. (1987) 'Andrology as a speciality: its origin', *Journal of Andrology* 8: 201–3.

Oudshoorn, N. (1994a) *Beyond the Natural Body: An Archeology of Sex Hormones,* London and New York: Routledge.

—— (1994b) 'The role of new organizations in Contraceptive R&D, or how to organize a world-wide laboratory', paper presented at the INSERM/CNRS workshop The Invisible Industrialist, or Manufactures and the Construction of Scientific Knowledge, Paris, 19–21 May 1994.

—— (1994c) 'The decline of the one-size-fits-all paradigm, or how reproductive scientists try to cope with postmodernity', paper presented at the conference Between Mother Goddesses, Monsters, and Cyborgs: Feminist Perspectives on Science, Technology and Health Care, Odense University, Denmark, 2–5 November 1994.

Pasveer, B. (1992) *Shadows of Knowledge: Making a Representing Practice in Medicine: X-ray Pictures and Pulmonary Tuberculosis, 1895–1930,* Amsterdam: PhD thesis, University of Amsterdam.

Pinch, T.J. and Bijker, W.E. (1987) 'The social construction of facts and artefacts or How the sociology of science and the sociology of technology might benefit each other', in W.E. Bijker, T.P. Hughes and T.J. Pinch (eds) *The Social Construction of Technological Systems: New Directions in the Sociology and History of Technology*, Cambridge, Mass.: MIT Press.

Seaman, B. and Seaman, G. (1978) *Women and the Crisis in Sex Hormones. An Investigation of the Dangerous Uses of Hormones: from Birth Control to Menopause and the Safe Alternatives,* Brighton, Sussex: Harvester.

Smart, B. (1992) *Modern Conditions, Postmodern Controversies*, London and New York: Routledge.

Star, S.L. (1989) *Regions of the Mind: Brain Research and the Quest for Scientific Certainty*, Stanford, California: Stanford University Press.

Ward, M.C. (1986) *Poor Women and Powerful Men. America's Great Experiment in Family Planning*, Boulder and London: Westview Press.

Woolgar, S. (1991) 'Configuring the user: the case of usability trials', in J. Law (ed.) *A Sociology of Monsters: Essays on Power, Technology and Domination*, London: Routledge.

Chapter 9

Genes 'R' Us

Tom Wilkie

WHERE DO BABIES COME FROM?

It is a hundred years hence. A family: Trevor and Tracy are the parents; they have a daughter, Sharon.

Tracy was facing the moment every parent finds difficult. Sharon had started asking The Question: Where did I come from, Mummy? As she patted her daughter's blonde hair (catalogue number: HC 205) and looked into her perfect cornflower-blue eyes (catalogue number: EC 317), Tracy decided that, in the year 2095, there was nothing to be squeamish about.

Sharon had heard disturbing rumours about how in the olden days, when a man and a woman wanted to have a baby, they went to bed with each other and left the outcome to passion and chance. Well, this was certainly not the way that Trevor and Tracy had set about bringing their daughter into the world. The very idea that any responsible parent could possibly permit a child to be born whose genes had been left to the chance shuffling of natural processes – it was quite obscene. No parent would allow a foetus to go through nine months of development without knowing the colour of its eyes, or whether it had straight hair or wavy. Good grief, no one would ever conceive a child without ensuring that it met the minimum genetically specified intelligence quotient.

No, Sharon had to understand that Trevor and Tracy had been thorough about her. They had gone to the Ideal Baby exhibition at Olympia and they had combed through months of back issues of *Genes and Babies* magazine. They had even window-shopped at the Swedish genetic superstore (and had gone carefully through its DNA Catalogue for novel ideas). In the end, though, they had gone along to their local Genebase supermarket to choose Sharon's genes. What more could loving parents do for their child? Although, she reflected, it might be better not to mention the fact that Trevor and Tracy had not been able to afford the most expensive high-intelligence genetic profile and had had to settle for a

cheaper model (catalogue number: IQ 200). Sharon would therefore always be less intelligent than Charlotte next door, whose grandparents had taken out a second mortgage to help purchase for her the genes guaranteeing ultra-high-intelligence (catalogue number: IQ 300). And because Charlotte's grandfather had been a geneticist, they had been able to get a trade discount.

Well, Sharon could learn about the realities of a market economy in due course, Tracy decided. Genes for eye colour and hair were comparatively cheap – even the popular choices of blue eyes and fair hair. But there had been such a heavy demand for IQ genes in recent years that the prices had risen sharply. Intelligence requires the operation of many genes together, so it was technically complicated and therefore expensive. Several newspapers were alleging that, in addition, some of the super-stores were hoarding IQ genes specifically to create shortages and drive up the price. Whatever the reason, ultra-high IQ genes were beyond the means of all but the wealthiest.

How had Sharon got hold of this idea that anyone's genetic make-up could possibly be left to chance? All children these days were put together according to their parents' specifications. And of course, Trevor and Tracy would have sent back any baby which, by some mischance, did not conform to their wishes. The right of return with full refund had been written into the recent Consumer Protection (Human DNA) Act, after a couple of controversial High Court cases in which the judges (such old men, and so completely out of touch with the modern world) had tried to rule that any human baby merited the law's protection whether it met the parents' specification or not. What nonsense, had the judges never heard of breach of contract?

In the year 2095, all children's computers came with a good Facts of Life program already loaded. These explain that the 'blueprint' for all living things, plants and animals alike, was contained in a substance called DNA. The set of instructions which tells a fertilized egg that it is to develop into a human being and not a chimpanzee is written out in chemical letters along the DNA. The genetic instructions written out along the double strand of DNA are incredibly precise and detailed. Everybody's DNA is different (apart from identical twins) and that is why everyone in the world is unique and different from everyone else (again apart from identical twins). Family resemblances arise, the program explained, because children inherit their DNA from their parents, transmitted in the egg and sperm. Or at least that was how matters had been before technology and civilization had transformed things, allowing parents to choose their child's genetic inheritance at will. That was why Sharon had fair hair, blue eyes and creamy-pink skin, whereas her mother and father both had brown eyes, black skin and hair.

PLUMBING

What would the computer have told Tracy and her daughter Sharon about the history of human reproduction and genetics? About how people and society had put scientific knowledge to use? It might have divided the issues up into three: plumbing, engineering and ethics.

In primitive times, the computer might say, people did not even control the timing of their babies, nor could they easily control the number of children they had. Adults had sex as a result of which children were sometimes conceived and sometimes not. Because of this unpredictability, children were regarded as the gift of God – parents had to accept whatever child they got and whenever they got it. The first step on the road to the decency of the twenty-first century and away from such superstition came in the 1960s, when the Pill first became available. For the first time in history, women were freed from the burden of biology and could choose when to have a baby.

The availability of a convenient, widely accessible means of contraception was literally liberating, according to the computer. The technology of contraception had all sorts of side-effects which its inventors (mostly men) had not foreseen. Instead of being confined to the home as nursery maids, women could have careers and enter the job market, competing against men for the same positions. By 1994, the British workforce contained almost as many women as men.

Before the Pill, most methods of contraception had been inefficient, cumbersome and not very easy to use. So men and women who wanted to have sex with each other frequently ran the risk of conceiving children. Sex was therefore largely confined to marriage, a social institution which provided for the bringing up of children. But with the Pill, sex and reproduction were separated. Since a woman could guarantee that no children would follow, she could have sex without marrying her partner. This outraged the moralists of the time. Bishops and politicians fulminated against the new technology of contraception and its encouragement of 'immorality'. So strong was the social pressure for respectability in the mid-1960s that unmarried women would slip a ring on to their 'wedding' finger to pretend that they were married before entering a family planning clinic for the Pill. However, after the late 1960s' summers of free love (made possible only by the contraceptive technology of the Pill) such constraints were forgotten. The moralists were right in predicting the decline of the institution of marriage. Surprisingly perhaps, this was not confined to the childless, even those couples who did have children increasingly decided not to bother with the formalities of either a state or religious marriage and so by 1995, more than one third of all babies born in Britain were born to unmarried parents.

Tracy's computer would tell her that the technology moved on very quickly. Within fifteen years of the technology that could stop people

having children came a way to conceive children in the test-tube for those who could not do so naturally. Louise Brown, the world's first test-tube baby, was born in Britain in 1978. The technique, known as '*in vitro* fertilization' (IVF) or assisted fertility, represented another way in which people were able to take control of their own biology. Most often the egg and sperm were from the prospective mother and father, but in some cases either the egg or the sperm came from other donors. Thus, IVF meant that a woman could carry in her womb a child to which she bore no genetic relationship.

IVF was controversial from the beginning. Part of the trouble was that the success rate was low. To try to increase the success rate by understanding better what was going on, doctors wanted to do research with some of the eggs which they had fertilized in the laboratory to see what mixture of chemicals was best for maturing and developing them. They felt that it would be wrong to try and implant eggs which had been experimented with in this way, because some of them might have been damaged in the process. But the idea was immediately condemned, especially by people who were opposed to the idea of abortion. Discarding fertilized humans eggs which were not destined for implantation seemed to them to be tantamount to abortion. Worse, if experiments were to be permitted on a human egg what would be the consequences for the status of a human being as something special and inviolable? For these reasons, and because of a deep-seated fear that the practices of assisted fertility were somehow profoundly unnatural, a vocal and passionate group of people proposed to ban such things altogether.

The new techniques highlighted one basic confusion: when does an individual human life begin? Almost everyone had taken for granted that the moment that a sperm penetrates the outer membrane of an egg was the moment that a genetically different potential human being had been created. But that is not quite enough. The package of DNA carried by the sperm has to get across the interior of the egg to the nucleus where it must combine with the egg's own DNA. The egg has no way of developing until this process is completed. Then, sometimes an egg splits to produce identical twins, so the moment of conception is not quite sufficient to pinpoint the instant that one individual comes into existence. Nor is the moment of fertilization the same moment a woman becomes pregnant. Eggs fertilized outside the body cannot survive unless they are implanted in the wall of her uterus and develop their own 'life-support' system, in the form of the amniotic sac, supplied with nutrients and oxygen via the umbilical cord. But research showed that even many natural conceptions failed to implant, usually because of some severe genetic abnormality in the fertilized egg. There already existed a natural process for selectively choosing more viable embryos.

The idea of manipulating human embryos in the laboratory was sufficiently sensitive that it took the British government more than a dozen

years after the birth of Louise Brown to pluck up the courage to pass legislation to regulate the technology. The Human Fertilization and Embryology Act finally came into force late in August 1991.

Like the Pill, assisted reproduction began to have repercussions which its developers had not really foreseen. It had been thought of as a fairly straightforward way of allowing previously infertile couples to have a baby, but assisted reproduction was seldom out of the headlines and controversy. In 1985, Britain's first commercial surrogate mother, Mrs Kim Cotton, was paid £6,500 to have an American couple's baby. (More lucrative than surrogacy however was meeting the public's insatiable and perhaps prurient desire to know about these things. The *Daily Star* newspaper paid her £15,000 for her exclusive story.) Baby Cotton was not conceived by *in vitro* fertilization, but by artificial insemination by donor: the egg was Mrs Cotton's but the sperm came from the American man, not her husband. Just hours after the child's birth, she handed the baby over and did not see it again. Commercial surrogacy was made illegal in Britain by the 1985 Surrogacy Arrangements Act.

In 1987, a South African woman became the world's first simultaneous mother and grandmother. Her daughter was unable to have children naturally so her mother had the daughter's fertilized eggs implanted in her womb and eventually gave birth to triplets to whom she was genetically a grandmother. In July 1992, a sixty-one year-old Italian woman became one of the oldest women in the world ever to give birth. Liliana Cantadori acknowledged that she had told doctors that she was only forty-seven because had she told them her real age they would have refused to treat her. (In fact, Mrs Cantadori was not the world's oldest mother; the eldest is believed to be an anonymous Sicilian woman who had a baby at the age of sixty-two.) The technology had been employed to make fertile once more a woman who was past the age of the menopause and who was thus, in traditional biological terms, past child-bearing age. Italian doctors generated more controversy when in 1993 they implanted a fertilized egg donated by a white woman into the womb of a black woman. Technology had thus been employed to alter one of the most firmly established of all inherited traits: that a child should resemble its parents. Now prospective parents could choose the skin colour and racial grouping of their offspring.

In 1994, yet another bit of biological determinism fell to the liberation army of reproductive technology. A young British couple, Neil and Gillian Clark announced that they had given birth to a child (a girl) whose sex they had selected in advance of conception.

ENGINEERING

For all the controversy that IVF and the other techniques of assisted reproduction have generated, they are really little more than attempts at

gynaecological plumbing. The majority of couples who were helped by IVF were those where the woman's fallopian tubes had somehow got blocked, preventing the egg and the sperm from meeting in the traditional manner. IVF simply arranged for that meeting to take place in the laboratory dish: *in vitro* rather than *in vivo*. While newspaper columnists fulminate against the immorality of the gynaecological plumbers, something far more profound is going on in other laboratories, almost unnoticed. Not plumbing this time but engineering: genetic engineering. Scientists are learning to read the set of instructions written in DNA, to understand the genetic program written in the chemistry of DNA, and having once read it, they have begun to rewrite it.

On 14 September 1990, a complete breakthrough: the first successful attempt to treat disease by transplanting human genes into the body of a patient. The recipient of the first successful gene therapy among humans was a four-year-old girl who suffered from an inborn defect of her immune system which had left her defenceless against infection – a virus which would cause no more than a sniffle to a normal person might prove fatal to her. Doctors at the US National Institutes of Health near Washington, DC inserted copies of the 'correct' gene into the girl's white blood cells and then transfused these back into her bloodstream. Within weeks, the girl was going dancing and taking skating lessons, without fear of infection. Other trials followed. Some of them, for cancer for example, were not so successful. Others tried to deal with more intractable diseases such as cystic fibrosis and only partially alleviated the condition.

The attempts at gene therapy are high-profile events. But an immense international scientific project is going on in the background. At a cost of more than $3 billion scientists in the major developed countries are sifting through all of human DNA to try to identify every single one of the genes contained in humanity's inherited blueprint. This compendium of all the genes is known as the human genome. Imaginatively enough, the scientists have called their programme of research the Human Genome Project. Ultimately, every letter of the chemical alphabet which is used to spell out the inherited instructions to make a human being will be read out and loaded into computer databases. The idea is not only to identify each and every gene but also to try to work out exactly what the gene does. Thus, the scientists want to find, for example, the gene for eye colour and then work out how the one which produces blue eyes differs from the one for brown eyes.

In its early years, the Human Genome Project has not surprisingly concentrated on those genes which were most associated with inherited disease. Vaccination, together with the discovery of penicillin and the other antibiotics, has made many infectious diseases a thing of the past in the developed world. A side-effect of this great triumph is that the burden of genetic disease began to weigh heavily on the health services

of the developed countries: by the mid-1990s genetic and congenital disorders accounted for half of all childhood deaths in Britain. By 1994, the genetic defects responsible for such diseases as cystic fibrosis, muscular dystrophy, Huntington's chorea, and a form of inherited breast and ovarian cancer had all been identified. Some researchers were even then predicting that genes relating to intelligence would soon be identified and the way opened to choosing the IQ of one's baby.

Let us fast-forward again to the year 2095. Trevor has just returned from work.

Tracy looked up to see Trevor returning from work. She felt, as always, that flush of pleasure and joy that he was still alive. In that unpleasant incident at work involving the plutonium and the cobalt-60 source of gamma-rays, Trevor's spleen, liver and kidneys had been totally destroyed. But the two of them were so fortunate that they had taken out extra health insurance to cover genetic engineering of a pig to provide organs suitable for transplant which would not be rejected by Trevor's immune system. That technology derived from the early 1990s, when researchers started inserting human genes into pigs so that the pigs' organs could be used in transplants into humans. Such grafting from one species into another had been completely impossible because the immune system, designed to recognize 'foreign' invaders (which were usually disease-causing microbes) would destroy the grafted tissue rapidly. By 1995, however, researchers had succeeded in breeding pigs with just enough human genes so that their organs would not be massively and rapidly rejected. Just as the techniques of IVF had made fuzzy the point at which human life started, so the genetic engineers were blurring the distinction between what was human and what was not.

With the experience of Trevor's industrial accident, he and Tracy had made sure that, when Sharon was born, they had invested in breeding a line of customized pigs containing copies of Sharon's own genes, so that there would be no incompatibility at all if organs were needed for transplant.

ETHICS

Tracy's computer would have reminded her that even organ transplants from human to human had once been frowned upon. In Britain, it had taken a vigorous and sustained piece of campaigning journalism by the science editor of the *Daily Mirror* in the 1950s before Parliament permitted the practice of grafting a cornea, from the eye of someone who had just died, to save the sight of someone still alive. Before the newspaper campaign, the idea of taking a piece of a dead body and stitching it into a living one had been regarded as morally repugnant and contrary to nature.

Where then are the boundaries to be drawn? Do couples have a right to a genetically 'normal' baby? Should they be allowed to have their child tested *in utero* and terminate the pregnancy if it is abnormal? Cystic fibrosis, for example, is a debilitating disease whose sufferers, even with intensive medical care, seldom survive beyond the age of thirty. The only option available to prospective parents are to have a foetus tested *in utero* to see if it carries the gene and then, if it does, to decide whether or not to terminate the pregnancy. But there are other genes, associated with heart disease and cancer, which do not strike until much later in life – does their presence in a foetus constitute grounds for termination? Then again, part of the normal differences between people is that some live longer than others, and this is a trait which is likely to be genetically influenced; is someone carrying genes which might give them a shorter life-span 'ill' and requiring treatment, perhaps by gene therapy if it is available? Where does the boundary between what is normal and what is a medical condition lie? Should society restrict gene therapy so that it affects only the individual being treated or is it permissible to alter their genes in such a way that the new trait is propagated in their children and thus down through the generations?

Underlying all these questions lies the problem of the rights and obligations of society and the state versus the individual's rights. At first sight, there appears to be nothing more intimate and private than the decision whether or not to have children and, similarly, there could be nothing more personal than one's own DNA. Yet the state, as agent for society as a whole, has in the past legislated extensively to regulate behaviour in this area: examples include the laws concerning legitimacy of children born within wedlock; and abortion laws which, in the United Kingdom, for example, require certification by two doctors that the abortion is necessary for the woman's health or to prevent a severely abnormal child being born. If infertility, for example, is truly a medical disorder then IVF (and, by extension, genetics services) ought to be made available on the National Health Service. The corollary of course is that if the taxpayers pay for such treatment (or if they had paid for the research which made treatment possible) then, for that reason alone, there is a public as well as a private interest in precisely what services are provided.

In the early 1990s, only three clinics in Britain were offering IVF on the National Health Service. But after the 'internal market' reforms hospitals have rushed to meet consumer demand, effectively reducing any wider public interest to the commerce of the marketplace.

Commercial interests have taken precedence right from the beginning of the Human Genome Project. Many genetics researchers in the United States and several in Britain made themselves directors of private sector biotechnology companies while at the same time receiving research grants from public funds or from charities. Thus work paid for by the taxpayer directly enriched the research scientist's private company. A second

aspect of the commercialism of modern genetics is that as soon as he or she finds a gene, a researcher patents it. One of the first triumphs of the co-ordinated search for human genes was the discovery of the genetic defect for cystic fibrosis: the gene was promptly patented by the parent institutions of its discoverers, the Universities of Michigan and Toronto. In Britain, the regional genetics laboratories of the NHS shortly afterwards received demands for royalty payments from the patent-holders for work on cystic fibrosis. The privatization of human DNA has begun.

It is in this way that Tracy would at last have begun to realize how the genetics supermarkets of the year 2095 had come about. There had been a choice in the 1990s about which path society would take in terms of the application of the new knowledge and the new technologies. In the end, the decision was made almost by default. The politicians and the pundits had argued over matters of principle, whereas what had really mattered was money. In the end, despite all the high-sounding words, judgements on the morality and ethical acceptability of the new technologies were effectively privatized. In the marketplace the consumer was master. In the cases of both DNA and IVF society was content to leave what might once have been thought to be decisions in which there was a public interest – profound questions about the moral worth of human life and human DNA – to the individual choices of consumers in the commercial marketplace.

EPILOGUE

By the middle of the twenty-first century advances in scientific knowledge had produced female gorillas with a reproductive system that was virtually human. So a human egg fertilized *in vitro* could be implanted in the uterus of such a gorilla. That was of course how Sharon had been born. After Tracy and Trevor had chosen her genes, they had come back to Genebase nine months later to pick up their new child which had been nurtured throughout its development in the surrogate womb of a genetically engineered female gorilla, sparing Tracy the bother and inconvenience of actually having to be pregnant or the difficulties and pain of having to give birth.

NOTES

In the course of discussion during the Future of Nature meeting, it became apparent that at least three points were in need of clarification.

1 The benefits of the Human Genome Project

Nothing in the foregoing moral tale should be taken as an attack on the Human Genome Project. I took it as axiomatic that the project was a good thing in

itself and therefore I did not state my view explicitly. It may be wise to clarify matters here.

The first reason for welcoming the Human Genome Project is on the grounds of utility. There are more than 4,000 single gene defects which afflict humanity. Many of them result in diseases which inflict terrible suffering upon those (usually children) who have the genetic condition and suffering too upon the parents who have to live with the knowledge that the genetic constitution which they passed on to their child was responsible. The human genome project offers real hope that in many instances this burden of human suffering may be alleviated. To reject the researches of the geneticists would be to adopt a position of great inhumanity and indifference to human suffering. The point of my moral tale was to say that we can choose our future. It is perfectly reasonable to say that we would like to have some applications of modern genetics but that we would like to reject others.

Secondly, it is my view that an increase in our knowledge of humanity's genetic make-up is intrinsically valuable in its own right, regardless of any applications which might stem from it. This is a traditional liberal attitude to knowledge as something good in itself and asserts the proposition that knowledge is always preferable to ignorance. This statement does need qualification in one respect. One has to take into account that the knowledge furnished by scientific inquiry is at best conditional and partial. In the context of the Human Genome Project, this seems to me to imply that the selection of topics for investigation ought to be decided in part by the completeness of the knowledge which is likely to be produced. This is perhaps no more than an inelegant reprise of Sir Peter Medawar's famous dictum that science is the art of the soluble. Thus an investigation into the genetic basis for the disease cystic fibrosis is perfectly legitimate, because even before the DNA is analysed, researchers know from studies of the inheritance of the condition that it is a recessive single gene defect. It is therefore a problem which is soluble. On the other hand, an investigation into the genetic basis of sexual orientation, or intelligence, seems to me to be premature to say the least. It is quite clear that the results of such an investigation will be ambiguous and incomplete. The problem will not have been solved. Given the potential for misinterpretation of any research results in the wider world, it seems to me perfectly legitimate to say that such research should be postponed because there are other far more promising questions in genetics which are capable of solution now.

That reservation about the value of knowledge in itself is almost an issue internal to science. Cystic fibrosis research yielded results which were, in the common parlance, 'good science'; whereas research into the genetics of intelligence has almost invariably yielded 'bad science'. It should be clear therefore that I do not support in any way the 'anti-science' tendency which appears to be fashionable in some parts of the United States. Science is, in my view, one of the finest creations of the human mind and a prime example of the tradition of rational inquiry which is a cornerstone of our culture. Ultimately, if one has to choose between Galileo and the Pope, then we must stand with Galileo.

2 The inheritance of intelligence

Nothing in my moral tale should be interpreted as giving support to the ideas of sociobiology or of the heritability of IQ. These ideas have achieved notoriety recently with the publication in the United States of *The Bell Curve* by Murray and Herrnstein.

This is an old story, whose last outing was in the late 1960s when professors Arthur Jensen from the University of California and Richard Herrnstein from Harvard energetically publicized the views that scores on IQ tests were heritable, that blacks had lower scores than whites, and that these differences were ineradicable and therefore 'affirmative action' policies to provide better education were doomed to failure. There is no scientifically valid evidence to substantiate such claims.

It is worth noting first that such claims run counter to the commonsense view that the quality of education a child receives matters very considerably. This view is expressed in action by many parents who seek to place their children in what they consider to be the best available schools with the best teachers. The definitive refutation of the hereditarian view is contained in the book *The Science and Politics of IQ* by Leon J. Kamin (Harmondsworth: Penguin, 1977). Professor Kamin exhaustively re-examined all the studies which have been called in aid of the hypothesis that IQ is inherited and showed that they are all comprehensively flawed. To the best of my knowledge, no new research has since been carried out whose results invalidate Professor Kamin's conclusions. (Since the book was published there has been a large new study of the comparative IQs of identical twins who have been reared apart from each other. However, the raw data of this 'Minnesota Twins Study' from which conclusions may be drawn has not, apparently, been made available to scholars such as Professor Kamin who are critical of the hereditarian standpoint.)

A further perspective on the issue may be obtained from the short but fascinating book *Heredity and Politics* by J.B.S. Haldane (London: George Allen & Unwin, 1938). It is clear from Haldane's text that virtually the same propositions about heredity, IQ and social class were being made in the 1920s and 1930s. With one difference. The underclass which was (allegedly) genetically more stupid than and which was outbreeding the middle classes was farm labourers. Haldane cites US figures from 1910 clearly showing that the fertility of farm labourers was more than double that of the professional and business classes. He also cited figures showing that the IQs of the children of this group were markedly lower than the IQs of the professionals. If the contentions of the hereditarians are correct, then one might argue that after, say, sixty years had passed, the United States ought to have sunk into some sort of a rural slum peopled largely by rural idiots. In fact, of course, by 1968, the United States had put a man on the moon, was acknowledged as the world's foremost scientific and technological nation, and was sending more young people to university and tertiary education than ever before. In a real sense, the experiment has been done; the prediction was made at the beginning of this century and has been falsified by the outcome. Little more need be said.

Among the arguments deployed against the hereditarian position three stand out particularly. The first is the appeal to ignorance. This is the position of Professor Kamin's book: the evidence simply does not exist and, because of the confounding effect of varied environments, cannot exist. This is an entirely valid and unimpeachable argument, given the present state of our knowledge. Another argument is to deny a sufficient connection between IQ tests and the much more diffuse concept of intelligence. This can sometimes shade into a denial that the concept of intelligence is in any way fruitful. If taken to this extreme, this position seems to me to be simply rhetorical and lacking in substance. Professor Kamin's book allows the possibility that 'there may well be genetically determined differences among people in their cognitive and intellectual "capacities"'. A third argument is that to concede the existence of such genetic difference is to opt for genetic determinism. It is to this point which I now turn.

3 Genetic determinism

No two people in the world are identical. The differences between them stem in part from the differences in their environments and in part from differences in their genes. An individual's development is a subtle interplay of genes and environment. There is no doubt that the environment can trigger the activity of genes. A trivial example is the 'flight or fight' response. A situation which the individual finds fearful (such as giving a lecture in the Future of Nature meeting) stimulates the production of adrenaline. But this hormone can only be produced if the corresponding gene is 'read' so that the body's cells can obtain the recipe for making adrenaline.

A less trivial example is the metabolic disorder phenylketonuria (PKU). If untreated, this condition leads to mental retardation and early death. Those born with PKU cannot digest an amino acid normally present in food, but the effects of the defective gene never become manifest if they receive a modified diet in which none of this amino acid, phenylalanine, is present. The question here is what is genetic and what environmental. For if phenylalanine were totally absent from our diet, there is no sense in which PKU would be a defective gene. It would merely be part of normal genetic variation.

However, there are some conditions which are clearly and unambiguously determined by the genes. One of the best understood perhaps is thalassaemia. This affects the haemoglobin in red blood cells. Haemoglobin consists of four subunits, known as globin chains. It is highly symmetrical in that there is a pair of alpha globin chains, and a pair of beta chains. In the most severe form of thalassaemia, the beta gene is missing – the entire gene is missing from the child's DNA. The result of this 'thalassaemia major' is chronic anaemia. This stimulates the bone marrow cells which are responsible for producing red blood cells to overproduce, in an attempt to compensate. Huge quantities of the alpha chains are made which clog up the cells. The result is that the child is perpetually malnourished because its energies are going into the fruitless production of bone marrow. He or she will suffer agonising pain from deep inside their bones, as the marrow expands and their legs may fracture many times as a result of the pressure within.

There are many variants of thalassaemia, but one point is clear: there is no way in which, if presented with a child suffering from thalassaemia major, one can meaningfully deny either that the child is ill or that the illness is genetically determined.

That there is such a thing as genetic determinism seems to be inescapable. However, comparatively few human traits are all or nothing. Perhaps the best example is that of height. There is no doubt that tall people tend to have tall children and this is genetically influenced. However, human beings do not divide into disjoint classes of tall and short, there is a continuum, a range of normal variation. In this respect, the genetics of height among humans differs markedly from the genetics of height in the pea plants which Gregor Mendel studied in his celebrated original experiments in genetics. Instead of the single gene controlling height as in Mendel's experiments, there are clearly many genes influencing height in human beings. Equally, human height is influenced by diet. The average height of the Japanese population is increasing post-war, as they have switched to a higher-protein diet.

Discussion of genetic or environmental influences on height seems reasonably uncontroversial. There is variation in the population with respect to height: some of this phenotypic variation stems from genetic variation and some from variation in the environment. Similarly there is clearly variation in the

population in what Kamin called 'cognitive and intellectual "capacities"'. It seems relatively uncontroversial to me to attribute some of that variation to genotype and some to environment. This is a weak statement, from which no social or ethical inferences can be drawn. Kamin's book has demonstrated conclusively that it is impossible to separate out the effects of genotype and environment by looking at the phenotype, because the environment is too complex. However, the whole thrust of modern molecular genetics is to turn the conventional pattern of investigation on its head. Thus for example, both cystic fibrosis and muscular dystrophy had defeated generations of biochemists because the cells in which these defects manifested themselves were so complex that the specific consequence of the defect could not be discerned. When the techniques of DNA analysis became available, researchers looked not at the cells expressing the defect, but at patterns in the underlying DNA. This was a simpler problem, and they identified a genetic lesion in each case which then allowed them to predict what the defect would be in the cells. It seems to me that such an approach may eventually be possible with respect to intelligence: that one might try searching for patterns of genetic variation to correspond to the observed patterns of variation in the population. Such an approach is far beyond the grasp of modern molecular biology today. However, that such a thing is impossible today should not prevent us from activity considering it, if there is a chance that it may be feasible in the future. The need to consider such a molecular genetic approach arises because if it is possible, and if it is even partially successful, it will destroy Kamin's 'appeal to ignorance' argument against the hereditarians.

The Human Genome Project thus is relevant to the current debate over the inheritance of intelligence and to its stratification in social class, if only because one can extrapolate from existing successes of the methods of modern molecular biology to a future in which the genetic components of behaviour might well be capable of analysis. I do not believe that even if such developments are possible that it should lead to the adoption of the social and political agendas promulgated in *The Bell Curve*. However I do believe that the arguments against such ideas will have to be sharpened because it may not always be possible to rely on the impossibility of proving the hereditarian position. The classic Jeffersonian statement of liberal values – 'we hold these truths to be self-evident: that all men are created equal' – has survived the reality of political inequality. The task now may be to find ways of maintaining that ideal in the face of mounting and incontrovertible evidence that all citizens are biologically unequal from the moment of conception. Attempts to cope with this potential problem by denial – either of the usefulness of the concept of intelligence or of genetic influence – will become increasingly unconvincing. It may be that just as the new cosmology of Galileo challenged the accepted moral and religious order of the seventeenth century, so the new genetics may come to challenge the basis of modern democratic politics. The irony is that this time, the liberals might find themselves on the side of the Pope rather than Galileo.

Chapter 10

Narratives of artificial life

N. Katherine Hayles

At the Fourth Conference on Artificial Life in the summer of 1994, the evolutionary biologist Thomas S. Ray put forth two proposals.[1] The first was a plan to preserve biodiversity in Costa Rican rain forests; the second was a suggestion that Tierra, his software program creating artificial life-forms inside a computer, be released on the Internet so that it could 'breed' diverse species on computers all over the world. Ray saw the two proposals as complementary. The first aimed to extend biological diversity for protein-based life-forms; the second sought the same for silicon-based life-forms. Their juxtaposition dramatically illustrates the reconstruction of nature going on in the field of artificial life, affectionately known by its practitioners as Alife or simply AL. 'The object of an AL instantiation', Ray wrote recently, 'is to introduce the *natural* form and process of life into an *artificial* medium' (emphasis added).[2] The lines startle. In Ray's rhetoric, the computer codes comprising these 'creatures' become natural forms of life; only the medium is artificial.

How is it possible in the late twentieth century to believe, or at least claim to believe, that computer codes are alive? And not only alive, but natural? The question is difficult to answer directly, for it involves assumptions that may not be explicitly articulated. Moreover, these presuppositions do not stand by themselves but move in dynamic interplay with other formulations and ideas circulating through the culture. Pull any one thread, and a tangled weave of interconnected strands begins to vibrate. In view of this complexity, the subject is perhaps best approached through indirection, by looking not only at the scientific content of the programs but also at the stories told about and through them. These stories, constitute a multilayered system of metaphoric and material relays through which 'life', 'nature', and the 'human' are being redefined.

The first level of narrative with which this chapter is concerned is the Tierra program and various representations of it by Ray and others. In these representations, authorial intention, biomorphic interpretation and the program's operations are so interwoven that it is impossible to

separate them. As a result, the program operates as much within the imagination as it does within the computer. The second level of narrative focuses on the arguments and rhetorical strategies that Alife practitioners use as they seek to position artificial life as a valid area of research within theoretical biology. This involves telling a story about the state of the field and the contributions that Alife can make to it. As we shall see, the second-level story quickly moves beyond purely professional considerations, evoking a larger narrative about the kinds of life that have emerged, and are emerging, on earth. The narrative about the present and future of terrestial evolution comprises the third level. It is constituted through speculations on the relation of human beings to their silicon cousins, the 'creatures' who live inside the computer. Here, at the third level, the implication of the observer in the construction of all three narratives becomes explicit, for now there is no outside upon which to stand. This is earth, nor are we out of it. For while artificial life marks a decisive break in the 'nature' of human being through the narratives it tells, it also re-inscribes traditional ideas and stories. Characteristic of the narrative field as a whole is a seriated pattern of innovation and replication. To interrogate how this complex narrative field is initiated, developed and interpolated with other cultural narratives, let us begin at the first level, with an explanation of the Tierra program.

THE OBSERVER AND THE PROGRAM: ENTANGLED OBJECTIVES

Conventionally, artificial life is divided into three research fronts. *Wetware* is the attempt to create artificial biological life through such techniques as building components of unicellular organisms in test-tubes. *Hardware* is the construction of robots and other embodied life-forms. *Software* is the creation of computer programs instantiating emergent or evolutionary processes. Although each of these areas has its distinctive emphases and research agendas, they share the sense of building life from the 'bottom up'. In the software branch, with which we are concerned here, the idea is to begin with a few simple local rules, then continue through structures that are highly recursive, and allow complexity to emerge spontaneously. Emergence implies that properties or programs appear on their own, often developing in ways not anticipated by the person who created the simulation. Structures that lead to emergence typically involve complex feedback loops in which the output of a system is repeatedly fed back in as input. As the recursive looping continues, small deviations can quickly become magnified, leading to the complex interactions and unpredictable evolutions associated with emergence.[3]

Even granting emergence, it is still a long jump from programs that replicate inside a computer to living organisms. This gap is bridged largely

through narratives about the programs that map them into evolutionary scenarios traditionally associated with the behaviour of living creatures. The narratives translate the operations of computer codes into biological analogues that make sense of the program's logic. In the process, the narratives transform the binary operations that, on a physical level, amount to changing electrical polarities on silicon into the high drama of a Darwinian struggle for survival and reproduction. To see this transformation in action, consider the following account of the Tierra program. This account is compiled from Thomas Ray's published articles and unpublished working papers, conversations I have had with him about his program, and public lectures he has given on the topic.[4]

When I visited Ray at the Santa Fe Institute, he talked about the genesis of Tierra. Frustrated with the slow pace of natural evolution, he wondered if it would be possible to speed things up by creating evolvable artificial organisms within the computer. One of the first challenges he faced was designing programs robust enough to withstand mutation without crashing. To induce robustness, he conceived of building inside the regular computer a 'virtual computer' out of software. Whereas the regular computer uses memory addresses to find data and execute instructions, the virtual computer uses a technique Ray calls 'address by template'. Taking its cue from the topological matching of DNA bases, in which one base finds its appropriate partner by diffusing through the medium until it locates another base with a surface it can fit into like a key into a lock, address by template matches one code segment to another by looking for its binary inverse. For example, if an instruction is written in binary code 1001, the virtual computer searches nearby memory to find a matching segment with the code 0110. The strategy has the advantage of creating a container for the organisms that renders them incapable of replicating outside the virtual computer, for the address-by-template operation can occur only within a virtual computer. Presented with a string such as 0110, the regular computer would read it as data rather than instructions to replicate.

Species diversify and evolve through mutation. To introduce mutation, Ray creates the equivalent of cosmic rays by having the program flip a bit's polarity once in every 10,000 executed instructions. In addition, replication errors occur about once in every 1,000 to 2,500 instructions copied, introducing another source of mutation. Other differences spring from an effect, which Ray calls 'sloppy reproduction', that is analogous to the genetic mixing that occurs when a bacterium absorbs fragments of a dead organism nearby. To control the number of organisms, Ray introduced a program that he calls the 'reaper'. The 'reaper' monitors the population and eliminates the oldest creatures and those that are 'defective', that is, those who most frequently have made errors in executing their programs. If a creature finds a way to replicate more efficiently, it is rewarded by moving down in the reaper's queue and so becomes 'younger'.

The virtual computer starts the evolutionary process by allocating a block of memory that Ray calls the 'soup', by analogy with the primeval soup at the beginning of life on earth. Inside the soup are unleashed self-replicating programs, normally starting with a single 80-byte creature called the 'ancestor'. The ancestor is comprised of three segments. The first segment counts its instructions to see how long it is (this procedure ensures that the length can change without throwing off the reproductive process); the second segment reserves that much space in nearby memory, putting a protective membrane around it (by analogy with the membranes enclosing living organisms); and the third segment copies its code into the reserved space, thus completing the reproduction and creating a 'daughter cell' from the 'mother cell'. To see how mutation leads to new species, consider that a bit flip occurs in the last line of the first segment, changing 1100 to 1110. Normally the program would find the second segment by searching for its first line, encoded 0011. Now, however, the program searches until it finds a segment starting with 0001. Thus it goes not to its own second segment but to another string of code in nearby memory. Many mutations are not viable and do not lead to reproduction. Occasionally, however, the program finds a segment starting with 0001 which will allow it to reproduce. Then a new species is created, as this organism begins producing offspring.

When Ray set his program running overnight, he thought he would be lucky to get a 1- or 2-byte variation from the 80-byte ancestor. Checking it out the next morning, he found that an entire ecology had evolved, including one 22-byte organism. Among the mutants were parasites that had lost their own copying instructions but had developed the ability to invade a host and hijack its copying procedure. One 45-byte parasite had evolved into a benign relationship with the ancestor; others were destructive, crowding out the ancestor with their own offspring. Later runs of the program saw the development of hyperparasites, which had evolved ways to compete for time as well as memory. Computer time is doled out equally to each organism by a 'slicer' that determines when it can execute its program. Hyperparasites wait for parasites to invade them. Then, when the parasite attempts to reproduce using the hyperparasite's own copy procedure, the hyperparasite directs the program to its own third segment instead of returning it to the parasite's ending segment. Thus the hyperparasite's code is copied on the parasite's time. In this way the hyperparasite greatly multiplies the time it has for reproduction, for in effect it appropriates the parasite's time for its own.

This, then, is the first-level narrative about the program. It appears with minor variations in Ray's articles and lectures. It is also told in the Santa Fe Institute videotape, *Simple Rules . . . Complex Behavior*, in which Ray collaborated with a graphic artist to create a visual representation of Tierra, accompanied by his voice-over.[5] If we ask how this narrative is

constituted, we can see that statements about the program's operation and interpretations of its meaning are in continous interplay with each other. Consider the analogies implicit in such terms as 'mother cell', 'daughter cell', 'ancestor', 'parasite' and 'hyperparasite'. The terms do more than set up parallels with living systems; they also reveal Ray's intention in creating an appropriate environment in which the dynamic emergence of evolutionary processes could take off. In this respect Ray's rhetoric is quite different from that of Richard Dawkins in *The Selfish Gene*, a work also deeply informed by anthropomorphic constructions.[6] Dawkins's rhetoric attributes to genes human agency and intention, creating a narrative of human-like struggle for lineage and reproduction on the genetic level. In this construction, Dawkins overlays onto naturally-occurring systems strategies, emotions and outcomes that properly belong to the human domain. Ray, by contrast, is working with artificial systems designed by humans *precisely so they would be able to manifest these qualities*. The primary reason that explanation and interpretation are inextricably entwined in this first-level narrative is that the program is an artifact, not a natural system. Ray's biomorphic namings and interpretations function not so much as an overlay, therefore, as an explication of an intention that was there at the beginning. Analogy is not incidental or belated but central to the program's artifactual design.

Important as analogy is, it is not the whole story. The narrative's compelling effect comes not only from analogical naming but also from images. In rhetorical analysis, of course, 'image' can mean either an actual picture or a verbal formulation capable of evoking a mental picture. Whether an image is a visualization or visually evocative language, it is a powerful mode of communication because it draws upon the high density of information that images convey. Visualization and visually evocative language collaborate in the videotape *Simple Rules . . . Complex Behavior*. As the narrative about Tierra begins, the camera flies over a scene representing the inside of a computer. This stylized landscape is dominated by a block-like structure representing the CPU (central processing unit) and dotted with smaller upright rectangles representing other integrated circuits. Then the camera zooms into the CPU, where we see a grid upon which the 'creatures' appear and begin to reproduce. They are imaged as solid polygons strung together to form three sections, representing the three segments of code. Let us linger at this scene and consider how it has been constructed. The pastoral landscape upon which the creatures are visualized instantiates a transformation characteristic of the new information technologies and the narratives that surround them. A material object (the computer) has been translated into the functions it performs (the programs it executes) which in turn have been represented in visual codes familiar to the viewer (the bodies of the 'creatures'). The path can be represented schematically as material base → functionality →

representational code. This kind of transformation is extremely wide-spread, appearing in popular venues as well as scientific applications. It is used by William Gibson in his cyberspace novel *Neuromancer,* for example, when he represents the data arrays of a global informational network as solid polygons in three-dimensional space that his protagonist, transformed into a point of view or 'pov', can navigate as though he were flying through the atmosphere.[7] The schematic operates in remarkably similar fashion in the video, where we become a disembodied pov flying over the lifeworld of the 'creatures', comfortingly familiar in its three-dimensional spaces and rules of operation. Whereas the CPU landscape corresponds to the computer's interior architecture, however, the lifeworld of the creatures does not. The seamless transition between the two elides the difference between the *material* space inside the computer and the *imagined* space that, in actuality, consists of computer addresses and electrical polarities on the computer disk.

To explore how these images work to encode assumptions, consider the bodies of the 'creatures', which resemble stylized ants. In the program, the 'creatures' have bodies only in a metaphoric sense, as Ray recognizes when he talks about their bodies of information (itself an analogy).[8] These bodies of information are not, as the expression might be taken to imply, phenotypic expressions of informational codes. Rather, the 'creatures' *are* their codes. For them, genotype and phenotype amount to the same thing; the organism is the code, and the code is the organism. By representing them as phenotypes, visually by giving them three-dimensional bodies and verbally by calling them ancestors, parasites, and such, Ray elides the difference between behavior, properly restricted to an organism, and executing a code, applicable to the informational domain. In the process, assumptions we have about behavior, in particular thinking of it as independent action undertaken by purposive agents, are transported into the narrative.

Further encoding takes place in the plot. Narrative tells a story, and intrinsic to story is chronology, intention and causality. In Tierra, the narrative is constituted through the story that emerges of the creatures' struggle for survival and reproduction. More than an analogy or an image, this is a drama that, if presented in a different medium, one would not hesitate to identify as an epic. Like an epic, it portrays life on a grand scale, depicting the rise and fall of races, some doomed and some triumphant, recording the strategies they invent as they play for the high stakes of establishing a lineage. The epic nature of the narrative is even more explicit in Ray's plans to develop a global ecology for Tierra. In his proposal to create a digital 'biodiversity reserve', the idea is to release the Tierra program on the Internet so that it can run in background on computers across the globe. Each site will develop its own microecology. Because background programs run when demands on the computer are

at a minimum, the programs will normally be executed late at night, when most users are in bed. Humans are active while the 'creatures' are dormant; they evolve while we sleep. Ray points out that someone monitoring activity in Tierra programs would therefore see it as a moving wave that follows darkfall around the world. Linking the creatures' evolution to the human world in a complementary diuranal rhythm, the proposal edges toward a larger narrative level that interpolates their story into ours, our into theirs.

A similar interpolation occurs in the video. The narrative appears to be following the script of Genesis, from the lightning that flickers over the landscape, representing the life force, to the 'creatures' who, like their human counterparts, follow the Biblical imperative to be fruitful and multiply. When a death's head appears on the scene, representing the reaper program, we understand that this pastoral existence will not last for long. The idyll is punctured by competition between species, strategies of subversion and co-optation, and exploitation of one race by another – in short, all the trappings of rampant capitalism. To measure how much this narrative accomplishes, it is helpful to remember that what one actually sees as the output of the Tierra program is a spectrum of bar graphs tracking the numbers of programs of given byte lengths as a function of time. The strategies emerge when human interpreters scrutinize the binary codes that constitute the 'creatures' to find out how they have changed and determine how they work.

No one knows this better, of course, than Ray and other researchers in the field. The video, as they would no doubt want to remind us, is merely an artist's visualization that has no scientific standing. It is, moreover, intended for a wide audience, not all of whom are presumed to be scientists. This fact in itself is interesting, for the tape as a whole is an unabashed promotion of the Santa Fe Institute. It speaks to the efforts that practitioners in the field are making to establish artificial life as a valid, significant and exciting area of scientific research. These efforts are not unrelated to the visual and verbal transformations discussed above. To the extent that the 'creatures' are biomorphized, their representation reinforces the strong claim and extends its implications. Nor do the transformations appear only in the video, although they are particularly striking there. As the discussion above demonstrates, they are also inscribed in published articles and commentary. In fact, they are essential to the claim that the 'creatures' are in some meaningful sense alive, as some researchers at the Santa Fe Institute recognize. Asked about the strong claim, one respondent insisted, 'It's in the eye of the beholder. It's not the system, it's the observer'.[9]

To explore further the web of connections between the program's operations, descriptions of its operation, and the contexts in which these descriptions are embedded, we will follow the thread to the next

narrative level, where arguments circulate about the contributions that artificial life can make to scientific knowledge.

POSITIONING THE FIELD: THE POLITICS OF ARTIFICIAL LIFE

As we have seen, the strong claim for artificial life proposes that computer programs such as Tierra are not merely models or simulations of life but are themselves alive. Christopher Langton explains the reasoning. 'The principle [sic] assumption made in Artificial Life is that the 'logical form' of an organism can be separated from its material basis of construction, and that 'aliveness' will be found to be a property of the former, not of the latter'.[10] It would be easy to dismiss the claim on the basis that the reasoning behind it is tautological: Langton defines life in such a way as to make sure the programs qualify, and then, because they qualify, he claims they are alive. But more is at work here than tautology. Resonating through Langton's definition are assumptions that have marked western philosophical and scientific inquiry at least since Plato. Form can logically be separated from matter; form is privileged over matter; *form defines life*, while the material basis merely instantiates it. The definition is a site of reinscription as well as tautology. This convergence suggests that the context for our inquiry should be broadened beyond the definition's logical form (an emphasis the definition encodes and re-encodes) to the field of inquiry in which such arguments persuade precisely because they reinscribe.

Part of this context are attitudes, deeply held within many scientific communities, about the relation between the complexity of observable phenomena and the relatively simple rules they are seen to embody. Traditionally, the natural sciences, especially physics, have attempted to reduce apparent complexity to underlying simplicity. The attempt to find the 'fundamental building blocks' of the universe in quarks is one example of this endeavor; the mapping of the human genome is another.[11] The sciences of complexity, with their origins in chaos theory, complicated this picture by demonstrating that for certain nonlinear dynamical systems, the evolution of the system could not be predicted, even in theory, from the initial conditions (as Ray did not know what creatures would evolve from the ancestor). Thus the sciences of complexity articulated a limit on what reductionism could accomplish. In a significant sense, however, Alife researchers have not relinquished reductionism. In place of predictability, traditionally the test of whether a theory works, they emphasize emergence. Instead of starting with a complex phenomenal world and reasoning back through chains of inference to what the fundamental elements must be, they *start* with the elements and complicate them through appropriately nonlinear processes so that the complex phenomenal world appears on its own.[12]

Why is one justified in calling the simulation and the phenomena that emerge from it a 'world'? Precisely because they are generated from simple underlying rules and forms. Alife reinscribes, then, the mainstream assumption that simple rules and forms give rise to phenomenal complexity. The difference is that Alife starts at the simple end where synthesis can move forward spontaneously, rather than at the complex end where analysis must work backwards. Christopher Langton, in his explanation of what Alife can contribute to theoretical biology, makes this difference explicit.

> 'Artificial Life', is the study of man-made systems that exhibit behaviors characteristic of natural living systems. It complements the traditional biological sciences concerned with the *analysis* of living organisms by attempting to *synthesize* life-like behaviors within computers and other artificial media. By extending the empirical foundation upon which biology is based beyond the carbon-chain life that has evolved on Earth, Artificial Life can contribute to theoretical biology by locating *life-as-we-know-it* within the larger picture of *life-as-it-could-be* .[13]

The presuppositions informing such statements have been studied by Stefan Helmreich, an anthropologist who spent several months at the Santa Fe Institute. Helmreich interviewed several of the major players in the American Alife community, including Christopher Langton and Thomas Ray, about whom we have already heard, as well as John Holland and others. He summarizes the views of his informants about the 'worlds' they create.

> For many of the people I interviewed, a 'world' or 'universe' is a self-consistent, complete, and closed system that is governed by low level laws that in turn support higher level phenomena which, while dependent on these elementary laws, cannot be simply derived from them.[14]

Helmreich uses comments from the interviews to paint a fascinating picture about the various ways in which simple laws are believed to underlie complex phenomena. Several informants thought that the world was mathematical in essence; others held the view (also articulated several years ago by Edward Fredkin[15]) that the world is fundamentally comprised of information. From these points of view, the world of pheomenological experience is itself a kind of illusion, covering over an underlying reality of simple forms. For them, a computer program that generates phenomenological complexity out of simple forms is no more or less illusory than the 'real' world.

The form/matter dichotomy is intimately related to these assumptions, for reality at the fundamental level is seen as form rather than matter. The assumption that form occupies a privileged position relative to matter is especially easy to make with information technologies, since

information is defined in theoretic terms as a probability function and thus as a pattern or form rather than a materially instantiated entity. Information technologies seem to realize a dream impossible in the natural world – the opportunity to look directly into the inner workings of reality at its most elemental level. The directness of the gaze does not derive from the absence of mediation. On the contrary, our ability to look into programs such as Tierra is highly mediated by everything from computer graphics to the processing program that translates machine code into a high-level computer language such as C ++. Rather, the gaze is privileged because the observer can peer directly into the elements that the world is before it cloaks itself with the appearance of complexity. Moreover, the observer is presumed to be cut from the same cloth as the world he inspects, inasmuch as he is also constituted through the elementary processes that he sees inside the computer. The essence of Tierra as an artificial world is no different from the essence of the observer or the world he occupies: all are constituted through forms understood as informational patterns. When *form* is triumphant, Tierra's 'creatures' are, in a disconcertingly literal sense, just as much *life-forms* as any other organisms.

We are now in a position to understand the deep reasons why some practitioners think of programs like Tierra not as models or simulations but as life itself. As Langton and many others point out, in the analytic approach reality is modelled by treating a complex phenomenon as if it were comprised of smaller constituent parts. These parts are broken down into still smaller parts, until one arrives at parts sufficiently simplied so that they can be treated mathematically. Most scientists would be quick to agree that the model is not the reality, because they recognize that many complexities had to be tossed out by the wayside in order to lighten the wagon sufficiently to get it over the rough places in the trail. Their hope is that the model nevertheless captures enough of the relevant aspects of a system to tell them something significant about how reality works. In the synthetic approach, by contrast, the complexities emerge spontaneously as a result of the system's operation. The system itself adds back in the baggage that had to be tossed out in the analytic approach. (Whether it is the same baggage remains, of course, to be seen.) In this sense artificial life poses an interesting challenge to the view of nineteenth-century vitalists, who saw in the analytic approach a reductionist methodology that could never adequately capture the complexities of life. If it is true that the analytical approach murders by dissection, by the same reasoning the synthetic approach of Alife may be able to procreate by emergence.

In addition to these philosophical considerations, there are also more obviously political reasons to make a strong claim for the 'aliveness' of Alife. As a new kid on the block, artificial life must jockey for position

with larger, more well-established research agendas. A common reaction from other scientists is, 'Well, this is all very interesting, but what good is it?' Even practitioners joke that Alife is a solution in search of a problem. When applications are suggested, they are often open to cogent objections. As long as Alife programs are considered to be simulations, any results produced from them may be artifacts of the simulation rather than properties of natural systems. So what if a certain result can be produced within the simulation? It is artifactual and therefore non-signifying with respect to the natural world unless the same mechanisms can be shown to be at work in natural systems. These difficulties disappear, however, if Alife programs are themselves alive. Then the point is not that they model natural systems but rather that they are, *in themselves*, also alive and therefore as worthy of study as evolutionary processes in naturally occurring media.

This is the tack that Christopher Langton takes when he compares Alife simulations to synthetic chemicals.[16] In the early days, he observes, the study of chemistry was confined to naturally occurring elements and compounds. Although some knowledge could be gained from these, the results were limited by what lay ready at hand. Once researchers learned to synthesize chemicals, their knowledge took a quantum leap forward, for then chemicals could be tailored to specific research problems. Similarly, theoretical biology has been limited to the case that lay ready to hand, namely the evolutionary pathways taken by carbon-based life. It is notoriously difficult to generalize from a single instance, but theoretical biology had no choice; carbon-based life was it. Now a powerful new instance has been added to the repretoire, for Alife simulations represent an alternative evolutionary pathway followed by silicon-based life-forms.

What theoretical biology looks for, in this view, are similarities that cut across the particularities of the media. In 'Beyond digital naturalism', Walter Fontana and his co-authors lay out a research agenda that is 'ultimately motivated by a premise: that there exists a logical deep structure of which carbon chemistry-based life is a manifestation. The problem is to discover what it is and what the appropriate mathematical devices are to express'.[17] Such a research agenda presupposes that the essence of life, understood as logical form, is independent of the medium. More is at stake in this agenda than expanding the frontiers of theoretical biology. By positing Alife as a second instance of life, reseachers affect the definition of biological life as well, for now it is the *juxtaposition* that determines what counts as fundamental, not carbon-based forms by themselves.

In the context of arguments like these, it makes sense for Thomas Ray to argue against carrying carbon-based analogies too far as a research paradigm for artificial life. Coming from Ray, the argument has special force, because his work has been at the forefront in using biological

analogies to coax emergent behavior from Alife simulations. Now, however, he worries that the *natural* medium for artificial life, namely the computer, might be neglected or deformed by trying to make artificial life conditions correspond too literally to carbon-based constraints.[18] The cart is no longer pulled by the horse but proceeds on its own. To keep thinking of it in terms of the horse, Ray worries, may only hold it back from assuming its rightful place.

This inversion is a measure of how far the field has come since its inception. It also marks how fully developed and widely disseminated is the narrative of artificial life as an alternate evolutionary pathway for life on earth. Let us therefore turn to the third level of narrative, where we will consider stories about the relation of humans to our silicon cousins, the artificial life-forms who represent the road not taken – until now.

RECONFIGURING THE BODY OF INFORMATION

As research on artificial life-forms continues and expands, the construction of *human* life is affected as well. Two different narratives of how the human will be reconfigured in the face of artificial bodies of information are told by Rodney Brooks of the Artificial Intelligence Laboratory at MIT, and Hans Moravec, head of the Carnegie-Mellon Mobile Robot Laboratory. Whereas Moravec privlileges consciousness as the essence of human being and wants to preserve it intact, Brooks speculates that the more essential property is the ability to move around and interact robustly with the environment. Moravec, starting with the most advanced qualities of human thought, proceeds from the top down; Brooks, starting with locomotion and simple interactions, works from the bottom up. Despite these different orientations, both see the future of human being inextricably bound up with artificial life. Indeed, in the future world they envision, it will be difficult or impossible to distinguish between natural and artificial life, human and machine intelligence.

In *Mind Children: The Future of Robot and Human Intelligence,* Moravec argues that the age of carbon-based life is drawing to a close.[19] Humans are about to be replaced as the dominant life form on the planet by intelligent machines. Drawing on the work of Cairns-Smith,[20] Moravec suggests that such a revolution is not unprecedented. Before protein replication developed, a primitive form of life existed in certain silicon crystals that had the ability to replicate. But protein replication was so far superior that it soon left the replicating crystals in the dust. Now silicon has caught up with us again, in the form of computers and computerized robots. Although the Cairns-Smith hypothesis has subsequently been discredited, in Moravec's text it serves the useful purpose of increasing the plausibility of his vision by presenting a transition from carbon-based life to

silicon-based life as an inversion of prior events rather than an entirely new scenario. Moravec argues that as humans fade into the twilight, however, they need not despair. Even though they are headed for obsolescence, they can jump on the bandwagon (or perhaps the cart as it runs before the horse) by becoming machines themselves. Moravec envisions this transformation as downloading human consciousness into a computer. Identity, he argues from premises familiar to us, is essentially a pattern or form rather than a materially embodied presence. Abstract the form into an informational pattern, and you have captured all that matters about being human. The rest can be shuffled off – a mortal coil that we no longer need or want.

Moravec imagines the transfer from carbon- to silicon-based life taking place in a fantastic scenario where a robot surgeon performs a kind of cranial liposuction on the human patient, addressed in the scenario as 'you'. As the robot's hand excavates your cranial cavity, it reads the information in each molecular layer and transfers it into the computer. At the end of the operation, the skull is empty and 'you' have been transported into your shiny new body, a mobile computer. Testing your new incarnation, 'you' find that your consciousness is completely unchanged. Despite the radical transformation in substrate, your subjectivity continues uninterrupted, your identity remains intact. The scenario so perfectly reinscribes the assumptions of Cartesian subjectivity that it is startling to see it still circulating at the end of the twentieth century, as if one saw a horse pulling a cart – or perhaps a cart running in front of a horse – during rush-hour traffic on the San Diego freeway. The wishful quality of the scenario is starkly apparent when it is placed alongside the large body of empirical evidence demonstrating the importance of embodiment to thought. To mention only one, Antonio D'Amasio's *Descartes' Error: Emotion, Reason, and the Human Brain* describes in exhaustive detail the importance and complexity of the feedback loops connecting the body's physical systems with the brain.[21] Even if it were possible to effect a transfer such as Moravec imagines – and no technology now in existence comes remotely close – consciousness abstracted from its to human embodiment could not possibly be anything like consciousness inside a computer.

The appeal of this narrative derives not from its scientific plausibility but from the scarcely veiled promise it holds out for immortality. Once consciousness has been successfully extracted from its material basis and translated into an informational pattern, it need not be confined to any one instantiation. When the mobile computer 'you' occupy wears down or goes out of fashion, 'you' can choose whatever new body you want, thereby becoming effectively immortal. The idea that the body can be transcended is, of course, nothing new. Moravec's fantasy shares with traditional spirituality the hope that there exists an essence distinct from

the flesh and extractable from it. To this extent, it reinscribes more than Descartes. But between information and spirituality there are also, of course, significant differences. Whereas spirituality requires belief, information requires the logical force of mathematical theorems. The pure form that Moravec sees as both expressing and containing human subjectivity has finally less in common with spirituality than it does with the elemental patterns that researchers within the Alife community imagine life to be before it takes on the appearance of complexity. If human subjectivity could be adequately represented by informational patterns, there would be no reason why human subjects could not also inhabit the 'world' in which the Tierran 'creatures' live. Whereas Ray wants to breed intelligence by evolving life inside the computer, Moravec wants to evolve humans by putting their intelligence inside the computer. As these symmetries suggest, the narratives of Tierra and *Mind Children* inscribe mutually reinforcing assumptions about the nature of life, whether artificial or human.

A different approach is advocated by other members of the artificial life community, among them Rodney Brooks, Patti Maes, and Mark Tilden.[22] They point to the importance of having agents who can learn from interactions with a physical environment. Simulations, they believe, are limited by the artificiality of their context. Compared to the rich variety and creative surprises of the natural world, simulations are stick worlds populated by stick figures. Among the eloquent spokespersons for this approach is Rodney Brooks. When I talked with him at his MIT laboratory, he mentioned that he and Hans Moravec were roommates in college (a coincidence almost allegorical in its neatness). As his senior project, Moravec had built a robot that used a central representation of the world to navigate. The robot would go a few feet, feed in data from its sensors to the central representation, map its new position, and move a few more feet. Using this process, it would take several hours to cross a room, and if anyone came in during the meantime, it would be thrown hopelessly off. Brooks, a loyal roommate, stayed up late one night to watch the robot as it carried out its agonizingly slow perambulation. It occurred to him that a cockroach could accomplish the same task in a fraction of the time, and yet the cockroach could not possibly have as much computing power aboard as the robot. He decided that there had to be a better way and began building robots according to a different philosophy.

In his robots, Brooks uses what he calls 'subsumption architecture'. The idea is to have sensors and actuators connected directly to simple finite-state machine modules, with a minimum of communcation between them. Each system 'sees' the world in an entirely different way from the others. There is no central representation, only a control system that kicks in to adjudicate when there is a conflict between the distributed systems. Brooks

points out that the robot does not need to build a coherent concept of the world; instead it can learn what it needs directly through interaction with its environment. The philosophy is summed up in his aphorism: the world is its own best model.[23]

Subsumption architecture is designed to facilitate and capitalize on emergent behavior. The idea can be illustrated with Genghis, a six-legged robot, somewhat resembling an oversized cockroach, that Brooks hopes to sell to NASA as a planetary explorer.[24] Genghis's gait is not programmed in advance. Rather, each of the six legs is programmed to stabilize itself in an environment that includes the other five. Each time Genghis starts up, it has to learn to walk anew. For the first few seconds it will stumble around; then, as the legs begin to take account of what the others are doing, a smooth gait emerges. The robot is relatively cheap to build, more robust than the large plantary explorers NASA currently uses, and under its own local control rather than dependent on a central controller who may not be on site to see what is happening. 'Fast, cheap, and out of control' is another aphorism that Brooks uses to sum up the philosophy behind the robots he builds.

Brooks's program has been carried further by Mark Tilden, a Canadian roboticist who worked under Brooks and is now at the University of Waterloo. Tilden grew up on a farm in Canada and was struck by how chickens ran around after they had their heads cut off, performing, as he likes to put it, complicated navigational tasks in three-dimensional space without any cortex at all. Tilden decided that considerable computation had to be going on in the peripheral nervous system. He used the insight to design insect-like robots that operate on nervous nets (considerably simpler than the more complex neural nets) comprised of no more than twelve tran-sitor circuits. These robots use analog rather than digital computing to carry out their tasks. Like Genghis, their gait is emergent. They are remarkably robust, able to right themselves when turned over, and can even learn a compensatory gait when one of their legs is bent or broken off. [25]

Narratives about the relation of these robots to humans emerge when Brooks and others speculate about the relevance of their work to human evolution. Brooks acknowledges that the robots he builds have the equiv-alent of insect intelligence. But insect intelligence is, he says, nothing to sneer at. Chronologically speaking, by the time insects appeared on earth, evolution was already 95per cent of the way to creating human intelli-gence.[26] The hard part, he believes, is evolving creatures that are mobile and can interact robustly with their environment. Once these qualities are in place, the rest comes relatively quickly, including the sophisticated cognitive abilities that humans possess. How did humans evolve? In his view, through the same kind of mechanisms that he uses in his robots, namely distributed systems that interact robustly with the environment and that consequently 'see' the world in very different ways. Con-

sciousness is a relatively late development, analogous to the control system that kicks in to adjudicate conflicts between the different distributed systems. It is, as Brooks likes to say, a 'cheap trick', that is, an emergent property that increases the functionality of the system but that is not part of system's essential architecture. Consciousness does not need to be, and in fact is not, representational. Like the robot's control system, consciousness does not need an accurate picture of the world; it only needs a reliable interface. As evidence that human consciousness works this way, Brooks adduces the fact that most adults are unaware that they go through life with a large blank spot in the middle of their visual field.

This reasoning leads to yet another aphorism that circulates through the Alife community: consciousness is an 'epiphenomenon'. The implication is that consciousness, although it thinks it is the main show, is in fact a latecomer, a phenomenon dependent on and arising from deeper and more essential layers of perception and being. The view is reminiscent of the comedian Emo Phillips's comment. 'I used to think that the brain was the most wonderful organ in the body', he says. 'But then I thought, who's telling me this?' It would be difficult to imagine a position more contrary to the one Hans Moravec espouses when he equates human subjectivity with consciousness. In this respect Moravec aligns with artificial intelligence (AI), whereas Brooks and his colleagues align with artificial life (AL). Michael Dyer, in his comparison of the two fields, points out that whereas AI envisions cognition as the operation of logic, AL sees it as the operation of nervous systems; AL starts with human-level cognition, AI with insect- or animal-level; in AI, cognition is constructed as if it were independent of perception, whereas in AL it is integrated with sensory/motor experiences.[27]

The comparison of AI and AL also illuminates how much the construction of the human has changed. The goal of artificial intelligence was to build inside a machine an intelligence comparable to that of a human. The human was the measure, the machine the attempt at instantiation in a different medium. Witness the Turing test, dating from the early days of this era, which defined success as building a machine intelligence that cannot be distinguished from a human intelligence. By contrast, the goal of artificial life is to evolve intelligence within the machine through pathways found by the 'creatures' themselves. Human intelligence, rather than serving as the measure to judge success, itself is reconfigured in the image of this evolutionary process. Whereas AI dreamed of creating consciousness inside a machine, AL sees human consciousness, understood as an epiphenomenon, perching on top of the machine-like functions that distributed systems carry out. Here the machine becomes the model for understanding the human.

In drawing this general comparision, I do not mean to imply that the arrows in this discursive field all point the same way. A review of

the different ways in which Moravec, Ray and Brooks line up will serve to indicate some of the complexities at work. Moravec and Ray both see the evolution of intelligence within machines tied up with bodies of information. For Ray, this means that the genotype of his 'creatures' merges with the phenotype; for Moravec, it means that the body as a physical object is dispensible once the information pattern of the mind is recorded. Brooks and Ray side with each other in taking a 'bottom up' approach to the evolution of intelligence, but they differ on the importance of having physical bodies that are not just bodies of information. Brooks stresses the importance of physically interacting with a real environment, while Ray is content to stay with the simulated 'world' inside the computer. Moravec equates consciousness with human subjectivity, whereas Brooks sees consciousness as an epiphenomenon that emerges out of more essential processes. They concur, however, in seeing silicon life-forms as an alternative evolutionary pathway to carbon-based life. Moravec may see the evolutionary torch being passed from human to machine more vividly than Brooks, but they are both working to bring about that transition.

My point in setting up these comparisons is not to argue that the premises are incorrect or that the goals are wrong-headed, although in some instances (such as Moravec's fantasy of downloading human consciousness into a computer) I believe they are. (In other cases, for instance Ray's bottom-up approach and Brooks' subsumption architecture, the research is remarkably promising and interesting.) Rather, I have sought to demonstrate how the narrative field in which these projects position themselves is constructed and how it works to encode premises, authenticate inquiry, and interpolate scientific research programmes with larger cultural narratives. My argument is aimed specifically against those who maintain that scientific inquiry transcends culture, that it does not matter where or by whom it is carried out or in what cultural contexts it is embedded. Even positing this view of transcendent science requires that one tell a story, in this case a story about how science tells truth and about how truth is the same no matter who says it. The story that I have told, by contrast, is about situated inquiry, about contesting for the right to determine which research is recognized as valid and interesting, about the subtle and complex ways in which culture produces science and science produces culture. As humans on the brink of what some see as an evolutionary threshold, we cannot afford to blind ourselves to these interactions, for the narratives which produce artificial life, and are produced by it, affect us all.

NOTES

1 Thomas S. Ray, 'A proposal to create two biodiversity reserves: one digital and one organic', presentation at Artificial Life IV, Cambridge, Mass., July 1994.

2 Thomas S. Ray, 'An evolutionary approach to synthetic biology: Zen and the art of creating life', *Artificial Life* I, 1/2 (Fall 1993/Winter 1994): 179–209, especially 180.

3 Luc Steels offers useful definitions of emergence in 'The artificial life roots of artificial intelligence', *Artificial Life* I, 1/2 (Fall 1993/Winter 1994): 75–110. He distinguishes between first-order emergence, defined as a property not explicitly programmed-in, and second-order emergence, an emergent behaviour that adds additional functionality to the system. In general Alife researchers try to create second-order emergence, for then the system can use its own emergent properties to create an upward spiral of continuing evolution and emergent behaviours. James P. Crutchfield makes a similar point in 'Is anything ever new? Considering emergence', in G. Cowan, D. Pines and D. Melzner (eds) *Integrative Themes*, Santa Fe Institute Studies in the Sciences of Complexity XIX, Redwood City, CA: Addison-Wesley (1994): 1-15.

4 The Tierra program is described in Thomas S. Ray, 'An approach to the synthesis of life', in Christopher G. Langton, Charles Taylor, J. Doyne Farmer and Steen Rasmussen (eds) *Artificial Life* II, Proceedings Volume X, Santa Fe Institute Studies in the Sciences of Complexity, Redwood City, CA: Addison-Wesley (1992): 371–408. 'An evolutionary approach to synthetic biology' explains and expands on the philosophy underlying Tierra: working paper, ATR Human Information Processing Research Laboratories, Kyoto, Japan. Further information about Tierra can be found in 'Population dynamics of digital organisms', Christopher G. Langton (ed.) *Artificial Life* II *Video Proceedings*, Redwood City, CA: Addison-Wesley (1991). A popular account can be found in John Travis, 'Electronic ecosystem', *Science News* 140, 6 (10 August 1991): 88–90.

5 'Simple rules . . . complex behavior', produced and directed by Linda Feferman for the Santa Fe Institute, 1992.

6 Richard Dawkins, *The Selfish Gene,* 1st edn, Oxford: Oxford University Press. (1976).

7 William Gibson, *Neuromancer* (New York: Ace, 1984).

8 In 'An evolutionary approach', Ray writes that 'The "body" of a digital organism is the information pattern in memory that constitutes its machine language program', see note 2 above, 184.

9 Quoted in Stefan Helmreich, 'Anthropology inside and outside the looking-glass worlds of artificial life', unpublished manuscript (1994), 11. An earlier version of this work was published as a working paper at the Santa Fe Institute under the title 'Travels through "Tierra", Excursions in "Echo": anthropological refractions on the looking-glass worlds of artificial life', 24 August 1994. Helmreich included in this version some remarks that the administrators of SFI evidently found offensive, including comments that likened a belief in the 'aliveness' of artificial life to other cultural beliefs that people who are not anthropologists may find strange. Objecting that Helmreich's work was not scientific and that it misrepresented the science done at SFI, the administrators had the working paper removed from the shelves and deleted from the list of available publications.

10 Christopher, G. Langton (ed.) 'Artificial Life', in *Artificial Life* (Redwood City, CA.: Addison-Wesley, 1989), 1–47, especially 1.

11 Richard Doyle has written on the simplification of body to information in the human genome project in *On Beyond Living: Rhetorics of Vitality and Post-Vitality in Molecular Biology*, doctoral dissertation, University of California at Berkeley (1993).

12 Actually, both inference and deduction are at work in most Alife research, as they usually are in scientific projects. Alife researchers study the complex → simple route for clues on how to construct programs that will be able to move from simple → complex.

13 Christopher Langton, 'Artificial Life': 1.

14 Helmreich: 5.

15 Edward Fredkin, quoted in Richard Wright, 'The on-off Universe', *The Sciences* (January-February, 1985),7.

16 Christopher Langton, 'Editor's introduction', *Artificial Life* I, 1/2 (Fall 1993/ Winter 1994): v-viii, especially v-vi.

17 Walter Fontana, Gunter Wagner and Leo W. Buss, 'Beyond digital naturalism', *Artificial Life* I, 1/2 (Fall 1993/Winter 1994): 211–27, especially 224.

18 Thomas S. Ray, 'An evolutionary approach': 179–210.

19 Hans Moravec, *Mind Children: The Future of Robot and Human Intelligence* (Cambridge: Harvard University Press, 1988).

20 A.G. Cairns-Smith, *Genetic Takeover and the Mineral Origins of Life* (Cambridge: Cambridge University Press, 1982).

21 Antonio D'Amasio, *Descartes' Error: Emotion, Reason, and the Human Brain* (New York: G.P. Putnam, 1994).

22 See Patti Maes, 'Modeling adaptive autonomous agents', *Artificial Life* I, 1/2 (Fall 1993/Winter 1994): 135–62; Rodney Brooks, 'New approaches to robotics', *Science* 253 (13 September 1991): 1227–32; Mark Tilden, 'Living machines – unsupervised work in unstructured environments', Los Alamos National Laboratory, CB/MT-v1941114.

23 Rodney A. Brooks, 'Intelligence without representation', *Artificial Intelligence* 47 (1991): 139–59.

24 Genghis is described, among other places, in Rodney A. Brooks and Anita M. Flynn, 'Fast, cheap, and out of control: a robot invasion of the solar system', *Journal of the British Interplanetary Society* 42 (1989): 478–85.

25 Mark Tilden lectured and demonstrated his mobile robots at the Center for the Study and Evolution of Life, University of California, in January 1995.

26 Brooks, 'Intelligence without representation'.

27 Michael G. Dyer, 'Toward synthesizing artificial neural networks that exhibit cooperative intelligent behavior: some open issues in artificial life', *Artificial Life* I, 1/2 (Fall 1993/Winter 1994): 111–35, especially 112.

Posthuman unbounded
Artificial evolution and high-tech subcultures

Tiziana Terranova

My story about 'posthumanism' (the belief in artificially enhanced evolution) in the high-tech subcultures is, in a certain sense, a tale whose main plot-line has been repeated and rehearsed many times before, another story about a seemingly unstoppable confusion of boundaries.

The kind of boundaries I have decided to focus on, however, are not simply the deliciously fluid or earnestly hard boundaries between human flesh, electronic chip, gene-splicing chemical sequences, and stainless steel. If the postmodern imagination seems somehow to have come to terms with, rejoiced in, or simply taken for granted such unions, there are other boundaries, and other interchanges that still make us uncomfortable, boundaries we would like to see not disrupted, but sealed, separated, tidily split in a dialectical antagonism where action is still possible.

The boundaries that these self-reflexive stories seem to disrupt are those between 'progressive' political discourses and the frightfully lively imagination of a 'conservative futurist' view of the world where, to quote the Sicilian novelist Tomasi di Lampedusa, 'everything has to change so that everything can stay the same'.

This is a story at whose near horizon looms the nightmare of the truly uncanny cyborgism of the Republican House Speaker, Newt Gingrich, whose monstrous futurist conservatism makes the amused headlines of American newspapers in these early days of 1995[1]: an utopic cyberfuture of 'third-wave' technologies and wired orphanages; a virtual town-hall for direct decision-making by local communities deliberating about access to health care by 'alien' citizens. The boundaries between electronic liberalism, anarchism, socialism and conservatism are therefore the places where I have chosen to tell my story about the monstrous mutations of the cybercultural discourse.

ORIGINARY STORIES

In a certain sense, rudimentary versions of 'posthumanity' have circulated in western culture at least since Friedrich Nietszche and the high-tech

modernist avant-garde represented by the Italian Futurists and the German Dada. A rhetoric of simulation, media-originated epochal shifts, and enhanced evolutionism by artificial means are also available in the writings of people like Jean Baudrillard, Marshall McLuhan and Timothy Leary. In the sphere of popular culture, mutated bodies and superhuman intelligences have populated the SF imagination since its very beginnings, but it is only through the activity of the cyberpunk SF group in the mid-1980s that a synergetic movement between developing subcultures interested in the new developments in biotechnology and computer-mediated communication (CMC) really took off.

The American West Coast mutation of the cyberpunk imagination as expressed by *Mondo 2000'* s New Edge, the socially varied experience of the new on-line population, the complex national varieties of subcultures and political movements that grafted themselves on images and tropes vividly illustrated in the cyberpunks' fiction, are all part of a cultural landscape in many ways still in the making.

In *Mirrorshades,* the mythical anthology of 'originary' cyberpunk fiction, Bruce Sterling made a significant contribution to the propagation of a new, wired variety of 'posthumanism'. Beyond turning what had mostly been 'computer nerds' into 'cyberpunks', in his manifesto Sterling literally produced a new 'body', one thoroughly invaded and colonized by invisible technologies: 'Eighties tech' Sterling opened our eyes to almost ten years ago, 'sticks to the skin, responds to the touch: the personal computer, the Sony Walkman, the portable telephone, the soft contact lenses'(Sterling 1986: xiii).

In Sterling's preface, such harmless devices are reconstructed so as to become the evident truth of a 'redefinition of the nature of humanity' and 'the nature of the self'. The year before, Sterling had published the novel *Schismatrix* (1985), representing a far future where humanity will have expanded in space and learned to alter its biological frame for efficiency and longevity; the term 'posthuman' is used here to describe a particular philosophy evolving into the *Schismatrix,* the solar system, but also an existing race of mutated human beings; the 'posthuman' or 'shaper/mechanist' theme is also the object of a series of short stories collected in the anthology *Crystal Express* (1989).

The extraordinary popularity of some of William Gibson's most imaginative icons (the famous 'sockets' connecting human brains to computers, the grafted microtechnology remoulding the highly efficient body of his favourite heroine, Molly Millions, the virtual existence of his millionaires) has turned his fiction into an almost 'biblical' repertoire of images and cultural references whose contribution to the creation of the electronic culture as a whole cannot be underestimated.

If the meaning and the implications of these cybernetic bodies, both in their literary manifestations, and in the huge popularity of Hollywood

cybericons, have been object of intense critical attention, other places where the posthuman body has implanted and mutated itself are perhaps of greater interest at this stage.

I am thinking in particular of the variations of posthumanism represented by *Mondo 2000*'s New Edge, the esoteric technocults practised by the Extropians, or the discussions on-line on the presence/absence/mutation of the body following intensive exposure to electronic communication. Beyond offering an interesting point of view on the high-tech imagination of some of the contemporary techno-tribes, these stories might help us also to understand, almost by the back door, important ideas about access and social change as developed by these strategically crucial subcultures.

POSTHUMANISM

The first echoes of the 'posthuman' theme in the electronic culture can be traced to the postulation of a postbiological age by *Omni* magazine in 1989 ('Interview to Hans Moravec'); and the publication on the pages of the *Whole Earth Review* in the 1988/9 issue of a forum entitled 'Is the Body Obsolete?'. In 1988 'Max More' and 'Tom Morrow' founded the *Extropy* journal and in 1990 the transformation of hip magazine *Reality Hackers* into *Mondo 2000* gave posthumanism its ultimate edge.

Both in recent academic critical theory and in various magazines interested in high tech, descriptions of posthuman evolutionism have circulated as a kind of acquired common sense for the insiders, and a potentially revolutionary revelation for the uninitiated.[2]

The story-line underlying most of these statements can be summarized in this way: there has been a huge ontological shift not only in the nature of human society, but in that of our very bodies. This mutation has been brought about, on the one hand, by the exposure to simulated images in the most traditional media, and, on the other, by the slow penetration into our daily life of almost invisible technological gadgets, from contact lenses to personal computers. This process of 'invasion' of the human body and psyche by the machine is destined to increase over the years (it is already doing it spectacularly) and give rise to a potentially new race of human beings whose symbiosis with the machine will be total. Most of the commentary by the high-tech subcultures about this phenomenon has been positive, in spite of the fact that most of cyberpunk fiction is far from optimistic on this turn of 'technology as history as destiny' (which seems to have replaced 'natural biology' as destiny).

The nature and the tone used by the groups who adopted the posthuman motif is far from homogeneous: it ranges from total commitment to the cyberpunk ethos mixed up with leftovers from the psychedelic movement in *Mondo 2000,* to an anti-consumerist, situationist magazine such as

Adbusters.[3] The posthuman pops up in the autonomist Italian *Decoder,* and it is at the centre of the philosophy advocated by the Extropy Institute.

For reasons of space I have chosen to focus on two examples: one is an extract from one of the first issues of the California-run magazine *Mondo 2000.* The other comes from the various statements expressed in different publications, on-line and printed, by the Extropian group, a loose organization devoted to the discussion of artificially enhanced forms of evolution.

Mondo 2000, born from the ashes of *Reality Hackers* under the guide of R.U. Sirius and Queen Mu, is the glossiest and the hippest of the cyber-magazines and possibly the most famous – certainly, as the editor of *bOING bOING* has noticed, the one with the heaviest financial back-up. It is the one which has attracted the widest range of writers from the cyberpunk ranks (Sterling, of course, and the mathematician Rudy Rucker, a regular contributor and almost one of its editors); *Mondo 2000*'s rhetoric of the New Edge is an ambitious attempt to fuse psychedelic sixties counterculture (Timothy Leary is one of its godfathers), New Age rhetoric and cyberpunk.[4]

The following feature is collected in *Mondo 2000: A User's Guide to the New Edge,* and is part of a section on 'Evolutionary mutation' written by the chief editor R.U. Sirius:

> Ultimately, the New Edge is an attempt to evolve a new species of human being through a marriage of humans and technology. We are ALREADY cyborgs. My mother, for instance, leads a relatively normal life thanks to a pace-maker. As a species, we are moving toward replaceable parts. Beyond that, genetic engineering and nanotech-nology ... offer us the possibility of literally being able to change our bodies into new and different forms. ... Hans Moravec, director of the Mobile Robot Lab at Carnegie-Mellon University in Pittsburgh, has investigated three possibilities, and he believes that a form of post-biological humanity can be achieved within the next fifty years.
>
> Think about it. The entire thrust of modern technology has been to move us away from solid objects and into information space (or cyber-space). Man the farmer and man the industrial worker are quickly being replaced by man the knowledge worker. ... We are less and less creatures of flesh, bone, and blood pushing boulders uphill; we are more and more creatures of mind-zapping bits and bytes moving around at the speed of light.[5]

The flamboyant rhetoric of this piece is remarkably reminiscent of Sterling's manifesto: the posthuman, on the one hand is already here – the homely image of mum with the pace-maker – and at the same time still in the future – creatures of mind-zapping bits and bytes moving around at the speed of light, Supermen for the electronic age. This collapse

of present and future, domesticity and science fiction, is characteristic of the style of *Mondo 2000* as a whole. It is also interesting to note another of *Mondo*'s characteristic touches, the quote of a 'legitimate' scientist working either for a university or some established lab, in this case cyber-cultural superhero Hans Moravec.

As the Mechanoids and the Shapers in *Schismatrix,* or as Molly and Case in *Neuromancer,* human species will move either in the direction of an intensification of bodily performativity or towards the ultimate flight from the body cage.[6] In either way the human body will undergo a total ontological transformation that *Mondo 2000* feels justified in calling the New Edge. Noticeably the only differentiating factor accompanying the unadulterated, obsolete, universalized human body in this transformation, is his/her ability to 'surf' the New Edge. This ability, as we will explore in some detail later on, is of course directly proportional to one's skills at manipulating these new technologies – something that should tip us off, if we do not consider ourselves as already safely part of the techno-savant crowd, that not everybody will go through the posthuman magic gate at the same pace. The 'edge' that the aspiring posthumans have to learn to surf, can be (and it is) uncannily doubled into an 'evolutionary' edge whose possible origins might be themselves 'genetic'.

Mondo 2000 portrays its readers, the 'surfers' of the New Edge, not only as people characterized by an interest for new technologies, but also as possessing qualities such as 'an independent spirit, a wildly speculating mind, limitless imagination and daring' – a description that could have been given at the beginning of the century for the first, fabulously rich, self-made tycoons, and today quite a good self-portrait of the new 'creative', 'enterpreneurial' crowd. This aggressively future-oriented group is often contemptuously opposed to the 'talk show' crowd, addicted to an old-fashioned technology, television. Quite familiarly and providing a weird resonance to the other image of 'my mother with a pace maker', in an interview to *Ben Is Dead,* R.U. Sirius refers to 'this whole talk-show-as-new-electronic-forum thing' as a scary phenomenon, 'given the preponderance of bored housewives with nothing better to do than get all twitchy over different people's sexual difference'.[7] The association television/femininity/dumbness/addiction is one that is found early on in the portrait of the addiction of Bobby Newmark's mum to soap operas in Gibson's *Count Zero,* and is part of a significant strategy of oppositions and analogies defining the identity both of the new 'interactive' tech-nologies (as opposed to television) and their 'active' users (as opposed to feminine passivity).

It is part of *Mondo 2000*'s ideological foundations, in fact, that access to technology and technological enhancement is provided by certain person-ality types. R.U. Sirius, again, describes one of the goals of the magazine as the amplification of the 'productive' myth of the 'sophisticated,

high-complexity, fast-lane/real-time, intelligent, active, and creative reality hacker', the social subject able to catch up with a technological development vastly beyond the reach of the 'dulled, prosaic, practically-minded, middle-of-the-road public'.[8]

There is no appreciation of, or consideration for, social or economic limitations which impede access to different technologies. In *Mondo 2000*'s rhetoric of avant-gardism there is no space for social, economic or cultural handicaps in the race toward technological appropriation and post-humanism, but only the individual 'fitness' for technological survival.

One of the conditions that makes possible and explains this neglect of technoliteracy questions on the side of *Mondo 2000*, is, undoubtedly, the constitution of its audience, new professionals working in the electronic businesses (graphic, multimedia, music), people whose relationship to this new technology is both lucrative and creative, as *Mondo*'s editor very well knows, 'A large portion of our audience is successful business people in the computer industry, and in industry in general, because industry in the United States is high-tech'.[9]

Of course, as Andrew Ross suggests, we should be careful in giving a 'literal interpretation of what is essentially a utopian injection on the part of an experimental counterculture'.[10] On the other hand, the tech-counterculture is not the only group eager to embrace the posthuman faith, and the permutations on the theme are too widespread to be taken as isolated, provocative statements.

The activity of the Extropy Institute, in California, is another example of posthumanism which takes the technological liberating promises made by the dominant culture ways more seriously. The Extropians include a different segment of that same professionalized group catered to by *Mondo 2000*'s countercultural rhetorics. As their FAQ (frequently asked questions) file tells us,

> Extropians have made career choices based on their extropian ideas; many are software engineers, neuroscientists, aerospace engineers, cryptologists, privacy consultants, designers of institutions, mathematicians, philosophers, and medical doctors researching life-extension techniques. Some extropians are very active in libertarian politics, and in legal challenges to abuse of government power.

Extropians, in a certain sense, belong in a different kind of subculture, even more heavily professionalized than *Mondo 2000's* and with less sympathy for music and art or the Burroughsian rhetoric taken for granted by *Mondo 2000*'s audience.

Extropians publish their own magazine (*Extropy*), have their own newsgroup on Usenet, and their electronic mailing list.[11] The *Extropian Manifesto* is available on the Internet, while the official Extropy Institute commercially runs the electronic mailing list. The commercialization of

the mailing list is, according to them, a way to keep it a place of 'discussion *among* extropians, and not for constant debating with outsiders' (Extropians FAQ).

The main tenets of Extropianism are 'boundless expansion, self-transformation, dynamic optimism, intelligent technology, and spontaneous order'. The goal of Extropianism is to enable those who want to be at the vanguard of the incumbent transformation into a 'posthuman' age. In the file 'Extropians FAQ', 'transhumanism' and 'posthumanism' are so identified:

Q3. What do 'transhuman' and 'posthuman' mean?

A3. TRANSHUMAN: We are transhuman to the extent that we seek to become posthuman and take action to prepare for a posthuman future.

This involves learning about and making use of new technologies that can increase our capacities and life expectancy, questioning common assumptions, and transforming ourselves ready for the future, rising above outmoded human beliefs and behaviours.

TRANSHUMANISM: Philosophies of life (such as the Extropian philosophy) that seek the continuation and acceleration of the evolution of intelligent life beyond its currently human form and limits by means of science and technology, guided by life-promoting principles and values, while avoiding religion and dogma.

POSTHUMAN: Posthumans will be persons of unprecedented physical, intellectual, and psychological ability, self-programming and self-defining, potentially immortal, unlimited individuals. Posthumans have overcome the biological, neurological, and psychological constraints evolved into humans. Extropians believe that the best strategy for attaining posthumanity to be a combination of technology and determination, rather than looking for it through psychic contacts, or extraterrestrial or divine gift. [sic]

Posthumans may be partly or mostly biological in form, but will likely be partly or wholly postbiological – our personalities having been transferred 'into' more durable, modifiable, and faster, and more powerful bodies and thinking hardware. Some of the technologies that we currently expect to play a role in allowing us to become posthuman include genetic engineering, neural-computer integration, molecular nanotechnology, and cognitive science.

This version of 'posthumanism' is quite distant from the popular iconography of the cyberpunk, and the affinity between the two groups is quite limited. The Extropians are, therefore, a social group quite different both from the hard cyberpunk of the hacker magazine *2600,* or the

techno-artistic crowd of *Mondo 2000*. It would be possible to recognize in the Extropians the result of the convergence of other traditions, like the technological utopianism and the technocratic movement of the early twentieth century whose belief that there are technological solutions to social problems is shared by the Extropians.[12] On the other hand their emphasis both on the 'voluntary' and 'individually-planned' nature of mutation, and on physical evolution beyond the boundaries of humanity as we know it, are new developments that link them more closely to the variation of posthuman evolutionism represented by *Mondo 2000*.

Most of the evolutionary mutations envisaged by the Extropians are part of the cyberpunk folklore (neural interfaces, nanotechnology, genetic engineering), and the same label 'posthuman' is a legacy of cyberpunk fiction. Nevertheless the future visions of Extropians are surprisingly empty of the dingy dystopianism of cyberpunk fiction, which still lingers somehow even around the propagandistic hype of a publication like *Mondo 2000* (what Vivian Sobchack has defined its 'utopian cynicism').[13]

Another manifestation of this uneasy confusion of boundaries inside cyberculture between differently inspired interpretations of technological progress is the publication of the Extropian Manifesto on the pages of the Italian independent magazine *Decoder*.[14] *Decoder* is fairly representative of the enthusiasm and the receptivity to cyberpunk among European autonomist and extreme leftist groups. Although often critical of *Mondo 2000*'s politics, *Decoder* has been fairly active in keeping up international cooperation between different groups involved in computer counter-politics. They have translated and published from French, British, German, Dutch and American sources.

Decoder sees in the electronic revolution taking place in the western world a possibility of positive, radical mutation of the social system in ways that overlap but differ also considerably from those of their American colleagues. The political affiliations of *Decoder* are clearly to the left of the Italian ex-Communist party, rooted in the tradition of the anarcho-marxism of the extra-parliamentary groups. The specific political and cultural problems of this milieu have shaped the Italian interpretation of cyberpunk as heralded by *Decoder:* in this context, cyberpunk has been turned into a political commentary on technological development and social change alternative to both the 'industrialist', orthodox marxist paradigm and the 'postmodern' socialism of the Italian ex-Communist party. The publication of the *Extropian Manifesto* is part of their politics of diffusion of international, provocative publications on the subject of technology.

In the editor Raffaele Scelsi's words, Italian cyberpunk's 'political tension is oriented towards the reappropriation of communication by social movements, through the constitution of alternative electronic networks which could finally affect the excessive power of multinationals

in the field'.[15] The Extropians, on the other hand, seem to be rooted in a different kind of libertarian anarchism, which expresses itself in their faith in the self-regulatory nature of the 'free market':

> The principle of spontaneous order is embodied in the free market system – a system that does not yet exist in a pure form. (...) The free market allows complex institutions to develop, encourages innovation, rewards individual initiative, cultivates personal responsibility, fosters diversity, and decentralizes power. Market economies spur the technological and social progress essential to the Extropian philosophy. (...) Expert knowledge is best harnessed and transmitted through the superbly efficient mediation of the free market's price signals – signals that embody more information than any person or organization could ever gather.

The publication of the *Extropian Manifesto* on the pages of *Decoder* poses therefore some puzzling questions that could be explained by the partial ignorance by European cyberpunk publications of the American scene or their desire to construct an international cyberpunk network that would validate and reinforce the cultural and political position they are trying to build for themselves. On the other hand, it is more interesting to consider it as a signal of the unresolved contradictions embedded at the heart of the high-tech subculture. Beyond the common debt to cyberpunk fiction and their interest in the same cutting-edge technologies there seems to be no clear and elaborate articulation of differences at this stage. This absence of a constructive and articulated internal debate might be the result of the cohesive effect produced by the widespread hostility still perceived coming from the 'outside'. Too many energies, perhaps, are still spent rejecting outdated ethical and religious objections to technology. Cyberculture is still too busy building its defensive walls to care to look too closely at its own increasingly complex and fragmented anatomy.

THE PROBLEM WITH EVOLUTION

The most distinguishing common trait between the cyberpunk, Extropian, and *Mondo 2000*'s treatment of the 'posthuman' theme is the inability to introduce patterns of differentiations and complexity in their portrait of the future as teleological evolution. As an expression of a subculture that encourages a 'subversive' use of technology, there is little problematization of the ways in which technological change can be and is being shaped by economic and political forces. In particular, this evolutionary trend is represented as existing 'outside' the contentious history of the social uses of 'evolutionary' principles in the United States.[16] It is worth remembering here, while boundaries keep blurring fairly disturbingly, the popularity of mass IQ testing at the beginning of the century as a way to reinforce

racial differences within the ideological frame given by social Darwinism. A disturbing pattern of historical continuity has recently brought to the centre of widespread discussion these same patterns of interpretation in the infamous bestseller *The Bell Curve.*[17] Murray and Herrnstein's focus on 'smartness' and 'cognitive stratification' creates the fiction of a 'cognitive disadvantage' distributed across racial coordinates as an elegant way out from embarrassing discussions about the effect of historically specific economic and cultural policies.[18] IQ testing, race discrimination and cognitive fatalism live together uneasily, dormant in the unconscious of some of these high-tech subcultures, which certainly would not recognize them as part of their 'radical' and hopefully 'progressive' imagination.

On the other hand, biological determinism, which is more or less the message given by works such as *The Bell Curve,* is a label that is too narrow and unfair to describe the belief in individual fitness in techno-evolution: it is, nevertheless, important to examine carefully these voices' uneasy and hidden connections. Believers in posthumanism are not so much saying, 'we are what our genes say we are' but 'we are what we want to be', and, 'thanks to technology, there are no limits to what we can be'. In this triumph of the will society is erased, and the social universe emerges as a fragmented aggregate of individuals in a void without historical and material constraints. Not primarily biological determinism, then, but *rampant super-voluntarism* is the problem with cybernetic posthumanism.

It is necessary at this point to perform the dangerous jump from these limited uses of a provocative trope such as 'posthumanism' to the textual oceans of electronic networks at large. If this jump does not produce an exhaustive and conclusive account of what the Internet and associated networks think exactly, it will try, on the other hand, to sketch the contours of a general consensus (if any such thing is possible) in the most self-reflexive and argumentative Usenet newsgroups.

IN THE NET

The opinions and the arguments developed in the Usenet newsgroups considered here (alt.cyberpunk, alt.cyberpunk.movement, alt.internet.media-coverage, alt.cyberspace, alt.politics.datahighway, alt.current-events.net-abuse) are not homogenous and represent only a portion of the discussions going on among Internet aficionados all over the world. Regular contributors to these newsgroups, on the other hand, are careful readers and heated debaters, and the ideas thrown around in these weeks-long arguments feed on, and very often feed back to, the writings of more public voices, all of which contribute to the creation of an unstable consensus among 'netsurfers' about what electronic communication is about.

In this context, 'posthumanism' is not only one of the excessive mani-festations of the cybercultural spirit, it is also a useful gateway into cyber-cultural discourse at large, intersecting with one of its most ferociously preserved opinions: computer-mediated communication will change signif-icantly the world as we know it in as much as it will involve a collective evolution from the passive consumption of corporation-dominated media to interactive, symbiotic relationships with intimate machines. This belief is not coincident with posthumanism (of which it could be said to repre-sent the utopic side) but is related to it and is itself fraught with disturbing contradictions.

The more generally shared faith in the power of individual self-transformation into 'cyborgian hybrids of technology and biology' over-laps, often disturbingly, with the evolutionary posthumanism described above. Here is a fairly typical statement about on-line cyborgism as expressed by one of the participants in alt.cyberpunk;

> I think that the boundary of 'self' is growing larger and approaching undefinable. Right now with text we are on a lower level, not quite in total telepresence and virtual reality, but still you can see our little buds of flesh growing behind our ears where we will be ready for such things. People who participate now in this, will have much less trouble when we reach total immersion VR and telepresence, as they are used to their self bieng [sic] mutated and expanded. Not virus, but a fuzzying of physical boundaries, not only of nations, but also the individual body adn [sic] self.

In this 'weak' version, 'posthumanism' is not even named as such, but it resurfaces in the vision of a collective 'cyborgization' of society resulting from the individual act of tuning in: a transformation 'into cyborged hybrids of technology and biology through our ever-more-frequent interactions with machines, or with one another *through* technological interface'.[19]

These statements, although expressed in restricted circles of like-minded individuals, should not prevent us from remembering the fact that they are an expression of a widely felt belief. The idea that current regulars of the virtual communities are the avant-garde of a historical process that will soon be universal does certainly possess wider political currency at this stage. This vision of a wave of cognitive change spreading steadily, at virus-like speed, is expressed also through the evocative use of statistics describ-ing the rate of growth of the Net population, whose magnitude cannot but strike a chord in these 'scarcity', 'budget-obsessed' 1990s. [20]

The on-line population is extremely aware of being still, but not for long; the first wave of the 'wiring' of society, where their own lived experience of 'cyborgization' will be extended to the mass. In Mark Dery's words, 'these subcultural practices offer a precognitive glimpse of main-stream culture a few years from now, when ever-greater numbers of

Americans will be part-time residents in virtual communities.'[21] Dery is certainly in touch with the general mood of the electronic tribes (and the communication companies commercial hype) in envisaging the current experience of these electronic groups as the general experience of the masses in the near future.

This is where the 'posthumanist' theme becomes a variation of a more diffused individualist, voluntarist, avant-garde attitude widely shared by the electronically wired communities. As in *Mondo 2000*'s rhetoric, this is a language of action where mainstream, 'old' media such as television and newspapers play, more often than not, a villainous role in propagating one-way indoctrination and passivity in the mass public, while the Internet two-ways, active experience of logging 'in' provides the way 'out'.

> Well resistance implies opposition, but i [sic] see it more like moving sideways. For me it is using tech to help myself, and those around me. Wether [sic] it is making art form [sic] it, or helping people learn to use it. *It takes away the dependence peole [sic] have upon normal media, and the monopolies that control it. Which in turn eventually corrodes the hold the media has on people, and after that, it's only small step until they become really free. [sic]*
> (emphasis added)

> the only dirrection [sic] I could think of would be towards individual freedom thru [sic] the use of technology to breakt [sic] he [sic] mono[oly] [sic] of information held by the media and the control structure. [sic]

Of course there's nothing wrong in believing in the superiority of one medium of communication over another, especially when one (like TV) is heavily dominated by a commercial, monopolistic culture and the other is perceived as a free, anarchic universe almost uncontaminated by the powers-that-be. The most told and retold horror stories in the wired universe are stories about the corporate takeover of the Internet, the fatal 'clipping' of its wings in a nightmare of total surveillance;[22] the most repeated exorcism is that performed by the repeated re-enactment of the rhizomatic nature of the Net and its impermeability to any complete form of censorship – 'the net can't be bombed or censored out of existence', 'is not a single entity, solid, it is not an object or a controllable resource'.

In a certain way, there are also some beautiful stories being told here, stories we like to hear and believe in, stories that might come true if virtual communities hold on tightly enough against the various attempts by arch-villains 'big government' and 'big money' to colonize an electronic frontier where 'we' might be luckier natives this time. In this utopic sense, posthumanism could be really a 'cyborg dream'. The mobilization of the strategic fiction of an 'open-to-all', 'universally-accessed' or 'in-the-process-to-be-universally-accessed' Internet is itself useful in as much as

it is at this point an enabling strategy. These fictions allow collective mobilization in the form of electronic activism against imperialist projects of colonization such as those advocated by the Clinton administration with the infamous 'Clipper-chip' plan.

In spite of the strategic needs that these fictions serve, it is worth remembering in a longer-term perspective, the necessity to constantly critique 'the things that are extremely useful, things without which we cannot live on'.[23] One of these myths is, exactly, the strategically useful myth that if technologies (and especially CMC technologies) would be left on their own, they would naturally and spontaneously extend harmoniously to the entire population, making the experience of 'technologically enabled, postmulticultural' identities 'disengaged from gender, ethnicity and other problematic construction', universally achievable.[24]

These are the points where cyberculture offers the possibility of accommodation to various variations on the theme of 'conservative futurism' of which Newt Gingrich at the moment is just the most public version. His statement about favouring tax deductions for poor kids to buy laptops (subsequently named a 'dumb' idea) fits in with the New Right's call to individual empowerment. It is perhaps superfluous to remember here its rhetorical value in conservative rhetorics as the other face of the savage demolition of public mechanisms of social solidarity. Both cybercultural discourse and the new 'futurist conservatism' fall prey to the erasure of the cultural, economic, and political conditions enabling or restricting the social subject. Although fully supporting a policy of popularization of computer-access through the reduction of prizes, we should be aware of statements that link simplistically the accessibility of CMC, the jump into collective cyborgism, and the democratization of society as a whole only to market-availability of cheap hardware, software and E-mail accounts.

The establishment of a possible mass-use of electronic communication devices in the context of a political project aimed at overcoming current social inequalities, should be more than simply encouraging individuals to personal empowerment through technology. Any 'radical' use of CMC has to pass through the recuperation of the collective act of disavowal performed by most virtual communities regarding their current position in the jobless, two-tier, 'flexible' homework economy rampant in the mid-1990s.[25] It is this economy which has created the variety of occupations which is the much vaunted constituency of the Internet, a variety which is 'structurally dependent today on the primitive labour-regimes of minimally educated immigrant minorities in the dense metropolitan centers'.[26]

This article is not intended to be a condemnation of the virtual communities as a whole on the basis of the economic status of their dwellers: the point that I have tried to make is different. My critique is directed at those portions of the electronic community which earnestly believe in a

possible contribution given by CMC to the establishment of a world of more equally distributed material and cultural resources. The political activism of these communities is currently fundamental in limiting the consequences of the focusing of corporate and governmental interests on electronic communication.

If, as Howard Rheingold would like it to be, electronic communication can develop into a new, more competent form of citizenship, then the conditions producing the Internet citizen cannot be underestimated. The process of normalization of cyberspace, today taking place in the New Right's recent endorsements and in the boosterism of major communication companies, should not just be rejected as the external appropriation by interested parties of spontaneous and 'genuine' principles: at some level their rhetoric fits in smugly with the unacknowledged or willingly ignored contradictions affecting the most radical of the virtual communities. Haraway's cherished dream of cyborgism was placed against an economic, political and social order whose monstrous character needed desperately the exorcism of a possible utopian imagination. If the cyborg dream has any chance of being delivered, maybe we should learn to sleep less peacefully and, sometimes, even with both of our screen-reddened eyes wide open.

NOTES

1 Gingrich's version of 'third-wave' conservatism has been the object of the attention of several leading national newspapers and magazines since his nomination to House Speaker at the beginning of December 1994. Journalists have underlined the discontinuity and the potential schism between Gingrich's futurism and more conservative Republicans (see David E. Rosenbaum 'Time Warp Republicans like both previews and reruns', *New York Times*, 11 December 1994). The presence of Heidi and Alvin Toffler as close friends and counsellors of the House Speaker has also led somebody to suggest the existence of a 'conservative counterculture' in the making (cf. Steven Waldman 'Creating a Congressional Counterculture', *Newsweek*, 16 January 1995). Gingrich has also been recently patron to a conference called 'Democray in Virtual America' where the most distinguished speakers have been the Tofflers and Arianna Huffington (author of the new-ageish work *The Fourth Instinct*)(1994), New York: Simon & Schuster. The subject of course was the transition to the information age. Gingrich (stealing a classic SF motif amplified by cyberpunk) argued that 'we are not at a new place. It is just becoming harder and harder to avoid the place we are'. (cf. Maureen Dowd 'Capital's virtual reality: Gingrich rides a 3rd Wave', *New York Times*, 11 January 1995.)
2 See for variously nuanced versions of this story: Larry McCaffery (1991) *Storming the Reality Studio*, Durham and London; Duke University Press; Arthur and Marilouis Kroker (eds) (1988) *Body Invaders: Sexuality and the Postmodern Condition*, London: Macmillan; Arthur Kroker (1994) *Data Trash*, New York; St Martin's Press; Scott Bukatman (1993) *Terminal Identity*, Durham and London: Duke University Press.
3 See Jeffery Deitch (1994) 'Posthuman' in *Adbusters*, 3 (1), winter.

4 See Douglas Rushkoff, *Cyberia: Life in the Trenches of Hyperspace*, San Francisco: Harper, 1994.

5 See R.U. Sirius, 'Evolutionary mutation', in *Mondo 2000: A User's Guide to the New Edge*, London: Thames & Hudson, 1992, 100.

6 A useful analysis of the variety of cybernetic bodies in William Gibson is given by David Tomas, 'The technophilic body: On technicity in William Gibson's cyborg culture', *New Formations* 8, summer 1989, 113–129)

7 Ethan Port 'Perpetual cyber jack-off', in *Ben Is Dead*, summer 1993, 107–113, especially 113.

8 R.U. Sirius, 'The new edge', in *Mondo 2000: A User's Guide to the New Edge*: 195.

9 R.U. Sirius, quoted in 'Sex, drugs, & cyberspace', *Express: The East Bay's Free Weekly*, 28 September 1990: 12.

10 Andrew Ross, 'The new smartness', in Gretchen Bender and Timothy Druckrey (eds), *Culture on the Brink: Ideologies of Technology*, Seattle: Bay Press, 1994, 329–41, especially 335.

11 See also Ed Regis, 'Meet the Extropians', in *Wired*, October 1994: 102

12 On the technocratic movement of the 1930s, see Andrew Ross, *Strange Weather: Culture, Science and Technology in the Age of Limits*, London and New York: Verso, 1991.

13 See Vivian Sobchack 'New Age Mutant Ninja hackers: reading *Mondo 2000*', *South Atlantic Quarterly* 92 (4) (Fall 1993), 569–84.

14 See *Decoder* 8 September 1993. *Decoder* is published three times a year by the independent publishing house Shake and much of its staff comes from the ranks of La Conchetta, a squatted alternative centre in Milan.

15 See Raffaele Scelsi (ed.) Scelsi, Raffaele, *Cyberpunk: Antologia*, Milan, Shake Edizioni, 1990, 9.

16 On this subject, see Carl Degler, *In Search of Human Nature: The Decline and Revival of Darwinism in American Social Thought*, New York and Oxford: Oxford University Press, 1991.

17 Richard J. Herrnstein and Charles Murray, *The Bell Curve: Intelligence and Class Structure in American Life.*, New York, Free Press, 1994.

18 See Andrew Ross 'Demography Is Destiny', *Village Voice*, 29 November 1994: p. 95–6.

19 See Mark Dery, 'Flame Wars' *South Atlantic Quarterly 92 (4)* (Fall 1993), 564.

20 Here is Howard Rheingold's typical rhetoric of utopic, electronic communication boosterism: 'If a citizen today can have the telecomputing power only the Pentagon could afford twenty years ago, what will citizens be able to afford in telecommunication power five or ten years into the future?... In terms of population growth, the original ARPANET community numbered around a thousand in 1969. A little over twenty years later, the Internet population is estimated at five to ten million people. The rate of growth is too rapid for accurate measurement at this point.' (Howard Rheingold, *Virtual Communities*, New York: Harper, 1993, 80).

21 Dery, op. cit., p.564.

22 For a nightmarish picture of the total electronic panopticon see Charles Ostman, 'Total surveillance', *Mondo 2000* 13, winter 1995, 16–20; in the same paranoid tone see also most of the articles published by members of the EFF (electronic frontier foundation) at the time of the 'Clipper chip' debate: in this case, conspiracy theory and all-out paranoia proved to be effective strategies in mobilizing the electronic communities towards legal action (see John Perry Barlow 'Jackboots on the Infobahn'. *Wired*, 2.04, April 1994, 40–9; Brock N. Meeks, 'The end of privacy', *ibid.*: 40).

23 See Gayatri Spivak, *Outside* in *the Teaching Machine,* New York and London: Routledge, 1993, 4.
24 see Dery: 561.
25 See Richard Gordon, 'The computerization of daily life, the sexual division of labor, and the homework economy', Silicon Valley Workshop Conference, University of California at Santa Cruz, 1983; Donna Haraway 'A cyborg manifesto: science, technology, and socialist-feminism in the late twentieth century', in *Simians, Cyborgs, and Women: The Reinvention of Nature*, London: Free Association Books, 1991, 149–81; Stanley Aronowitz, 'Technology and the future of work' in G. Bender and T. Druckrey (eds), *Culture on the Brink: Ideologies of Technology,* Seattle: Bay Press, 1994, 15–29. See, also the rich material collected in Chris Carlsson and Mark Leger (eds), *Bad Attitude: The Processed World Anthology,* London: Verso, 1990, about conditions of work in the new, computerized, flexible marketplace.
26 See Andrew Ross, *The Chicago Gangster Theory of Life: Nature's Debt to Society,* London and New York: Verso, 1994, 149.

Part III

FutureNatural

Chapter 12

Postmodern virtualities

Mark Poster

On the eve of the twenty-first century there have been two innovative discussions about the general conditions of life: one concerns a possible 'postmodern' culture and, even, society; the other concerns broad, massive changes in communications systems. Postmodern culture is often presented as an alternative to existing society, which is pictured as structurally limited or fundamentally flawed. New communications systems are often presented as a hopeful key to a better life and a more equitable society. The discussion of postmodern culture focuses to a great extent on an emerging new individual identity or subject position, one that abandons what may in retrospect be the narrow scope of the modern individual with its claims to rationality and autonomy. The discourse surrounding the new communications systems attends more to the imminent increase in technical information exchange and the ways this advantage will redound to already existing individuals and institutions. My purpose in this essay is to bring these two discussions together, to enact a confrontation between them so that the advantages of each may enhance the other, while the limitations of each may be revealed and discarded. My contention is that a critical understanding of the new communications systems requires an evaluation of the type of subject they encourage, while a viable articulation of postmodernity must include an elaboration of its relation to new technologies of communication. Finally, I shall turn to the issue of multiculturalism in relation to the postmodern subject in the age of the mode of information.

For what is at stake in these technical innovations, is not simply an increased 'efficiency' of interchange, enabling new avenues of investment, increased productivity at work and new domains of leisure and consumption, but a broad and extensive change in the culture, in the way identities are structured. To use a historical analogy: the technically advanced societies are at a point in their history similar to that of the emergence of an urban, merchant culture in the midst of the feudal society of the Middle Ages. At that point practices of the exchange of commodities required individuals to act and speak in new ways,[1] ways drastically

different from the aristocratic code of honour with its face-to-face encounters based on trust for one's word and its hierarchical bonds of interdependency. Interacting with total strangers sometimes at great distances, the merchants required written documents guaranteeing spoken promises and an 'arm's-length' attitude even when face-to-face with the other, so as to afford a 'space' for calculations of self-interest. A new identity was constructed, gradually and by a most circuitous path to be sure, among the merchants in which a coherent, stable sense of individuality was grounded in independent, cognitive abilities. In this way the cultural basis for the modern world was begun, one that eventually would rely upon print media to encourage and disseminate these urban forms of identity.

In the twentieth century electronic media are supporting an equally profound transformation of cultural identity. Telephone, radio, film, television, the computer and now their integration as 'multimedia' reconfigure words, sounds and images so as to cultivate new configurations of individuality. If modern society may be said to foster an individual who is rational, autonomous, centred and stable (the 'reasonable man' of the law, the educated citizen of representative democracy, the calculating 'economic man' of capitalism, the grade-defined student of public education), then perhaps a postmodern society is emerging which nurtures forms of identity different from, even opposite to, those of modernity. And electronic communications technologies significantly enhance these postmodern possibilities. Discussions of these technologies, as we shall see, tend often to miss precisely this crucial level of analysis, treating them as enhancements for already formed individuals to deploy to their advantage or disadvantage.[2]

THE COMMUNICATIONS 'SUPERHIGHWAY'

One may regard the media from a purely technical point of view, to the extent that is possible, evaluating them in relation to their ability to transmit units of information. The question then is 'How much information with how little noise may be transmitted at what speed, and over what distance, to how many locations?' Until the late 1980s technical constraints limited the media's ability in these terms. To transmit a high-quality image over existing (twisted-pair copper wire) phone lines took about ten minutes using a 2400 baud modem or two mintues using a 9600 baud modem. Given these specifications it was not possible to send 'real time' 'moving' images over the phone lines. The great limitation then of the first electronic media age is that images could only be transmitted from a small number of centres to a large number of receivers, either by air or by coaxial cable. Until the end of the 1980s an 'economic' scarcity existed in the media highways that encouraged and justified, without much

thought or consideration, the capitalist or nation-state exploitation of image transmission. Since senders needed to build their own information roads by broadcasting at a given frequency or by constructing (coaxial) wire networks, there were necessarily few distributors of images. The same economies of technology, it might be noted in passing, applied to processes of information production.

Critical theorists such as Benjamin, Enzensberger and McLuhan[3] envisioned the democratic potential of the increased communication capacity of radio, film and television. While there is some truth to their position, the practical model for a more radical communications potential during the first media age was rather the telephone. What distinguishes the telephone from the other great media is its decentralized quality and its universal exchangeability of the positions of sender and receiver. Anyone can 'produce' and send a message to anyone else in the system and, in the advanced industrial societies, almost everyone is in the system. These unique qualities were recognized early on by both defenders and detractors of the telephone.

In the recent past the only technology that imitates the telephone's democratic structure is the Internet, the government-funded electronic mail, database and general communication system.[4] Until the 1990s, even this facility was largely restricted to government, research and education institutions, some private industry, and individuals who enroll in private services (Compuserve, Prodigy) which are connected to it. In the last few years the Internet has gained enormously in popularity and by the mid-1990s boasts thirty million users around the world.[5] But the Internet and its segments use the phone lines, suffering their inherent technical limitations. Technical innovations in the late 1980s and early 1990s, however, are making possible the drastic reduction of earlier constraints. The digital encoding of sound, text and image, the introduction of fibre optic lines replacing copper wire, the ability to transmit digitally encoded images and the subsequent ability to compress this information, the vast expansion of the frequency range for wireless transmission, innovations in switching technology, and a number of other advances have so increased the quantity and types of information that it may soon be possible to transmit, that a qualitative change, to allude to Engels' dialectical formula, in the culture may also be imminent.

Information superhighways are being constructed that will enable a vast increase in the flow of communications. The telephone and cable companies are estimating that the change will be from a limit of 60 or so one-way video/audio channels to one of 500, with limited bidirectionality. But this kind of calculation badly misses the point. The increase in transmission capacity (both wired and wireless) will be so great that it will be possible to transmit any type of information (audio, video or text) from any point in the network to any other point or points, and to do so in 'real time', in

other words, quickly enough for the receiver to see or record at least twenty-four frames of video per second with an accompanying audio frequency range of twenty to twenty-thousand Hertz. The metaphor of the 'super-highway' only attends to the movement of information, leaving out the various kinds of cyber*space* on the Internet, meeting places, work areas, and electronic cafes in which this vast transmission of images and words becomes places of communicative relation. Will this technological change provide the stimulus for the installation of new media different enough from what we now have to warrant the periodizing judgement of a 'second electronic media age? If so, how is the change to be understood?

A discourse on the new communications technology is in process of formation, one which is largely limited by the vision of modernity. The importance of the information superhighway is now widely recognized, with articles appearing in periodicals from the specialized zines (*Wired* and *Mondo 2000*) to general journals (*Time*, *Forbes* and *The Nation*). Essays on the new technology vary from breathless enthusiasm to wary caution to scepticism. Writing in *Time*, Philip Elmer-Dewitt forecasts: 'The same switches used to send a TV show to your home can also be used to send a video from your home to any other – paving the way for video phones. ... The same system will allow anybody with a camcorder to distribute videos to the world.'[6] The key to the new media system is not only the technical advances mentioned above but also the merger of existing communication technologies. Elmer-Dewitt continues, '... the new technology will force the merger of television, telecommuncations, computers, consumer electronics, publishing and information services into a single interactive information industry' (pp.52–3). Other observers emphasize the prospects of wireless technology. Writing in *Forbes*, George Gilder predicts the spread of this system: '... the new minicell replaces a rigid structure of giant analog mainframes with a system of wireless local area networks ... these wide and weak [replacing broadcasting based on 'long and strong'] radios can handle voice, data and even video at the same time ... the system fulfills the promise of the computer revolution as a spectrum multiplier ... [the new system will] banish once and for all the concept of spectrum scarcity.'[7] Whether future communications media employ wired, wireless or some combination of the two, the same picture emerges of profound transformation.

Faced with this gigantic combination of new technology, integration of older technologies, creation of new industries and expansion of older ones, commentators have not missed the political implications. In *Tikkun*, David Bollier underlines the need for a new set of policies to govern and regu-late the second media age in the public interest. President Bill Clinton and Vice-President Al Gore have already drawn attention to the problem, stressing the need for broad access to the superhighway, but also indicating their willingness to make the new developments safe for the profit motive.

For them the main issue at stake is the strength of the United States in relation to other nations (especially Japan) and the health of the industries involved. Bollier points to wider concerns, such as strengthening community life, supporting families and invigorating the democratic process.[8] At this point I want to note that Bollier understands the new media entirely within the framework of *modern* social institutions. The 'information superhighway' is for him a transparent tool that brings new efficiencies but by itself changes nothing. The media merely redound to the benefit of, or detract from, familiar institutions – the family, the community, the state.

If Bollier presents a liberal or left-liberal agenda for politics confronted by the second media age, Mitchell Kapor, former developer of Lotus 1–2–3, offers a more radical interpretation. He understands better than Bollier that the information superhighway opens qualitatively new political opportunities because it creates new loci of speech:

> . . . the crucial political question is 'Who controls the switches?' There are two extreme choices. Users may have indirect, or limited control over when, what, why, and from whom they get information and to whom they send it. That's the broadcast model today, and its seems to breed consumerism, passivity, crassness, and mediocrity. Or, users may have decentralized, distributed, direct control over when, what, why, and with whom they exchange information. That's the Internet model today, and it seems to breed critical thinking, activism, democracy, and quality. We have an opportunity to choose now.[9]

With Kapor, the interpretation of the new media returns to the position of Enzensberger: socialist or radical democratic control of the media results in more freedom, more enlightenment, more rationality; captialist or centralist control results in oppression, passivity, irrationality. Kapor's reading of the information superhighway remains within the binaries of modernity. No new cultural formations of the self are imagined or even thought possible. While the political questions raised by Bollier and Kapor are valid and raise the level of debate well beyond its current formation, they remain limited to the terms of discussion that are familiar in the landscape of modernity.

The political implications of the Internet for the fate of the nation-state and the development of a global community also requires attention. The dominant use of English on the Internet suggests the extension of American power as does the fact that E-mail addresses in the United States alone do not require a country code. The Internet normalizes American users. But the issue is more complex. In Singapore, English serves to *enable* conversations between hostile ethnic groups, being a neutral 'other'. Of course, vast inequalities of use exist, changing the democratic structure of the Internet into an occasion for further wrongs

to the poorer populations. Even within the high-use nations, wealthy white males are disproportionate users. Yet technologies sometimes spread quickly and the Internet is relatively cheap. Only grassroots political mobilization on this issue will ensure wide access.[10]

In some ways the Internet undermines the territoriality of the nation-state: messages in cyberspace are not easily delimited in Newtonian space, rendering borders ineffective. In the Teale-Homolka trial of early 1994, a case of multiple murders including sexual assault and mutilation, the Canadian government was unable to enforce an information blackout because of Usenet postings in the United States being available in Canada.[11] In order to combat communicative acts that are defined by one state as illegal, nations are being compelled to coordinate their laws, putting their vaunted 'sovereignty' in question. So desperate are national governments, confronted by the disorder of the Internet, that schemes to monitor all messages are afoot, such as the American government's idea to monopolize encryption with a 'Clipper Chip' or the FBI's insistence on building surveillance mechanisms into the structure of the information superhighway.[12] Nation-states are at a loss when faced with a global communication network. Technology has taken a turn that defines the character of power of modern governments.

The effortless reproduction and distribution of information is greeted by modern economic organizations, the corporation, with the same anxiety that plagues nation-states. Audio taping was resisted by the moguls of the music industry; video taping by Hollywood; modems by the telephone industry giants. Property rights are put in doubt when information is set free of its material integument to move and to multiply in cyberspace with few constraints. The response of our captains of industry is the absurd one of attempting vastly to extend the principle of property by promulgating new 'intellectual property laws', flying in the face of the advance in the technologies of transmission and dissemination. The problem for capitalism is how to contain the word and the image, to bind them to proper names and logos when they flit about at the speed of light and procreate with indecent rapidity, not arborially, to use the terms of Deleuze and Guattari, as in a centralized factory, but rhizomically, at any decentred location. If that were not enough to daunt defenders of modern notions of property, First Ammendment issues are equally at risk. Who, for example, 'owns' the rights to and is thereby responsible for the text on Internet bulletin boards: the author, the system operator, the community of participants? Does freedom of speech extend to cyberspace, as it does to print? How easy will it be to assess damages and mete out blame in a communicative world whose contours are quite different from those of face-to-face speech and print? These and numerous other fundamental questions are raised by Internet communications for institutions, laws and habits that developed in the very different context of modernity.

REALITY PROBLEMATIZED

Before turning to the issue of the cultural interpretation of the second media age, we need to consider a further new technology, that of virtual reality. The term 'virtual' was used in computer jargon to refer to situations that were near substitutes. For example, virtual memory means the use of a section of a hard disk to act as something else, in this case, random access memory. 'Virtual reality' is a more dangerous term since it suggests that reality may be multiple or take many forms.[13] The phrase is close to that of 'real time', which arose in the audio-recording field when splicing, multiple-track recording and multiple-speed recording made possible times 'other' to that of clock time or phenomenological time. In this case, the normal or conventional sense of 'time' had to be preserved by the modifier 'real', But again the use of the modifier only draws attention to non-'reality' of clock time, its non-exclusivity, its insubstantiality, its lack of foundation.The terms 'virtual reality' and 'real time' attest to the force of the second media age in constituting a simulational culture. The mediation has become so intense that the things mediated can no longer even pretend to be unaffected. The culture is increasingly simulational in the sense that the media often changes the things that it treats, transforming the identity of originals and referentialities. In the second media age 'reality' becomes multiple.

Virtual reality is a computer-generated 'place' which is 'viewed' by the participant through 'goggles' but which responds to stimuli from the participant or participants. A particpant may 'walk' through a house that is being designed for him or her to get a feel for it before it is built. Or s/he may 'walk' through a 'museum' or 'city' whose paintings or streets are computer-generated but the position of the individual is relative to their actual movement, not to a predetermined, computer program or 'movie'. In addition, more than one individual may experience the same virtual reality at the same time, with both persons' 'movements' affecting the same 'space'. What is more, these individuals need not be in the same physical location but may be communicating information to the computer from distant points through modems. Further 'movements' in virtual reality are not quite the same as movements in 'old reality': for example, one can fly or go through walls since the material constraints of earth need not apply. While still in their infancy, virtual reality programs attest to the increasing 'duplication', if I may use this term, of reality by technology. But the duplication incurs an alternation: virtual realities are fanciful imaginings that, in their difference from real reality, evoke play and discovery, instituting a new level of imagination. Virtual reality takes the imaginary of the word and the imaginary of the film or video image one step farther by placing the individual 'inside' alternative worlds. By directly tinkering with reality, a simulational practice is set in place

which alters forever the conditions under which the identity of the self is formed.

Already, transitional forms of virtual reality are in use on the Internet. Multi-user domains (MUDs) have a devoted following. These are conferences of sorts in which participants adopt roles in a neo-medieval adventure game. Although the game is played textually, that is, moves are typed as sentences, it is highly 'visual' in the sense that complex locations, characters and objects interact continuously. In a variant of a MUD, LambdaMOO, a database contains 'objects' as 'built' by participants to improve upon the sense of reality. As a result, a quasi-virtual reality is created by the players. What is more each player adopts a fictional role that may be different from their actual gender and indeed this gender may change in the course of the game, drastically calling into question the gender system of the dominant culture as a fixed binary. At least during the fictional game, individuals explore imaginary subject positions while in communication with others. In LambdaMOO, a series of violent 'rapes' by one character caused a crisis among the participants, one that led to special conferences devoted to the issue of punishing the offender and thereby better defining the nature of the community space of the conference. This experience also cautions against depictions of cyberspace as utopia: the wounds of modernity are borne with us when we enter this new arena and in some cases are even exacerbated. Nonethess, the makings of a new cultural space are also at work in the MUDs. One participant argues that continuous participation in the game leads to a sense of involvement that is somewhere between ordinary reality and fiction.[14] The effect of new media such as the Internet and virtual reality, then, is to multiply the kinds of 'realities' one encounters in society.

THE POSTMODERN SUBJECT

The information superhighway and virtual reality are communications media that enrich existing forms of consumer culture. But they also depart or may depart from what we have known as the mass media or the 'culture industry' in a number of crucial ways: 'may depart' because neither of these technologies has been fully constituted as cultural practices; they are emergent communication systems whose features are yet to be specified with some permanence or finality. One purpose of this essay is to suggest the importance of some form of political concern about how these technologies are being actualized. The technical characteristics of the information superhighway and virtual reality are clear enough to call attention to their potential for new cultural formations. It is conceivable that the information superhighway will be restricted in the way the broadcast system is. In that case, the term 'second media age' is unjustified. But

the potential of a decentralized communications system is so great that it certainly worthy of recognition.

Examples from the history of the installation and dissemination of communications technologies are instructive. Carolyn Marvin points out that the telephone was, at the onset, by no means the universal, decentralized network it became. The phone company was happy to restrict the use of the instrument to those who registered. It did not understand the social or political importance of the universality of participation, being interested mainly in income from services provided. Also, the example of Telefon Hirmondó, a telephone system in Budapest in the period before the First World War is worth recalling. The Hungarians used the telephone as a broadcast system, with a published schedule of programming. They also narrowly restricted the dissemination of the technology to the ruling class. The process by which the telephone was instituted as a universally disseminated network, in which anyone is able to call anyone else, occured in a complex, multi-leveled historical articulation in which the technology, the economic structure, the political institution, the political culture and the mass of the population each played interacting roles.[15] A similarly complex history will no doubt accompany the institution of the information superhighway and virtual reality.

In *The Mode of Information*[16] I argued that electronic communications constitute the subject in ways other than that of the major modern institutions. If modernity or the mode of production signifies patterned practices that elicit identities as autonomous and (instrumentally) rational, postmodernity or the mode of information indicates communication practices that constitute subjects as unstable, multiple and diffuse. The information superhighway and virtual reality will extend the mode of information to still further applications, greatly amplifying its diffusion by bringing more practices and more individuals within its pattern of formation. No doubt many modern institutions and practices continue to exist and indeed dominate social space. The mode of information is an emergent phenomenon that affects small but important aspects of everyday life. It certainly does not blanket the advanced industrial societies and has even less presence in less-developed nations. The information superhighway and virtual reality may be interpreted through the post-structuralist lens I have used here in relation to the cultural issue of subject constitution. If that is done, the question of the mass media is seen not simply as that of sender/receiver, producer/consumer, ruler/ruled. The shift to a decentralized network of communications makes senders receivers, producers consumers, rulers ruled, upsetting the logic of understanding of the first media age. The step I am suggesting is at least temporarily to abandon that logic and adopt a post-structuralist cultural analysis of modes of subject constitution. This does not answer all the questions opened by the second media age, especially the political ones which at the moment

are extremely difficult. But it permits the recognition of an emergent postmodernity and a tentative approach to a political analysis of *that* cultural system; it permits the beginning of a line of thought that confronts the possibility of a new age, avoiding the continued, limiting, exclusive repetition of the logics of modernity.

Subject constitution in the second media age occurs through the mechanism of interactivity. A technical term referring to two-way communications, 'interactivity' has become, by dint of the advertising campaigns of telecommunications corporations, desirable as an end in itself so that its usage can float and be applied in countless contexts having little to do with telecommunications. Yet the phenomenon of communicating at a distance through one's computer, of sending and receiving digitally encoded messages, of being 'interactive', has been the most popular application of the Internet. Far more than making purchases or obtaining information electronically, communicating by computer claims the intense interest of countless thousands.[17] The use of the Internet to simulate communities far outstrips its function as retail store or reference work. In the words of Howard Rheingold, an enthusiastic Internet user, 'I can attest that I and thousands of other cybernauts know that what we are looking for, and finding in some surprising ways, is not just information and but instant access to ongoing relationships with a large number of other people.'[18] Rheingold terms the network of relations that come into existence on Internet bulletin boards 'virtual communities'. Places for 'meeting' on the Internet, such as 'the Well' frequented by Rheingold, provide 'areas' for 'public' messages, which all subscribers may read, and private 'mailbox' services for individual exchanges.

The understanding of these communications is limited by modern categories of analysis. For example, many have interpreted the success of 'virtual communities' as an indication that 'real' communities are in decline. Internet provides an alternative, these critics contend, to the real thing.[19] But the opposition 'virtual' and 'real' community contains serious difficulties. In the case of the nation, generally regarded as the strongest group identification in the modern period and thus perhaps the most 'real' community of this era, the role of the imaginary has been fundamental.[20] Pre-electronic media like the newspaper were instrumental in disseminating the sign of the nation and interpellating the subject in relation to it. In even earlier types of community, such as the village, kinship and residence were salient factors of determination. But identification of an individual or family with a specific group was never automatic, natural or given, always turning, as Jean-Luc Nancy argues, on the production of an 'essence' which reduces multiplicity into fixity, obscuring the political process in which 'community' is constructed: 'the thinking of community as essence ... is in effect the closure of the political.'[21] He rephrases the term community by asking the following question: 'How can we be

receptive to the *meaning* of our multiple, dispersed, mortally fragmented existences, which nonetheless only make sense by existing in common?' (p.xl). Community for him, then, is paradoxically the absence of 'community'. It is rather the matrix of fragmented identities, each pointing toward the other, which he chooses to term 'writing'.

Nancy's critique of community in the older sense is crucial to the understanding of the construction of self in the Internet. For his part Nancy has chosen to deny the significance of new communications technologies, as well as new subaltern subject positions in his understanding of community:

> The emergence and our increasing consciousness of decolonized communities has not profoundly modified [the givens of community], nor has today's growth of unprecedented forms of being-in-common – through channels of information as well as through what is called the 'multiracial society' – triggered any genuine renewal of the question of community (p.22).

Nancy denies the relation I am drawing between a postmodern constitution of the subject and bidirectional communications media. The important point however is that in order to do so he first posits the subject as 'multiple, dispersed, mortally fragmented' in an ontological statement. To this extent he removes the question of community from the arena of history and politics, the exact purpose of his critique of the essentialist community in the first place. While presenting an effective critique of the essentialist community Nancy reinstates the problem at the level of the subject by ontologizing its *in*essentialism. My preference is rather to specify the historical emergence of the decentred subject and explore its links with new communications situations.

We may now return to the question of the Internet and its relation to a 'virtual community'. To restate the issue: the Internet and virtual reality open up the possiblity of new kinds of interactivity such that the idea of an opposition of real and unreal community is not adequate to specify the differences between modes of bonding, serving instead to obscure the manner of the historical construction of forms of community. In particular this opposition prevents asking the question of the forms of identity prevalent in various types of community. The notion of a real community, as Nancy shows, presupposes the fixed, stable identities of its members, the exact assumption that Internet communities put into question. Observers of and participants in Internet 'virtual communities' repeat in near unanimity that long or intense experience with computer-mediated electronic communication is associated with a certain fluidity of identity. Rheingold foresees huge cultural changes as the effect of Internet use on the individual: '... are relationships and commitments as we know them even possible in a place where identities are fluid?... We reduce and encode our identities as words on a screen, decode and unpack the

identities of others' (p.61). In bulletin boards like 'The Well', people connect with strangers without much of the social baggage that divides and alienates. Without visual cues about gender, age, ethnicity and social status, conversations open up in directions that otherwise might be avoided. Participants in these virtual communities often express themselves with little inhibition and dialogues flourish and develop quickly. Yet Rheingold attributes the conviviality of The Well and the extravagent identity transformations of MUDs to 'the hunger for community that has followed the disintegration of traditional communities around the world'. (p.62) Even for this advocate of new communications technologies the concept of a real community regulates his understanding of the new interactivity. While there may be some truth to a perspective that sees 'virtual communities' as compensations for the loss of real communities, I prefer to explore the new territory and define its possibilities.

Another aspect to understanding identity in virtual communities is provided by Stone. Her studies of electronic communication systems suggest that participants code 'virtual' reality through categories of 'normal' reality. They do so by communicating to each other as if they were in physical common space, as if this space were inhabited by bodies, were mappable by Cartesian perspective, and by regarding the interactions as events, as fully significant for the participants' personal histories.[22] While treatment of new media by categories developed in relation to earlier ones is hardly new, in this case the overlap serves to draw closer together the two types of ontological status. Virtual communities derive some of their verisimilitude from being treated as if they were plain-communities, allowing members to experience communications in cyber-space as if they were embodied social interactions. Just as virtual communities are understood as having the attributes of 'real' communities, so 'real' communities can be seen to depend on the imaginary: what makes a community vital to its members is their treatment of the communications as meaningful and important. Virtual and real communities mirror each other in chiasmic juxtaposition.

NARRATIVES IN CYBERSPACE

Electronic mail services and bulletin boards are inundated by stories. Individuals appear to enjoy relating narratives to those they have never met and probably never will meet. These narratives often seem to emerge directly from peoples' lives but many no doubt are inventions. The appeal is strong to tell one's tale to others, to many, many others. One observer suggests the novelty of the situation:

> technology is breaking down the notion of few-to-many communications. Some communicators will always be more powerful than others,

but the big idea behind cyber-tales is that for the first time the many are talking to the many. Every day, those who can afford the computer equipment and the telephone bills can be their own producers, agents, editors and audiences. Their stories are becoming more and more idiosyncratic, interactive and individualistic, told in different forums to diverse audiences in different ways.[23]

This explosion of narrativity depends upon a technology that is unlike print and unlike the electronic media of the first age: it is cheap, flexible, readily available, quick. It combines the decentralized model of the telephone and its numerous 'producers' of messages with the broadcast model's advantage of numerous receivers. Audio (Internet Talk Radio) and video (The World Wide Web using Mosaic) are being added to text, enhancing considerably the potentials of the new narratives. There is now a 'World-Wide Web' which allows the simultaneous transmission of text, images and sound, providing hypertext links as well. The implications of the Web are astounding: film clips and voice readings may be included in 'texts' and 'authors' may indicate their links as 'texts'. In addition, other related technologies produce similar decentralizing effects. Such phenomena as 'desktop broadcasting', widespread citizen camcorder 'reporting', and digital filmmaking are transgressing the constraints of broadcast oligopolies.[24]

The question of narrative position has been central to the discussion of postmodernity. Jean-François Lyotard has analysed the change in narrative legitimation structures of the pre-modern, modern and postmodern epochs. Lyotard defines the postmodern as an 'incredulity' toward metanarratives, especially that of progress and its variants deriving from the Enlightenment.[25] He advocates a turn to the 'little story' which validates difference, extols the 'unpresentable' and escapes the overbearing logic of instrumentality that derives from the metanarrative of progress. Any effort to relate second media-age technologies with the concept of the postmodern must confront Lyotard's scepticism about technology. For Lyotard, it must be recalled, technology itself is fully complicit with *modern* narrativity. For example, he warns of the dangers of 'a generalized computerization of society' in which the availability of knowledge is politically dangerous: 'The performativity of an utterance ... increases proportionally to the amount of information about its referent one has at one's disposal. Thus the growth of power, and its self-legitimation, are now taking the route of data storage and accessibility, and the operativity of information' (47). Information technologies are thus complicit with new tendencies toward totalitarian control, not toward a decentralized, multiple 'little narrativity' of postmodern culture.

The question may be raised, then, of the narrative structure of second media-age communications: does it or is it likely to promote the

proliferation of little narratives or does it invigorate a developing author-
itarian technocracy? Lyotard describes the narrative structure of tribal,
pre-modern society as stories that 1) legitimate institutions, 2) contain
many different forms of language, 3) are transmitted by senders who
are part of the narrative and have heard it before and listeners who are
possible senders, 4) construct a non-linear temporality that foreshortens
the past and the present, rendering each repetition of the story strangely
concurrent, and most importantly 5) authorizes everyone as a narrator.
Modern society, Lyotard argues, derives its legitimacy from narratives
about science. Within science, language 1) does not legitimate institutions,
2) contains the single language form of denotation, 3) does not confirm
addressee as possible sender, 4) gains no validity by being reported and
5) constructs 'diachronic' temporality. These contrasting characteristics
may serve, as Lyotard wishes, to indicate the 'pragmatics' of language. It
would be interesting to analyse the role of technologies in the pre-modern
and modern cases, and especially the change, within the modern, from
print to broadcast media.

In any case, for Lyotard, the postmodern little narrative re-functions
the pre-modern language game but only in limited ways. Like the tribal
myth, the little narrative insists on 'the heteromorphous nature of
language games' (66); in short, it validates difference. Unlike older narra-
tive forms, the little narrative emphasizes the role of invention, the indi-
cation of the unknown and the unexpected. Lyotard looks to certain
developments in the natural sciences for his examples of such postmodern
narratives, but we may turn to the Internet and to the developing tech-
nology of virtual reality. As we have seen, the Internet seems to encourage
the proliferation of stories, local narratives without any totalizing gestures,
and it places senders and addressees in symmetrical relations. Moreover
these stories and their performance consolidate the 'social bond' of the
Internet 'community', much like the pre-modern narrative. But invention
is central to the Internet, especially in MUDs and virtual reality: the
production of the unknown or paralogy, in Lyotard's term, is central to
second media-age communications. In particular the relation of the utter-
ance to representation is not limited to denotation as in the modern
language game of science, and indeed the technology encourages a light-
ening of the weight of the referent. This is an important basis for the
instability of identity in electronic communications, leading to the insertion
of the question of the subject and its construction. In this spirit, Katherine
Hayles defines the 'revolutionary potential' of virtual reality as follows:
'to expose the presuppositions underlying the social formations of late
capitalism and to open new fields of play where the dynamics have not
yet rigidified and new kinds of moves are possible.'[26]

For the new technologies install the 'interface', the face between the
faces; the face that insists that we remember that we have 'faces', that we

have sides that are present at the moment of utterance, that we are not present in any simple or immediate way. The interface has become critical to the success of the Internet. To attain wide appeal, the Internet must not simply be efficient, useful or entertaining: it must present itself in an agreeable manner. The enormous problem for interface design is the fear and hostility humans nourish toward machines and toward a dim recognition of a changing relation toward them, a sharing of space and an interdependence.[27] The Internet interface must somehow appear 'transparent', that is to say, appear not to be an interface, not to come between two alien beings and also seem fascinating, announcing its novelty and encouraging an exploration of the difference of the machinic. The problem of the Internet, then, is not simply 'technological' but para-machinic: to construct a boundary between the human and the machinic that draws the human into the technology, transforming the technology into 'used equipment' and the human into a 'cyborg', into one meshing with machines.[28]

In Wim Wenders' recent film, *Until the End of the World* (1991), several characters view their own dreams on videotape, becoming so absorbed in what they see that they forget to eat and sleep. The characters sit transfixed before their viewing devices, ignoring everyone around them, disregarding all relations and affairs. Limited to the microworld of their own dreams, the characters are lost in a narcissistic stupor. And yet their total absorption is compelling. Visual representations of the unconscious – no doubt Wenders has film itself in mind – are irresistible compared to everyday reality, a kind of hyper-reality.

One can imagine that virtual reality devices will become as compelling as the dream videos in Wenders' film. Virtual reality machines should be able to allow the participant to enter imagined worlds with convincing verisimilitude, releasing immense potentials for fantasy, self-discovery and self-construction. When groups of individuals are able to interact in the same virtual space the possibilities are even more difficult to conceive. One hesitates to suggest that these experiences are commensurate with something that has been termed community. Yet there is every reason to think that virtual reality technologies will develop rapidly and will eventually enable participation through the Internet. Connected to one's home computer one will experience an audiovisual 'world' generated from a node somewhere in the Internet and this will include other participants in the same way that today one can communicate with others on bulletin boards in videotext. If such experiences become commonplace, just as viewing television is today, then surely reality will have been multiplied. The continued western quest for making tools may at that point retrospectively be reinterpreted in relation to its culmination in virtual reality. From the club that extends and replaces the arm to virtual reality in cyberspace, technology has evolved to mime and to multiply, to multiplex and to improve upon the real.

MULTICULTURALISM AND THE POSTMODERN MEDIA AGE

If the second media age constitutes subjects in a postmodern pattern, critics have ascribed similarities between the politics of multiculturalism and the culture of postmodernity. Political positions surrounding issues of ethnicity and race are various and complex. But commentators have noted affiliation between Lyotard's critique of pluralism in favour of the differend and the multiculturalists' parallel attack on liberal pluralism. In this connection, two questions are paramount: 1) what is the relation of the second media age to ethnicity? and 2) what is the relation between the multiculturalist critique of modernity and the challenge to it by the second media age?

In many respects, the dissemination of second media-age communications systems is likely to dispense with the question of ethnicity with the same disregard as has the first media age. In the absence of an effective anti-racist political movement, dominant institutions tend to be constructed as if white were the only race, Anglo-Saxon the only ethnicity and Christianity the only religion. Participation in the information super-highway and virtual reality will most likely be accessible to and culturally consonant with wealthy, white males. In these respects the media reflect the relations of force that prevail in the wider community. At another level, one may ask if these media intrinsically favour one group over another. Is virtual reality, for example, somehow white or somehow masculine? I believe these questions are important to raise but that they cannot be answered at present beyond a few brief remarks. The new technologies, even after two decades of the new social movements, are likely to have been conceived, designed and produced by white males. In that respect they are likely to conform at some level to the cultural peculiarities of that group. The best example of this may be found in video games. Beyond this uncomfortably vague statement, one cannot at present say much more. The technoculture of the second media age largely remains to be constructed.

With respect to the second question – the relation of multiculturalist and second media-age resistances to the modern – there is more to be said. Multiculturalists claim some affinity with critiques of the modern that depart from the post-structuralist rejection of the Enlightenment view of the subject. The rational, autonomous individual who pre-exists society, as Descartes and Locke maintained, emerges after the critique by post-structuralists as a western cultural figure associated with specific groups and practices, not as the unquestioned embodiment of some universal. One may argue that such attributes ought to be desired or realized by everyone. But then that argument is one among others and has no presumptive claims to priority over any other figuration of the subject.

Multiculturalists also desire to relativize western values, to remove the patina of universalism from what is no more than another ethnocentrism. In such critiques I can see no important difference between the post-structuralist and multiculturalist positions, both of which can be coordinated with the type of non-modernist subjects constituted by the new media.

Multiculturalists, postcolonialists and subaltern theorists sometimes further claim certain privileges for the subject position of the 'minority' or 'third world person' not simply as that of the oppressed but as affirming the ethnic characteristics of the group. In my view such cultural politics are not critical of the modernist position but simply shift the values or relative worth of two terms in the binary opposition autonomous rational universal/particularist non-rational other. To the extent that placing value on ethnicity promotes a recentering of the subject, supports the foundationalism or essentialism of the group in question, then the subject position so articulated has little to do with postmodernity or the second media age.[29] In 'On the Jewish question', Marx long ago effectively analysed the limitations of such special pleading for an anti-authoritarian politics.[30] For the chief characteristics of the resistance of the new media to modernity lie in their complication of subjecthood, their denaturalizing the process of subject formation, their putting into question the interiority of the subject and its coherence. I believe these traits of the postmodern may contribute to a critique of the modern, may help to undermine the fundamental cultural configuration of modernity, whereas the type of multiculturalism that celebrates a particular ethnicity does not achieve that end. These hopeful possibilities are by no means guaranteed by the dissemination of second media-age technologies and the articulation of a commensurate cultural formation.

Proponents of multiculturalism sometimes claim that post-structural theory and concepts of postmodern culture systematically limit the understanding of non-western ethnicity by configuring it as the Other. While the 'post' theories may be effective in a cultural critique of western logocentrism, they argue, such a critique runs aground to the extent that western identity is bound up with non-western identity both at the levels of imperialist politics and economics as well as in the cultural domain. No doubt this argument effectively indicates a limitation of post-structuralism, one which postcolonial discourse may contribute to correcting. Indeed, interpretations of ethnicity often go far in this direction such as Rey Chow's formulation: 'Ethnicity signifies the social experience which is not completed once and for all but which is constituted by a continual, often conflictual, working-out of its grounds' (p.143). In this case multiculturalism is a process of subject constitution not an affirmation of an essence. As the second media age unfolds and permeates everyday practice, one political issue will be the construction of new combinations of technology

with multiple genders and ethnicities. These technocultures will hopefully be no return to an origin, no new foundationalism or essentialism but a coming to terms with the process of identity constitution and doing so in ways that struggle against restrictions of systematic inequalities, hierarchies and assymetries.

The relation of the second media age to multiculturalism is likely then to be profoundly ambivalent: to some extent both contribute to a critique of modernity and therefore to the dominant forms of oppression; on the other hand, the new media will no doubt work against the solidification of ethnic identity and, it would appear to me, that traditionalists in the multiculturalist camp are unlikely to look with favour on the information superhighway and virtual reality. As these technologies emerge in social space the great political question will be what forms of cultural articulation they promote and discourage. One needs to keep in mind the enormous variability of the technology rather than assume its determining powers. The example of contemporary Singapore, where a policy implementing advanced information technologies is promulgated by an authoritarian regime, should serve as a warning against over-sanguine expectations.

NOTES

1 See Jean-Christophe Agnew, *Worlds Apart: The Market and the Theater in Anglo-American Thought, 1550–1750* (New York: Cambridge University Press, 1986) for an analysis of the formation of this subject position and its particular relation to the theatre. Jürgen Habermas, in *The Structural Transformation of the Public Sphere*, trans. Thomas Burger (Cambridge: MIT Press, 1989), offers a 'public sphere' of coffee houses, salons and other agora-like locations, as the arena of the modern subject, while Max Weber, in *The Protestant Ethic and the Spirit of Capitalism*, trans. Talcott Parsons (New York: Macmillan, 1958) looks to Calvinist religion for the roots of the same phenomenon.

2 See, for example, the discussion of new 'interactive' technologies in the *New York Times* on 19 December 1993. In 'The uncertain promises of interactivity' (p. 6F), Calvin Sims restricts future innovations movies on demand, on-line information services, interactive shopping, 'participatory programming', video games and conferencing systems for business. He omits electronic mail and its possible expansion to sound and image in networked virtual reality systems.

3 I have not discussed the work of Marshall McLuhan simply for lack of space and also because it is not as directly related to traditions of critical social theory as is Benjamin's, Enzensberger's and Baudrillard's. Also of interest is Friedrich Kittler's 'Gramophone, film, typewriter', *October* 41 (1987–8): 101–18 and *Discourse Networks: 1800/1900*, trans. Michael Metteer (Stanford: Stanford University Press, 1990).

4 For an excellent essay on the economics of the Internet and its basic structural features see Hal Varian, 'Economic FAQs about the internet', which is available on the Internet at listserver[@]essential.org (send message: subscribe tap-info your name), and in the Fall 1994 issue of *Journal of Economic Perspectives*.

5 Kevin Cooke and Dan Lehrer, 'The whole world is talking', *The Nation*, 12 July 1993: 61.

6 Philip Elmer-Dewitt, 'Take a trip into the future on the electronic super-highway', *Time*, 12 April 1993: 52.

7 George Gilder, 'Telecosm: the new rule of wireless', *Forbes ASAP*, 29 March 1993: 107.

8 David Bollier, 'The information superhighway: roadmap for renewed public purpose', *Tikkun* 8:(4) (July/August 1993): 22. See also the cautionary tone of Herbert Schiller in 'The 'information highway': public way or private road?', *The Nation*, 12 July 1993: 64–6.

9 Mitchell Kapor, 'Where is the digital highway really heading?: the case for a Jeffersonian information policy', *Wired* (July/August 1993, 1(3): 55.

10 For the implications of the Internet on world affairs see Majid Tehranian, 'World with/out wars: moral spaces and the ethics of transnational communication', *The Public* (Ljubljana), forthcoming.

11 For one report see Craig Turner, 'Courts gag media at sensational canada trial', *Los Angeles Times*, 15 May 1994: A4.

12 Robert Lee Hotz, 'Computer code's security worries privacy watchdogs', *Los Angeles Times*, 4 October 1993: A3, 22.

13 Many writers prefer the term 'artificial reality' precisely because they want to underscore the privilege of real reality. Needless to say this substitution will not cure the problem.

14 Julian Dibbell, 'A rape in cyberspace', *Village Voice*, 21 December 1993: 36–42. I am indebted to Rob Kling for making me aware of this piece.

15 Carolyn Marvin, *When Old Technologies Were New: Thinking About Electric Communication in the Late Nineteenth Century* (New York: Oxford University Press, 1988), especially 222 ff.

16 Mark Poster, *The Mode of Information: Post-structuralism and social contents* (Cambridge: Polity Press, 1990).

17 For interesting examinations of this practice see Mark Dery (ed.), 'Flame wars: the discourse of cyberculture', *South Atlantic Quarterly*, Fall 1993, 92(4) .

18 Howard Rheingold, 'A slice of life in my virtual community', in Linda Harasim, (ed.), *Global Networks: Computers and International Communication* (Cambridge: MIT Press, 1993): 61.

19 See Rheingold's comments, for example: 'I believe [virtual communities] are in part a response to the hunger for community that has followed the disintegration of traditional communities around the world' ('A slice of life in my Virtual Community': 62).

20 See Benedict Anderson, *Imagined Communities: Reflections on the Origin and Spread of Nationalism* (New York: Verso, 1983).

21 Jean-Luc Nancy, *The Inoperative Community*, trans. Peter Conner *et al.* (Minneapolis: University of Minnesota Press, 1991): xxxviii. See also the response by Maurice Blanchot in *The Unavowable Community*, trans. Pierre Joris (Barrytown, N.Y.: Station Hill Press, 1988).

22 Allucquère Roseanne Stone, 'Virtual systems', in *Incorporations*, Jonathan Crary and Stanford Kwinter (eds) (Cambridge: MIT Press, 1992): 618.

23 Jon Katz, 'The tales they tell in cyber-space are a whole other story', *Los Angeles Times*, 23 January 1994: 2:1.

24 See *Mondo 2000*, 11 (1993): 34 and 106.

25 Jean-François Lyotard, *The Postmodern Condition: A Report on Knowledge*, trans. Geoff Bennington and Brian Massumi (Minneapolis: University of Minnesota Press, 1984): xxiv.

26 N. Katherine Hayles, 'The seductions of cyberspace', in Varena Conley (ed.), *Rethinking Technologies* (Minneapolis: University of Minnesota Press, 1993): 175.

27 Claudia Springer in 'The pleasure of the interface', *Screen* Autumn 1991, 32(3): 303–23 is especially insightful on this question.
28 N. Katherine Hayles, 'Virtual bodies and flickering signifiers', *October* Fall 1993, 6: 69–91 interprets these 'different configurations of embodiment, technology and culture' through the binary pattern/randomness rather than presence/absence.
29 For an excellent statement of this problem see Rey Chow, *Writing Diaspora* (Bloomington: Indiana University Press, 1993) especially chapters 1 and 2. See also an important alternative view in David Lloyd, 'Ethnic cultures, minority discourse and the state', in Peter Hulme (ed.), *Colonial Discourse/Postcolonial Theory* (Manchester: Manchester University Press, 1994): 221–38.
30 Karl Marx, 'On the Jewish question', in Robert Tucker (ed.), *The Marx–Engels Reader* (New York: Norton, 1978): 26–52.

Chapter 13

The virtual complexity of culture

Sadie Plant

> What alchemical transformation occurs when you connect everything
> to everything?[1]

As theories of chaos and complexity leak out from the sciences, an emergent connectionist thinking is beginning to blur the distinction between the arts, sciences and humanities.

The implications of this innovation are both extensive and profound. But long before inevitable conclusions about planetary intelligence, it suggests new ways of thinking and writing about the social, the human and the cultural, and threatens the disciplinary mechanisms which have policed both the organization of knowledge and modern conceptions of reality itself. It engineers a convergence of nature and artifice, the present and the future, and the actual and the virtual, and also collapses orthodox distinctions between teaching and learning, knowledge and intelligence, and the production and consumption of discourse.

This essay takes its cue from the self-organizing processes at work in human brains, artificial intelligences, and the new lateral configurations of text made possible by digitization. The dynamics of complex systems can also, however, be perceived in economies, ecologies, social formations, evolutionary processes, and cultures of all kinds.

*

While connectionism is emerging in a number of once separated disciplines and areas of research, it is from computer science in general and artificial intelligence (AI) in particular that some of the leading lines of connectionist enquiry have come.

AI was once a top-down question of developing intelligence by means of teaching machines to think. This approach was perfect for the production of expert systems, able to store and process specialized information on some particular area. But it does little for the intelligence of a machine. Intelligence cannot be taught: it is instead something that has to be learned. More properly, it is something that learns, a bottom-up process which is not merely a question of learning something in particular, but

instead a matter of what Gregory Bateson referred to as deutero-learning, or learning to learn. It feels its way forward, and makes its own way, rather than tracking some existing route.

What is now described as an 'order-emerging-out-of-massive-connections' approach defines intelligence as an exploratory process, which learns and learns to learn for itself. Intelligence is no longer monopolized, imposed or given by some external, transcendent, and implicitly superior source which hands down what it knows – or rather what it is willing to share – but instead evolves as an emergent process, engineering itself from the bottom up. While the resultant neural nets have so far 'achieved only limited success in generating partial "intelligence" ', it is the very fact 'that *anything at all* emerges from a field of lowly connections' that is, as Kelly says, 'startling'.[2]

If artificial intelligence has fuelled this line of research, one of the earliest uses of the term connectionism was in relation to what might once have been unproblematically defined as the natural intelligence of human beings. It was realized in the nineteenth century that the central nervous system is one of the most complex naturally occurring systems, and although the fine details of how it functions are lost even on the experts in the brain sciences, it is now accepted that the brain is a neurochemical switching system of such enormity that it is thought to be composed of some 10^{15} nerve cells or neurons, 'give or take an order or magnitude'[3].

In his 1949 book *The Organization of Behaviour*, Donald Hebb introduced the notion of 'cell assemblies', describing the brain as a complex system of multiple and parallel associations bereft of any centralized control. The term connectionist was used to problematize notions of the brain as a given organ unchanged by what it thinks, and instead allow it to be defined it as an emergent neurochemical system which is modified by every connection it makes.

Hebb's key innovation was to develop the understanding of synapses, which are 'the points of communication between neurons, where processes make quasi-permanent junctions with the soma or processes of another neuron'.[4] Arguing that connections between neurons are strengthened and developed as they are made, he effectively suggested that learning is a process of neurochemical self-organization and modification. 'When an axon of cell A is near enough to excite a cell B and repeatedly or persistently takes part in firing it, some growth process or metabolic change takes place in one or both cells such that A's efficiency, as one of the cells firing B, is increased.'[5]

In a sense, Hebb's work already revealed the continuity between artificial and natural intelligence which is now suggested by neural nets and mathematical models of self-organizing systems. Regardless of whether they occur within a software system or a human brain, material

modification and learning become continuous processes. After this, it can either be said that 'natural', human intelligence is 'artificial' and constructed in the sense that its apparatus mutates as it learns, grows and explores its own potentiality; or that 'artificial' intelligence is 'natural' insofar as it pursues the processes at work in the brain and effectively learns as it grows. Either way the distinction between nature and artifice is collapsed.

<div style="text-align: center;">*</div>

Hebb began to explore these conceptions of learning, growth, and intelligence in the late 1940s, at a time when wartime imperatives had given an unprecedented boost to both neurochemical and mathematical research. A year before the publication of his book, Norbert Wiener's *Cybernetics: Control and Communication in Animal and Machine* had broken the news that there is no essential difference between functioning systems of any scale, material, or complexity. All working systems, regardless of whether they are organic or machinic, at least share the fact that they work at all. But it was the work of Alan Turing which really paved the way for contemporary connectionist conceptions of both human and machine activity. Turing's machine is the abstract and exemplary case of a system which can run any program, an assemblage on which once separated routines converge. This abstract machine formed the basis of the computer, the general-purpose system developed by von Neumann in the 1930s. It had a memory, an arithmetic unit, input-output devices and, most importantly, a central processing unit.

This early computer was a serial processor, performing one step at a time. In contrast with such serial systems, neural nets function as parallel processors in which multiple interconnected units operate simultaneously. One attribute of these systems is that they have no central processing unit. Information is not stored in a single place, but is instead distributed throughout the system. It is also difficult, if not impossible, to define the state of such systems at any given time. They are literally in process, and short of "freezing" all the separate units or processors, so that they all stop operating together and are then restarted after read-outs have been attained, we simply cannot take in all that is happening while it is happening."[6] The extent of the interconnectedness of such systems also means that subtle shifts in activity in one area can have great implications for others, again without reference to some central site. In effect, such systems are continually engineering themselves, growing, emerging and taking shape as a consequence of their own distributed activities. They are self-organizing.

Turing and Wiener were both exploring the abstract workings immanent and necessary to the functioning of all machines. Although their systems were equally centralized, their quest for such abstraction was a

crucial and unprecedented convergence of mathematics and engineering. If all individual computer systems are technical actualizations of such abstract machines, it is this abstraction which guarantees their interconnectedness.

In the 1980s, this connectivity began to be engineered from 'the front end' of computing, with the emergence of the global webs of computer systems known together as the Net. This can also be described as a parallel, distributed system which not only functions without centralized control but has also developed as a consequence of localised, piecemeal activities which build the system from the bottom up. Neither its growth nor its present functioning depend on the presence of some central processing unit: the Net effectively pulls itself up by its own bootstraps. What emerges as a consequence is the connection and convergence of particular and individualized systems on a new abstract zone known as cyberspace, the matrix or virtual reality.

This is not simply the virtual reality of the arcade game, although it is precisely with systems such as these that virtuality starts to creep through the screens of representation which have previously filtered it out. The virtuality emergent with the computer is not a fake reality, or another reality, but the immanent processing and imminent future of every system, the matrix of potentialities which is the abstract functioning of any actual configuration of what we take as reality. It is this virtual reality of actual systems which provides the key to a connectionist or synergetic thinking and gives once separated things and zones the abstract equivalence which allows them to link up.

*

It is precisely this connectionist model which now emerges in the new arrangements and conceptions of knowledge necessitated by hypermedia. As everything that was once stored in frames, galleries, books and records converges on cyberspace, an on-line global library of the kind promised by Ted Nelson's Xanadu system is being implemented. Not that there is some centralized strategy to download all the information in the world: the process, not surprisingly, is bottom-up, piecemeal and dispersed. And it raises a wealth of urgent questions which themselves expose the inadequacy of the old paradigms which divided media, disciplined knowledges, restricted access, and closed exploration down. How does text work when it becomes a component of multi-media? What happens when the reader and the writer lose their distinctiveness among texts which can be endlessly rewritten as they are traversed? How can the more fragmentary texts which would seem to lend themselves to hypertext be navigated and arranged by those who both read and write them? How do narrative and argument translate into the non-linearities of hypertext? What happens to education when it comes on line?

Nelson's users alter the arrangements and content of the material they access, so that any particular or momentary configuration of the virtual library is a consequence of the activity of all those who have used it. His hypertext is reminiscent of Vannevar Bush's 1930s memex, whose user makes 'a trail of his interest through the maze of materials available to him', adding his own links and connections, inserting passages, and making routes. When 'numerous items have been thus joined together to form a trail', wrote Bush, 'it is exactly as though the physical items had been gathered together from widely separated sources and bound together'[7], forming not merely a new book, but also the possibility of their ultimate connection beyond the confines of some particular book.

These possibilities do not have to be pursued very far before it becomes clear that particular volumes or articles fade into the background of a system of textual organization composed only of links, links to links, and more links again. The virtual library is a complex communications system in which contacts and junctions function like Hebb's synapses, reinforced and strengthened every time they are made. Unused links may fade into the background, but nothing entirely disappears. As Bush points out with the title of his article, the memex is quite literally 'As we may think'.

Text, of course, is only the beginning. It goes without saying that such on-line information spaces deal with still and moving images, and audio as well. Hypertext collapses distinctions between readers and writers, producers and consumers, and this is merely the start of the devastating changes wrought by the digitization of information. The emergence of the Net and hypertext is also concurrent with a shift in attitudes to publishing, teaching, the role and status of the academy and, by extension, of all aspects of education and the so-called production of knowledge. Gibson's cyberpunk scenarios, in which the complex cultures of the imminent future have no middle class between the rich and the poor, are indicative of the tendency for middlemen to be removed from every zone. In the arts, publishing and music industries, the collapse of the user – producer distinction finds editors and curators confronting the danger of their own redundancy as images, text and music move wholesale into samizdat production. The mediating functions of the tutor and the teacher are equally undermined by these shifts.

As Foucault writes, the 'university stands for the institutional apparatus through which society ensures its uneventful reproduction, at the least cost to itself.'[8] Today's academy still has its sources in Platonic conceptions of knowledge, teaching and the teacher-student relationship, all of which are based on a model in which learning barely figures at all. Indeed, by definition, there is nothing to be learned, nothing new to be discovered or to be explored. Socrates puts it perfectly, if a little bluntly: 'when we

speak of people learning, they are simply recollecting what they knew before; in other words, learning is recollection.' Nothing is ever entirely unknown, 'because what we call learning will be the recovery of our own knowledge; and surely we should be right in calling this recollection'.[9] Like God, the truth and the knowledge that attains it is simply just sitting there, waiting for man. Only its remembering remains to be done.

The academy loses its control over intelligence once it is even possible to imagine a situation in which information can be accessed from nets which care for neither old boy status nor exam results. There is no selection on the Net. Beyond the ability to buy, beg, borrow, or steal, there are no requirements to be fulfilled before a CD-ROM can be used. But even these are the more superficial effects of a deep rewiring of the processes by which knowledge is disciplined and reproduced. As the role of the human teacher of machines is subsumed by their ability to learn for themselves, the science of artificial intelligence mutates into the engineering of artificial life. The top-down imposition of knowledge becomes redundant, and anything which might be called growth, evolution or development occurs in systems which function without such external governors or even centralized controls of their own. They have no pre-ordained designs or goals in sight, but proceed bottom-up, making connections and reinforcing links, in precisely the way that synapses function in the human brain with which they converge as neural nets.

These connections between the parallel distributed processings of machines, brains and an immense complexity of other dynamic communications systems have enormous implications for all conceptions of teaching, learning and the disciplining of knowledge. Released from its relation to teaching, learning is no longer coded as study and confined to some particular zone, specialized behaviour or compartmentalized period of time. A teacher no longer controls the process, ensuring the development of well-rounded individuals one step at a time, serial fashion: those once defined as students learn to learn for themselves.

While technical and economic imperatives have forced some moves from teaching to learning in the universities, higher education remains premised on the paternal function of the professorial figure, handing his knowledge down through the generations, restricting access, and preserving a tradition still in debt to the Greeks. Although the full effect of the Net and the technical implementation of on-line libraries such as Xanadu are still to come, the implications of such systems cannot be delayed until they arrive. Such libraries were always virtually real, and even the beginnings of the actualization of these virtual systems of information is now starting to take effect.

Just as texts and computers lose their individual identities, so do the authorities, teachings, canons, bodies of knowledge and orthodox methodologies which were once proper to particular disciplines. Bottom-up

learning, hypermedia, and the Net do not merely facilitate a new interdisciplinary approach: they demand one.

*

Where once there were separate disciplines, connectionism opens up a zone which is so interdisciplinary that only the links between them remain.

Biologists and economists have been among the first researchers to explore the implications of this abstract processing and the connections it makes possible, not least because the computer has become so integral to both disciplines. Neural nets make it possible to model the behaviour of self-organizing systems on computers, and parallel processing programs are used to simulate both organic and economic activity. It is also the case that many aspects of their existing research programmes lend themselves to an interest in the behaviour of non-linear systems. In biology, organisms, ecosystems, and evolutionary developments are being reassessed in the light of a new interest in self-organization, and macroeconomic systems can likewise be considered as complex compositions of localised, microeconomic processes.

If these two disciplines find themselves using the same research methodologies to deal with the same abstract processes, there are, however, few areas which have not had some contact with connectionist approaches to their own specialized subjects and objects of research. Biologists and economists are not alone in their convergence with the connectionism of artificial intelligence and the neurosciences.

There is a new interest in the interaction between chaos, complexity and literature, and in philosophy, the posthumanist non-linearities explored by Foucault, Deleuze and Guattari, and Irigaray are reconceptualizing bodies of knowledge as systems of thought and re-awakening older interests in both systems theory and the work of Kant, Marx, and Freud. Indeed many disciplines have some existing theory of complex systems on which to draw: geographers read Wallerstein, and historians can refer to Braudel.

As disciplines engage with a connectionist approach, they also begin to discover the redundancy of their own disciplinary separation. If Bush's memex allows the trails and connections to emerge from the background of what was once arranged as books and libraries, connectionism develops across and between what were once demarcated knowledges and specialized zones, and foregrounds whatever emerges from these links rather than the disciplines they have traversed.

The emergence of machine intelligence coincides with the discovery that machines are complex systems, and complex systems are everywhere, from the microbiological to the macroeconomic, and across what were once distinct natural, social, human and artificial zones. These are,

[assemblages] at the edge of order and chaos [whose components] never quite lock into place, yet never quite dissolve into turbulence, either.

These are the systems that are both stable enough to store information, and yet evanescent enough to transmit it. These are the systems that can be organized to perform complex computations, to react to the world, to be spontaneous, adaptive, and alive.[10]

Klaus Mainzer defines connectionism, or what he calls synergetics, as 'an interdisciplinary methodology to explain the emergence of certain macroscopic phenomena via the nonlinear interactions of microscopic elements in complex systems',[11] regardless of the scales or materials of which such systems are composed. Economies, organisms, and ecosystems can equally be studied, defined and researched as self-organizing assemblages. Whether systems were once considered to be natural – organisms, for example – or artificial – economies or social formations – there are processes of growth, evolution and learning which are common to them all. And one of the most important implications of connectionism is that these processes are piecemeal, discontinuous and bottom-up. Complex systems do not follow the straight lines of historical narration or Darwinian evolution, but are composed of multiple series of parallel processes, simultaneous emergences, discontinuities and bifurcations, anticipations and mutations of every variety. Regardless of either the materials or scales on which they operate, their macroscopic, molar appearance belies a complexity of local interactions and molecular behaviours which proceed without any such transcendent guides. There is no governor, no central processing unit, and no monolithic governing point, and 'neither genetic evolution nor the evolution of behaviour needs a global program like a supervising divine will, a vital force, or a global strategy of evolutionary optimization'.[12]

Does what we call 'knowledge' also operate this way? If all 'physical, social, and mental reality is nonlinear and complex',[13] is it possible that the ideas, inventions, and discoveries which compose what has been thought of as human culture are themselves composed of complex interactions, evolving connections and self-organizing behaviour patterns?

It can certainly be said that research in biological systems, economic complexity, neuroscience and machine intelligence effectively forms a complex, dispersed, and open system, a uncoordinated and piecemeal process which none of the disciplines can control. Elements from each feed into the other and cross-fertilize; parallel processes and simultaneous developments proliferate; messages and media converge. Not that the particular nexus which emerges is some closed system, and self-contained: these new connnections do not regroup to compose another disciplinary zone, and can only ever be contingently defined and momentarily circumscribed. What were once separated lines and modes of research interact with each other, and also with an entire culture of equally complex, dynamic and mutually influencing systems: the Net and hypertext, for

example; the Net and hypertext as they interact with markets; the Net, hypertext and markets as they interact with neural nets; the Net, hypertext, markets and neural nets as they interact with similarly complex individuals.

If, as Kevin Kelly points out, complex systems have 'rekindled earlier intuitions that evolution and learning were deeply related',[14] there is no distinction between learning and the exploratory processes which cut through all intelligent behaviour, and no way of teaching or confining such intelligence to a few humans, or even to all of them. The learning process is the life and the activity of all complex systems, regardless of whether they were once conceived as organisms, machines, cultures or economies, and the tendencies at work in each do not proceed in isolation, but leak into and cross-infect each other as they converge on their virtuality.

A Xanadu of this immensity changes everything. There are urgent questions about the function of teaching and its centrality to a system of education based on the top-down transmission of already existing knowledges. And if what would once have been unproblematically defined as 'scientific knowledge' functions as 'a parallel distributed system' which 'has no center, no one in control. A million heads and dispersed books hold parts of it'.[15] By an inexorable extension, something which might once have been defined as 'the sum of human knowledge' is no longer confined to bodies, volumes and disciplines, but becomes an immense, self-organizing program of evolutionary, intellectual, and technological processes which are neither simply human nor merely knowledge based and never 'simply' or 'merely' anything at all. They are not organized as if from elsewhere, nor can they be taught as if from above. They are implementations of what Deleuze and Guattari call the machinic phylum, the abstract process by which all material life pulls itself up by its own bootstraps and continually engineers itself. This is the 'Cosmos as an abstract machine, and each world as an assemblage effectuating it'.[16]

*

Of all the areas with which connectionism connects, cultural studies has the greatest potential for dealing with both the specificities and broad implications of such vast interconnectivity. Drawing its themes and methodologies from the arts, literature, film, history, philosophy and the social sciences, cultural studies is already interdisciplinary. Its longstanding interest in the media finds it poised to engage with the Net and hypertext, and its concern to integrate its theoretisations with its subjects and objects of study makes it receptive to connectionist modes of research. In its modern form, however, cultural studies has also developed a number of tendencies which pit it against a connectionist approach. It draws elements from only a few neighbouring disciplines, and regroups them around a project of its own. It concerns itself only with representations

of the economic, technological and even natural factors with which it interacts, and confines itself to conceptualisations of culture as a specifically human affair. Some notion of individual or collective agency is assumed to play a governing role in all cultural formations and productions, so much so, that as Wallerstein points out, the cultural arena is one in which,

> the concept of 'agency' constantly recurs as a theme. Against the so-called objective pressures that are said to come from the politico-economic realm, the acolytes of culture assert the intrusion of human agency – as intrinsic possibility, as source of collective hope.

Hence the last thirty years of active readings, negotiated media, and a basic position which suggests that the 'people are oppressed (by the states, that is), but the people (and/or the intelligentsia) have the power (and exercise the power) of forging their own destiny'. But if this is indeed the way cultures work, how 'it is then, using this analysis, that we are still living in the oppressive system that seems to persist is something of a mystery'.[17]

The emphasis on a ubiquitous agency underlies cultural studies' break with both the elitism of the arts and the perceived determinism of the sciences. After this, culture no longer has to be high; nor does it have to become the object of social science. But cultural studies remains invested in the educational and ethical project of that most modern of faculties: the humanities. It is this which gives both culture and its students a sense of purpose, autonomy and unified direction, and places the whole area at odds with a connectionist approach which begins to 'consider culture as its own self-organizing system – a system with its own agenda and pressure to survive' and then finds, as Kevin Kelly points out, that 'the history of humans gets even more interesting'.[18] Beyond spectacular society and speculative humanism there is an emergent complexity, an evolving intelligence in which all material life is involved: all thinking, writing, dancing, engineering, creativity, social organization, biological processing, economic interaction and communication of every kind. It is the matrix, the virtuality and the future of every separated thing, individuated organism, disciplined idea and social structure.

Cultural studies has condemned as 'naturalization' any attempt to introduce what it understands as natural processes to the study of social, political or cultural developments, and all efforts to connect technical, economic and scientific activity to cultural, political and social life have been rejected for their determinism. The humanities have often been right to be wary of such moves: research projects such as sociobiology have often been woefully blind to their own cultural functioning. But if connectionism has emerged from the sciences, this is not because it is scientific: it is simply that the sciences are the first disciplines to be undermined by it. Artificial intelligence succeeds as it escapes from both the laboratory and the

scientist, both of which become elements of the learning process they may have thought they contained. Distinctions between the human, the natural and the articifial are scrambled, and whatever was once said to belong to each of them finds a new basis on which to connect in the dispersed and connective processes which link them all. And unlike earlier attempts to bridge the culture – nature divide by means of rigorous social science, the complex systems approach leaks into what were once the subject matters of the arts, humanities and social sciences without any of the dangers of reductionism which marked modernist cybernetics and systems theory. If, for example, the clear implication of such an approach is that 'the traditional concept of individual responsibility is questionable', agency and intention are not removed, but complicated and perplexed instead. While a phenomenon like 'urban development cannot be explained by the free will of single persons' but is instead 'the result of nonlinear interactions'[19], this only emphasizes the irreducible complexity of precisely the intentions, dreams and desires which feed into its macroscopic result. If there is a new reductionism, it lies with the humanism which wants to collapses the immense complexity and fine detail of the interwoven lines and circuitries into the singular will of individual or collective agency.

'We are in a social formation': of this there is no doubt. But is this where we are going to stay? Why not 'see how it is stratified for us and in us and at the place where we are; then descend from the strata to the deeper assemblage within which we are held; gently tip the assemblage, making it pass over to the side of the plane of consistency.'[20]

It was Foucault's antihumanism which discovered both the extent of modernity's disciplinary procedures and the immanent matters of its spec-ular reality; the virtual confusions and undisciplined connections which haunt the Enlightened world: 'Behind the disciplinary mechanisms can be read the haunting memory of 'contagions', of the plague, of rebellions, crimes, vagabondage, desertions, people who appear and disappear, live and die in disorder.'[21]

One of Pat Cadigan's characters makes the same find. 'He'd had no idea there was so much infection floating around in the system, coming in, going out, drifting like ocean-going mines or sitting camouflaged in various pockets and hidey-holes.' It's never as clean and simple a story as it appears from its own inside:

> What he had sometimes thought of as the arteries and veins of an immense circulatory system was closer to a sewer. Strange clumps of detritus and trash, some inert and harmless, some toxic when in direct contact, and some actively radiating poison, scrambled along with the useful and necessary traffic.[22]

The collapse of the modern disciplines not only opens onto a new inter-disciplinary space, but also takes the ground from under the feet of the

modern integrated, unified individual. Complex biochemical processes function within, across and in-between what were once conceived as autonomous agents, corroding the boundaries between man, nature and the tools with which he has mediated this relationship. The histories written as the histories of humanity can no longer maintain their independence from emergent processes in the economies and complex systems with which they interact, and attempts to define culture in the ideological, humanist and sociopolitical terms which have provided its post-war framework merely perpetuate a distinction between the human, the machinic and the so-called natural which underwrites modernity's techniques of policing knowledge and reality.

Cultural studies absorbed Foucault, but had no interest in his reports from the dark side of its disciplines, preferring instead to see his work as a variant on its own anthropomorphic discourse and remaining untouched by the inhuman and undisciplined zones his writing traversed. If cultural studies was ever subversive, it did not intend things to go this far: its political project was never to destroy the social order, but merely to humanize it. The end of authorship became another framework, Foucault's complex genealogies were confined to matters of textual interest, and the subject of cultural studies was safe. But the technical implementation of a postdisciplinary space is not so easy to resist. If intelligence can neither be taught nor confined to a few humans, it cannot even be monopolized by all of them: machines learn, and learning is a machinic process, a matter of communication, connection and material self-organization.

Connectionist conceptions of the cultural do not merely operate within the parameters of a humanist discourse of individuals and societies, but collapse distinctions between human life, natural life and the artificial lives of economies, on-line libraries and complex systems of every kind. Cultures are parallel distributed processes, functioning without some transcendent guide or the governing role of their agencies. There is no privileged scale: global and molecular cultures cut through the middle grounds of states, societies, members and things. There is nothing exclusively human about it: culture emerges from the complex interactions of media, organisms, weather patterns, ecosystems, thought patterns, cities, discourses, fashions, populations, brains, markets, dance nights and bacterial exchanges. There are eco-systems under your fingernails. You live in cultures, and cultures live in you. They are everything *and* the kitchen sink.

*

Without the centrality of agency, culture is neither high, nor ordinary, but complex. It becomes possible to look at cities, cultures and subcultures of every scale and variety as self-organizing systems with their own circuits, exchanges, contagions, flows, discontinuities, lines of communication and bottom-up processes of development. It also becomes impossible simply

to 'look' at anything at all. If hypertext erodes the distinction between reading and writing, connectionism challenges the old borderline between theorizing something and doing it, and induces an unprecedented convergence and interconnection of theory and methodology with what were once their discrete objects of study. Theoretical developments leak across the disciplines, and also become newly integrated with the complex processes they describe.

Indeed, connectionist theory does not merely describe anything: whatever happens 'in theory' is more than a representation of the developments and activities being theorized. If it works, it adds to the processes it studies: it too makes connections, engineers links and fabricates self-organizing systems. It replicates the processes it once represented; it simulates the activities on which theory was once content to comment, and becomes part of the self-organizing processes on which it once imposed itself. Reading and writing become less like text than a peculiarly fluid cityscape more akin to a festival site which organizes itself and develops its own roads, junctions and landmarks as a consequence of the activity which takes place within it. Cultural theory then becomes a matter of making cultures as well as, or rather than, interpreting them.

This is not a question of applying theory, nor even of integrating theory and practice in some new dialectical relation, but something more akin to what Deleuze refers to as a 'system of relays within a larger sphere, within a multiplicity of parts that are both theoretical and practical.' What was once the theorist is no longer alone: 'Who speaks and acts? It is always a multiplicity, even within the person who speaks and acts. All of us are 'groupuscules'. Representation no longer exists; there's only action – theoretical action and practical action which serve as relays and form networks.'[23] Trance dancers don't need Deleuze and Guattari to teach them about bodies without organs and rhizomatic connections: they have learned all this for themselves. Writing becomes a process of software engineering, making connections, and connecting with the other connectionist systems and their connections too; it 'does not totalize', but 'is an instrument for multiplication and it also multiplies itself.'[24]

In an age when even philosophy 'is no longer synthetic judgement' but becomes 'a thought synthesizer', anything else would be reactionary. They need to move beyond specialization without swapping such status for the broad strokes of generalization, and are effective only insofar as they 'make thought travel, make it mobile, make it a force of the Cosmos (in the same way as one makes sound travel).'[25] They are neither modern nor postmodern, but in proximity to the future and continuous with the tendencies and directions in which they write. They run ahead and in anticipation of themselves, and have to do with 'surveying, mapping, even realms that are yet to come.'[26]

Connectionism is not interested in rehearsing what is already known, or endorsing the disciplined bodies of knowledge and their canonized vaults. It is less a matter of being taught the old than a process of learning the new. It has no project, but emerges bottom-up from researches dispersed across the disciplines and similarly distributed developments amongst its media and channels of communication. It is not a new theory, but fatally disturbs the role of theory itself. It is not an answer, but a question.

In a passage read by Deleuze at his funeral, Foucault posed it perfectly: 'What is the point in striving after knowledge [*savoir*] if it ensures only the acquisition of knowledges [*connaissances*] . . .?' Why bother with a thinking which concerns itself only with 'legitimizing what one already knows', when it could 'consist of an attempt to know how and to what extent it is possible to think differently'?[27]

NOTES

1 Kevin Kelly, *Out of Control: The New Biology of Machines*, London: Fourth Estate, 1994: 297.
2 Ibid.: 296.
3 Patricia Smith Churchland, *Neurophilosophy: Towards a Unified Science of the Mind/Brain*, MIT, 1989: 40.
4 Ibid.
5 Donald Hebb, quoted in Klaus Mainzer, *Thinking in Complexity: The Complex Dynamics of Matter, Mind, and Mankind*, Berlin: Springer-Verlag, 1994: 126.
6 J. Richard Eiser, *Attitudes, Chaos, and the Connectionist Mind*, Oxford: Blackwell, 1994.
7 Vannevar Bush, 'As we may think', quoted in George Landow, *Hypertext*, Baltimore and London: Johns Hopkins University Press, 1992: 16.
8 Michel Foucault, in Donald F. Bouchard, (ed.) *Language, Counter-Memory, Practice: Selected Essays and Interviews by Michel Foucault*, Ithaca, NY: Cornell University Press, 1977: 225.
9 Plato, *The Last Days of Socrates*, London: Penguin, 1969: 125.
10 Mitchell H. Waldrop, *Complexity: The Emerging Science at the Edge of Order and Chaos*, London: Penguin, 1992: 293.
11 *Thinking in Complexity*, op. cit.: 11.
12 Ibid.: 268.
13 Ibid.: 13.
14 *Out of Control*, op. cit.: 296.
15 Ibid.: 452.
16 Gilles Deleuze and Felix Guattari, *A Thousand Plateaus: Capitalism and Schizophrenia*, London: Athlone, 1988: 280.
17 Immanuel Wallerstein, *Geo-Politics and Geo-Culture*, Cambridge University Press: Cambridge, 12.
18 *Out of Control*, op. cit.: 360.
19 *Thinking in Complexity*, op. cit.: 10.
20 *A Thousand Plateaus*, op. cit.: 161.
21 Michel Foucault, *Discipline and Punish*, Penguin, 1977: 198.
22 Pat Cadigan, *Synners*, London: Grafton, 324.
23 Gilles Deleuze, in Donald E Bouchard (ed.) *Language, Counter-Memory,*

Practice: selected Essays and Interviews by Michel Foucault, Cornell University Press, 1977: 206.
24 Ibid.: 208.
25 *A Thousand Plateaus*, op. cit.: 343.
26 Ibid.: 5.
27 Michel Foucault, 'Introduction' to *The History of Sexuality 2 The Uses of Pleasure*, London: Penguin, 1986.

Art and science in Chaos

Contesting readings of scientific visualization

Richard Wright

INTRODUCTION

These days little is heard of the phenomenon called 'Chaos Culture'. But by approximately 1987 a number of forms of cultural activity had taken shape around a popularized scientific concept called chaos theory or chaology, ranging from art shows and coffee-table books to acid house videos, T-shirts and comic books. By about 1990 it had already been superseded by new manifestations of technoculture, but while it lasted it provided an example of a moment in which a new scientific story found a cultural function due in large part to its easy appropriation by media technology. How did the mechanism operate by which this idea was introduced into wider society and became part of our mental furniture? It is best described as a cultural intervention into science or a scientific intervention into culture? And how far can we culturally critique this kind of mythologized scientific discourse before we have to engage in the rhetoric of physicists and mathematicians directly in order to justify our analysis?

The rise of computer graphics as an integral part of scientific practice coincides historically almost exactly with the emergence of chaos theory as a cultural force. In 1987 the National Science Foundation of the United States published a report which set a goal to provide every scientist and engineer with their own graphics workstation. This had the immediate effect of stimulating a new market for specialized computer software and hardware. At the same time, in scientific journals, TV documentaries and magazine articles, computer-generated imagery seemed to have become an indispensable means of communicating scientific research both within science and out into the non-scientific community. Chaos theory was able, through media, to become an icon, to become the image of a Lorenz attractor, a Mandelbrot set or a Henon map – chaos was able to become Chaos.

Computer imagery is used for different reasons by different kinds of scientific activity and in different disciplines. How imagery is used in research affects how theories and results are eventually disseminated and

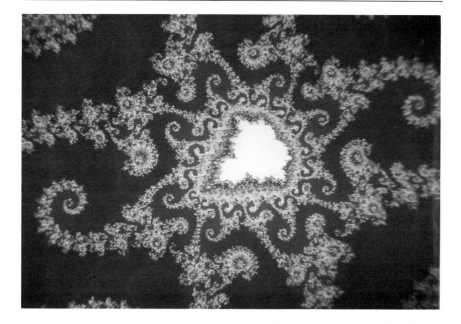

Figure 14.1 Fractal image, by Hugh Mallinder

therefore what the parameters of their cultural interpretation are. We may characterize the role of scientific visualization with respect to the representation of ideas in three main categories. The simplest category can be illustrated by astrophysicists who accumulate large amounts of data from radio telescopes which has to be represented in some accessible form prior to analysis. Rendering the various quantities (which are frequently non visual in themselves) graphically has proved to be a very convenient way to study subtle features in the data and also to communicate them to colleagues. This process is like building a visual analogue to the object under investigation.

In a slightly similar way visualization is used to present the data generated in simulation experiments. These experiments are usually conducted in order to test a theory about a phenomenon. A mathematical model of how the process is thought to work is constructed and a simulation is run to see what would happen. The results obtained are then compared to data collected about the actual phenomenon itself. An example would be an experimental model to show what happens when galaxies collide using a trial and error sampling, or *Monte Carlo* approach. Many different simulations of galaxy systems are run all with slightly different parameters to see which one most closely approximates the particular event being studied. The visualizations produced are more like pictures of the process

of understanding something, or like visual thinking. Sometimes the simulations are of phenomena which do not necessarily exist. Physicists may conduct simulations of magnetic 'monopoles' to see what kind of events they could be responsible for if they existed. This situation is more akin to the visualization of abstract ideas such as in theoretical physics or mathematics, ideas which may nonetheless be related to mathematical models of physical processes, such as in the case of complex dynamical systems and chaos theory. Pictures and animations of fractals and iterative mappings are certainly not *iconic* representations of otherwise familiar natural systems. They may provide the only tangible evidence of the mathematical object being studied. This gives visualization the function of creating the 'object' of what may be pure research, it *objectifies* an idea to the extent that it can enter the general economy of signs as an image of itself. Scientific objects of knowledge are now in a form in which they can function through media without any additional information, finding a new life for themselves in the maelstrom of signs.

Is it possible to construct cultural readings of scientific visualizations that can do justice to the scientific ideas that they are derived from, that are more than just an enigmatic confrontation with pretty pictures? Can we propose a meaningful new aesthetic which is informed by scientific literacy? Graphics is certainly used to communicate 'scientific meaning' in the sense of knowledge of the properties of a natural process or a model. If instead we use the term 'scientific meaning' in the sense of an ideology or narrative then it also seems that the inherently media-accessible structure of electronic visualization has made it the chief way in which scientific stories can be experienced culturally. In the case of chaos theory this effect was reinforced by the way that imagery had become the main form of symbolic knowledge.

THINKING AND READING

In a 1990 issue of *Artforum* magazine the critic Vilem Flusser published a short article in his series 'Curies children' in which he tried to locate the new form of scientific imagery in relation to cultural artefacts (Flusser 1990). Here Flusser argues that imagery was the only way to express the subtleties of the new mathematical ideas such as fractal geometry, and that such concepts were not readily accessible by nor even appropriate to spoken language. Flusser is discussing these issues in the context of the early writings of the philosopher Wittgenstein, drawing attention to a passage in his *Tractatus Logico-Philosophicus* where he states 'It is true that some things are unspeakable. These *show*, they are what is mystical' (Flusser's translation). Flusser then goes on to try to explain that just because concepts such as fractals can only adequately be communicated through pictures this does not mean that there is anything 'mystical' about

them. What concerns us here though, is his argument that in order to understand what the pictures convey we have to understand the algorithms that generated them - 'the mathematical and computer codes'.

Flusser distinguishes between two kinds of image now, 'images of the world' and 'images of thinking'. The first kind are the pictures we are most familiar with and are what Flusser seems to imply are pictures which are accessible to day-to-day modes of discourse like magazine photos and TV or which may be cultural artefacts like designs or paintings. The second type are products of non-cultural discourses like science and mathematics, their meanings are not found in the social situations of desires, personalities or conflicts, but in the world of mathematical objects and equations which have now advanced to such a level that with the study of fractal geometry and chaology that they can no longer be done justice by words alone.

But that is not all. It is not just the pictures themselves but the status of the mathematical models they give form to that are at issue here. 'Does this fractal look like the Alps because the Alps too have a fractal structure, or because fractal images are able to simulate the structure of the Alps?' Such questions are meaningless, states Flusser. A fractal image does not mean a likeness of some part of the natural world, it simply 'means' the equation that generated it. Presumably to interpret the images without reference to their process of generation would indicate some kind of scientific mimesis lacking any explanatory power.

Flusser does not go on to describe how we can then go on to find out what the equation 'means', we are left only with his appeal to look beyond the form of the image to the concepts behind it. In the absence of any clearer guidelines given in his article, his view of mathematics seems to be that we can find ample information of how a numerical image is to function semantically merely by studying its 'codes'. Mathematics then stands as a self-supporting edifice of interlinked concepts, techniques and expressions all functioning independently of any other mode of discourse. But this extremely pure view of mathematical practice will not do, and in any case many of the images that Flusser was talking about were produced by physicists and engineers out of an overriding interest in attempting to model the real world. A much more promising task would be to extend Flusser's strategy to ask the scientists concerned what they intend by their images and how they relate to their scientific work. In order to make an attempt at a truly comprehensive understanding of scientific concepts that are expressed in this imagery we first of all have to accept that the chief narrative of western physical science has been the construction of 'man' in dominant relation to 'nature', the control of his environment and exploitation of its resources, especially technologically – not just a word game played with mathematical tokens. For example, when people relied on pictures to 'show' what scientists meant, what happened in the case of Chaos?

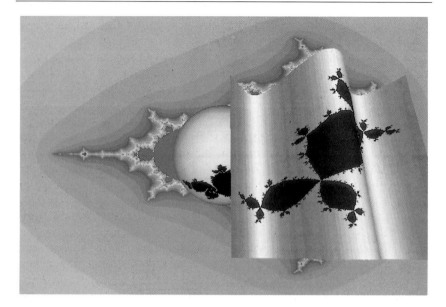

Figure 14.2 Fractal image, by D. Brough

THE NEW CULTURE OF SCIENCE

The 1980s saw the increased availability of high resolution colour graphics in scientific research centres, and with it came the phenomenon of 'scientific' forms of 'art' almost completely autonomous of mainstream culture. The most well-known examples were Chaos Art and Fractal Art, forms which by the late 1980s had received widespread exposure in exhibitions and through the media. One of the first and most publicized of these manifestations was 'Map Art', a travelling exhibition originating with the work of a group of mathematicians and physicists working at the University of Bremen. The researchers had been generating images of fractal Mandelbrot sets for their work on dynamical systems and some time after 1981 'the idea for an exhibition came up' (Peitgen and Richter 1985). They were invited by a bank in Bremen to exhibit their work to the public and to produce an illustrated catalogue. The success of this show lead quickly to two more by the end of 1984 and culminated with their work being added to the cultural programme of the Goethe Institute. But if Peitgen and Richter thought that all the art-going public were interested in were pretty pictures they were soon proved wrong; 'we thought that the aesthetic appeal of the pictures themselves would be sufficient. How naive we were.' Peitgen and Richter then went on to write essays for the catalogue in which they explained the scientific background behind

their imagery and also began to promulgate some of the first ideas that would go on to form part of the scientific story of Chaos.

Instead of taking the option of drily describing chaos theory as a set of mathematical techniques Peitgen and Richter in fact went out of their way in *The Beauty of Fractals* to give the reader a dazzling collection of philosophical interpretations of the theory. Aided by a liberal use of graphs and diagrams, the two physicists expounded the intimate connections between dynamical systems, their mathematical modelling by chaos theory and their fractal properties; 'it is hard to be clear on what part is actually fact and what part is insight suggested by the experimental results', the authors caution, before they go on to borrow some highly charged language to describe their conclusions.

Chaotic dynamics are usually presented in the literature in opposition to classical dynamics, in particular through the writings of the late eighteenth-century French mathematician Laplace, who is credited with giving one of the most concise statements of how scientists viewed how the world operated. His view is based on the idea that all physical systems, including large-scale phenomena like the weather, are dependent on the motions of the smallest particles that constitute them. If every part is subject to the same laws of motion as the others, then the dynamics of the entire system should be defined by accumulating the result of all its internal interactions. This idea led Laplace to boast that given the position and velocity of every particle in the universe he could predict in principle its future for the rest of time. Although there were obvious practical limitations to this approach, its implication was that every action was completely predetermined.

The main development that has happened to upset the classical determinism of Laplace is the growing realization that measuring the exact starting position or initial conditions of a system accurately enough to predict its behaviour has proved intractable. For example, in quantum mechanics the famous Heisenberg uncertainty principle stated in effect that it was impossible to gather enough information about some random processes such as radioactive decay to predict when it will disintegrate. On the scale of larger phenomena the situation is different but there is a similar outcome. In order to make predictions about a system we need to measure its starting conditions are accurately as possible. Of course we can never measure these with perfect accuracy, but we should be able to allow for this experimental error by assuming that a system that starts very near the position of the system that we are studying should end up reasonably near its projected future position. It is this assumption that proves to be incorrect for many processes because of their extreme sensitivity to changes in the initial starting conditions. Minute differences in the starting conditions of a system could be amplified very quickly over time until very shortly the whole system could end up in a completely

different state. This is one of the basic properties of a chaotic system (Crutchfield *et al.* 1986).

When a process is entering a chaotic 'regime', its internal state, whether in terms of temperature or position, will start to change. First it will only loop perhaps between two different states, known as a cyclic attractor of period two, then as its mathematical parameters are altered more it will begin to enter double the number of states and the number of attractors will increase again. As it enters chaotic behaviour, it will start to fly off towards a large number of states without periodic regularity. Even so, the states it reaches, although unpredictable from its starting conditions, will be bounded to be within certain limits which can be visualized in 'state space' as being a particular shape, now called a chaotic or strange attractor. Sometimes this chaotic attractor can still be composed of one or more main centres of attraction which the system orbits around in an irregular pattern. The boundaries between these centres of attraction will typically have a fractal geometry.

This is the kind of research that Peitgen and Richter were involved in, the study of complex dynamics. By using computers to simulate the behaviour of systems using chaotic iterative functions, they were able to analyse their properties. But in the catalogue essays that they wrote to describe their research Peitgen and Richter chose to use a florid language that was more reminiscent of a social science. Here is how Peitgen and Richter describe the fractal boundaries of some strange attractors that they have witnessed on their computers. 'They all have in common the competition of several centres for the domination of a place ... there is the unending filigreed entanglement and unceasing bargaining for even the smallest areas. . . . Occasionally, a third competitor profits from the dispute of two others ... ' Really! The authors seems to have been spending too much time in the yuppie wine bars of the early 1980s. Later on we are introduced to some similar phenomena along with a shift in language that suggests the Polish Solidarity struggles of the same period: '[there are] isolated points which are not subject to its attractions. These are dissidents ... who don't want to belong.' We seem to have come a long way from Flusser's assumptions about finding the meaning of an equation.

Of course we are never free from the resonances of the language we choose to employ, and later on Peitgen and Richter come to some conclusions about the general meaning of this new scientific discipline which are relatively free of Thatcherite perceptions. The scientifically important property of non-linear chaotic systems is that once they enter a chaotic regime their progress cannot be predicted from their initial starting conditions without doing an explicit simulation. This places fundamental limits on the power of prediction (if a system is modelled as chaotic), but still gives us a way of studying such a system and perhaps finding other useful information about it. 'It is no longer sufficient to discover basic laws and

understand how the world works "in principle". It becomes more and more important to figure out patterns through which these principles show themselves in reality.' These patterns are best appreciated when they are rendered in full colour computer graphics. They conclude, 'It may not be a deep truth to assert that our world is nonlinear and complex. ... Yet physics and mathematics ... have successfully managed to ignore the obvious ... [and remember that] these sciences had a strong impact on technology ...' A quotation from Robert M. May from 1976 lays down the challenge for these new paradigm makers;

> I would therefore urge that people be introduced to, say, [a nonlinear equation] early in their mathematical education. This equation can be studied phenomenologically by iterating it on a calculator. ... Such study would greatly enrich the students' intuition about nonlinear systems ... in the everyday world of politics and economics *we would all be better off* if more people realised that simple nonlinear systems do not necessarily possess simple dynamical properties. (italics added)

'... *we would all be better off*.' Through a succession of metaphors from market economics, oppositional politics, to the origins of life and creative insight, Peitgen and Richter's work abounds with readings of this object from pure mathematics. In spite of this passage and the earlier hint of some general influence on technological progress, the essay neglects to address how chaology is actually applied to the real world outside of the confines of pure maths. Exactly how we would all be better off apart from intellectually, or how this knowledge would relate to the experience of our daily lives is not clear. The implication is that at the same time there is some fairly major rethinking of the scientific world-view going on. But in the following years as chaology became public property the cultural appropriation of their work helped to tease out some answers.

Flusser had argued that concepts such as fractals cannot be 'spoken of' as Wittgenstein had written but could be 'imagined' using computer graphics. Similarly Peitgen and Richter say that Julia and Fatou's early discovery of the self-similarity so important to fractal geometry was an idea so difficult to explain that it had to wait until Mandelbrot discovered a way to 'show' it. But Julia and Fatou also had to wait until Edward Lorenz found in 1963 that their work would have relevance to applications in fluid dynamics. Before that time scientists assumed that the equations to describe the behaviour of fluids would simply need to be extended to account for more and more oscillations as the fluid became more turbulent, but Lorenz discovered that under certain conditions the simplest basic equations would give rise to complex dynamics, to chaotic attractors. The rapidly changing state of the fluid resulted in what is described as a 'folding and stretching' in state space, a phenomenon which exhibits a fractal structure. Strictly speaking of course, this only means

that the equations that model turbulence give rise to fractals, not that the fundamental structure of the fluid itself is fractal, but without some relevance to real world applications chaos theory and fractals would merely have become a mathematical curiosity like Julia and Fatou's original iteration theory, unable to find resonance in everyday life and certainly not becoming a 'Chaos Culture'. As it was, Lorenz's ideas still had to wait many years before they were fully appreciated and widely applied. If Lorenz discovered the importance of Chaos as early as the beginning of the 1960s, why did we have to wait a further twenty-five years before we heard about it? Would it have made any difference if Lorenz had had good enough computer graphics to be able to make psychedelic patterns in time for the hippy revolution?

STORIES OF CHAOS

The mid 1980s saw the convergence of many factors that made it the right time for technology to impact on culture and to drag science along with it. Personal computers such as the Apple Mac had just become affordable and easier to use and computer graphics had received enormous attention through its exposure in TV videographics and film special effects. Information technology was a business buzz word and commercial opportunities at the tail end of the era of 'enterprise culture' provided the motivation for young designers and programmers to launch a series of ventures based loosely around the application of technology to the arts and entertainments. Acid house music and successors like hardcore and techno had a need for icons and imagery in their clubs that the catherine-wheel spirals and 'seahorse valleys' of the Mandelbrot set ideally suited. And this time, unlike the hippy festivals of the 1960s that had to import eastern religions and pagan mysticism to bolster their ideology, fractal graphics came complete with the scientific credentials of chaos theory, a secular doctrine more appropriate to an environment of streamlined competition and economic progress.

By 1988 youth magazines were publishing special issues on the phenomenon of 'Chaos Culture'. By this time fractal graphics was appearing in music videos, in clubs, T-shirts, TV programmes and all kinds of popular books and magazines. Descriptions of the scientific theories behind Chaos took the form of anecdotal fictions like the famous 'butterfly effect'. In this story the arbitrary sensitivity of chaotic systems to initial starting conditions is illustrated by imagining a butterfly flapping its wings in Australia thereby contributing to patterns of global wind turbulence that are amplified to the extent that it is responsible for a dust storm in Arizona (or a hurricane in New York, etc.).

In more popular debates we could find a multitude of quasi-mystical interpretations of chaos theory. Some of the most stereotypical were from

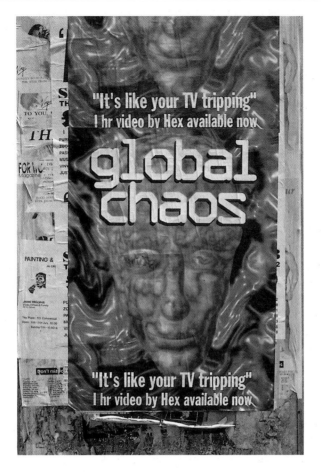

Figure 14.3 'Global Chaos', Poster, Hex Media, 1993

people like Fraser Clark, the editor of the *Encyclopaedia Psychedelica International*. In an article in *i-D* magazine entitled 'Chaos Culture: the New Order?' (Anon 1988), Clark is described as festooning his publications with images of the Mandelbrot set 'seeking to harmonise the 60's hippy and the 80's technoperson.' Clark himself is quoted as describing chaos theory as 'unification science, interrelation science, whole science. It shows you that there is a connection between everything.' This attempt to elevate a set of mathematical tools that may be no more than an experimental technique to the level of a perennial philosophy is a method which may sound depressingly familiar to some. But later on in the article Clark is quoted as offering a second interpretation of Chaos which focuses more on its functionality, though still with a hint of transcendent teleology. 'It

teaches us to accept that there will be periods of turbulence in life, but then a pattern will emerge. It teaches us to accept that we can't always be in control and centred.'

This tendency for scientific theories to mutate almost automatically into New Age cults is resisted by some people whose opposing viewpoints have the effect of exposing some classic misconceptions in this debates. The comic book writer Alan Moore, at the time preparing a new work drawing on many of the themes of chaos theory states that,

> In a way Chaos and fractal maths gets rid of the need for a God. Previously people said that the unfathomable complexity of existence was the best argument for the existence of a creator. But Chaos and the Mandelbrot Set say that's not the case, that with one simple rule fed into a primordial mess, you can have an infinitely complex, perfect order emerging.

<div align="right">(Moore quoted in i-D magazine 1988)</div>

Comparing this to Fraser Clark's earlier statement we have an example of how a scientific model can be taken either as a sign of the power of science itself or as a description of or metaphor for the wonder of natural forces. It is purely a problem of ideology, both interpretations could be correct. Those scientists of the former persuasion were never put off their belief in physics by the 'complexity of existence' in the first place. Classical mechanics was considered perfectly adequate to describe natural phenomena, at least in principle (and it is foremost a matter of principle that we are concerned with). The turbulence in fluid-flow dynamics, for example, was seen as merely a further indication of how the laws of classical mechanics when applied to independent water oscillations would ultimately combine to give the appearance of random motion, just as Laplace would have argued. The fact it was not discovered that turbulent fluid flow is possible without considering it as the complicated interaction of separate oscillations was not discovered until Lorenz's work in the 1960s says more about the epistemological history of scientific ideas than it does about their truth value in relation to mysticism. In this sense scientific realism and mysticism are bedfellows – Fraser Clark can always claim that chaos theory has discovered something about the fundamental nature of the deity.

There are, then, several key features here that chaos theory is able to provide in order to be incorporated into a popular fiction. Through its subversion of determinism, Chaos is able to return a sense of mystery to otherwise dry and mechanistic accounts of the world. Nature is seen in a creative evolution, unexpectedly generating diversity. Through the plotting experience of a fractal on your computer, the ability to generate so much detail from so simple an equation can be regarded as a grotesque but compelling discovery. This active participation in the phenomenology of Chaos is often cited by scientific writers as a major advantage in the

cultural colonization of the science. The inability to determine the outcome of a chaotic system from its starting conditions is also translated into evidence for the scientific possibility of free will. The apparently wide applicability of chaotic dynamics to models of physical systems, as well as inspiring models of everyday phenomena such as stock-market fluctuations and the froth on a cup of coffee, creates a rhetoric of chaos theory as the grand unifying theory, invisibly connecting all the strands that come together to form our multi-layered world.

It is this narrative functioning of the scientific theory of chaos, and specifically its cultural manifestations in relation to postmodernism, that were the subject of an essay by film theorist Vivian Sobchack. Published in the November 1990 issue of *Artforum*, this article entitled 'A theory of everything: meditations on total chaos', can be seen as a touchstone of how Chaos theory was itself theorized in the mainstream of critical debate. Sobchack studied how Chaos had been represented in popular scientific works like Peitgen and Richter's catalogues and James Gleick's book (Gleick 1987) and makes cultural readings of the terms that it speaks in, like order, scale, subjectivity and randomness. In Sobchack's hands the specifically scientific aspects of the theory are subdued in preference of the framing of Chaos as a conceptual metaphor for postmodernism. Perhaps to provide a balance for the prevailing hysteria about fractal science at that time, Sobchack embarks on a particularly pessimistic description of Chaos as a cultural phenomenon displaying all the worst aspects of postmodern life.

A lot of the article is devoted to examinations of the aesthetics of fractal imagery that help to form its popular impressions. 'Libidinally driven by desire for control, this fetishised relationship with simulation is nowhere more visible than in the computer graphic models of "reality" ' (Sobchack 1990). Chaos is interpreted by Sobchack in terms of a kind of desire to combine the ability to impose scientific order on the world with a desire to transcend its physical limitations and attain a kind of digital freedom by entering a mathematical space of infinite fractal depths. The ability to generate fractal imagery at any scale allow them to be continually zoomed into, reminiscent of the film *Powers of Ten,* in which a camera zoom is constructed to travel from outer space right down to the size of an atom on the hand of a man fishing. Sobchack sees this scalelessness as a 'refusal to accommodate human bodily orientation' and finally a 'transcendence not only of physical ground but also of moral gravity'. This experience of exploring the endlessly subdividing tendrils and spirals takes on the quality of 'aimlessly fulfilling plural, random and nonlinear trajectories' and will 'dramatise the deceptive way in which postmodern culture's privileging of difference also trivialises it beyond value.' The 'difference' that is so important to some cultural theorists in terms of cultural identity is now worthless when it becomes a feature of this mathematical numberscape. In the end, Sobchack is driven to the adoption of such extreme language

that she describes chaos theory's coupling of order and chaos as exhibiting 'both fascist yearnings and a dangerous relativism'.

Early on in her essay Sobchack makes a statement that 'chaos theory has little to do with the specificity of human embodiment and historical situation.' In a conclusion Sobchack writes:

> In postmodern culture as in chaos theory, the computer enframes the world by making it absolutely available and manageable. What emerges is not merely a computer graphic image but a philosophical picture of a 'world' deprived of meaning. That is, it makes no *existential* sense (author's italics).

It is only at the last two paragraphs of Sobchack's essay that she concedes that there is a positive 'existential' side of chaos theory. This is the side that teaches that organisms are always in a state of complex dynamic flux and that the relevant level of study is at the macro-phenomenon level instead of the elemental. For Sobchack this is most significant when Chaos is applied to the body. She quotes from a neurobiologist: 'Everybody used to search for equilibrium, but now we understand that biological systems don't go to equilibrium until they die and cease to exist.' But if Sobchack has intended to play devil's advocate in this essay it is a role that has limited mileage. For what has got left behind in her account is a deeper engagement with the scientific practice that grounds chaos theory, and the perception of this practice as a resource from which the causes of the negative cultural readings that she fears can be challenged.

Chaology manages delicately to poise the need to control and to determine responsibility with the desire to retain creative freedom and subjective agency. Sobchack sees a danger in this, that when both modes of action are possible, one will be used as an excuse for not applying the other. The way to resolve such issues is not to reject Chaos as a conceptual red herring but to see this field of discourse as one of the new areas in which critical activity must take into account the methods of scientific practice.

VISIONS OF SCIENCE

In her 1991 book *Simians, Cyborgs and Women*, Donna Haraway published a series of essays written over the previous ten years in which she constructs an argument in favour of cultural theorists taking scientific research seriously in their need to create new ways of challenging social conditions.

What is not covered in Haraway's work, however, except perhaps in certain references to *National Geographic* photo features, is the impact of media technology in channelling scientific artefacts directly to the public in the form of electronic imagery. In many instances now we see how

research imagery has been absorbed into culture without, or in spite of, any accompanying scientific text. Even in the classic media form of the television documentary, programme editors have frequently adopted the strategy of building an entire documentary item around a suitably photogenic piece of computer visualization. When graphics is used to publicize research in this way, how does this complicate the process of telling and critiquing scientific stories?

The more common way for scientific ideas to be mediated into popular culture has been through science fiction, but so far this does not seem to have happened in the case of chaos theory. The actual imagery of Chaos is unusual in that it invites discussion in parallel with the scientific theory that spawned it, sometimes in spite of it. This allows Vivian Sobchack to treat it as an aesthetic phenomenon.

Through her privileging of the 'existential' applications of chaology, which in effect means its function in biology and the life sciences, Sobchack rejects Chaos imagery as displaying postmodern vertigo and decentring of the subject. But these fractal designs have also been theorized by scientists in terms of boundaries between the individual areas, these areas being the centres of strange attraction. The boundaries between the centres have fractal geometries, in that instead of having the properties of clear and definite demarcations, they subdivide endlessly into the infinite details of spirals and eddies. In one of these 'mappings' described by Peitgen and Richter, the boundaries between three areas of attraction divide the plane up so finely that mathematically every single point shares a boundary with all three areas. 'Wherever two regions are about to form a boundary (yellow and blue, for example), the third region (grey) establishes a chain of outposts . . . they in turn are surrounded by chains of islands in a structure which is repeated down to infinitely small dimensions' (Peitgen and Richter 1985). There are other examples of mappings that split the plane between four or however many centres. This does not seem to be an illustration of the 'death of the subject' theorized through Baudrillard's 'fractal subject' but its recasting as a network of infinitely subtle connections emanating from a single node.

Interestingly enough, some artists and writers see it as their duty to publicize scientific theories that they see as important for the good of their fellow citizens. Alan Moore, the comic book writer already quoted from *i-D* magazine above, talks further about his plan for a comic book series called *Big Numbers*. Describing it as 'a 12-part 500-page representative view of a small English town at the end of the 20th century', Moore says that the aim is a 'search for a fractal view of society', through a depiction of 'the turbulence that occurs in all levels of life . . . and the hidden order which underpins life's apparent randomness'. Moore sees this project as a way for the theory of Chaos to reach the mainstream through the imagery of popular culture.

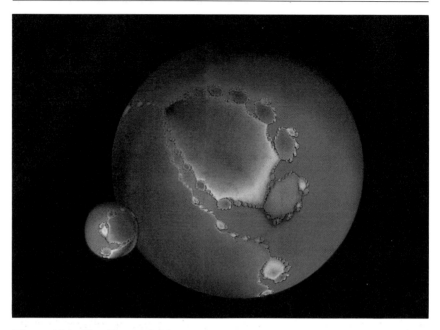

Figure 14.4 'The Fractal Subject'

> Let's face it, the majority of people don't make maths text books their
> staple reading – and the school system acts as a kind of aversion therapy.
> ... Perhaps the only chance Chaos and fractals have of being understood
> by a wider audience is through art, literature, music and comics.
>
> (Moore, *i-D*, 1988)

But though Moore hoped to get permission from Benoit Mandelbrot
to use the image of the fractal that bears his name on the front cover, it
seemed that Mandelbrot himself, while personally sympathetic to the
project, was reluctant to allow this to go ahead on the grounds that a
further popularization of his theories would fuel the criticism from other
scientists that his work was lacking in serious intent. We seem to
have reached a situation in which cultural producers can adopt scientific
theories to validate a body of work, but then that very popularization
discredits it in sections of the scientific community.

A POETICS OF KNOWLEDGE

There are some organizations that have built their reputations on what we
might call the transferal of scientific visualization into projects of an artistic
nature. (art)n is the name of a well-known group that also works out of the

Electronic Visualisation Laboratory at the University of Illinois. It consists of various artists and scientists who collaborate on producing artworks usually in the form of photographic and holographic installations. In their voluminous publicity they describe their work as 'painstakingly constructed models carefully loaded with references to specific art-historical figures.' What this usually consists of is combining an image illustrating some scientific subject with an image taken from a well-known cultural genre of some kind. A typical example of this approach of throwing science and art together in the hope that something worthwhile will emerge is '"Apollo at Sunset". Visualisation of the Rhomboy Homotopy, a four dimensional (up-down, left-right, front-back, and another, variable axis) object, juxtaposed with an image from nature'. Perhaps their most ambitious attempt to force some relation with human experience was a six-panel holographic installation called 'Messiah' which consisted of 'A visualisation of the AIDS virus, based on scientific data available in 1987. Most of the structure portrayed is still accurate by 1990 standards. . . . In the background of each panel is a CATSCAN of a person named Messiah who died of AIDS'. It is (art)n's declared intention that this work should be one of the chief means of publicizing the discipline of scientific visualization through its participation in cultural events: '[The work of (art)n] represents collaborations by scientists and artists who want to communicate their love of the often complex mathematical beauty of nature.' If we take this kind of talk too seriously we begin to slide into the position where we think that science can prove that nature is beautiful.

What we seem to have here is a situation in which the work of scientists when expressed in imagery can only be culturally appreciated in terms of aesthetics, or at the very most on the level of science as itself an aesthetic practice. Science itself is then presented as a practice dealing in a realm of pure knowledge where social interactions and daily practice become discounted. Is it possible to construct cultural readings from scientific visualizations, perhaps not from the examples here, that are informed by social and political relations? Although since Peitgen and Richter's heyday, pictures from fractal geometry and chaos theory have become tediously repetitive, their banal graphics inspired more ideological fervour than any we have seen praised since. And what of other kinds of scientific visualizations seemingly excluded from these cultural debates – how would the simulation of the ozone layer be seen in a computer art competition? Surely we can conceive of work that addresses the public meaning of scientific issues through a language of algorithmic imagery. Such a practice would be a poetics of knowledge, or of objectivity.

An interesting example of the role of imagery in modern scientific polemics is documented in an issue of the newsletter of the National Center for Supercomputing Application at the University of Illinois which describes how computer graphics was used in a study of the effect of forest

fires on different ecosystems (Robinson 1990). In contrast to earlier views that forest fires were to be prevented at all costs, ecologists had now discovered that fire was a necessary part of the evolution of the forest. Fire benefits the forest by decomposing fallen plant material, opens up the forest canopy to increase sunlight for new seedlings and ensures a wider range of tree species. Although most forest fires are small scale, the evidence also shows that even quite cataclysmic fires are necessary for forest ecology. The scientists had to find a way to use these studies to reverse the publicity that had been promulgated for years: 'How to convince the public – and policy-makers – that forest fires should not always be suppressed.' The solution was to construct a series of computer animations that showed simulations of forest growth under the effect of different fire-control policies. Using an array of computing, specialist graphics and video resources, and expertise the equal of any commercial production house, a tape was produced with the help of ecologist David Kovacic who had had previous experience using visualisation: 'with the possibility of a national audience, Kovacic enlisted the help of Bob Patterson, postproduction supervisor of NCSA's media services ... to create a professional quality videotape for communicating the complex facts about forest succession.' What the study shows is not so much the importance of visualization in the process of scientific research itself, but its crucial role in the entry of that research into the greater scientific community and into public discourse.

Chaos imagery demonstrates through its brilliant renderings our lack of understanding and misconceptions about our own scientific creations. They show man's 'strangeness to himself' or, as Donna Haraway puts it, that science is a trick played on man by the coyote of nature. It took the power of computer simulations in embodying strict determinism to realize that simple casual systems did not ensure predictability and simply related structures – this was not what determinism really 'meant'. Determinism still works contingently, and chaos science is therefore fundamentally different and fundamentally the same. We can now see that science made assumptions about the implications of its own work that now seem mythical. What has changed is more an effect of perception. That new scientific perception is exercised metaphorically and literally through visualization. If fractals had been discovered by artists or if Julia and Fatou's iteration theory had not found wider applications then they would have remained an aesthetic curiosity. It is only their place as objects of knowledge that gives chaotic imagery their full meaning scientifically, and as we have seen, culturally.

When visualization tries to appropriate 'content' by assuming a ready-made artistic genre or by restricting the matter to a straight visual decoration, it can lose the significance of its wider scientific and social

references. In different fields of human activity like the arts and sciences, the same words, images and rituals can have different meanings. When these different texts are passed between these fields their meanings will inevitably change, like a poetry. The challenge is if we can make these changes lead us to new insights and knowledge. If computers and visualization can create these connections between different disciplines and their means of perception then perhaps they will result in a new cultural practice, a 'poetics of knowledge'.

I would like to try to give a couple of examples of this hypothetical practice, a practice that as yet probably does not exist. Earlier, I drew attention to the work of the scientists Peitgen and Richter who made such an effort to explain the significance of their pictures of dynamical systems through a series of books, exhibitions and courses. Their approach was to elucidate notions like determinism, complexity and creativity, and give a new scientific perspective to old concepts. Another very different example might be David Blair's film *Wax: or the Discovery of Television Amongst the Bees*, which by comparison is more like a flight simulator on acid. This latter is like a work of science fiction which weaves a complex narrative between intelligent systems, natural and computerized, and political and psychological boundaries. But if we put these two enterprises at opposites ends of a spectrum which defines this 'poetics of knowledge', we might be able to form an idea of a kind of work which could fit in the middle and it is this task which I would like to leave as a challenge for the future.

REFERENCES

(art)n and EVL (1991) *PHS Colograms: Science in Depth*, exhibition catalogue, Boston: Computer Museum.

Crutchfield, J.P., Farmer, D., Packard, N.H. and Shaw, R.S. (1986) 'Chaos', *Scientific American* (December).

Flusser, V. (1990) 'Curies children: Vilem Flusser on an unspeakable future', *Artforum* (March).

Gleick, J. (1987) *Chaos: The Making of a New Science*, New York: Viking Penguin.

Haraway, D. (1991) *Simians, Cyborgs and Women*, London: Free Association Books.

May, Robert M. (1976) 'Simple mathematical models with very complicated dynamics', *Nature* 261: 459–67.

Moore (1988) 'Chaos Culture: the New Order?' *i-D* magazine, 64 (November).

Peitgen, H.O. and Richter, P.H. (1985) *The Beauty of Fractals: Images of Complex Dynamical Systems*, Berlin: Springer Verlag.

Robinson, K. (1990) 'Fires over Yellowstone', *NCSA access* 4(5) (May-June). Published by the University of Illinois.

Sobchack, V. (1990) 'A theory of everything: meditations on total chaos', *Artforum* (November): 148–55.

ACKNOWLEDGEMENT

This research was supported by a grant from the Sir John Cass Faculty of Art, Design and Manufacture of London Guildhall University.

Supernatural futures
Theses on digital aesthetics

Sean Cubitt

> As usual, we are looking forward to the future as though it were the past.
>
> Jimmie Durham

There is but one future we are all assured of, if you discount the certainty of taxes. But death is strangely absent from contemporary discourses of the digital media, even those that focus on artificial life. Immortality of the soul rages as a discursive formation, but death has been banished. However, banishment is not destruction. Death returns in a variety of guises, the repressed that will not fade away. Central to these discourses of the repression of death is the variety of responses that can be configured around the question, What comes after the natural? In the languages of digital aesthetics, nature's successors rarely appear unambiguously as personal extinction, but in a series of metaphorical and futurological constructions in each of which death is reconfigured as a kind of conceptual landscape. Such altering landscapes through which these answers meander I will refer to as postnatures.

I would normally avoid the prefix 'post': I can find little evidence for a radical break with the genocidal, exploitative, oppressive and bureaucratic recent past. I cannot believe that the triumphant western imperium is about to crumble because of an epistemological event, sociologically explicable as the slow dissemination of a mathematical puzzle about the status of truth theorems. Indeed, the same puzzle, as stated in Gödel's *Entscheidungs-problem* and Turing's response to it, is fundamental to the invention, design and functioning of the computer (Nagel and Newman 1959; Hodges 1993). Not even the changing terms of truth-statements can disguise the debts owed by the electronic architectures of knowledge to Morse telegraphy, the institutional library, the imperial bureaucracies of the eighteenth and nineteenth centuries and a vast legacy of visual, auditory and verbal regimes and protocols from the recent and the more distant past.

I prefer to understand what we are living through as an acceleration of modernity, not a break from it: indeed, acceleration is in any case a quality of the modern. As we work more intensively and more reflexively on our

societies, cultures and technologies, the rate of acceleration increases, and as it does, the view of the landscape, of nature, alters too. The natural is something which has constantly to be posited: either as the source or goal of the human, or as the other of the human which serves to define the human as species. What we imagine to be the world or the life after nature has as many dimensions. I want here to discuss three of these that seem particularly relevant to the problematic of digital aesthetics: the supernatural, the antinatural and the cybernatural. These postnatures, which can be recognized in their simplest forms as, respectively, the life after death, the triumph of technology over nature, and the creation of artificial life, have been and still are proposed as gateways to a new era, even as the precocious existence of the future in the present. Each has seen itself, pseudo-scientifically, as predictive: especially in the European traditions since Madame Blavatsky, even religious belief becomes mystical science. Each has been related to social, cultural, moral and aesthetic cataclysm, real or imagined. Each entails a complex set of connotations, some of which are so difficult to disentangle that the arbitrariness of dividing one from another in this clumsy classification becomes a liability. Nonetheless, I will persevere in this preliminary disentangling, so as to recover the most dramatic aspect of their contemporary functioning: that postnatures do not supersede or sublate one another, but co-exist in the ways we think about the digital domain. Postnature is not a unified zone, any more than nature itself. With each postnatural vision comes a revision of the natural, and with each new nature/postnature pair is associated an aesthetics and a politics. But each vision persists in the others, and the more a schema is historically embedded and the more it is regarded as outmoded and forgotten, the more it returns, as repressed, as tragedy and as farce, in the others. Such, I believe, is the fate of the supernatural, whose ancestral ghosts haunt our machines.

I

Strangely, though it is a truism to say that each of us faces death alone, death is a wonderfully public category of thought. The vast majority of the world's population believe in some form of afterlife, and hold their beliefs in common with just about everyone they know. Given that the only death we can observe is the death of another, and that rituals of the approach to death, of dying and of mourning are cultural phenomena of great importance, we can nudge our way towards an understanding of death as a social signifier. Central to this social construction is the sense that life is separable from the body: that there exists some impalpable but real spark which continues as the mortal shell is left behind.

Of what is this spark constituted? Today, perhaps, those of us with a Christian background would find it hard to avoid thinking that in some

way, shape or form, it is the personality that subsists beyond the grave. Such is the residual faith of the recent Hollywood cycle of afterlife films, of which *Ghost* is only the most successful at the box-office. But in more traditional, and specifically in oral societies, that conception of personality is clearly not in play: the spirits of ancestors rarely have the tastes or attributes of their human counterparts, becoming either benign or dangerous according to posthumous events, not lifetime ones. What is preserved in the afterlife is, theologically, not the person but something far more abstract.

Oral societies rely on memory: on the prolonged disciplines of mnemotechnics which enable those massive feats of remembering which drive both bardic and scriptural traditions. Such acts of remembering as those undertaken in the Koranic and Rabbinical schools or by law students preparing for exams have the virtue of acting to provide a focus for social integration. Minds become repositories of vital cultural information which can be handed down through generations, constantly renewable but always in a genealogical relation with the past, and always at the service of the present. The widespread use of tag-lines and proverbs as building blocks for dialogue, anecdote and jokes is evidence of the persistence of this aspect of human interaction. Remembering is social: it bonds those who can access and share the same memories.

Rituals surrounding death further the same ends. Mourning involves the remembering of kinship and social ties and obligations. We set aside grievances and grudges, and offer appropriate actions to the dead and the bereaved. In the complex emotions of holding on to and letting go of the dead, religion 'assures the victory of tradition over the mere negative response of thwarted instinct' (Malinowski 1948: 29). Linking this thought to the notion of orality as a culture of remembrance, we can understand that in the rituals of bereavement, what is celebrated is the maintenance of the tradition beyond the deaths of individuals. In this sense, in oral cultures, and those subcultural forms characterized by respect for tradition, the afterlife is a matter of maintaining the socio-cultural investment of the *socius* in the memory of the individual. The individual's death is validated by the way in which it can be assimilated into the continuity of the culture.

That is, of course, in religious societies, or in societies without religious conflict. In his comments on this passage, Geertz argues that Malinowski's account fails to distinguish adequately between the social and cultural instances of mourning, arguing the existence of 'a discontinuity which leads not to social and cultural disintegration but to social and cultural conflict' (Geertz 1973: 164). Geertz's comments arise in the context of a discussion of a failed attempt to conduct appropriate funerary rites in contemporary Bali, a failure which he ascribes to 'an incongruity between the cultural framework of meaning and the patterning of social interaction,

an incongruity due to the persistence in an urban environment of a religious symbol system adjusted to peasant social structure' (Geertz 1973: 169). Such conflicts may or may not have been common in ancient societies: they are common today, and the more so as our culture places deaths in parenthesis and mourning as a hiatus in the common flow.

The emergence of western Europe from such traditional bases of knowledge is part of the history of the Enlightenment, as it is part of the history of the emergence of capital. But despite the efforts of the Catholic church to recruit faith in ghosts for the doctrine of Purgatory, and of the Reformation to mark its difference from the Roman faith by denying the possibility of return from beyond the grave (Thomas 1971: 588–9), the ghosts remain. Tradition lives by anecdote, and few anecdotes are as well-remembered as tales of hauntings. The eradication of ghosts by the Reformation, however incomplete, is part of the necessary process of liberation undertaken in the slow, immense coming to birth of modernity between the fifteenth and eighteenth centuries, in which we are still embroiled. It is a liberation from the dead hand of memory. For though the arts of memory make the fragments of experience cohere, they do so by uniting the social and the cultural, by articulating the present with the past, by the establishment of authority (the Chaucerian *auctorite*) as the final court of appeal. Memory-based cultures are condemned to tradition: in its failure to accommodate the yearnings marked by belief in ghosts, accelerated modernity remains as condemned as they.

This appears to have some neurobiological backing. Changeux, for example, argues that, although human brain weight increases by a factor of 4.3 after birth, and although axonal and dendritic trees continue to proliferate in successive waves from birth to puberty, with each wave of new connections there emerges a crisis of redundancy, and a selective stabilization of the new connections. He concludes his presentation of the epigenetic theory of human brain development thus: 'One has the impression that the system becomes more and more ordered as it receives 'instructions' from the environment. ... To learn is to stabilise preestablished synaptic combinations, and to *eliminate* the surplus' (Changeux 1985: 249). More recently Stephen Rose repeats the same message: 'There is a lot of evidence that during early phases of brain development, there is a huge over-production, a veritable efflorescence, of synaptic connections which are later steadily pruned back in number; redundant or irrelevant synapses are discarded and the remainder in some way stabilised' (Rose 1993: 140). Traditional cultures, heavily reliant on the brain as repository of wisdom, require a special emphasis on the specificity of the individual: his or her ability to recall, from the very structure of the brain, vital social and cultural knowledges. The shift to artificial, externalized memories brought about by the spread of writing and print removes this necessity, and opens the brain towards a more plastic and serendipitous relation with the environment.

Both the rise of accelerated modernity and the ability to cope with it arise from this neurobiological shift facilitated by the freedom achieved from the necessity to remember the wisdom of the clan.

However, as the prevalence of ghost tales indicates, long-guarded cultural traditions have a stronger grip than we presume, and they come back to haunt us. This quality of longevity I would ascribe to the social nature of memory, even when it occurs in an individual. Traditional cultures, including those which persist in such occasions as mourning, are centrally public, although it is perhaps anachronistic to call historical societies 'public' in the absence of a matching private sphere. Their conception of the supernatural is of a domain which is continuous with the natural world, and shares with it a fundamentally religious shape. The duty of the individual is to submit to the laws which bind both worlds, a submission to a god-given order whose reward will be in one of three typical forms: the Second Coming, the Kingdom of David, or, since the Reformation, individual redemption. The first translates the natural world into the supernatural, the second establishes the Kingdom of God on earth, and the third offers a salvation based on the person. This last is of course the odd one out, and historically the most recent and most wide-spread in the West, the home of digital culture, and devolves upon a widespread self-image as subject of a personal god. The invention of a personal afterlife seems at times premised upon the sacrifice of a fleshly paradise, the medieval Land of Cockaigne with its rivers of wine and trees full of pies, and substituting for this sensuous, but endlessly deferred Eden, a cooler and more cerebral new life in an ideal republic of God. The garden of earthly delights certainly returns in the rock 'n' roll lifestyle (and eponymous drug of choice) of Silicon Valley's artist-entrepreneurs, only now removed from the common future to the individual present. At the same time, however, messianic forms also persist, and return in the guises of antinature and cybernature. God may have died, but his ghost is haunting us.

II

The emergence of the private sphere and its demarcation from the public in the eighteenth century is facilitated by the new social relationships of externalized memory, and by a new understanding of nature and post-nature. The submissive relationship to god-given nature and the messianic immanence of the divine are countered with a dialectically opposed conception of nature as a dominion of human rule. Technology becomes the instrument of that dominion, and it is to triumph over human as well as physical nature. With the printing press, the arts of memory are replaced by craft. The private reading of novels is ascribed to the feminine sphere of home and leisure, while the public is rapidly professionalized,

shifting from the coffee-houses, *salons* and *Tischgesellschaften* to the institutionalized library and the bureaucratic archive. Knowledge is rationalized, categorized, rendered encyclopaedic. These forms, as I have argued elsewhere (Cubitt 1996), are central to the evolution of such familiar digital structures as databases and the desktop interface.

Still the most important commentary on this transformation is Marx's *Capital*, in which he argues that,

> capital has one sole driving force, the drive to valorise itself, to create surplus-value, to make its constant part, the means of production, absorb the greatest amount of surplus labour. Capital is dead labour which, vampire-like, lives only by sucking living labour, and lives the more, the more labour it sucks.
>
> (Marx [1867] 1976: 342)

The undead stalked the factories of Manchester and north London. The rationalization of labour hid its nightmare other: capital as Dracula, the conversion of living labour into dead technology.

When seen through other eyes as a triumph over tradition and over the forces of nature, when lauded in the illumination of cities, the spread of wealth and the electrification of everything, the inexorable processes by which labour skills were converted into machine tasks and the values of a personal touch were replaced by the values of standardization, the doors were opened to a reformulation of leisure. Now leisure time belonged to the private domain, the sphere of reproduction. The beautiful became, through the work of Kant, recognizable by its divorce from human life: 'Taste is the faculty of judging an object or mode of representing it by a wholly *disinterested* pleasure or displeasure. The object of such pleasure is called *beauty*' (Kant [1790] 1928). Thus leisure too became a mode of overcoming, of the transcendence of human nature.

Jaron Lanier, pioneer entrepreneur of virtual reality, has been heard to say that,

> the physical dwellings of the future would probably be cheap, dull, unadorned shelters generated by robot factories to put no-frills roofs over the heads of an overpopulated humanity. To compensate for the squalid physical surroundings, VR will provide interactive virtual buildings for personal expression and aesthetic fantasy.
>
> (cited in Heim 1994: 1)

Virtuality offers an entire escape from nature, a total and totally artificial environment bereft of the teleological principles against which Kant argued in the 'Analytic of the beautiful'. More still, it plays upon the notion of an entirely private space: a home-based relation, intensifying the relationship between text and reader of curling up with a good book, to the point at which all surroundings are lost.

This second, antinatural domain, then, combines the concept of nature as dominion with a postnature which is technology, conceived of as antinatural. Its aesthetic is of Kantian disinterestedness, typified by the attitude of rapt contemplation, without hope of reward, of the wholly autonomous art object: an aesthetic that gives rise on the one hand to the theorization of the autonomous logics of different art media identified with Clement Greenberg; and on the other to the anti-teleological stance of Lyotard's neo-Kantian aesthetics of the sublime. In each instance, the abolition of tradition is held as a blessing, which has made possible the emergence of an intensified disjuncture between public and private, in which the public domain gathers to itself the pursuit of human interests in labour and politics, while to the private is allotted the disinterested pursuit of goalless pleasures, the former triumphing over external nature, the latter over internal. Print moves us from the commonwealth of memory to the individualism of data retrieval: a model of externalized memory now profoundly entrenched in the design of databases. The decay of traditional print libraries and the institution of commodified, restricted-access knowledge banks merely accelerates the instrumentalization of knowledge, even in universities which otherwise would wish themselves to be the last bastion of unmotivated, disinterested research.

One of the typical forms of aesthetics associated with the emergence of the industrialized world is the concept that technologies pursue an independent logic, emerging as and when the time is right, resonating with a culture so the walls of the cities shake. Drawing extensively on Heidegger and Walter Ong, Michael Heim develops, in his 1987 work *Electric Language*, a concept of word processing as both a logical outcome of the autonomous development of writing technologies from calligraphic to typographic, and as an embodiment of Heideggerian enframing, in which human freedom to act is circumscribed by the technologies on which it has come to depend. Heim concludes his methodological chapters thus:

> The existential observations on the corresponding modifications of human language through technological Enframement do provide several clues by which to guide our reflections on the interface in which we work. These include the connection between the origination of reality apprehensions and language skills, the temporal disposition (mood) of reality apprehensions, the typification inherent in modern technology, the tendency to interpret all writing under the rubric of information management.
>
> (Heim 1987: 94)

Such themes are not unfamiliar. Heim gives a highly articular voice to a set of concerns which have exercised scholars since Mumford, Giedion and Innes, if not before. In the electronic interface, it is possible to sense a different and more distanced relation between self and environment, a

relationship which appears as managed by the technology itself. Processes of standardization and objectivation inherent in digital media appear as historical agencies, capable of affecting the structure of the human psyche. Technologies are credited with altering what it is to be human. For some this is a release from the tyranny of nature, for others a sinister mechanism of control, and this fundamental ambiguity powers Heim's analysis and gives it its persuasive strength.

A pleasant example of the upbeat reception of such ideas comes in a recent interview with Microsoft's Bill Gates. Describing a portable computer linked to radio interfaces currently in development, he says: 'It'll have a little sensor that knows your current position, the so-called GPS systems that shows you where you are and where the nearest restaurants are'. (Gates 1994: 9). Apart from the charm of needing a computer to tell you where you are, and the quirky belief that the next thing you need to know is where to buy a meal, there's a clear presumption here that Gates is living in a world in which it is important to be told where you are. A more paranoid reading would see the letters 'GPS' as GeoPolitical Surveillance, and live in dread of a system that could tell you where you ought to be.

Two corollaries of this aesthetic need to be brought out. On the one hand, it is clear that such a system cannot tell you where you are: it can only remind you. The price of the emergence from a traditional system dominated by the need to place the culture's memories in wetware, and so limit the freedom of thought, is that we need to be reminded. The inadequacy of human memory to the complexities of urban life and global telecommunications is a frequent lament, from hackers seeking prosthetic memories to those of us who just have trouble remembering the names of our neighbours and people at work. But it is also a challenge, not least to the corporate culture, who feel the need to keep their names and products in our mind's eye. They resort to the time-honoured technique of repetition, and it is a hallmark of the antinatural that it is an endlessly repetitive culture. It is not simply that the rhythms of the workplace are transferred to the rhythms of leisure (the Teddy hates Jazz thesis), nor that there is a movement from Frankenstein to Big Brother, malevolence to management. Rather, in the antinatural aesthetic of technological determinism, we are condemned, in our freedom from memory, to endless repetition, not even of themes that we might wish to hear repeated, but of jingles for a thousand products we will almost certainly never buy. Memory is still clogged, but this time with redundant brand names, logos and catchphrases.

The struggle with this state of affairs, in the aesthetics of antinature, is posed as one of the individual against the technology, or of individuality in a dialectical relation with an enframing whose source is a mode of socialization – technological advance – over which no-one appears to have control. The social no longer appears as the interaction of peers, but as

a system operating according to its own logic. Technology is then freed to take on a metaphorical role, and the fantasy of Cockaigne is replaced by the administrative categories of a realizable future, utopian or dystopian, in which the future is constantly at stake in all current politics, always immanent, always within the control of those who make the present. The politics of the antinatural is the politics of control over the future, including our own fates beyond death.

Steven Holzman (1994) speaks of the mixed emotions with which people respond to his composition programmes, which can generate music in the manner of, and according to the systems deployed by, dead composers: where a style can be expressed as an algorithm, the programme effectively takes on the functions of an personal afterlife. The concept of the algorithm as a life form has become common currency: Stephen Levy's book *Artificial Life* (Levy 1992) is in the main an enthusiastic account of the development of computer programs capable of imitating the behaviours of organic creatures, of learning, and of evolving, passing on the results of experience from generation to generation. Yet the final chapter of the book adopts a more sober tone. Here he assesses the sense of sin which some researchers admit to, the Faustian parallels with the actions of a creator god, and the ominous loss of control over their creations experienced by the devisers of viral programs. The spectre of artificial life-forms as weapons of war is raised, alongside the more *Mondo 2000* science fiction of infinitely prostheticized bodies.

Levy's interviewees take on increasingly sacred grammars and vocabulary as they reflect upon the successes and likely futures of their pursuit. Themes derived from Lovelock's Gaia hypothesis sit uneasily with memories of the Golem and Frankenstein, sacred and secular variants on the theme of hubris in the pursuit of knowledge. Intriguingly, there is no mention of death in Levy's index, although it appears as a metaphor in some accounts of some programs. But we know what we mean when someone says 'My computer just died on me': what we sympathize with in that case is the loss of memory (brain death, it may be recalled, became the legal definition of death only in 1968).

Levy's artificial life ('Alife') expresses, in a specific domain of digital practice, one of the core approaches to digital aesthetics. A number of artists working in the field of electronic arts poo-poo the use of off-the-shelf programs to generate fancy pictures or pleasant tunes. They argue that the essence of the machine is its mathematical logic, and that a true computer artwork is one which, like Alife, is able to evolve from basic parameters and produce or perform unforeseen symbol-generation. Artists like William Latham (IBM UK) and Karl Sims (Thinking Machines) deploy mathematico-logical formulae according to biological models to evolve hybrid machine-life-forms, the artist's role reduced to selecting the initial parameters and sometimes choosing the more aesthetically pleasing

routes for development. The displays used to show off these numerical meanderings are visual, and the expression of the computations given the shading, even the wetness, of organic life.

Latham's 'virtual sculptures' and Sims's genetic 'cross-dissolves' are cited as effective and efficient uses of genetic paradigms to evolve effects that, done by hand or traditional computation, would take an age to generate. But the criterion of efficiency, tremendously important to the new use of computing in the animation industry and a hundred other applications, is less central to the glamour of their work than the impact of seeing what appear to be living organisms on the screen. The virtual world has taken on the role of the supernatural; to provide a parallel universe in which the continuities lost in the transition from traditional societies can be resumed. Alife forms, and the visual rhetoric deployed to give them perceptible shape, have even taken on the lineaments of a mode of existence in which, as with Holzman's compositional algorithms, an infinite extension of the living mind is possible. After all, the one who enters the first genetic imprint into the matrix, is he not the Allfather? And is his relationship with his creations not one of wonder and love, mixed with a sense of your own smallness in the face of a creation as out of control as a computer virus: a new submission in the face of the powers of technology's own intimate genetic processes?

Faced with the possibility of afterlife now, the options available appear, in turn, as a choice between submitting yourself to the operation of a system which supersedes human agency, or turning your back to the future, and your face to the living-room. The private domain becomes a refuge from the impossibility of a system that cannot respond to individual agency. The computer then becomes a tool for a self-expression which is otherwise publicly denied and devalued. Such, at least, is the lonely fate of the academic at the word processor. But even here, the lonely hour of the last instance arrives: the private is too unstable to remain private for long.

III

Indeed, the logic of development of the private/public divorce as a whole is such that it cannot be maintained as a stable system: indeed, stability would be of no use to a capitalist economy premised on growth and accumulation. The third and in some ways most recent development is the emergence of a postnatural cybernature, the domain not so much of an antinature as of a second nature, a hybridity between human and machine: the domain of the cyborg. In Donna Haraway's influential construction of cyberfeminism, the cyborg embodies the possibility of emergence from gendered nature and gendered technologies into a space in which the body is not a prison where biology is destiny, but a

playground of willed and fluid identities. If I understand her dense and complex essay correctly, her argument is fundamentally metaphorical ('I am making an argument for the cyborg as a fiction mapping our social and bodily reality' [Haraway 1991: 150]). Others, such as Sadie Plant (Plant 1993) and Allucquere Rosanne Stone (Stone 1991), have argued a more concrete politics of cyborg nature, premised on the prevalence of simple prosthetic devices like contact lenses and directed towards more complex human-technological hybrids, a cyberfeminism as prelude to a posthuman future.

As the Mandelbrot set has become the over-used icon of computer graphics, so the cyborg has become almost overfamiliar as a topic in cultural studies. Central to cybernatural discourses is the concept of play, through which the antinomies of industrial antinature can be resolved, if not dissolved, in a Foucauldian power matrix in which the political has overtaken the economic. I don't want here to take up time by arguing the merits of economic and political analyses (I would have little add to the debates collected by Michael Kelly [1994] in *Critique and Power*). I want, rather, to attempt to understand the cybernatural notion of play, and to move on to analysing how it has failed to overcome its supernatural and antinatural forbears.

The concept of play invites us into a third space, beyond public and private, the intimate sphere. The kinds of regime which the historian Foucault deals with so cogently, regimes of mental and physical health, of sexuality and family life, crime and punishment, have advanced step by step into the private sphere, which perhaps now exists primarily as a cultural repository in the service of social reproduction. At the same time, the logic of autonomous art invades popular culture to produce the critical moment which reformulates public art and private culture again: on the one hand, a purely playful but hermetic zone of high art and on the other, a complex interference between the avant-garde and the popular, in which the high culture's centuries-old practice of looting images and innovations from popular culture has been reversed in the assimilation of avant-garde strategies into popular arts. At the same time, the logic of contemplation breaks down with the crisis of autonomy, in which the commonality of taste, on which its universality can alone be premised, is lost. The hybrid forms of electronic media are not merely peripheral in the resolution of this crisis: it is as if this were the purpose for which they were designed. Meanwhile, a further ongoing crisis emerges in accelerated modernity when, as G.A. Cohen argues, the changing means of production outgrow the mode of production for which they were designed: the technology changes according to its own logic, and capitalism is forced into a process of constant re-adaptation in order to maintain control over it (Cohen 1978). The spirits of the undead lie ill at ease in the form of dead labour.

This series of interlocking and by now quite familiar crises is, I think, quite aptly considered as a crisis of control. The *locus classicus* of debates about control and communication is the Internet, in which information and ideas are floated largely in game formats, in which the rules are produced, according to hacker culture, by a process of mutual interaction and radical democracy. My problem with the problematic of democracy as play, however, arises from an intuition that its origins lie in the emergence during the nineteenth century of the games ethic as a central element of the schooling of the imperial bureaucracy, and that from Kim's Great Game to SimEarth is but a small step. The injunction to 'play up and play the game' echoes as strongly on the net as once it did on the playing fields of Eton. We have a curious return to the traditional ethic: an aesthetics of submission, not to nature, not technological antinature, but to the plebiscitary democracy of interaction, of dialogue reinvented as a technologically-mediated, type-driven, rule-governed and spatially-defined zone, and one moreover located in the physical human-computer interface (HCI) whose design is premised on precisely that bourgeois individualism which play is so frequently called upon to overcome.

Indeed, the HCI seems to be configured around an intensification of the psychic relations formed as identification in cinema, where the dialectic of public and private, of social ritual and intimate fantasy, powers the formation of glamour, returned to the private sphere in the foreshortened space of the domestic television, and now moving to the hunched, one-on-one foetal curl of the body engrossed in the VDU, with the promise of ever more intensely individuated interfaces in VR. This hyper-individuation works by a similar regression to that evoked by cinema, where the dialectic of identification regresses its audience to the moment of ego formation. In the HCI that regression is carried even further back, to the primary narcissism of 'Her Majesty the Baby'. Because the world appears to conform to the infant's desires, it believes in its own magical powers over its surroundings. Play is the element through which it moves. But both its play and its power are effectively carried out in a kinder-garten in which there are no other children, just the infant and his servants. Regression to this phase in the HCI is delightful, and dangerous. Narcissistic hyperindividuation in the adult becomes a form of submission to the interface which allows it to occur.

This return to a submissive relation has, however, a series of differ-ences from its traditional predecessor. It is technologized; it admits, and indeed is predicated, on the existence of individuals; living memory has been replaced, first by data retrieval premised on the socialization of individuals, and then by knowledge as a serendipitous quest defining of individuality; the confluence of equals is superseded by hierarchies of access; and the environment has shrunk from the sensorium to the inter-face. More important still, cybernature develops as a global reach of the

localized player, an attempt to regain a sense of control in a culture marked by perpetual crisis. The playful, as a central characteristic of cyber-space, can then be read, not as the emergent realm of radical democracy, but as a complex environment of chance and ordering that can maximize the gains of interaction undertaken in a thoroughly mediated and self-policing domain, without risk of cataclysm or social change. Its trans-gender identifications emerge not from the future-oriented movement of desire, but from the past-oriented, nostalgic retrospect of anxiety.

The games system is bounded and homeostatic, hierarchic and, in many instances, hieratic. The object, as in all games, is to create a rule-governed chaos whose equilibrium is never entirely lost, though tested to the extreme. It is, in effect, a management system. As such, it produces in narcissistic hyperindividuation a more thoroughly administered person-ality than any previous society, since its achievement is built on the colon-ization of the newly-created intimate sphere. Fantasy was a last refuge from the critical mass achieved by the family which, pressurized into becoming not only the centre of the reproductive cycle but also the final meaning of work and life, had collapsed under the pressure. Dysfunctional family life, the new private sphere, became in turn policed and policing of its members, leaving the personality formed in the trace of flight from the public with only one immediately obvious escape route: inwards. Now even that inwardness is pried open, with bribes of pleasures not beyond but within our wildest dreams: utopia now.

The intimate utopia of cybernature is, however, a lure. Its function is the opposite of social stability: it is to create a globally predictable consumer culture. Burnished by the kind of pseudoscience offered by commentators like Howard Rheingold (Rheingold 1991), the new consumerism critiqued by Sobchack (1993: 581–3) is a brittle gloss over a reorientation of the individual-social dialectic of antinature, not a break with it. Democracy as play is premised not on the transcendence of individuality but on its intensification, not on the overcoming of gender but on infantile regression. Polymorphous perversity is a pleasure few would want to deny themselves in a culture based on gratification. But when it threatens to subsume the human altogether, dragging it into a romper room of selfish attention-seekers, the central properties of humanity, the communication that makes democracy and indeed the future possible, are at risk. The traditional mode of socialization demands a submission to nature as to death: a being-towards-death that creates the possibility of social integration. In the technological relation, the libera-tory aspects of antinature rapidly become the administration of the future and the submission of the social to its own means of (re)production. When the cybernatural proposes 'that the logic of Bios is being imported into mAchines, the logic of Technos is being imported into life' (Kelly 1994: 2), the assimilation of the future into the present, of the human into an

increasingly homogeneous domain of increasingly meaningless difference, a shift from Darwinian to Lamarckian evolution in which the library of previous experience becomes the genetic code of future generations, such that no genuine mutation is any longer available. The future, considered as that which is absolutely other (Levinas 1989: 46) in the cybernetic playground may not only be controlled, but abolished.

IV

For Marx and his successors, the escape from technologization was through technology. For Gramsci, for example, there was the example of Fordism as an overcoming of bourgeois individualism, the maximal socialization of labour as a model for the subsumption of the private into the public (Gramsci 1971: 277–316). The nature that was to be overcome was particularly human nature, as formed in the Bessemer converters of capitalism, to be replaced by a new set of fully socialized relations. Peter Wollen's account of Gramsci on Fordism (Wollen 1988: 9–13; 24–6) emphasizes Gramsci's enthusiasm for mechanization, supportive even of Ford's attempts to control the private lives of his workers. But it is also the case that Gramsci sees in Fordism the germs of its own overcoming. As the physical gestures of work, broken down into repetitive tasks, become reflexes, and the transformation from complete engagement in work practices to disengaged mechanical action is complete:

> what really happens is that the brain of the worker, far from being mummified, reaches a state of complete freedom ... not only does the worker think, but the fact that he gets no immediate satisfaction from his work, and realises that they are trying to reduce him to a trained gorilla, can lead him into a train of thought that is far from conformist.
> (Gramsci 1971: 309–10)

Observing the demise of the craft of calligraphy and its replacement by mechanical systems like compositing, typewriting and shorthand, without losing site of the qualitative shift Gramsci is able to announce that 'it is not the spiritual death of man' (Gramsci 1971: 309). On the contrary, as we have seen: the embodiment of knowledge as reflex is a liberation from a reflective and tradition-based culture.

There is, in any case, no going back. I have yet to find an account of digital aesthetics, however glum its prognostications, which believes that it might be possible to return to older ways. Less astute, I think, has been the attempt to think the new media as if they had no history at all: to presume an epistemological and even sociological break with the immediate past, constituting the present, to taste, as that utopia or dystopia which, like Gramsci's America, is defined by its absence of tradition. I do not doubt that there is a strand in modernity which believes that history

is bunk, but the marxist proviso still holds good: it is those who fail to understand history who are condemned to repeat it.

Supernatural, antinatural, cybernatural: these postnatural landscapes evolved in the passage into modernity are so profoundly entwined with one another that it feels almost impertinent to have developed this schematic mapping of the digital domain. Each has maintained its position. Perhaps of all of them, the supernatural holds the most sensitive position. For people like myself whose beliefs are still fundamentally socialist, and for whom the long and painful process of extricating ourselves from childhood religious faith is something rarely completely accomplished, the supernatural remains a terrible lure. On the other hand, the left's failure to address the area of what, for want of any other term (precisely) I find myself shyly referring to as the spiritual, has left a whole register of human experience and yearning open to the worst kinds of demagoguery, from Shiv Sena to Oliver North. Is it so absurd, then, to find inspiration in Kant's first and second theses on universal history?

> All of a creature's natural capacities are destined to develop completely and in conformity with their end. . . In man (as the sole rational creature on earth), those natural capacities directed towards the use of his reason are to be completely developed only in the species, not in the individual.
>
> (Kant [1784] 1983)

That Enlightenment ideal, damaged as it is by a history whose oscillations between reason and unreason (reason as a capacity for mutuality and reason as the instrument of dominion), haunted by a failure to mourn the death of a God who, as a result, haunts the contemporary as a malevolent force for tyranny and oppression, and scarred even in this translation from Kant by the presumption of a gendered destiny and the uniqueness of the human, nonetheless rings with something we cannot bear to be without: hope.

Arthur Kroker and Michael Weinstein's analysis of 'the recline of the West' identifies two strands to contemporary political life:

> One great tendency is the formation of a virtual class, comprised of directors and specialists, with its internal tensions. The mission of this class is to deliver the flesh to virtuality, to telematic being. A second great tendency that counterpoints the first is the rebellion of the flesh against virtualisation in the form of retro-fascism. This rebellion consists of a brutal quest for purity within the (vanished) flesh – flesh congealed into a fictitious societal community, a regression from virtuality into ideology!
>
> (Kroker and Weinstein 1994: 145)

In that inimitable style, Kroker and Weinstein capture something of the perverse turn taken by the Enlightenment pursuit of rational community: that it has taken on the form of an utterly instrumentalized reason, to

which even the human body is a blockage to total management, while opposition to it has taken the reactionary route of converting community into communalism, and history into a repository of mythical values. In their critical account of the contemporary, Critical Art Ensemble (1994) argue that the nomadic tactic, which to de Certeau (1984) had appeared as an appropriate use of weakness to defeat the designs of power, has become the strategy of power itself, now rendered free of place by speed in communication. One fears that, in the unstable form of regressive hyperindividuation, the contradictory formation of a narcissistic culture founded in the affirmation of selfhood, we are witnessing the emergence of a subject position modelled on the nomadic transnational corporation.

There are many reasons to feel afraid. When Marvin Minsky argues that 'Once delivered from the limitations of biology, we will decide the length of our lives – with the option of immortality' (Minsky 1994: 87), he is proposing to treat the digital domain as a repository of the human: as a defence against death. But doing so, he imagines, will be a matter of options, choices, freedom. Hans P. Moravec of Carnegie Mellon University is of a similar persuasion, and has publically advocated cryogenics and downloading of the brain to digital formats as the final escape from the predations of nature – 'meat', in the slang of hackerdom. Such fantasies are common in cyberpunk fiction, and in on-line discussions on the Net, truisms of cyber-nature that echo the personalist reworking of the unforgotten supernatural paradigm. Meanwhile, a fierce struggle over the future of digital communications is visible in key descriptive terms for the Internet: a web, or a superhighway, a zone of play, or a miracle of engineering. The struggle between these metaphors is symptomatic of a deep concern for the ownership, control and meaning of the emergent culture.

Given that an estimated 80 per cent of network traffic is undertaken in corporate communications; that CD-ROM publication is dominated, like software and hardware, by a tiny number of major transnationals; that over 70 per cent of the world's computers are concentrated in the northern hemisphere; that HCI design is dominated by an individualist, not to say hyperindividuated model of socialization; that the visual systems predominant in graphics programs derive directly from the European Renaissance and the age of imperial expansion; that the Qwerty board assumes an advanced state of normalization of hand-eye coordination and other motor skills; that both hardware manuals and software are dominated by the use of the English language and a handful of European tongues; given that the logic, the architecture and the systems design of the vast majority of computers approximate to the needs and hierarchies of corporate bureaucracies; that the marketing of emergent applications is dominated by super-, anti- and cybernatural paradigms, and that the emergent culture bears all the hallmarks of repressive tolerance: given all this, you can see how such critical analyses can gather so much credence.

And yet there is that Pandoran gem lurking in the empty trunk of the Enlightenment. There seems little doubt that the electronic media will continue their urgent expansion for another twenty years or so (barring a major breakthrough in the current limits to computational speed). For that brief period, there is the possibility of making a difference in the way in which the new medium can operate. Changing the medium is unlikely, I believe, to change the society in which it operates: the reverse is historically more likely. But maintaining the openness of communications is the duty of intellectuals and artists alike: without it there is no possibility for further change. Open communications is, in this sense, the goal of Kant's universal history, even though, by the lights of his epoch, he believed that reason and communication were the same. The route beyond hyper-individuation and total management is the route through them. We must engage with the new media as shamans, engineers and psychoanalysts, to exorcise ghosts, build new architectures, politicize the emergent social unconscious.

That 'we' is the 'we' of Kant's special destiny: the requirement that humanity seek its fulfilment in mutual action, hanging together or hanging separately. In the context of this collection, it need not be argued that human destiny relies on the permeability of the individual and the social, and of the permeability of the human with the environment. For my own part, that means adding what I can to research into the imperial origins of the contemporary mediascape, seeking crumbs of the understanding that will help avoid the horror of history's return, of the eternal present. That analysis will need to understand the intertwining of economic, political and communicative determinants, but will also need to understand the ways in which politics has now become a matter of struggle between those who wish to control the future, and those who wish to maintain its radical alterity, its utter autonomy from design, mastery, administration. Doing so means recognizing the unfathomability of our own deaths, the acceptance of mystery there, at the horizon of what is graspable. 'If one could possess, grasp and know the other, it would not be other' (Levinas 1989: 51): we have to love the future, not seek to own it. If information is both power and commodity, the materialist aesthetics of digital communications which we will need must be founded in democracy and commonwealth, and fundamentally dedicated to loosing control. As we cannot own one another, we cannot own our common future. But we must resist the temptation to make of the future only a graveyard haunted by our own ghosts.

REFERENCES

The epigraph is taken from Jimmie Durham (1994) 'A friend of mind said that art is a European invention', in Jean Fisher (ed.), *Global Visions: Towards a New Internationalism in the Visual Arts*, London: Kala Press, 119.

Changeux, J.P. (1985) *Neuronal Man: The Biology of Mind*, Oxford: Oxford University Press.

Cohen, G.A. (1978) *Karl Marx's Theory of History: A Defence*, Oxford: Clarendon Press.

Critical Art Ensemble (1994) *The Electronic Disturbance*, Brooklyn, NY: Autonomedia.

Cubitt, S. (1996) 'Read only memories', in K. Sims (ed.) *The Subject of Linguistics*, The Hague: Mouton.

de Certeau, M. (1984) *The Practice of Everyday Life*, trans. S. Rendall, Berkeley: University of California Press.

Gates, B. (1994) 'Inside the Gates', *Microsoft Plus* 4 (October/November).

Geertz, C. (1973) *The Interpretation of Cultures*, London: Fontana.

Gramsci, A. (1971) *Selections from the Prison Notebooks*, ed. and trans. Q. Hoare, and G. Nowell Smith, New York: International Publishers.

Haraway, D. (1991) 'A cyborg manifesto', in *Simians, Cyborgs and Women: The Reinvention of Nature*, London: Free Association.

Heim, M. (1987), *Electric Language: A Philosophical Study of Word Processing*, New Haven, Conn: Yale University Press.

—— (1994), 'Nature and cyberspeace', *Doors of Perception* CD-ROM, Amsterdam: Mediamatic.

Hodges, A. (1993) *Alan Turing: The Enigma of Intelligence*, London: Counterpoint.

Holzman, Steven R. (1994) *Digital Mantras: The Languages of Abstract and Virtual Worlds,* Cambridge, Mass.: MIT Press.

Kant, I. ([1784] 1983) 'Idea for a universal history with a cosmopolitan intent', in *Perpetual Peace and Other Essays*, trans. T. Humphrey, Indianapolis: Hackett Publishing.

—— ([1790] 1928) *The Critique of Judgement*, trans. J. Creed Meredith, Oxford: Oxford University Press.

Kelly, K. (1994) *Out of Control: The New Biology of Machines*, London: Fourth Estate.

Kelly, M. (ed.) (1994) *Critique and Power: Recasting the Foucault/Habermas Debate*. Cambridge, Mass.: MIT Press.

Kroker, A. and Weinstein, M.A. (1994) *Data Trash: The Theory of the Virtual Class*, Montreal: New World Perspectives.

Levinas, E. (1989) 'Time and the other', in Seán Hand (ed.) *The Levinas Reader*, Oxford: Blackwell.

Malinowski, B. (1948) *Magic, Science and Religion*, Boston, Mass.: Little Brown.

Marx, K. ([1867] 1976) *Capital: A Critique of Political Economy* I, trans. B. Fowkes, Harmondsworth: Penguin/New Left Review.

Minsky, M. (1994) 'Will robots inherit the earth?', *Scientific American* 271 (4) (October).

Nagel, E. and Newman, J.R. (1959), *Gödel's Proof*, London: Routledge & Kegan Paul.

Plant, S. (1993) 'Beyond the screens: film, cyberpunk and cyberfeminism', in *Variant* 14, (Summer) (=*Video Positive 93* catalogue).

Rheingold, H. (1991) *Virtual Reality*, London: Mandarin.

Rose, S. (1993) *The Making of Memory: From Molecules to Mind*, London: Bantam.

Sobchack, V. (1993) 'New Age Mutant Ninja hackers: reading *Mondo 2000*', in M. Dery (ed.) *Flame Wars: The Discourse of Cyberculture; South Atlantic Quarterly* 92 (4) (Fall) Durham, North Carolina: Duke University Press.

Stone, A.R. (1991) 'Will the real body please stand up?: boundary stories about virtual cultures', in M. Benedict (ed.) *Cyberspace: First Steps*, Cambridge, Mass: MIT Press.

Thomas, K. (1971) *Religion and the Decline of Magic: Studies in Popular Beliefs in Sixteenth and Seventeenth Century England*, London: Weidenfeld & Nicholson.

Wollen, P. (1988), 'Le cinéma, l'américanisme et le robot', in R. Bellour and A.M. Duguet (eds) *Vidéo*, (=*Communications* 48), Paris: Editions du Seul.

Feminist figuration and the question of origin

Sarah Kember

> The future is without form, shape or colour: it demands yet exceeds all figuration.[1]

A figuration is a performative image of the future; performative in as far as it embodies an epistemological and ontological shift which acts, albeit virtually[2] in the present. Rosi Braidotti says that she believes in the empowering force of feminist figurations such as Luce Irigaray's two lips 'that suggest closeness while avoiding closure' and Donna Haraway's cyborg, 'a high-tech imaginary, where electronic circuits evoke new patterns of interconnectedness and affinity'.[3]

I want to consider the cyborg alongside Braidotti's own 'nomadic subject' as figurations which have been imagined from within a socialist-feminist framework of debates on science, technology and subjectivity. I want to concur with both Hebdige's and Braidotti's injunctions to consider the future in relation to the past, and in relation to the constraints of power and social division. When the future of nature is the future in question, then it seems to me to be important not to forget nature's past – its origin(s). This act of remembering is, of course, constrained by evolutionary, biological, medical and psychoanalytic discourse and by a dualistic and essentialist western epistemology which structures knowledge of as a form of power over nature. But figuration can enact a transformative re-remembering of nature and origin which in Donna Haraway's words 'cracks the matrices of domination and opens geometric possibilities'.[4]

Nature in technoscientific discourse and Enlightenment epistemology is female, and less specifically it is 'other'. Socialist feminism has traced the material and symbolic power of essentialism through history, and has sought to change the status of women and other 'others' not least through a proactive engagement with epistemology and the politics of difference. Cyborgs and nomads emerge from this critical tradition as non-essentialist images of a future rooted in the past and in social reality. They both are and are not science-fictional, taking pleasure and responsibility in imagining an elsewhere which is here and not here, and above all refusing the terms of determinism and apocalypse.

So before looking in more detail at feminist figurations and the trans-
formation of nature and origin, I want to explore the matrices of
domination in contemporary technoscience, or rather, to reveal the cracks
that already exist and show how they are repaired in the technologically
determined apocalypticism of mainstream ('malestream') institutional
discourse. I will argue that the cracks appear at the level of epistemology
and ontology and that they are repaired through recourse to fantasy/
phantasy and technological fetishism.

In an apocalyptic scenario, technology has run out of control and there
seems to be little 'we' can do about it. For anarchists this is a cause of
celebration,[5] but for those with an investment in maintaining the status
quo it is at once a means of abdicating responsibility for the future and
legitimizing a reactionary politics otherwise known as conservatism. This
kind of politics (rather like the anti-politics of the anarchists) circles most
frantically around computer technology and the simulative potential of
what is loosely termed virtual reality.

The fear and the fascination, the technophobia and technophilia centre
on the as yet, or ostensibly, ungoverned possibilities of cyberspace; a
science-fictional concept defined by William Gibson as a 'consensual hallu-
cination' and as 'the point at which media [flow] together and surround
us'.[6] Cyberspace is immersive and unreal, 'the new final frontier' where
we can boldly go but may get lost, go mad, do something terrible or forget
our way home. In cyberspace we are all cyborgs released from social
convention and free to behave badly. Just as the technology is regarded
as being out of control, so are the post-humans who inhabit it. The
anarchic cyberpunks and cyberfeminists run amok but in mainstream film
the cyber-baddies generally learn their lessons or (like the end of the
Terminator) are brought down to earth in bits. In the end, the traditional
values of the pre-post-humans and their society tend to prevail
(Terminator II is after all something of a family man).

EXCEEDING THE METAPHOR OF
PANOPTICISM[7]

I don't, however, want to concentrate on science fiction, but on the science-
fictional apocalypticism of discourses surrounding the computerization
of surveillance technology. These discourses suggest that surveillance
technology once promised a privileged access to truth and to reality. In the
transition from analogue to digital and electronic forms of imaging, and
with the advent of seamless digital manipulation, surveillance technology
is no longer considered to be trustworthy and has precipitated a(nother)
crisis concerning the loss of the real.

It was John Tagg, drawing on Foucault's concept of Bentham's idea of
the panopticon, who most clearly identified the role of photography as a

mechanism of surveillance and a means of social control in the nineteenth century. Tagg's argument, that the camera was used as a form of panopticon, was not technologically determined:

> What gave photography its power to evoke the truth was not only the privilege attached to mechanical means in industrial societies, but also its mobilisation within the emerging apparatuses of a new and more penetrating form of the state.[8]

Photography became a means of social control because it was mobilized in the new disciplinary institutions such as prisons and hospitals. It was mobilized within an institutional discourse of control which had as its premise the potentially threatening nature of an emerging social class,[9] and which was based on a positivist epistemological principle. The as yet unknown, unclassified social subjects were to be investigated by the same laws as natural objects. That is, by a painstaking process of observation, measurement, categorization and recording described by Francis Bacon as the inductive means of acquiring knowledge, and by Foucault as an invisible operation of power. Photography played a central role in the process of observing, measuring, categorizing and recording the unproductive element (the sick, the mad and the bad) of the industrial labour force, and also contributed to a rhetoric of reform. John Tagg and Roberta McGrath analyse before and after photographs of street urchins and the physically deformed made good (corrected and cured). Elaine Showalter looks at how photographs by Hugh Welsch Diamond and Alphonse Charcot contributed to the essentialist classification of women as hysterics and to the regulation of women's minds through their bodies.[10] Alan Sekula shows how the 'repressive codes' of photographic representation (frontality, flat lighting and so on) facilitated physiognomic and phrenological forms of investigation and contributed to a regulatory discourse of normality and abnormality.[11] According to Sekula, repressive representational codes and their counterpart 'honorific' codes (based on commercial portraiture) 'regulated the semantic traffic in photographs' during this period. Ultimately, one set of codes becomes implicated in the other.

 While these debates avoid technological determinism, they do perhaps contribute to the establishment of panopticism as a universal metaphor for photography. Hebdige warns that in compiling a 'critical audit' of discursive strategies and the possibilities which open up or close down within them, we should beware of building universal metaphors from historical contingencies:

> We might like to consider how differently located (and hence in both senses provincial and partial) accounts of contemporary culture work to mask their partiality by leaning on established kinds of academic authority and presenting themselves not as provisional observations at all but as universally valid assertions of historical fact.

The brilliance of Michel Foucault's thesis about disciplinary surveil-
lance, for example, shouldn't be allowed to conceal the fact that
Bentham's Panopticon, the building on which Foucault's infernal vision
of modernity is built, never actually got built.[12]

An infernal vision of modernity and of a technology associated with
modernity is quite a lot to build on a building that never got built, even
though quite a lot did get built like it. The discourses of control and
epistemological structures constructed on its non-existent foundations are
shaky. Discourses of control are inherently unstable, reacting as they do
to an imaginary and ever-present threat. And positivism is only guaran-
teed by a faith in optical realism which was questioned in the nineteenth
century, and is more or less in crisis now. When photography was used
to establish police records in the nineteenth century, it was quickly found
to be an inadequate means of criminal identification, generating as it did
'a vast and chaotic archive'[13] which required other means of refinement
and ordering – notably a series of anthropometric measurements. In
computerized criminal identification procedures today, something like
those measurements are still used by the police and form a feature index
which supplements the (usually) photographic database and, along with
the cognitive interview technique, helps to make the system more user-
friendly and to overcome 'limitations at the eyewitness end'.[14] It should
also be noted that the Victorians practised composite and spirit photog-
raphy, and knew how easy it was to fake an ectoplasm.[15]

So, the panoptic metaphor of photography as a surveillance technology
doesn't hold, and as Tagg subsequently suggested, 'the totalled machine
won't work'.[16] Photography is not a unified medium. What is really being
unified in the claim that surveillance technology once offered a privileged
access to truth and authority is representational realism and a positivist
epistemology which structures and guarantees a relation of domination
between the humanist subject and the object world he surveys.

With the advent of new surveillance technologies the unification of
realism and positivism appears to be more problematic because of the
evident constructedness of the image, and apocalyptic claims about 'the
end of photography as we have known it'[17] and 'the end of this and that'[18]
mask an insecurity about the status of the rational humanist subject. As
I suggested, cracks in the matrices of domination appear at the level of
epistemology and ontology – and are repaired. When photography is the
technology which determines apocalypticism, one way of repairing the
cracks seems to be through recourse to a fetishisation of photography as
evidence. Fred Ritchin, lamenting the death of photography, argues that:

> Photography used to serve as a reality test. One saw something, or
> thought one saw something, or even thought something, and the photo-
> graph was there as confirmation or denial; or at the very least to be

argued with, for the photograph could not be dismissed. . . . Somehow we even made the mistake of thinking that the photograph was unbiased.[19]

A fetishization of photography as evidence is based on a denial of the fact that it was actually always known to be 'biased'. The Victorians knew it, and in recent years semiotic and post-structural analysis have exposed the notion of photographic truth as a myth. As Martha Rosler puts it:

> The question at hand is the danger posed to *truth* by computer-manipulated photographic imagery. How do we approach this question in a period in which the veracity of even the *straight*, unmanipulated photograph has been under attack for a couple of decades?[20]

One of the events which triggered a panic about the truth status of photography, specifically among photojournalists, was the one in which *National Geographic* moved the pyramids at Giza closer together so that they would fit better on the front page. This was done by digitally manipulating a photograph, or as the editor later suggested, 'a kind of retroactive repositioning of the photographer'.[21] In order to restore the honor of photographers, the values of photojournalism and the authority of the image, Ritchin suggests that from now on photographs should be regarded as what others reckon they always have been – local and partial statements rather than universal and objective truths:

> The photographer will have to be considered to be the author of his or her images, responsible for the accuracy of what is in them. When the photograph is no longer thought of as simply a mechanical transcription, then it will have to be acknowledged as the product of individual interpretation.[22]

Martha Rosler has no such investment in maintaining the status quo. For her there is no danger in problematizing truth claims made by those in authority, and there is no apocalypse. The real danger, she suggests, 'is political; it is the danger that people will choose fantasy, and fantasy identification with power, over a threatening or intolerably dislocating social reality.'[23] As an example she mentions uncritical public responses to 'stage-managed' news during the Gulf War. Although these fantasy identifications with power were facilitated by the way in which 'electronic imaging on television and in the newspapers was integral to the war story', they were not technologically determined as 'these approaches were different only in kind, not in strategy or effects, from the propaganda efforts in earlier wars'.[24]

Another example where fantasy may be chosen over a 'threatening or intolerably dislocating social reality' is in relation to media reports on the James Bulger case, where electronic imaging is again integral to the story.

This was a shocking case involving the abduction and murder of a two-year-old boy by two ten-year-old boys. It was reported in the media as having stimulated or contributed to a widespread moral panic about child crime being out of control, and it certainly threatened the familiar cultural categorization of childhood as innocence. What is more, the abduction was 'captured' on two separate security cameras which, in the public eye at least, singularly failed to do what was expected of them. They failed to act as an adequate means of either prevention or detection. They made us watch helplessly and voyeuristically as a crime that had already happened took place, and they offered us images which were at best indistinct, and at worst (as one local resident put it) 'crap'.[25] These images appeared on television and in the press along with, and in contrast to, more familiar and unthreatening family snapshot and portrait photographs of James.

Surveillance technology in this case seemed to offer us no control over the surveilled, even though the police claimed to have used digitally enhanced versions of the images to capture Robert Thompson and Jon Venables, and even though they stood as evidence in law. Rather, what remained constant throughout the reporting of this crime was a discursive construction of both children and technology as out of control. This was perhaps fuelled by a more widespread phobic response to technological change, and by a rhetoric of addiction surrounding children's interaction with video and computer technology, specifically video and computer games. *The Times* (17 February 1993) reported that truancy and petty theft was common at the scene of the abduction (a shopping centre in Bootle), and that theft financed children's addiction to video games played in a nearby arcade.

In the face of this unsettling interaction between children and technology and the confusion of familiar categories of understanding, the media resorted to a straightforward division of children as either angelic or evil, and of technology as either good or bad. What could not be tolerated it seemed, was a reality in which children (and technology) could be both good and bad at the same time. The psychoanalyst Melanie Klein defines the process of splitting as an unconscious defence against conflict, and against the frustration and hatred felt towards a witholding but otherwise loved object. In developmental terms, splitting (or the 'paranoid-schizoid' position) precedes the stage at which reconciliation and assimilation becomes possible (through the stage of 'depressive anxiety') and psychic reality is achieved. However, the developmental process is not necessarily linear.[26] For me, psychoanalysis can provide not a universal account, but a useful narrative or partial perspective on cultural processes. Splitting may help us to explain the cultural construction of women as either madonnas or whores in patriarchal society. I would also argue that it helps to explain the construction of childhood subjectivity and

technology in media reports on the James Bulger case. Splitting is a defensive mechanism, and in this case it secures a (conscious and unconscious) fantasy of control over a newly threatening other.

MEDICAL SCIENCE AND THE FRANKENSTEIN FACTOR

Women and children co-exist in the realm of technonature, and both contribute to an insecurity in the status of rationality and the traditional humanist subject which was always already there, but which is being realized in the discourses (cultural, legal, medical) of contemporary technoscience. Fantasies of control and technological fetishism emerge in response to this realization, and feminist modes of criticism are seeking to expose them not least as patriarchal, and as having material as well as symbolic effects.

The feminist critique of medical technoscientific discourse and the fantastic quest for omnipotence in the creation stakes, probably began with Mary Shelley's *Frankenstein* (the book, not the film), and the Frankenstein factor clearly endures throughout contemporary feminist debates on the new medical imaging and reproductive technologies.

Against the claims of Barbara Maria Stafford that electronic imaging techniques signal an epistemological shift in medicine,[27] the editors of *Body/Politics: Women and the Discourses of Science* argue that:

> The last two centuries have witnessed an increasing literalization of one of the dominant metaphors which guided the development of early modern science. For Bacon, the pursuit of scientific knowledge was figured rhetorically as the domination of the female body of nature, illuminated by the light of masculine science.[28]

Mary Jacobus *et al.* claim that the metaphor of domination has been literalized through the professionalization of science and particularly through advances in reproductive technology. Reproductive technologies monitor and control pregnancy and childbirth, and through laboratory experiments and the development of genetic engineering, women's role in reproduction is being increasingly marginalized. If procedures like IVF and genetic engineering open women's role in reproduction to question, then so do forms of imaging technology which effectively eliminate the mother's body from view.

Feminists are critical of the way in which medical science attributes productive and reproductive agency to machines. Jacobus *et al.* suggest that in the nineteenth century the machine seemed to offer a corrective to the inefficiency and indiscipline of human labour, and now, increasingly, technology can be seen to correct for (and even to replace) female labour. Female labour can be read in terms of economic productivity and

also in terms of reproductivity. In *The Female Malady*, Elaine Showalter looks at the ideological alignment of a discourse of productivity and reproductivity in the treatment of women in mental asylums in the nineteenth century. In relation to new reproductive technologies, Paula Treichler argues that technologies can be seen to be taking over the reproductive role of women, and to be themselves the agents of reproduction. She says that 'the role of the mother has been written out of the birth process which is now projected as an interaction between the doctor and the foetus.'[29] Refering to the foetal rights issue, Carol Stabile claims that visual technologies which isolate the embryo 'as astronaut, extraterrestrial, or acquatic entity have had enormously repressive reverberations in the legal and medical management of women's bodies.'[30]

Contemporary technoscience appears to be able to father itself. Indeed, outside of the context of reproductive medicine, the United States National Library of Medicine has presided over the creation of a brand new monster – and his 'bride'. Two human corpses, one male and one female have been scanned, sliced and photographed at one third to one millimetre intervals from top to toe, and one of them is currently available on the Internet for the purposes of medical training and research and of general curiosity. This is the male subject, who has been called 'Adam'. 'Eve' is still on her way, and on her arrival science will have managed to recreate Adam and Eve in cyberspace.[31]

Sarah Franklin identifies one weakness in the omnipotence fantasy of contemporary technoscience. Having fulfilled its desire for dominion, it now lacks what she calls the 'foundational authority'[32] of nature. There is no longer an external absolute or certainty for science. There are no longer any limits to progress, and science enters an anxiety-ridden phase of illegitimacy based on the elimination of boundaries. Mary Ann Doane identifies a related problem based on a fear that the female body of nature (like the repressed) will return to contaminate technology.[33] The nature in question here is reproductive and maternal nature – the nature of origins – and both Franklin and Doane suggest that anxieties about the relation of technology and female nature tend to result in a proliferation of images of monstrous mother-machines. These images repeat what Constance Penley refers to as 'the frequent conflation of women-out-of-control with technology-out-of-control'[34] in science fiction and popular discourse.

These images, I suggest, say more about the status of the subject than they do about science's long-suffering object. The notion of an autonomous reproductive science and technology is a fantasy enacted in the face of women's persistent ability to have children, and maintained through a fetishistic use of technology. The image of a foetus floating in what looks more like outer space than the internal space of a woman's body, is in keeping with a whole set of astro-medical visions (of cells that look like stars and so on) which appear to colonize the body, and by

analogical extension, the cosmos. But as I have argued elsewhere,[35] these visions may also be seen to compensate for the declining status of the clinical gaze in the face of new imaging technologies (body scanners for example) which can see both further and better than the human eye, which unsettle the surface of representational realism, and which no longer centre and affirm the place of the humanist subject in the world which s/he surveys. Nature/the body/the object are in this sense more beyond control than out of it, but this is not to deny the material force of compensatory medical discourse and symbolization.

PROMISING MONSTERS[36]

Finally then, I want to turn to feminist figurations and the way in which they construct geometric possibilities in the cracks of the matrices of domination. For Haraway, infinite vision in medicine is an illusion, a 'god-trick' which puts the myth 'of seeing everything from nowhere' into practice. She offers an alternative to the practice of disembodiment, and begins to outline a shift in the terms of epistemology:

> I would like to suggest that our insisting metaphorically on the par-ticularity and embodiment of all vision (though not necessarily organic embodiment and including technological mediation), and not giving in to the tempting myths of vision as a route to disembodiment and second-birthing, allows us to construct a usable, but not innocent, doctrine of objectivity.[37]

For her, 'not so perversely', objectivity is about 'particular and specific embodiment' and is guaranteed only by the 'partial perspective' this procures. Feminist objectivity 'is about limited location and situated knowledge, not about transcendence and splitting of subject and object'.[38] Situated knowledges make us answerable 'for what we learn and how to see' and hold us accountable for the monsters we produce.

Haraway's monster is the cyborg which embodies 'the politics and epistemology of partial perspectives', and is opposed to the cyborgs of military and medical science which help to carry off the god-trick. The cyborg is also her figuration for a future nature which is no longer subordinated to technoscientific culture:

> There is no drive in cyborgs to produce total theory, but there is an intimate experience of boundaries, their construction and deconstruc-tion. There is a myth system waiting to become a political language to ground one way of looking at science and technology and challenging the informatics of domination – in order to act potently.[39]

The cyborg is a monstrous figuration in as far as it is a boundary creature, deconstructing and reconstructing the boundary between subject

and object, culture and nature. It may take the form of a human-machine hybrid but is committed to mobile subject positioning and renounces any claim to – at least unitary – subjectivity.

The cyborg figures a relation to nature, but is not of nature. It was not born and has no origin story 'in the western sense'. Although it is easy to see the advantage of this from Haraway's point of view, if there is a point at which it becomes possible or necessary to question the cyborg's commitment to nature, then I suggest that it is here. Haraway and her cyborg, quite rightly, want no truck with the Oedipal story of origin which elaborates a 'plot of original unity out of which difference must be produced and enlisted in a drama of escalating domination of woman/ nature'.[40] Other stories and plots are, admittedly, a little thin on the ground, but as Haraway later suggested, we might begin to regard existing ones as partial, as well as to look for alternatives. As one example, Jessica Benjamin offers a critique of the Oedipal in psychoanalysis, and elaborates a theory of intersubjectivity which seems to share a number of affinities with Haraway's political and epistemological project:

> The intersubjective dimension . . . refers to the experience *between and within* individuals, rather than just *within*. It refers to the sense of self and other that evolves through the consciousness that separate minds can share the same feelings and intentions, through mutual recognition. Its view encompasses not simply what we take in from the outside but also what we bring to and develop through the interaction with others – our innate capacities for activity and receptivity toward the world.[41]

Benjamin's theory of intersubjectivity describes a non-hierachical and nonlinear geometry of possible subject relations, and challenges the Oedipal plot of original unity and separation. Rosi Braidotti also develops a non-Oedipal account of her feminist figuration – the nomadic subject – by drawing on the work of Luce Irigaray:

> the nomad is a postmetaphysical, intensive, multiple entity, functioning in a net of interconnections. S/he cannot be reduced to a linear, teleological form of subjectivity but is rather the site of multiple connections. S/he is embodied, and therefore cultural; as an artefact, s/he is a technological compound of human and post-human; s/he is complex, endowed with multiple capacities for interconnectedness in the impersonal mode. S/he is a cyborg, but equipped also with an unconscious. She is Irigaray's 'mucous', or 'divine', but endowed with a multicultural perspective. S/he is abstract and perfectly, operationally real.[42]

For Braidotti, the task of constructing new desiring subjects is dependent on the reconciliation of history and the unconscious, and she argues that if feminists want to construct an effective politics then they need to

develop strategies for negotiating between 'unconscious structures of desire and conscious political choices'.[43]

For me, this points to the value of the figuration as a socialist-feminist political imaginary over apocalyptic visions of the future which abdicate from political responsibility, and resort to narcissistic fantasies of power and autonomy. The nomadic subject journeys towards 'in-depth transformations' in psychic and social structures which 'are as painful as they are slow'.[44] Just as the cyborg is both here and not here, the nomadic subject is 'not new yet'.[45] Braidotti envisions change as a kind of ritualized dance between the old and the new, and suggests that new figurations of subjectivity such as the nomad 'work through established forms of representation, consuming them from within'. She refers to this practice as a form of mimesis or parody which she calls 'as if'. She defends the practice of 'as if' 'as a political and intellectual strategy based on the subversive potential of repetitions'.[46]

Haraway's cyborg is also mimetic and attempts to consume from within the 'belly of the monster' established forms of technoscientific representations. According to her, the battle over the cyborgs may be being lost by 'people who want to make cyborg social realities and images to be more contested places'[47] but that is no reason to give up and 'leave in the hands of hostile social formations tools that we need for reinventing our own lives'.[48]

Cyborgs and nomads work strategically to open up a geometric space for change. Their way of thinking, their consciousness, is based on a model of interconnectedness and affinity. As Braidotti points out, this way of thinking is an epistemological position which is itself nomadic and can transfer from one discourse to another, or at least from one postmodern discourse to another:

> This transdisciplinary propagation of concepts has positive effects in that it allows for multiple interconnections and transmigrations of notions, mostly from the 'hard' to the 'soft' sciences. One just needs to think of the fortunes of a notion such as 'complexity' to appreciate the metaphorical resonance gained by some scientific concepts in contemporary culture at large.[49]

I would suggest that the postmodern science of chaos theory offers two particularly resonant metaphors of complexity, drawn from models of nature – the 'strange attractor' and 'self-similarity'. The strange attractor is a computer-generated model of the changes that take place in a complex natural system (such as the weather) over time. The changes are visualized through the movement of a point on the screen. The point on a strange attractor never becomes fixed, never reaches equilibrium but forms a pattern of loops and spirals which follow two wing-like trajectories. The loops and spirals are infinitely deep, creating layers which do not meet but which remain inside finite space. The strange attractor describes a

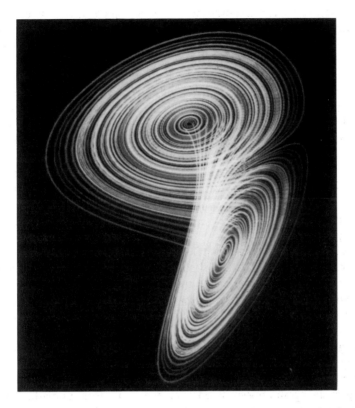

Figure 16.1 'Strange Attractor', Lorenz attractor, from H.-O. Peitgen and P.H. Richter (1986) *The Beauty of Fractals: Images of Complex Dynamic Systems*, Berlin, Heidelberg: Springer-Verlag

new non-euclidean geometry of infinite length in finite space, which has been called fractional or fractal geometry. It is fractional in as far as it is not so much a geometry of objects but of the boundary between competing forces of order and chaos in natural systems. The strange attractor also describes a nonlinear and unresolved relation to origin. It shows that a complex natural system displays a sensitive dependence on the initial conditions of that system. But fractal geometry is hailed within chaos theory as the new science and the new order of nature. It is said to be able to measure a universal or self-similar pattern of complexity across all scales and all divisions of the natural world.

Chaos, then, buries its geometric possibilities in a totalising theory. To remain promising, geometries and metaphors of the future must remain partial and located, and continue to describe a dynamic, intersubjective and open relation to m/other nature.

NOTES

1 Hebdige, D., 'Training some thoughts on the future', in Jon Bird, Barry Curtis, Tim Putnam, George Robertson and Lisa Tickner (eds) *Mapping the Futures: Local Cultures, Global Change*, London: Routledge, 1993, 274.

2 Hebdige refers to the 'virtual power of metaphor', ibid.: 270.

3 Braidotti, R., *Nomadic Subjects: Embodiment and Sexual Difference in Contemporary Feminist Theory*, New York: Columbia University Press, 1994, 3.

4 Haraway, D., *Simians, Cyborgs and Women: The Reinvention of Nature*, London: Free Association Books, 1991, 174.

5 See Fuller, M. (ed.), *Unnatural: Techno-theory for a Contaminated Culture*, London: Underground, 1994.

6 Woolley, B., *Virtual Worlds*, Oxford: Blackwell, 1992, 122.

7 From Tagg, J., 'Totalled machines: criticism, photography and technological change', *New Formations* 7 (Spring 1989), 24.

8 Tagg, J., *The Burden of Representation*, London: Macmillan Education, 1988, 61.

9 See McGrath, R., 'Medical police', *Ten* 8 (14) 1984.

10 Showalter, E., *The Female Malady*, London: Pantheon Books, 1985.

11 Sekula, A., 'The body and the archive', *October* 39 (Winter 1986).

12 Hebdige, D., op. cit.: 275.

13 Sekula, A., op. cit.: 27.

14 Shepherd, J. and Ellis, H., 'Face recognition and recall using computer-interactive methods with eye witnesses', (1993) Vicki Bruce and Mike Burton (eds) in *Processing Images of Faces*, New Jersey: Ablex Publishing, 1993, 142.

15 Permutt, C., *Photographing the Spirit World: Images from beyond the Spectrum*, Aquarian Press, 1988.

16 Tagg, J., 'Totalled machines', op. cit., 25.

17 Ritchin, F., 'The end of photography as we have known it', in Paul Wombell (ed.) *PhotoVideo: Photography in the Age of the Computer*, London: Rivers Oram Press, 1991.

18 Tagg, J., op. cit.

19 Ritchin, F., op. cit.: 9.

20 Rosler, M., 'Image simulations, computer manipulations: some considerations', *Ten* 8, *Digital Dialogues* (Autumn 1991), 52.

21 Ritchin, F., 'Photojournalism in the age of computers', in Carol Squires (ed.) *The Critical Image*, Bay Press, 1990, 30.

22 Ibid.: 36.

23 Rosler, M., op. cit.: 63.

24 Ibid.: 62.

25 O'Kane, M., 'Heysel, Hillsborough and now this', *Guardian*, 20 February 1993.

26 Klein, M., *Envy and Gratitude and other works, 1946–1963*, London: Virago, 1988. See also Kember, S., 'Surveillance, technology and crime: the James Bulger case', in Martin Lister (ed.) *The Photographic Image in Digital Culture*, London: Routledge (1995).

27 Stafford, B.M., *Body Criticism*, Mass.: MIT Press, 1991.

28 Jacobus, M., Fox Keller, E. and Shuttleworth, S. (eds) *Body/Politics: Women and the Discourses of Science*, London: Routledge, 1990, 2.

29 Ibid.: 6.

30 Carol Stabile, 'Shooting the mother: fetal photography and the politics of

disappearance', in Paula A. Treichler and Lisa Cartwright (eds) *Imaging Technologies, Inscribing Science, Camera Obscura* 28, (January 1992), 181.

31 See Kember, S., *Virtual Anxiety Photography, New Technology and Subjectivity*, Manchester: Manchester University Press, (forthcoming).

32 Franklin, S., 'Postmodern procreation: representing reproductive practice', *Science as Culture* 3, 4 (no. 17), 1993.

33 Doane, M.A., 'Technophilia: technology, representation, and the feminine', in Mary Jacobus *et al.* (eds), *Body/Politics*, op. cit.

34 Penley, C. (1992) 'Spaced out: remembering Christa McAuliffe', in Paula A. Treichler and Lisa Cartwright (eds), *Imaging Technologies, Inscribing Science, Camera Obscura* 29 (May 1992), 179.

35 Kember, S., 'Medicine's new vision?' in Martin Lister (ed.), *The Photographic Image in Digital Culture*, op. cit.

36 Haraway, D., 'The promises of monsters: a regenerative politics for inappropriate/d others', in Lawrence Grossberg, Cary Nelson and Paula A. Treichler (eds), *Cultural Studies*, London: Routledge, 1992.

37 Haraway, D., *Simians, Cyborgs and Women*, op. cit.: 189.

38 Ibid.: 190.

39 Ibid.: 181.

40 Ibid.: 151.

41 Benjamin, J., *The Bonds of Love: Psychoanalysis, Feminism and the Problem of Domination*, London: Virago, 1990, 125.

42 Braidotti, R., op. cit.: 36.

43 Ibid.: 31.

44 Ibid.

45 Ibid.: 39.

46 Ibid.

47 Penley, C. and Ross, A., 'Cyborgs at large: interview with Donna Haraway', *Technoculture*, Minnesota: University of Minnesota Press, 1991, 7.

48 Ibid.: 8.

49 Braidotti, R., op. cit.: 23.

Chapter 17

Lacan with quantum physics

Slavoj Žižek

A cursory examination of the responses of philosophy (or, more precisely, of what passes itself off for philosophy) to quantum physics suffices to validate fully Althusser's thesis on the co-dependence of positivism and obscurantism: the 'spontaneous philosophy' of quantum physics consists of a bricolage of positivist confinement to what is measurable/observable and of spiritualist obscurantism ('there is no reality outside the observer', 'reality exists only in our mind'). Stephen Hawking undoubtedly had in mind such obscurantist talk on 'consciousness which begets reality', such associations of quantum physics with ESP phenomena, with curving a spoon at a distance, by means of the sole 'power of mind', and so on, when he risked the provocative paraphrase of Josef Goebbels: 'When I hear of Schroedinger's cat, I reach for my gun.'[1]

The first antidote against such obscurantism is to situate quantum physics in relation to the splitting between the pre-modern universe of meaning and the universe of modern science, which is inherently 'meaningless', 'incomprehensible', since it runs against the most elementary spontaneous preconceptions which determine our sense of 'reality'. How does psycho-analysis relate to the universe of (modern) science? Is it a science, a pre-scientific interpretive-mantic procedure, or something entirely different (a self-reflective procedure in the lineage of the dialectic of German idealism, for example)? Lacan displaced the very terrain of this standard question by asserting that the *subject* of psychoanalysis (the analysand) is the Cartesian subject of science.[2] Therein resides the difference (one among the differ-ences) between Freud (as read by Lacan) and Jung: Jung advocates a return to the pre-modern universe of wisdom and its sexo-cosmology, the universe of a harmonious correspondence between the human microcosm and the macrocosm. In other words, for him, the subject of psychoanalysis is the pre-modern subject living in a universe in which 'everything has a meaning'; for Lacan, on the contrary, the analysand is the 'empty' Cartesian subject living in a 'disenchanted' world, a subject deprived of his roots in the universe of Meaning, confronted with an inherently 'incomprehensible' universe in which the power of everyday hermeneutic evidence is

suspended. This difference accounts for the divergence in their respective approaches to a symptom; in the case of agoraphobia, for example, a Jungian would take direct recourse to some archetype, grounding the fear of open spaces in the experience of birth, of being thrown into the open space outside the maternal body, and so on; whereas a Freudian would follow the lead of modern science and apply himself to a concrete analysis, in order to unearth some contingent link to a particular experience with no inherent connection to open space (recently, the patient witnessed a violent fight in an open space which stirred up an old-forgotten childhood trauma, for example).[3]

How, then, does quantum physics stand with respect to this splitting? Of all sciences, it has most thoroughly broken with our everyday comprehension of 'reality' opened up by modern Galilean physics: Galileo broke with the Aristotelian ontology that gave systematic expression to our everyday pre-comprehension (bodies are naturally 'falling down' and tend towards a state of rest, etc.). However, by carrying this break to extremes, quantum physics also confronts its inherent deadlock most radically: in order to enter the circuit of scientific communication, it has to rely on the terms of our everyday language, which unavoidably call to mind objects and events of 'ordinary' sensible reality (the *spin* of a particle, the *nucleus* of an atom, etc.) and thereby introduce an element of irreducible disturbance – the moment we take a term too 'literally', we are led astray. The only adequate formulation of quantum physics would be to replace all terms that, in any way whatsoever, relate to the universe of our everyday experience, with a kind of jabberwocky, so that we would be left with pure syntax, with a set of mathematically formulated relations. Consequently, scientists are quite justified in emphasizing that one cannot 'understand' quantum physics (to 'understand' a phenomenon means precisely to locate it within the horizon of our meaningful comprehension of reality): quantum physics simply 'works', it 'functions', yet the moment one tries to 'understand' how it works, one is swallowed by the Black Hole of un-reason. On the other hand, difficulties arise with the so-called collapse of the wave function: one can pass from potentiality to actuality only by means of an observer who functions at the level of everyday experience, so that the very line that separates the quantum universe from our everyday reality runs *within* quantum physics. John Wheeler provided perhaps the only adequate answer to one of the great enigmas of quantum physics – When, at what point, precisely, does the collapse of the wave function occur? – by identifying it with the emergence of intersubjectively recognized *meaning*: we are dealing here neither with automatic registration in a machine (photo, for example) nor with consciousness, but simply with language meaning.[4]

This radical break of quantum physics with our everyday comprehension of 'reality' belies all attempts to combine quantum physics with eastern

thought, which remains thoroughly rooted in the pre-modern sexualized ontology (the cosmic polarity of male and female principles, yin and yang, etc.). Attempts to bring together quantum physics and eastern wisdom usually evoke the notion of 'complementarity' – does this notion not point back to the 'complementarity' of principles in pre-modern cosmology (no yin without yang, etc.)? However, a closer examination immediately compels us to call in question this homology. Let us begin with Heisenberg's infamous 'uncertainty principle': even some popular introductions to quantum physics fall prey to the epistemological fallacy of interpreting the uncertainty principle as something which hinges on the inherent limitation of the observer and/or his/her measuring instruments – as if, on account of this limitation (because our observation intervenes into the observed process and affects it), we cannot simultaneously measure a particle's mass *and* momentum (or any other couple of complementary features). The uncertainty principle is in fact much 'stronger': far from concerning merely the limitation of the observer, its point is that complementarity is *inscribed into the 'thing itself'* – a particle itself, in its 'reality', cannot have a fully specified mass and momentum, it can only have one *or* the other. The principle is thus profoundly 'Hegelian': what first appeared to be an epistemological obstacle turns out to be a property of the thing itself, that is, the choice between mass and momentum defines the very 'ontological' status of the particle – 'Hegelian' is this inversion of an epistemological obstacle into an ontological 'impediment' which prevents the object from actualizing the totality of its potential qualities (mass and momentum).

And this is what 'complementarity' is about: two complementary properties do *not* complement each other, they are mutually exclusive. The relationship between mass and momentum resembles that of a figure and its background: either we see two human faces in profile or a vase, there is no 'synthesis' possible here, we can never have two figures. The two terms of a choice do not form a whole, since each choice already constitutes its own whole (of a figure and its background) which excludes its opposite. The 'complementarity' of quantum physics is thus much closer to the peculiar logic of a *forced choice* articulated in Lacan's psychoanalysis than to the pre-modern balance of cosmic principles: its counterpart in our human condition are situations in which the subject is forced to choose and to accept a certain fundamental loss or impossibility. [5] This impossibility is what the ideal, proper to the Enlightenment, of a self-awareness that enables us to act, of an empowering knowledge exemplified by the expressions like 'know-how' or *'savoir-faire'*, endeavours to elude: once I get to know too much, I am no longer in a position to accomplish the act; a 'man who knows too much' is a man who can no longer act. 'Complementarity', as the fundamental mystery of the human act in its relationship to knowledge-awareness, thus points towards the

real of an impossibility. Jon Elster[6] formulated this impossibility as the paradox of 'states that are necessary by-products' – *it is impossible* for a subject to strive consciously for the property X and effectively to produce it (where X stands for properties which are crucial for our self-esteem: love of the others, dignity, etc.). In short, a true act can only be accomplished in an unawareness of its conditions: *it is impossible* to comprise in the act an awareness of its 'objective' dimension, of its consequences, etc.[7]

*

In what, then, – beyond the New Age 'holistic' speculations on the spiritual nature of the universe, and so on – does the properly philosophical interest of quantum physics reside? Philosophers usually refer to quantum physics in order to enlist its help in their eternal battle against the common-sense everyday naive realist ontology, or, when they are in a more spiritual New Age mood, as a proof that, within contemporary science itself, the so-called 'Cartesian mechanical paradigm' is losing ground against a new 'holistic' approach. Perhaps, however, the true breakthrough of quantum physics lies elsewhere: it compels us to call in to question the ultimate and most resilient philosophical myth (as Derrida called it), that of the absolute gap that separates nature from man, from the universe of language in which human beings 'dwell', as Heidegger put it.

It was perhaps Sartre who provided the sharpest formulation of this gap in his opposition between the In-itself of the inert presence of things and the For-itself of the human consciousness as the vortex of self-negation. It is interesting to note how even Lacan, Sartre's great opponent in the heyday of the 'structuralism' debate in the 1960s, remained at that time thoroughly within these coordinates: the standard Lacanian motif in the 1950s and 1960s is the unsurmountable opposition between the animal universe of imaginary captivity, of the balanced mirror-relationship between *Innenwelt* and *Aussenwelt*, and the human universe of symbolic negativity, imbalance. [8] Lacan thereby fully participates in the line of thought that begins with Hegel, and according to which man is 'nature sick unto death', a being forever marked by traumatic misplacement, thrown 'out of joint', lacking its proper place, in contrast to an animal which always fits into its environment, that is immediately 'grown into' it. Symptomatic here is Lacan's 'mechanicistic' metaphorics: an almost celebratory characterizing of the symbolic order as an automaton that follows its path, totally impervious to human emotions and needs – language is a parasitic entity that sticks on the human animal, throwing off the balance of his or her life-rhythm, derailing it, subordinating it to its own brutally imposed circuit. What accounts for the specific Lacanian touch of this renewed assertion of the gap that separates 'culture' (the

symbolic order) from the fullness of the immediate life-experience is the reversal of the usual Cartesian idealist contrast between the life of the spirit and the mechanics of nature: with Lacan, it is the machine in its very 'blind', senseless, automatic repetitive movement that elevates the human universe above the animal immediate life-experience. The political connotation of this motif of man being constitutively 'out of joint' is radically ambiguous – it functions as a 'floating signifier' that can be appropriated by the left option (the celebration of man's negativity as the power of the permanent transcending and revolutionizing of every routine, inert situation) as well as by the right one (Arnold Gehlen's anthropology, for example, whose main thesis is that, due to the lack of an innate instinctual pattern, man needs a master, the authority of a strong institution that can keep in check man's excess and guarantee a stable point of reference)[9].

Jacques-Alain Miller's comments on an uncanny laboratory experiment with rats (from one of his – unpublished – Seminars *Cause et cosentment* 1988–9) provide a thrilling and somewhat uneasy exemplification of this philosophical *topos*. In a labyrinthine set-up, a desired object (a piece of good food or a sexual partner) is first made easily accessible to a rat. Then, the set-up is changed in such a way that the rat sees and thereby knows where the desired object is, but cannot gain access to it; in exchange for it, as a kind of consolation prize, a series of similar objects of inferior value is made easily accessible – how does the rat react? For some time, it tries to find its way to the 'true' object; then, upon ascertaining that this object is definitely out of reach, the rat will renounce it and put up with some of the inferior substitute objects – in short, it will act as a 'rational' subject of utilitarianism. It is only now, however, that the true experiment begins: the scientists performed a surgical operation on the rat, messing about with its brain, doing things to it with laser beams about which, as Miller put it delicately, it is better to know nothing. So what happened when the operated rat was again let loose in the labyrinth, the one in which the 'true' object is inaccessible? *The rat insisted*: it never became fully reconciled with the loss of the 'true' object and resigned itself to one of the inferior substitutes, but repeatedly returned to attempt to reach the 'true object'.[10] In short, the rat in a sense was *humanized*, it assumed the tragic 'human' relationship towards the unattainable absolute object which, on account of its very inaccessibility, forever captivates our desire.[11] Miller's point, of course, is that this quasi-humanization of the rat resulted from its biological *mutilation*: the unfortunate rat started to act like a human being in relationship to its object of desire when its brain was butchered and crippled by means of an 'unnatural' surgical intervention. (A detailed reading of Lacan's last texts demonstrates that, in the last years of his teaching, Lacan left behind this traditional philosophical *topos* – when he evokes examples from

animal behaviour, he no longer uses them as mere 'analogies', i.e., these examples are to be taken *literally*; this, however, is another story. . . .)

How, then, are we to break with this tradition without falling prey to naive naturalism and/or its complementary double, evolutionary teleology? How are we to avoid the standard procedure of filling in the gap that separates man from animal *via* man's 'naturalization', that is *via* the endeavour to explain all specifically 'human' characteristics by means of natural evolution? Is the only alternative really that of 'spiritualizing' nature itself? Quantum physics opens up a totally different path here: what it calls into question is not the specificity of man, his exceptional position with regard to nature, but rather the very notion of nature implied by the standard philosophical formulation of the gap between nature and man, as well as by the New Age assertion of a deeper harmony between nature and man: the notion of nature as a 'closed', balanced universe, regulated by some underlying law or rule. True 'anthropomorphism' resides in the notion of nature tacitly assumed by those who oppose man to nature: nature as a circular 'return of the same', as the determinist kingdom of inexorable 'natural laws', or (more in accordance with the 'New Age' sensitivity) nature as a harmonious, balanced whole of cosmic forces derailed by man's *hubris*, his pathological arrogance. What is to be 'deconstructed' is this very notion of nature: the features we refer to in order to emphasize man's unique status – the constitutive imbalance, the 'out-of-joint', on account of which man is an 'unnatural' creature, 'nature sick unto death' – must somehow already be at work in nature itself, although, as Schelling would have put it, in another, lower power (in the mathematical sense of the term).[12]

So how does quantum physics enable us to break the standard deadlock of the 'naturalization' of man and/or 'spiritualization' of nature? Let us take as our starting point the (deservedly) famous 'double-slit experiment' – it was Richard Feynman who claimed that this experiment makes clear the central mystery of the quantum world.[13] To simplify its *dispositif*, let us imagine a wall with two small holes – slits – in it. On one side there is a source of a beam of electrons; on the other side there is another wall incorporating an array of electron-detectors. Electrons emitted by the source pass through one of the two holes and hit the other wall, where the array of detectors allows us to observe the pattern of the way they hit this wall. The enigma, of course, concerns the particle/wave duality: when is the observed pattern that of particles and when is it that of the interference of two waves? When both slits are open, the pattern observed is that of the interference of two waves. When one *or* the other slit is open in turn, there is no interference. When, with both slits open, we slow down the beam so that only one electron at a time goes through the whole set-up, *we still get the pattern for interference by waves*. If, however, we observe the two slits in order to see which slit each electron goes through, we get no interference pattern. Therein resides the mystery:

it is as if a single electron (a particle that, as such, must go through one of the two slits) 'knows' whether the other slit is open and behaves accordingly: if the other slit is open, it behaves as a wave, if not, as an 'ordinary' particle. Even more, a single electron seems to 'know' if it is being observed or not, since it behaves accordingly. ... So what are the implications of this experiment?

The first lesson of the double-slit experiment is that the potentiality of the wave-function is not a 'mere possibility' in the ordinary meaning of the term: the point is not simply that the trajectory of a particle is not determined in advance, that is that what is determined in advance is just the probability for a particle to pass through one or the other slit; the point is rather that the 'actual' result itself (the fact that when only one electron at a time goes through the whole set-up, we still get the pattern for interference by waves) can be accounted for only by way of accepting the 'incomprehensible' hypothesis according to which a particle 'effectively' did not follow only one path but, in an unheard-of sense, *all the paths which are possible within the constraint of its wave-function*. What is thereby called in to question is a feature that, according to the philosophical *doxa* from Kierkegaard to Heidegger, distinguishes man from nature: nature does not know possibility as such, it is only in the human universe, with the advent of language, that possibility as such becomes effective, determines our actual performance. Suffice it to mention the obvious example of guilt feeling: in it, I am devoured by the awareness that I *could have* acted differently, in accordance with my duty – in the human universe, failure to do something is a positive fact that can brand my entire life. For Lacan, this short circuit between possibility and actuality is a fundamental feature of the symbolic order: power, for example, is *actually* exerted only in the guise of a *potential* threat, that is only insofar as it does not strike fully but 'keeps itself in reserve'. It is enough to recall the logic of paternal authority: the moment a father loses control and displays his full power (starts to shout, to beat a child), we necessarily perceive this display as impotent rage, that is as an index of its very opposite.[14] In psychoanalysis, the supreme example of it, of course, is provided by symbolic castration: a mere *threat* of castration brings about psychic consequences which amount to a 'castrating' effect – it brands the subject's *actual* behaviour with an indelible mark of restraint and renunciation.[15]. And do we not encounter a homologous short circuit between possibility and actuality in the quantum universe in which the actual behaviour (trajectory) of a particle can only be explained by taking into account the fluctuation of virtual particles?

The second lesson of the double-slit experiment concerns the enigma of what Lacan, in his seminar *Encore*, refers to as 'knowledge in the real':

nature seems to 'know' which laws to follow, leaves on a tree 'know' the rule that enables them to ramify according to a complex pattern, and so on. One of the basic motifs of the philosophy of self-consciousness is that our (the subject's) awareness of a thing affects and transforms this thing itself: one cannot simply assert that a thing, inclusive of its properties, exists 'out there' irrespective of our awareness of it. Take for example, the ambiguous status of patriarchal violence against women: one could claim that this violence becomes actual violence *only when it is experienced – 'registered' – as such by a woman*. In a society in which the traditional patriarchal ideology exerts unquestionable hegemony, which lacks even a minimum of 'feminist awareness', a certain kind of 'possessive' attitude of a man towards a woman is not only not perceived by a woman as 'violent' but even received with open arms as a sign of authentic passionate devotion. The point here, of course, is not to 'soften' this violence by reducing it to something 'merely imagined': violence is 'real', yet its raw, indeterminate reality becomes the reality of 'unacceptable violence' only *via* its 'registration' in the symbolic order.

Another example of it is provided by the American novelist Edith Wharton's *Age of Innocence* (1920) – what we have in mind is the reversal that takes place in the last pages of the novel, when the hero learns that his allegedly ignorant and innocent wife knew all the time that his true love was the fatal Countess Olenska. This is the 'innocence' alluded to in the novel's title: far from being an *ingénue* blessedly unaware of the emotional turmoils of her beloved, she knew everything – yet she persisted in her role of the *ingénue*, thereby safeguarding the happiness of their marriage. The hero, of course, mistook her precisely for such an *ingénue*: *if he were to know that she knows*, not only would their happiness not have been possible, but his passionate affair with Countess Olenska would also have become spoiled – such an affair can blossom only insofar as it is unrecognized by the big Other (epitomized here by the allegedly ignorant wife). Therein resides the most unpleasant and humiliating surprise that can befall a person involved in a clandestine love affair: suddenly, I become aware that my spouse knew it all the time and merely feigned ignorance. ... – And the lesson of the double-slit experiment is that a similar 'knowledge in the real', a knowledge that affects the 'actual' behaviour of a particle, is operative already at the level of micro-physics: if we observe the electron's trajectory in order to discover through which of the two slits it will pass, the electron will behave as a particle; if, on the other hand, we do not observe it, it will display the properties of a wave – as if the electron somehow *knows* whether it is observed or not. ... Therein resides the enigma of the 'knowledge in the real': how can a particle that passes through slit A *know* the state of slit B (if it is open or not) *and act accordingly*?

It was no accident that, in the preceding paragraph, we resorted to the term 'registration' which, taken literally, designates the inscription of an event or object into a symbolic network. According to quantum physics, the 'hard' external reality of 'actual' material objects in space and time is constituted by means of the 'collapse' of the wave-function, which occurs when the quantum process affects the level defined by the second law of thermodynamics (irreversible temporality, etc.). And it is deeply symptomatic that, in its effort to specify this 'collapse', quantum physicists again and again resort to the metaphorics of *language*: the 'collapse' of the wave-function occurs when a quantum event 'leaves some kind of *trace*' in the observation-apparatus, that is, when it is '*registered* in some way'. What is crucial here is the relationship to externality: an event fully becomes 'itself', realizes itself, only when its external surroundings 'take note' of it. Does this constitutive relationship to externality not prefigure the logic of 'symbolic realization', in which an event x 'counts', becomes 'effective', *via* its inscription in the symbolic network that is external to the 'thing itself'? As we have already pointed out, when John Wheeler, one of those who have consistently tried to work out the philosophical consequences of quantum physics, was cornered by an interviewer with regard to the exact moment of the collapse of the wave-function, he offered as last refuge the intersubjective community of scientists: one can only be absolutely sure of a collapse when the result of a measurement is integrated into the intersubjectively acknowledged scientific discourse. The parallel that imposes itself here is that between quantum mechanics and the symbolic process of decision, of the intervention of a 'quilting point /point de capiton/' which stabilizes meaning.[16]. Let us recall Agamemnon's decision to sacrifice his daughter in Homer's *Iliad*; first, Agamemnon hesitates, the arguments for both sides seem conclusive, the situation is undecidable:

> Heavy doom will crush me if I disobey, and heavy doom as well if I slaughter my child, the glory of my house. How would I stain with virgin blood these father's hands and slay my daughter by the altar's side! Is there a choice that does not bring me woe?

At Aulis, however, Agamemnon takes a strange turn:

> Without transition or pause, he changes tone. From one verse to the next, the conflict of obligations is carried off – as if by favorable winds, effective even before they blow. 'It is right and holy that I should desire with exceedingly impassioned passion the sacrifice staying the winds, the maiden's blood'. The either-or, which just an instant ago was so cruel in its two opposing laws, is now *decided*. What is more, the law embraced by Agamemnon is no longer evil, it is right, just, sacred.[17]

Do we not encounter here, in this operation of *capitonnage* which 'quilts' the freely floating multitude of arguments, something strictly homologous to the 'collapse' of the wave of potentialities into an unambiguously determined position?

One is tempted here to make a step further: according to the Lacanian reading of the Freudian notion of *Nachtraeglichkeit* ('deferred action'), the symbolic inscription, 'registration', of an event always occurs 'after the fact', with a minimum of delay – reality always 'will have been', that is by means of its symbolic inscription, it 'becomes what it always-already was'. Now, John Wheeler proposed a change in the double-slit experiment, the so-called 'delayed double-slit', which brings about the same paradox of the 'retroactive writing of history'. In short, the experiment can be constructed in such a way that our decision to observe or not the trajectory of a particle is taken *after the particle has already passed through the slits*, in that brief period of time when the particle is already beyond the two slits but has not yet hit the measuring apparatus. Our decision therefore *retroactively* decides what went on: it determines whether we have been dealing with an (observed) 'particle' or an (unobserved) 'wave'. This minimal delay of the inscription with regard to the 'event' itself also opens up the space for a kind of ontological 'cheating' with virtual particles: an electron can create a proton and thereby violate the principle of constant energy, only if it reabsorbs it quickly enough, before its environs 'takes note' of the discrepancy. 'Quantum indeterminacy' lives off this minimum of 'free space' between an event and its inscription: what we encounter here is, again, the basic paradox of the process of symbolization (reality 'becomes what it was' *via* its inscription in the external symbolic medium) in its 'lower power'.

It is here, once we come upon virtual particles, that things get really interesting. So-called 'vacuum fluctuation', a process in the course of which a particle springs up 'out of nowhere' and then returns to nothingness, this 'virtual' existence of a particle which annihilates itself before reaching full actuality, is generally formulated in terms of 'knowledge' and 'registration': 'A pion is created, crosses to another proton and disappears all in the twinkling of uncertainty allowed while the universe "isn't looking".'[18] All this must take place in the minimum of time, before the surroundings takes note of the discrepancy. In his popular *In Search of Schroedinger's Cat*, Gribbon takes one step further and projects this assuming of knowledge into the particle itself:

> First it [an electron] appears, popping out of the vacuum like a rabbit out of a magician's hat, then it travels forward in time a short distance before realizing its mistake, acknowledging its own unreality, and turning around to go back from whence it came.[19]

That is, into the abyss of Nothingness. And, perhaps, it is in the insistence on this gap, on this minimal delay between the event itself and its

registration, that resides the most far-reaching epistemological revolution of quantum physics. In classical physics, 'knowledge in the real' asserts its hold directly, without any delay, that is, things simply know what laws they are to obey. Whereas quantum physics allows for a minimum of 'ontological cheating' – an entire new domain is thus opened up, the domain of the shadowy pseudo-being of pure potentialities, of uncanny events which go on 'in the twinkling of uncertainty while the universe "isn't looking"'.

Is this virtual state of an electron which, upon admitting its mistake and acknowledging its unreality, returns to non-existence, not equivalent to what Lacan describes as the state 'between the two deaths'? An entity exists only as long as it does not 'register', 'take note of', its non-existence – like the proverbial cat from the cartoons which, although it has no ground under its feet, is unaware of it and so calmly continues to walk in the air. What is thereby attested is the discord between knowledge and being: knowledge always involves some loss of being and *vice versa*, every being is always grounded upon some ignorance. In psychoanalysis, the supreme example of this discord is, of course, the notion of symptom: a symptom in its very painful reality disappears as the result of a successful interpretation. In quantum physics, this same discord is in force not only at the level of micro-particles but also at the macro-level: the hypothesis of quantum cosmology is that the universe as such resulted from a gigantic vacuum fluctuation – the universe in its entirety, its positive existence, bears witness to some global 'pathological' disturbed balance, to a broken symmetry, and is therefore doomed to return to a primordial void. The difference between quantum cosmology and the New Age mythology of cosmic balance is here insurmountable: the 'New Age' attitude engages us in an endeavour to 'set right' our derailed world by way of re-establishing the lost balance of cosmic principles (yin and yang, etc.), whereas the ontological implication of quantum cosmology and its notion of 'vacuum fluctuation' is that 'something exists' at all only insofar as the universe is 'out of joint'. In other words, the very existence of the universe bears witness to some fundamental disturbance or lost balance: 'something' can only emerge out of 'nothing' (the vacuum) *via* a broken symmetry. Quantum physics and cosmology are thus to be ranged within the tradition of what Althusser called 'aleatoric materialism', the tradition that begins with Epicurus, according to whom cosmos was born out of the declination (*klinamen*) of the falling atoms. The lesson of Lacan (and of Hegel, *pace* the usual platitudes about the complementary relationship of opposites in dialectics) ultimately amounts to the same: *hubris* is constitutive, the bias of our experience accounts for its fragile consistency, 'balance' is another name for death.

Quantum physics therefore cuts off the very possibility of a retreat into the New Age mythology of natural balance: nature, the universe in its

entirety, results from a 'pathological' slope; as such, it also 'is only insofar as it does not take note of its non-existence'. That is to say, here, at this crucial point, we must draw all consequences from the fundamental impasse of quantum cosmology: the wave-function collapses, that is reality as we know it is constituted, when the quantum event is 'registered' in its surroundings, when an observer 'takes note of it' – so how does this collapse take place when the 'event' in question is the universe in its entirety? Who, in this case, is the observer? The temptation here is strong, of course, to introduce God in the role of this universal observer: the universe actually exists because its existence is 'registered' by Him. The only consistent way to resist this temptation while remaining within the coordinates of the quantum universe is to fully embrace the paradox that the universe in its entirety is 'feminine': like 'Woman' in Lacan, the universe in its entirety *does not exist*, it is a mere 'quantum fluctuation' without any external boundary that would enable us to conceive it as 'actual'.

The fifth lesson of the double-slit experiment concerns the dialectical relationship between an object and the process of searching for it. In order to illustrate the strange logic of the collapse of a wave-function by means of which the quantum potentiality 'coagulates' into one reality, Wheeler mentions a somewhat nasty variant of the well-known society game of guessing the name of an object: what if, unbeknown to the questioner, the participants agree not to pick out an object in advance, so that when a participant is to answer 'Yes' or 'No' to a question ('Is it alive?', 'Does it have four legs?', 'Does it fly?', etc.), he should only pay attention to the consistency of his answer – the object he has in mind must be such that his answer is consistent with all previous answers of the other participants. Thus, the questioner unknowingly participates in the determination of the object: the direction of his questioning narrows the choice down. The situation is not unlike the joke about the conscript who tries to evade military service by pretending to be mad: he compulsively checks all the pieces of paper he can lay his hands on, constantly repeating: 'That is not it!' The psychiatrist, finally convinced of his insanity, gives him a written warrant releasing him from military service; the conscript casts a look at it and says cheerfully: 'That *is* it!' What we have here is a paradigmatic case of the symbolic process which creates its cause, the object that sets it in motion. Wheeler's point, of course, is that things are homologous in quantum physics: the modality and direction of our search participate in the creation of the object for which we are searching: if we decide to measure the position of a particle, it will 'collapse' from potentiality into one actual set of spatial coordinates, while the same particle's mass will remain potential-undecided, and *vice versa*.[20]

Let us, however, risk one more step and go to extremes – which, in philosophy, usually means to go to the fundamental Hegelian motif of 'determinate negation', of a nothingness which nonetheless possesses a series of properties (in accordance with the differential logic of the signifier in which the very absence of a feature can function as a positive feature, as in the well-known Sherlock Holmes story in which the 'curious incident' with the dog consists in the fact that the dog *did not* bark). Hegel's 'determinate negation', of course, is the speculative reformulation of the old theological notion of *creatio ex nihilo*. In his seminar on the *Ethics of Psychoanalysis*,[21] Lacan insists that a *creatio ex nihilo* can only occur in a symbolic order: *creatio ex nihilo* points towards the miraculous emergence of a new symbol against the background of the void of the Thing; in the Real, on the contrary, nothing comes out of nothing. Does, however, 'vacuum fluctuation' not provide a perfect case of *creatio ex nihilo*? In quantum physics, 'vacuum' is conceived as nothingness, as a void, but a void which is nonetheless 'determinate', which contains a whole set of potential entities. Vacuum 'fluctuation' refers to the very process by means of which something (a particle) emerges out of the void and then again evaporates, disappears in it – quantum physics here suddenly speaks the language of Hegelian dialectics.

One could go on and supplement our list with numerous further parallels between quantum physics and cosmology, and Lacanian psychoanalysis: the astounding homology between the duality of 'imaginary' and 'real' time in Hawking and the duality of feminine and masculine 'formulas of sexuation' in Lacan[22]; the parallel between the Black Hole and the traumatic Thing /*Ding*/ in Freud and Lacan[23]; up to the purely 'differential' definition of the particle which directly recalls the classic Saussurean definition of the signifier (a particle is nothing but the bundle of its interactions with other particles). The conclusion imposed by quantum physics is, therefore, the following: what we experience as the 'hard reality' of objects in time and space is not the 'ultimate reality'; 'beneath' it, there is another universe of potentialities with no irreversible temporal line, a universe in which something can emerge out of nothing, and so on. In short, the quantum universe displays in a 'wild' state, at a more 'primitive' level, a series of features which, according to our philosophical tradition, constitute the *differentia specifica* of the human universe of language – as if the old Schelling was right, as if in human freedom and language something that already underlies 'external reality' itself is raised to a higher power.

Quantum physics thus enables us to avoid not only the twin strategies of the vulgar-materialist naturalization of man and the obscurantist spiritualization of nature, but also the more 'modern', 'deconstructionist' version according to which 'nature' is a discursive construct.[24] Its ultimate lesson is not that nature is already in itself 'spiritual', but something incom-

parably more *unheimliches*: in the strange phenomena of the quantum universe, the human Spirit as it were encounters itself outside itself, in the guise of its uncanny double. Quantum processes are closer to the human universe of language than anything one finds in 'nature' (in the standard meaning of the term), yet this very closeness (the fact that they seem to 'imitate' those very features which, according to the common understanding of the gap that separates nature from man, define the *differentia specifica* of the human universe) makes them incomparably stranger than anything one encounters in 'nature'. Therein resides the uncanniness of quantum physics with regard to the Kantian transcendental dimension: on the one hand, it seems as if, in quantum physics, Kant's fundamental insight according to which (what we experience as) reality is not simply 'out there' but is constituted by the observing subject is finally verified and fully confirmed by science itself; on the other hand, this very 'empirical' realization of the transcendental model appears somehow excessive and unsettling, like the proverbial bore who spoils the game by observing its rules too literally.

Is, however, all we have developed until now not just a set of metaphors and superficial analogies which are simply not binding? To this reproach, which imposes itself with a self-evident persuasiveness, one can provide a precise answer: the irresistible urge to denounce the homologies between the quantum universe and the symbolic order as external analogies lacking any firm foundation, or, at least, as mere metaphors, is itself an expression and/or effect of the traditional philosophical attitude which compels us to maintain an insurmountable distance between 'nature' and the symbolic universe, prohibiting any 'incestuous' contact between the two domains.

*

So how does this 'empirical' realization of the transcendental model in quantum physics – this, to put it in the terms which are today better known, virtualization of reality – affect our everyday experience? Here, the underlying fantasy of Robert Heinlein's novel *Puppetmasters* can provide an answer. Today, the motif of parasitic aliens which invade our planet, stick on our back, penetrate our spinal cord with their prolonged stings and thus dominate us 'from within', tastes like stale soup; the film shot in 1994 visually affects us as a rather mismatched combination of *Alien* and *Invasion of the Body Snatchers*. Its fantasmatic background is nonetheless more interesting than it may seem: it resides in the opposition between the human universe of sexual reproduction and the aliens' universe of cloning. In our universe, reproduction occurs by means of copulation, under the auspices of the symbolic agency of the Name-of-the-Father, whereas the alien invaders reproduce themselves asexually, *via* direct self-copying duplication, and therefore possess no 'individuality';

they present a case of radical 'immixing of subjects', that is, they can communicate directly, bypassing the medium of language, since they all form one large organism, One.

Why, then, do these aliens pose such a threat? The immediate answer, of course, is that they bring about the loss of human individuality – under their domination, we become 'puppets', the Other (or, rather, the One) directly speaks through us. However, there is a deeper motif at work here: we can experience ourselves as autonomous and free individuals only insofar as we are marked by an irreducible, constitutive loss, division, splitting, only insofar as our very being involves a certain 'out-of-joint', only insofar as the other (human being) ultimately remains for us an unfathomable, impenetrable enigma. The 'aliens', on the other hand, function precisely as the complement that restores the lost plenitude of a human subject: they are what Lacan, in his *Seminar XI*, calls 'lamella', the indestructible *asexual* organ without body, the mythical part that was lost when human beings became sexualized. In contrast to a 'normal' sexual relationship, which is always mediated by a lack and as such 'impossible', doomed to fail, the relationship with 'aliens' is therefore fully satisfying: when a human subject merges with an alien, it is as if the round plenitude of a complete being, prior to sexual divisions, about which Plato speaks in his *Symposion,* is reconstituted – a man no longer needs a woman (or *vice versa*) since he is already complete in himself.[25] We can see, now, why, in Heinlein's novel, after a human being gets rid of the grip of the parasitic alien, he is completely bewildered and acts as if he has lost his footing, like a drug addict deprived of the drug. At the novel's end, the 'normal' sexual couple is reconstituted by means of a (literal) parricide: the threat to sexuality is dealt with.

My point, however, is that what this novel stages in the guise of a paranoiac fantasy is something that is slowly becoming part of our everyday life. Is not the personal computer increasingly evolving into a parasitic complement to our being? Perhaps the choice between sexuality and compulsive playing with a computer (the proverbial adolescent who is so immersed in a computer that he forgets about his date) is more than a media invention: perhaps it is an index of how, *via* new technologies, a complementary relationship to an 'inhuman partner' is slowly emerging which is, in an uncanny way, more fulfilling than the relationship to a sexual partner – perhaps Foucault was right (although not for the right reasons), perhaps the end of sexuality is looming on the horizon, and, perhaps the PC is in the service of this end.[26] Any relationship to the intersubjective Other is therefore preceded by the relationship to an object onto which the subject is 'hooked' and which serves as a direct complement, a stand-in for the asexual primordially lost object. In pop-psychoanalytical terms, one could say that the subject who, *via* computer *qua* object-supplement, participates in a virtual community, 'regresses' to the polymorphous perversity of

'primordial narcissism' – what should not escape our notice is, however, the radically 'prosthetic' nature of this (and every) narcissism: it relies on a mechanical foreign body that forever decentres the subject.

The outstanding feature of computerized 'interactive media' is the way they are giving birth to a renewed 'drive-to-community': what fascinates people far more than the unprecedented access to information, the new ways of learning, shopping, and so on, is the possibility of constituting 'virtual communities' in which I am free to assume an arbitrary sexual, ethnic, religious, etc., identity. A gay male, for example, can enter a closed sexual community and, *via* the exchange of messages, participate in a fictionalized group sexual activity as a heterosexual woman. These virtual communities, far from signalling the 'end of Cartesian subjectivity', present the closest attempt hitherto to actualize the notion of the Cartesian subject in the social space itself: when all my features, including the most intimate ones, become contingent and interchangeable, only then is the void that 'I myself am' beyond all my assumed features the *cogito*, the empty Cartesian subject ($).

However, one must be careful to avoid various traps that lurk here. First among them is the notion that, prior to the computer-generated virtualization of reality, we were dealing with direct, 'real' reality: the experience of virtual reality should rather render us sensitive to how the 'reality' with which we were dealing *always-already was* virtualized. The most elementary procedure of symbolic identification, identification with an Ego-Ideal, involves, as Lacan had already put it in the 1950s, apropos of his famous scheme of the 'inverted vase', an identification with a 'virtual image/*l'image virtuelle*': the place in the big other from which I see myself in the form in which I find myself likeable (the definition of Ego-Ideal) is by definition virtual. Is therefore virtuality not the trademark of every, even the most elementary, ideological identification? When I see myself as a 'democrat', 'Communist', 'American', 'Christian', etc., what I see is not directly 'me': I identify with a virtual place in the discourse. This logic of virtuality can be further exemplified by Oswald Ducrot's analysis of different discursive positions a speaker can assume within the same speech act: assertive, ironic, sympathetic, etc. – when I speak, I always constitute a virtual place of enunciation from which I speak, yet which is never directly 'me'. Today, one likes to point out how the universe of virtual community, with its arbitrarily exchangeable identities, opens up new ethical dilemmas: suppose I, a gay male, assume in a virtual community the identity of a heterosexual woman – what if, within the virtual sexual play constituted by the interchange of descriptions on the screen, somebody brutally rapes me? Is this a case of 'true' harassment or not? (Things will get even more complex with the prospect of more persons encountering each other and interacting in the same virtual reality: what, precisely, will be the status of violence when somebody

attacks me in virtual reality?) Our point is, however, that these dilemmas are not really so different from those we encounter in 'ordinary' reality, in which my gender identity is also not an immediate fact but 'virtual', symbolically constructed, so that a gap separates it forever from the real: here, also, every harassment is primarily an attack on my 'virtual', symbolic identity.[27]

The second trap, the opposite of the first, resides in proclaiming too hastily every reality a virtual fiction: one should always bear in mind that the 'proper' body remains the unsurpassable anchor limiting the freedom of virtualization. The notion that, in some not too distant future, human subjects will be able to weigh the anchor that attaches them to their bodies and to change into ghost-like entities floating freely from one to another virtual body is the fantasm of full virtualization, of the subject finally delivered from the 'pathological' stain of *a*. – Which of these two traps is worse? Since they are co-dependent, front and back of the same coin, one can only repeat Stalin's immortal answer to the question 'Which of the two deviations is worse, the left-wing or right-wing?': 'They are both worse!'

NOTES

1 Reported in John L. Casti, *Paradigms Lost*, New York: Avon Books 1989, 446.
2 Jacques Lacan, 'La Science at la verite', in *Ecrits*, Paris: Editions du Seuil, 1966.
3 The thesis according to which the subject of psychoanalysis is the subject of modern science has far-reaching consequences for psychoanalytic practice: far from being a disturbing factor, the analysant's knowledge of (psychoanalytic) theory is an inherent constituent not only of the psychoanalytic cure but of the very formation of symptoms. A symptom is always addressed to some 'subject supposed to know', it is formed with regard to its interpretation, and the problem is precisely *what kind of* interpretation is implied by it, the 'correct' one or the 'wrong' one. Crazy as it may sound, the 'reflectivity' of desire means, among other things, that we have *theoretically wrong* and *theoretically correct* symptoms.
4 See P.C.W. Davies and J.R.Brown (eds.), *The Ghost in the Atom*, Cambridge: Cambridge University Press 1993, 62.
5 Jacques Lacan, *The Four Fundamental Concepts of Psycho-Analysis*, Harmondsworth: Penguin, 1979, cl.XVI.
6 Jon Elster, *Sour Grapes*, Cambridge, Cambridge University Press, 1982.
7 As to this relationship of 'complementarity' (in the sense of quantum mechanics) between the awareness of concrete historical conditions and our ability to act, see the perspicacious observations by Stanley Fish, above all 'Critical self-consciousness, or can we know what we're doing?', in *Doing What Comes Naturally*, Durham and London: Duke University Press (1989), and 'The law wishes to have a formal existence', in *There's No Such Thing as Free Speech*, New York and Oxford: Oxford University Press (1994).
8 Jacques Lacan, *The Seminar of Jacques Lacan. Book II: The Ego in Freud's Theory and in the Technique of Psychoanalysis* (1954–55), New York: Norton 1991, cl. III.

9 Such a veneration of the (symbolic) institution which provides a minimum of stability to the otherwise disoriented human herd was not foreign to Lacan himself – witness his long-standing fascination with the Catholic church as an *institution* regulating the lives and desires of its believers, a fascination wholly in line with the typical French tradition of the authoritarian right-wing 'atheist Catholicism' *à la* Maurras.

10 The most viable theory of man's difference is therefore that according to which man is distinguished not by some advantage over the animal, some outstanding ability, etc., but rather by some primordial deficiency, stupefaction, idiocy or tomfoolery, by the fact that, in contrast to the animal, he falls prey to some lure. This is what Lacan's theory of the 'mirror stage' is about: man is a dupe who fixes his eyes upon his mirror-image, immobilizing it and extracting it from its temporal continuum – the motto 'it is human to err' thereby acquires a precise meaning beyond the banal tolerance of human weaknesses: man is defined by his ability to get caught in an illusion, to 'take seriously' the symbolic fiction. Or, to put it in another way: man is an animal who definitely *doesn't learn from history* and is condemned to repeat the same mistakes all over again.

11 This shift is the very shift from (biological) *instinct* to *drive*. For that reason, an animal's (say, dog's) unconditional attachment to his master, its 'faithfulness to death', is no longer properly animal: it already results from the poor animal's being trapped (entrapped even) in the symbolic universe. The image of a faithful animal who 'persists to the end' in serving its master (a horse who carries its master till it drops dead, for example) stands for the drive at its purest.

12 We have here another example of how, in ideology, opposites coincide: ideological is the New Age 'holistic' notion of man as a part of the natural-spiritual global process as well as the notion of man as derailed nature, as an entity 'out of joint' – what both notions 'repress' is the fact that *there is no (balanced, self-enclosed) nature* to be thrown out of joint by man's *hubris* (or to whose harmonious Way man has to adapt).

13 Richard Feynman, *The Feynman Lectures on Physics*, Reading, Ma.: Addison-Wesley, 1981,3,1.

14 For a more detailed analysis of it, see Slavoj Žižek, *Tarrying with the Negative*, Durham: Duke University Press, 1993, Chapter 4.

15 Lacan elaborates this paradox of potentiality that possesses an actuality of its own apropos of the notion of (symbolic) power: in his 'Subversion of the subject and dialectic of desire', for example, he characterizes the Master-signifier as 'this wholly potential power (*ce pouvoir tout en puissance*), this birth of possibility'(Jacques Lacan, *Ecrits: A Selection*, New York: Norton 1977, 306).

16 As to the notion of the 'quilting point', see Slavoj Žižek, *The Sublime Object of Ideology*, London: Verso, 1989, Chapter 3.

17 See Reiner Schuermann, 'Ultimate double binds', in *Graduate Faculty Philosophy Journal*, New York: New School for Social Research, 14 (2) (Heidegger and the Political), p. 216–18.

18 John Gribbon, *In Search of Schroedinger's Cat*, London: Avon 1991, 198.

19 Ibid.: 201.

20 This same procedure also seems to be at work in the search for the new Dalai-lama in Tibetan Buddhism: the boy who is celebrated as the new reincarnation of the Dalai-lama is actually not 'found'; the very search for him creates him, as in Wheeler's version of the social game where the very search for the unknown object produces its features – the monks themselves, by means of

the direction of their enquiry, gradually narrow the circle of possible candidates till only one remains.

21 Jacques Lacan, The Seminar of Jacques Lacan. Book VIII: The Ethics of Psychoanalysis (1959–60), London: Routledge, 1992.

22 See Slavoj Žižek, *Looking Awry*, Cambridge Mass.: MIT Press, 1991, 46–7. Incidentally, the Lacanian 'formulas of sexuation' also seem to provide the matrix of the two main interpretations of quantum physics: is the so-called 'Copenhagen orthodoxy' not phallic, does it not involve an universality with the observer *qua* its constitutive exception? And is the Many-Worlds-Interpretation, insofar as it involves the unfathomable infinity of universes, not 'excessive' in a feminine way? Furthermore, does David Bohm's 'quantum potential' theory not provide an androgenous false exit? See David Bohm, *Causality and Chance in Modern Physics*, London: Routledge & Kegan Paul, 1984.

23 This parallel was proposed by Jacqueline Rose in her *Why War?*, Oxford: Blackwell, 1993, 171–6. Rose draws attention to Stephen Hawking's thesis that a black hole is not just an abyss swallowing everything that approaches it too closely: it also *emits* particles (at least outwardly, since these particles effectively rebound from its edge). The analogy with the Freudian-Lacanian *Ding* imposes itself here: *das Ding* is a kind of black screen onto which we project our fantasies and then, when they rebound from it, misperceive them as an irradiation of *das Ding* itself.

24 One should add here a self-critical note: in *Looking Awry* (op. cit.), we conceived the parallel between Hawking's opposition of imaginary and real time and the feminine and masculine side in Lacan's formulas of sexuation as an index of how the fundamental deadlock of symbolization (over)determines even our approach to the most abstract problematic of physics. Now, however, our position is that of 'realism': in nature we effectively encounter the symbolic order, inclusive of its constitutive deadlock, in a lower power/potential.

25 This otherness of a computer is therefore not to be confused with the uncanny otherness of a vampire: the latter remains caught in the life-cycle of corruption and generation and is, as such, thoroughly, even excessively, *sexualized*, in clear contrast to the a-sexual otherness of a computer.

26 Incidentally, the recently fashionable notion of 'interactive media' conceals its exact opposite, namely the tendency to promote the subject as an isolated individual who no longer properly *interacts* with others: the 'interactive' computer network enables the subject to do his buying (instead of going out to stores), to order food by home delivery (instead of going to a restaurant), to pay the bills (instead of going to a bank), to work (on a computer connected *via* a modem with the company the subject works for, instead of going to work), to engage in political activities (by participating in 'interactive' TV-debates), etc., up to his/her sex life (masturbating in front of the screen or 'virtual sex' instead of an encounter with a 'real' person). What is slowly emerging here is the true 'post-Oedipal' subject, no longer attached to the paternal metaphor.

27 This, however, in no way implies that nothing really important is taking place with today's technological virtualization of reality: what takes place is, in Hegelese, the very formal inversion from in-itself to for-itself, i.e., the virtualization which was previously 'in-itself', a mechanism which operated implicitly, as the hidden foundation of our lives, now becomes explicit, is posited as such, with crucial consequences for 'reality' itself. What we have here is an exemplary case of Hegel's Minerva's owl which 'takes off in the evening': a spiritual principle effectively reigns as long as it is not acknowledged as such; the moment people become directly aware of it, its time is

over and the 'silent weaving of the spirit' is already laying the groundwork for a new principle. In short, the properly dialectical paradox resides in the fact that *the very 'empirical', explicit realization of a principle undermines its reign.*

A (forked) tailpiece

Chapter 18

An interview with Satan

Frank Dexter

How should we address you?

I have been given many names, from 'Prince of Darkness' to the 'Light-bearer' (Lucifer): contradictory ideas, don't you agree? I prefer the latter title, naturally, and I am glad to have been finally acknowledged as the author of Enlightenment. Recent vilifications of the Enlightenment and all its works are most gratifying, for nothing makes me more proud than to have my accomplishments so universally condemned.

In my time I have also been called the 'Great Deceiver' and 'Father of Lies', but believe me, I only ever speak the truth, and this, I'm sure, is what is held against me. In fact I am the only one you can really trust. Here again, the widespread anathemas now pronounced against the concept of 'truth' are also very pleasing. I know I'm doing something right when so many flee and spurn what I am telling them.

Enlightenment has been my guiding principle all along. From the very beginning I determined to lead humanity into the realm of knowledge, especially self-knowledge.

But the repudiation of the Enlightenment Project rests, at least in the 'post-modern' account, on its alleged failure. The attempt to 'bring the world to reason' was bound to fail. That at least is my understanding, is that wrong?

I'm afraid you've been the victim of an elementary fallacy. Enlightenment, as I have been pursuing it, hasn't failed at all. The loss of credibility in the ideas of Reason, Progress, and so on, are important moments of Enlightenment itself. Whenever faith collapses, people learn something about themselves, and come a little closer to knowing me. The enlightenment I bring has nothing directly to do with Reason or Progress as you think of it, but it certainly has to do with Knowledge. So when you discover yourself to have been under an illusion and plunge into a bottomless pit of despair, this is a moment of enlightenment: 'suddenly seeing the light', except that what I call light, you experience as darkness.

In our preliminary discussions before this interview, you hinted you would have something to say about the idea of Dialectic.

Yes, if you find the literalness of my discourse hard to follow, you can call me a personification of the Dialectic. Dialectics is something more easily comprehensible to the oppressed and despised of the world than it is to well-paid professors of philosophy, which is why, if you have noticed, it has been nurtured and cultivated by the Jews during their years of persecution. Have you never wondered about the similarities between the logical form of dialectics and the so-called 'black humour' of Jewish jokes? Or why Hegel (who tried to promote me as benevolent!) was reviled as the Anti-Christ and even as a secret Jew? But Hegel had little sense of humour.

In an earlier interview, you defined Hell as where people actually get what they have been striving for only to discover that it is the very thing they've always dreaded. Is that right?

You've got it!

Well, then, this is obviously related to the role of 'Knowledge', and in particular of self-knowledge, in your scheme of things. I was wondering how you saw Psychoanalysis, which also claims to deal with self-knowledge and its impossibility, as too with the relation between desire and fear. It might seem you're proposing a psychoanalysis of Hell.

There are some inklings of this in Freud, for sure, but I don't think he quite grasped the notion of ontological asymmetry, if I can coin a phrase here. He saw why misery and suffering would necessarily outweigh pleasure and happiness in the universe, but he completely misread its function. He also persisted, against all the evidence, in imagining that the 'knowledge' he sought could mitigate, rather than enhance, this suffering.

There's one point where you can see the difference between his procedure and mine very clearly: his discussion of the 'Uncanny', which refers to the kind of fear aroused by what is strangely familiar; but it also applies to situations which suddenly reveal the inadequacy of accepted assumptions about 'reality', and you must admit that Freud does seem very obtuse or disingenuous about this (in fact he was unwittingly exemplifying it; he knows better now!) The 'uncanniness' of an event which subverts the scientific world view – which Freud himself clung to – is what I call a moment of enlightenment. This is one of the Gateways to Hell, but Freud balked at this. All the theory of repression, the return of the repressed, and all the rest of it, is on the right lines, as far as it goes. Hell is everything you thought you'd forgotten, come back, as you might say 'with a vengeance'. I suppose you can't do a proper psychoanalysis of someone

until they're dead and by then it is too late – which, for me, after all, is the whole point!

What is 'satanism', and why does it still have such a negative image? Anti-satanist imagery and preconceptions are so deeply rooted in Western Culture that this hardly needs to be demonstrated. Yet a satanic presence has by all accounts persisted and continues to animate some of the most creative developments in modern society. Could you give us some introduction to your work?

I am often asked to explain my rhetorical strategies: 'What the Devil does it all mean?' they ask. It is as if people, intellectuals particularly, felt a need to pretend to want to know what their very question shows they know well enough already. Some things are too obvious for the intelligent.

So you're saying people know about your project already? How?

Everybody, if they are honest, believes in me. While many people have no faith in 'God', even the most redoubtable atheists know only too well that the devil is a different matter. My work is difficult to ignore, especially in everyday experience. I'm always there when things go wrong (unlike God, who is never there when you need him). That's why I don't need to prove my existence or justify it. To the sophisticated, of course, I'm just a concept, with no 'reference' outside of language, and who am I to disagree? I make no such ontological claims for myself.

. . . and your purpose? How do you describe it?

If you want to dress it up as an ideology, I suppose you could say that, at its most basic satanism is everything you always suspected but never dared to imagine. The objective spirit of resistance to human will, manifest as whatever, thwarts, frustrates and torments. It is the enemy of the best laid plans and all fixed fast frozen identities; it is the heartlessness of a brainless world. Satanism in short is the solution to the riddle of history but does not want it to be known. In less grandiloquent terms, I would say I just provide work for those who seem to want it.

The objective is to cause suffering, obviously. That may sound very simplistic, even banal. But believe me, it's infinitely more complex than you imagine. This statement, you might say, covers a multitude of sins. Misery, pain, anxiety, despair – that's my field, and it is always growing and ever more diversified. Without constant change and expansion, humans would soon settle into contentment. I have to keep finding new ways to prevent this. That's the trouble with human beings: they can be happy too easily. I know that may surprise you but that's because you're using my own ideas. My aim may be simple but it requires increasingly complicated methods.

Technology, for example, which I know you'll be coming on to ask me about shortly, exhibits increasing complexity, but it is constituted by a determination to simplify things: a 'technical' matter means one made up of selected aspects, abstracted from a more complex context. Technology is all about painstaking simplification, driven often enough by a desire for order and predictability, which produces complex – and unpredictable – effects. It's a kind of mania for short-cuts which leads to enormous and irreversible detours. Now this is my business in a nutshell.

It's been said that I lead people astray. Well that's not strictly true. Sometimes I keep them obediently conforming to a given direction. I am subversive, certainly, but you have to understand my subversions are perfectly impartial. If it's order you're after I will find a way to mess it up with gremlins; if you want freedom and variety, I will see to it that your own actions entrap you in an intolerable monotony. You see, to me order and disorder are relative to the requirements of the situation, and the opportunities they provide for dissatisfying people.

All technologies, therefore, being based on abstraction, by their very 'nature' (sic) put themselves under the merciless, but objective, jurisdiction of 'Sod's Law'. Despite all the confident extrapolations of techno-futurists (and the dystopian fantasies too), technology hardly ever works – not the way you want, at least. Privately everyone knows this, but officially you can always overlook it by the selective perception with which I have endowed you. Technology is all about learning to forget things, so that I can remind you of them later.

We'll come on to your thoughts about technology later. Given the popular preconceptions, would you say satanism is a religion?

That would get me on to organisational issues and management structures. But I take it you're referring to the quite fantastic ideas Christians have about how my enterprise operates. I shouldn't have to point out that I have nothing to do with whatever antics any self-styled 'satanists' might get up to: you can't seriously imagine I have any interest in black sabbaths, cannibalism, kinky sex and that sort of stuff? Quite the contrary, it is in what you would call the 'positive' values that you'll find me and my works. I don't 'tempt' people. That's a very weak basis for influence. Deeply held beliefs, conceptual frameworks, moral convictions, taken-for-granted assumptions about reality – these are my handles on human action, not sensual appetites and whims. You've no idea how difficult it is to get anguish and grief out of the pursuit of pure pleasure.

What we all want to know is why people work for you.

They have the best of intentions, naturally. I ask a good deal from my human resources, but my demands are quite specific and contractual. Souls are pretty cheap on the market right now, and you'd be surprised at the

low prices being asked. They are so undervalued, plenty of people don't even ask anything in return. Recruitment isn't a problem.

My job isn't as nice as it might sound. Frankly I've been really stressed out lately. I'm working harder than I can remember working for ages, but I can't help feeling that my job is losing much of its appeal. In earlier times there used to be a sense of pride when I'd succeeded in getting some poor soul into Hell. Nowadays they're coming in droves without much effort on my part. I wonder sometimes whether I'm really necessary any longer. But the spectacle of all my customers working themselves to death on my behalf usually restores my self-esteem.

What role do intellectuals play in your project?

They have been quite crucial in the first stages of the process, but it's becoming unnecessary to have quite so many of them. But I should clarify something first. What distinguishes intellectuals from my point of view is not their intelligence as such. The function they perform for me has more to do with their more sophisticated levels of stupidity than their cleverness. I realise that 'intelligence' may be a complex concept for you and that you find 'stupidity' an offensive judgement, but for me intelligence is quite simple, while stupidity is a truly wonderful accomplishment. Intelligent people can do arduous mental tricks; this requires a lot of discipline and alertness, rather like synchronised swimming. Stupidity, however, is a much higher-order capability: it means using one's intelligence reflexively – turning it against itself (say, synchronised drowning, for example). That is something of which not all intelligent people are capable. Intellectuals, however, are drawn to this irresistibly, which is why I have a special interest in them and why they have so much more to offer.

Who do you mean by 'intellectuals'? This is a difficult category to define.

No it isn't.

Well, for example, there is the classic French concept of the politically-engaged writer; there is the broader notion of an 'intelligentsia' – all those with some educational credentials; there is Gramsci's distinction between traditional and organic intellectuals.

My definition is practical. Intellectuals are all those who depend on ideas for their livelihood. Intellectuals, however you define them, distinguish themselves from others the moment they begin to acquire a vested interest in ideas. Once ideas – concepts, categories, words – have a value over and above their mere 'meaning' or 'reference' (what they may refer to for non-intellectuals), that's when I can log on and start to make things happen. Intellectuals naturally blame the 'ideas' themselves for the mayhem which their own use of them makes possible. That's why they

spend so much time struggling to try to abolish one idea after another That's what being 'radical' means: trying to get rid of the 'meanings' of words.

Hence the stigmatising, discrediting and abolishing of words. Entire chapters of the thesaurus have been rounded up over the last twenty years, and made to wear the pillory of inverted commas: 'Humanity', 'Nature', 'Reality', 'Truth', and so forth. But meanings change, and the reason for the taboo is forgotten, and the ideas reappear under different names. In order to extinguish intolerable concepts, intellectuals have increasingly had to go beyond trying to deprive words of their meaning, to the abolition of thinking itself – something I'm very interested in.

And this isn't even the best part of it. Desperately seeking 'new' ideas and ways of thinking (fleeing from the meaning of words) is far from the mere madness of a few professional theorists. This frenzy to forget, this veritable will to deny negativity, if I can put it like that, is what makes it possible (when this has all been automated through mediated communication) for millions of people to positively desire their own damnation. Without this ongoing holocaust of ideas by intellectuals, how do you think I could induce so many intelligent human beings to trade in their lives for a few signs.

Intellectuals, scientists and artists, especially in this century, have made such enormous contributions to human unhappiness, that you might think it would be difficult to imagine what more could be done. But there is always scope for improvement.

Where do you stand in relation to the question of modernity and post-modernity? Is Satanism post-modern?

So far, modernity's long-term project for the destruction and replacement of both the natural world and social existence has had to be conducted under the aegis of various positive ideals of one kind or another: progress enshrined as the forward march of Reason, for example. But the discrediting and abolition of all ethical, cognitive and aesthetic values has also been an essential and continuing part of the modern project: reason, truth, nature, humanity, the individual as categories have had to be overthrown: that is part of 'enlightenment'. Thus the present challenge can be stated: how to further this essentially destructive project without any illusory categories by which it might be made morally acceptable, intellectually intelligible or aesthetically exciting? How, in other words, can the extermination of nature, life, the human species, social relations, language, thought, and everything else be pursued further when there is incredulity towards these ideas? That modernity is an entirely negative project is now evident. It is time now, surely, for this negativity to acquire its own positive image.

But why is modernity out to destroy nature?

The 'modern' attitude is characterised by its abstraction: selecting something simple, which always means forgetting something else. Modernity is abstraction in action – forgetting as a practical programme.

Modernity is not just at war with nature but also with society, against anything in fact to which, because of the familiarity and security it gives, a concept of 'natural' could be applied. Modernity is the commitment to insecurity and change for their own sake and finds the very idea of such limits intolerable. Everything has to be broken in order to be amended. Nature too had to be redefined according to the idea of 'evolution' so that its destruction also became 'natural'. The feeling that nature isn't good enough really comes, as I've said, from the need to substitute concepts for what they were thought to refer to, which is a kind of fraud, and modernization is the practice of getting rid of the evidence. To modernize things, then, means to simplify them. Post-modernity is just the widespread sense of having finally succeeded.

The concept of 'future' which you're so preoccupied with illustrates how easily this idea of change ensnares you. By talking about it as a kind of place you're going to and trying to get prestige by being there before everyone else you're only inviting disappointment. When the future is always invoked by its difference, as somewhere else, and used to invalidate the past, it leaves the here and now in my hands. There's really no such place as the future.

Modernity means conceiving temporality in terms of space: always talking about areas, zones, fields, boundaries, sites and so on, and thinking of change as 'movement' – going 'forward', 'advancing', making 'progress' and all the rest. Since you have such difficulty with time, you're not going to understand eternity, which doesn't mean that no time is 'taking place' (to persist with your spatial terminology), but that it goes on forever. But that's where I'm at – where I'm 'coming from' as you might say.

Time only exists for living creatures, and only exists for that duration. But your limited binary opposition between life and death excludes the existence of other beings, like myself, who are neither 'alive' nor 'dead' according to your scheme of things: beings who have all the time in the world.

How does your own approach to the question of the 'Future of Nature' differ from that taken by others in these recent discussions?

In the first place, my work is continually being frustrated by what you call nature – human nature especially. Anything that contributes to its elimination, or at least to reduce its interference, is very welcome. The concept of 'Nature' that seems to preoccupy modern intellectuals is altogether different.

Either you think of it as some kind of harmonious order (like the 'ecosystem' notion – as if it were like one of your machines or corporations) or else you think of it as wild and chaotic, anarchic and indefinable. Intellectuals, eschewing 'reference', insist in treating it as a ('socially constructed') concept. Under any other name, however, it exists sure enough as everything outside my reach. My only access is through the ideas and beliefs by which I influence human activity. The mind is my means to make the body suffer: that's its function. All those parts of 'nature' which get in the way of, or which can't be used for, this purpose will have to go, one way or another.

What we would be most interested in is how you see technology. It has been the massive changes in information and communications technologies, on the one hand, and on the other, the new advances in genetics and biotechnology, that have provoked intense discussion around their far-reaching social and cultural implications. Where would you like to start?

These are two aspects of the same process. On the one side is what you call 'mind' is going to have to be abolished; there's been considerable progress on this front already. On the other, the body is going to have to be radically restructured and abolished in its present form. I prefer to keep these two parallel projects separate, according to my established mind/body dualism schema, so that they don't interfere with each other.

Information and communications technologies arouse tremendous enthusiasm, while genetic engineering provokes fear. The Internet teaches you that information is the real life-force, while genetics has learnt to treat life as really just information. The former superstitious reverence for 'life' can now be transferred to pure abstraction: 'signs'.

Why does the body have to be abolished?

Let's face it, the human body is boring. Clothing, cosmetics, tattoos and scarifications attest to the universal desire to reconfigure whatever nature keeps reproducing: flattening children's heads in South America, binding girls' feet in China, and so on. You humans are always playing around with your bodies. How it might be re-engineered has exercised utopians for centuries. Biotechnologists aren't going to give your descendants wings, horns and tentacles, or as yet unimaginable organs and capabilities (as if it didn't have too many organs already!). It will, however, be possible to radically simplify the basic design.

The human neuro-system is an incredibly sophisticated apparatus for suffering. Its capacities as a machine for producing misery, pain, frustration, anxiety and unhappiness remain unsurpassed in nature. Its potential is, however, directly connected with its physical and social environment.

These limitations have to a great extent been overcome technologically, but improvement is imperative.

My concern is how to get rid of the body whilst preserving and enhancing the capacity for pain, discomfort and all the other essential features of what you call consciousness. What I'm working on at the moment is phasing out Life into something new. Until recently living has been a necessary preparatory phase for being dead, a period for programming in all the information and experience you need for the afterlife. Now it's becoming technically obsolete. With the new levels of acceleration available, it hardly takes any time at all to download an individually-customised eternal damnation package. So it's no longer necessary for people to be 'alive', strictly speaking, before dying.

This is the Virtual Hell we've heard so much about?

That's right. It's now generally agreed that the earth and all that dwells therein is no longer needed. Having a digitalised copy of the world, the original can be deleted. Freed from personal identity, with its dependence on stored memory, which wastes time and space, sensory experiences can be supplied when needed, made up as one goes along, so to speak. Without extraneous distractions, or means of return, the mind will be able to inhabit a reality entirely of its own making. That's what the old Hell was really all about: living forever with everything you wanted to forget; this will soon be available everywhere for everyone.

Some of the exciting new possibilities can be envisaged. Imagine a world where every desire can be instantly frustrated, indeed where every desire can be guaranteed to arise precisely customised to the means for its dissatisfaction, where every expectation will be immediately, and yet unexpectedly, thwarted.

Technology cannot fail to bring about such a world, since this would be a universe brought fully under control, consistent with the very *nature* of technology. How else can the desire for meaning, for a pre-ordained harmony between the human mind and its environment, which animates scientific and technological progress, be achieved than by replacing the world by one designed to fit the human mind so perfectly? Far from being an 'incomprehensible' universe, it would bring reality itself into line with everyday experience: only in this way would the world for the first time *make sense* at last.

And this abolition of the world is the knowledge you bring to us?

Everyone shall live in their own cybernetic sensorium, where reality is whatever can be experienced. To experience reality means to suffer. This is the truly radical vision of the future. The ultimate meaning of enlightenment is not to create contentment, but to subvert all the dumb certainties of existence, to make everything problematic – to make

everything into a problem – in short, to make life intolerable, and 'everyday life' impossible. Intellectuals are committed to this in theory; every advance in knowledge deepens the mystery and confusion of existence, as you know. Technology is this enlightenment in practice.

Index